OUR
CENTURY
IN
PICTURES

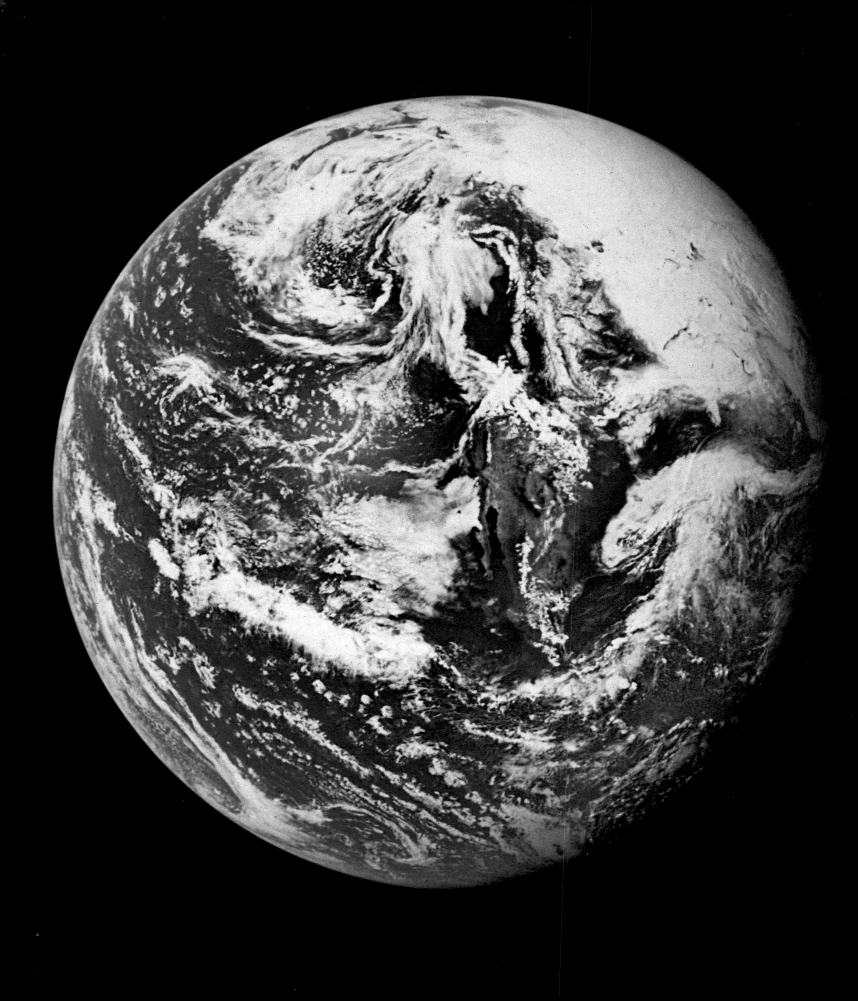

LIFE

OUR CENTURY IN PICTURES

EDITED BY RICHARD B. STOLLEY

TONY CHIU, DEPUTY EDITOR AND WRITER

A BULFINCH PRESS BOOK

LITTLE, BROWN AND COMPANY · BOSTON NEW YORK LONDON

Contents

209

242

317

373

416

Dust Bowls and Other Dreams

BY RICHARD B. STOLLEY, EDITOR

DON'T LOOK BACK, Satchel Paige advised, something may be gaining on you. Those of us who produced this book had no choice. While everyone else seemed to be breaking out party hats for the next millennium, we were steeping ourselves in the final century of the one fast slipping by.

Other fine books about the century use images to supplement the text. We went at the job the other way around. We were determined to tell the story in photographs. Our book has important words, of course — nine provocative essays by distinguished authors, information-rich captions for each of the 770 or so photographs. But we wanted pictures to carry the narrative; we felt that Americans today are visually sophisticated enough to read photographs and fully comprehend the information and emotion they impart. As our title promises, this is truly a picture history of the last 100 years.

We have divided the century into nine epochs, our book into nine chapters. We tell the story as the world lived it, chronologically. Within each epoch is a special section called Turning Point. Here, we put a key event in context by looking back in time at its antecedents, as well as forward in time to assess its impact. And following each epoch is Requiem, a roll call of some important newsmakers, especially cultural ones, who died during those years.

Deciding which pictures to use was a monumental, and agonizing, task. They came from the massive Time Inc. picture collection and from other archives around the world. We figure we inspected some 50,000 photographs; fewer than two percent of them made it into our book.

This immersion in the past had a peculiar effect on me. I found myself living those years during the day and dreaming about them at night. My dreams ranged across the century: One night I was a frightened doughboy in France; another, a Dust Bowl farmer hopefully heading west; a third, a laid-back dweller in a Sixties commune.

For all of us, the history lessons contained in the pictures were perhaps not surprising but overwhelmingly clear. Ours was an appallingly violent century; the death and destruction were almost beyond human comprehension. Yet again and again we discovered what Wordsworth described as the "little, nameless, unremembered acts of kindness and of love." And in the midst of worldwide terror, we saw evidence of astonishing ingenuity in science and the arts all around the beleaguered globe.

In selecting the pictures, we wanted to use the famous and familiar, yet illuminate them with companion images. Thus, you'll see the flag raising on Iwo Jima and a haunting picture of doomed Marines taken a few minutes later; the brave Chinese youth stopping the tanks in Tiananmen Square and then,

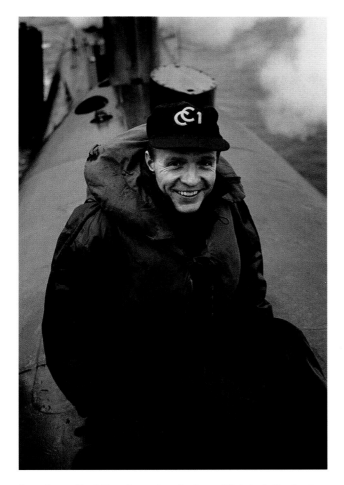

Reporting on the U.S. nuclear submarine base at Holy Loch, Scotland, in late March 1969, Dick Stolley, 41, was photographed on the deck of a sub about to embark on a 90-day Cold War patrol mission. He recalls, "Everyone topside was required to wear a life jacket because the wind — which the sailors called 'the hawk' — was strong enough to blow you overboard."

BILL RAY / LIFE

incredibly, climbing up on one to plead with the crew; the weeping Navy accordionist playing for the fallen Franklin D. Roosevelt, while a heartbreaking phalanx of the president's fellow polio victims line up in their wheelchairs to say farewell too; a rarely seen sequence of events just before and after a South Vietnamese general shockingly executed a Vietcong suspect on a Saigon street.

Finding pictures that were surprising and fresh was a constant wonder. Just to pick a disparate few: the first fatal airplane crash, which also badly in-jured pilot Orville Wright; the room where the Czar and his family were murdered, its walls pocked with bullet holes; Walt Disney and his staff unself-consciously wearing, of all Hollywood outfits, knickers, every last man; invading Soviet tanks lined up on a Prague side street like taxicabs, while shoppers casually stroll by.

Personally, this book is a kind of retrospective on my life as a journalist. I covered many of the events portrayed herein — among them, the Southern civil rights struggle, Elvis in his early days, Israeli-Arab combat along the Suez Canal, JFK's death in Dallas, the search for early man in Kenya. (I still have a hand-ful of two-million-year-old crocodile bones from that assignment.) I was actually present when some of the pictures were taken — integration in Little Rock, the H-bomb test high above the Pacific, street rioting in Paris, arming nuclear subs in Scotland.

For you, as it has been for me, I hope this book will be a keepsake, a provoker of memories, a guide to how things and people behaved and looked in the 20th Century.

Permit me one final observation. It is the re-markable extent to which the United States for the past 100 years has been spared so much of the misery inflicted elsewhere in the world. Our soldiers died, but rarely our civilians. Our cities were never bombed. Since 1865, we have endured internal strife but have not taken up arms against ourselves. We still suffer from the sordid legacy of slavery, but at home we are mostly at peace. God has indeed shed his grace on us, from sea to shining sea.

Joining Life *magazine in 1953, Richard B. Stolley served as chief of its bureaus in Atlanta, Los Angeles, Wash-ington and Paris, and later as its editor. He was found-ing editor of* People *magazine in 1974 and then editorial director of the parent company, Time Inc., for which he is now senior editorial adviser.*

Slipping the surly bonds of earth, Wilbur Wright, 35,
piloted a glider above North Carolina in 1902. Next
challenge for him and kid brother Orville: powered flight.

1900–1913

ACROSS THE THRESHOLD

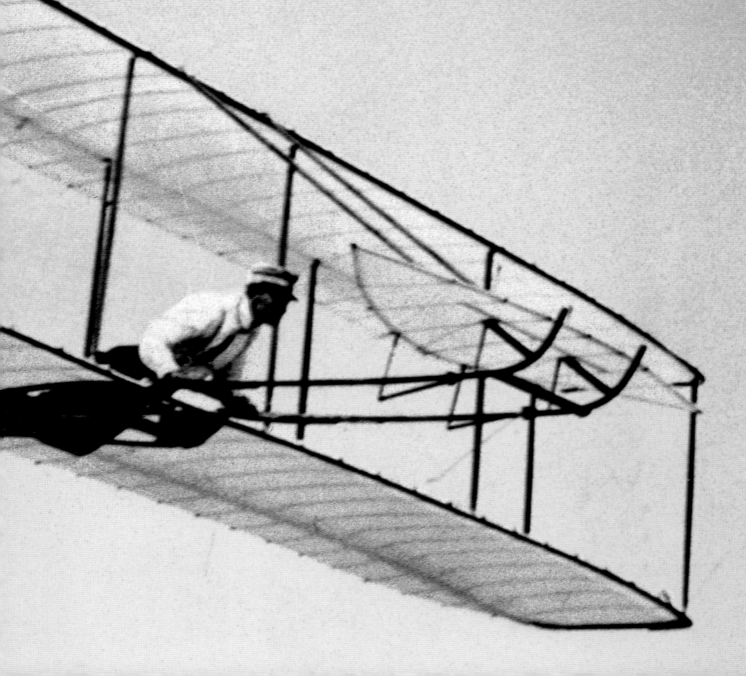

Rough-Riding into American Hearts

BY H.W. BRANDS

THE NATION NEEDED HEROES. Thirty-five years after Appomattox, the supply of Civil War heroes was slipping badly. The frontier was vanishing and with it the prospect of additional Daniel Boones and David Crocketts. The swelling cities swallowed individuals, erasing their faces and their freedom of action. Industrialization made men mere parts, interchangeable cogs in schemes far beyond their control.

What passed for heroes in that anonymizing age were the captains of industry: Carnegie, Rockefeller, Morgan. Carnegie's courage had been measured in the Battle of Homestead, waged by his hired army against his own Pennsylvania steelworkers while little Andy took his holiday in Scotland. Rockefeller's signal accomplishment consisted in cornering kerosene and making vassals of the millions who had the effrontery to wish to light their homes at night. Morgan commanded the money that commanded everything else; in the latest financial panic he had held hostage the very Treasury of the United States till President Cleveland met his exacting conditions. How high the ransom ran, Morgan disdained to reveal.

The people ached for a champion, one who could best the moguls and restore the promise of American democracy. Some thought they saw him in William Jennings Bryan, the silver-throated, iron-lunged orator from the plains of Nebraska. But the moguls and

their political allies scorched the earth around Bryan's 1896 candidacy for president, and power remained safely with the interests.

And then, like a bolt from the clear Cuban sky in the summer of 1898, a national hero, a popular champion, appeared. Theodore Roosevelt led his Rough Riders up the San Juan Heights and onto the plateau of American popularity — indeed, American adulation. The politicos tried to co-opt him by making him the Republican nominee for New York governor; but upon winning that office, he instantly exhibited the independent spirit expected of the Dakota ranchman he had been before the Spanish-American War. Thereupon the bosses sought to imprison him in the vice presidency, only to rue their choice when William McKinley died and "that damned cowboy" — in boss Mark Hanna's derisive phrase — assumed the highest office in the land.

During the first dozen years of the 20th Century, Theodore Roosevelt dominated American national life as no one had dominated it before. He was an arresting presence — that muscular figure, forever in motion; the blue eyes blazing behind his spectacles, transfixing friends with their exuberance and foes with their intensity; the teeth that bit his words like tenpenny nails and snapped defiance at all who trespassed upon the public interest.

Roosevelt was a character who became a caricature without ceasing to be a force. Acquaintances, in-

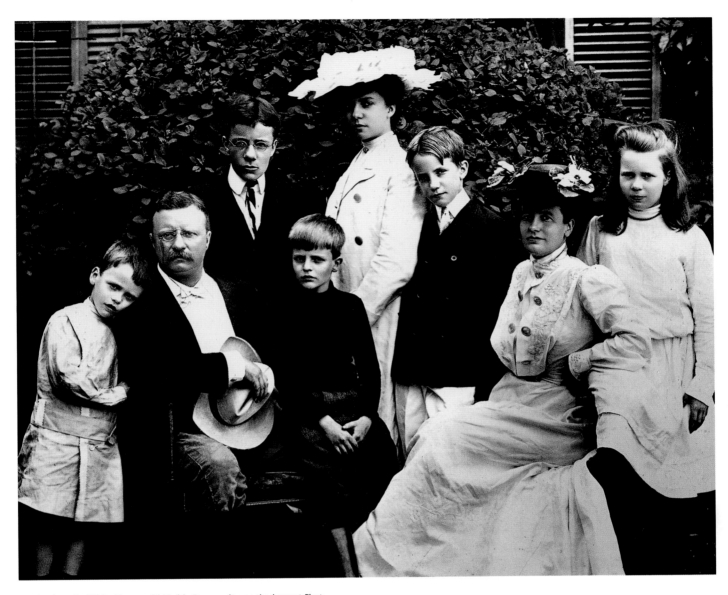

Moving into the White House with Teddy Roosevelt was the largest First Family ever. In this 1903 portrait, the President, then 44, posed with, from left: Quentin, 5; Theodore Jr., 16; Archibald, 9; Alice, 19; Kermit, 13; his second wife, Edith, 42; and Ethel, 12.

deed, likened him to a force of nature; Henry Adams called him "pure act." Roosevelt announced his presence in the White House by declaring war on J. Pierpont Morgan's newest brainchild, the Northern Securities railroad trust. Morgan had opened the new century by unveiling the world's first billion-dollar corporation, U.S. Steel; Wall Street thought him invulnerable to presidents and other mere mortals. But David slung his stones, the people cheered, and —

when the Supreme Court sided with TR and the people against Morgan and money — Goliath fell.

Roosevelt employed equal energy against big capital in a 1902 anthracite strike, threatening to use federal troops to keep the coal supply from failing and the nation from freezing. He reined in railroad rates and safeguarded the nation's food supply. He recaptured America's forests for America's people and harnessed the waterways of the West to the needs of Western farmers. He launched a successful assault on the biggest monopoly of all, Rockefeller's Standard Oil. In America's name he seized the Panama Canal Zone and started digging. He ap-

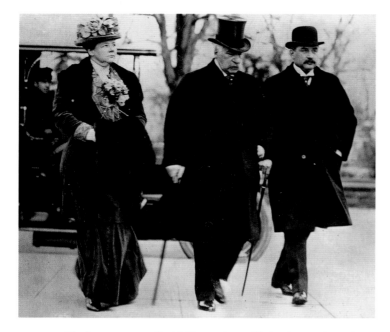

The fortune amassed by J.P. Morgan, here with daughter Louisa and son J.P. Jr., would today trail only those of Bill Gates and Warren Buffet. Among his holdings: England's White Star Line. In 1912, Morgan, 75, booked onto *Titanic*'s maiden voyage but canceled at the last minute. TIME INC.

pointed America the policeman of the Western Hemisphere. He established himself as arbiter between Russia and Japan in northeastern Asia — and won a Nobel Peace Prize for his pains.

Americans loved Roosevelt. They elected him by a historic margin in 1904 and would have re-elected him in 1908 had he not, with uncharacteristic modesty, forsworn another race. They hung on his hunting exploits in Africa after he left the presidency ("Let every lion do his duty" was the toast among the Morgan crowd as TR's boat left New York), and upon his return they demanded another try for the top. When the Republican bosses once more stood against him, he broke ranks and fashioned his own party, aptly nicknamed Bull Moose. At the climax of the 1912 campaign an aspiring assassin shot him; bloodied but undaunted, he staggered to the finish in the strongest third-party showing in American history.

Roosevelt's hold on the American psyche said much about him; it said more about the America of his era. America was not what it had been, and daily it was becoming less so. Cities replaced country at the nation's center of moral gravity; factories out-muscled farms. Immigrants by the millions swarmed the ports, planting cultural and linguistic beach-heads of their homelands on American shores. Radical labor unionists agitated for social revolution. Race riots and lynchings ravaged not simply the South but the Midwestern heartland of the country, sparing not even Springfield, Illinois, the home of the Great Emancipator, Abraham Lincoln. Muck-raking journalists revealed the insidious influence of money in politics, the corruption that mocked America's attachment to democracy.

Even the good news was unsettling. Henry Ford's Model T put the nation on wheels but in doing so changed the face of cities and small towns across the land — besides creating a rolling threat to life and limb. Frederick Taylor's gospel of "scientific management" boosted industrial output but dead-ened the souls of workers so scientifically managed. A revolution in printing technology drove down the price of newspapers, but competition for advertising to pay off the new presses drove down the editorial quality of the papers. Rural free delivery brought newspapers and magazines to farms but helped ho-mogenize American culture. Burgeoning industries opened new job opportunities for women but also sucked in thousands of children — and produced such workplace disasters as the appalling Triangle Shirtwaist fire of 1911.

The new century was carrying America forward, but with each step forward the country seemed to take a half step back. Reformers hopefully hitching themselves to the label "progress" sought to secure the benefits of industrialization while mitigating its costs. The progressives applied scientific manage-ment concepts to government, creating commis-sions and councils of the middle class to break the

hold of immigrant-backed bosses. Progressive editors like S.S. McClure employed the new printing technology to price their magazines at a dime and propagate their message to millions formerly beyond the reach of quality journals. Progressive lawyers like Louis Brandeis brought sociology and economics to the courtroom to defend statutes designed to end monopolistic practices and unsafe working conditions.

Yet though the progressives had a program, as a group they lacked the ability to inspire passion. Belligerent nickname and aggressive coiffure notwithstanding, "Battling Bob" La Follette hardly set hearts pounding with his "Wisconsin idea" of political and economic reform. Nor could ordinary Americans get exercised over initiative, referendum and recall.

What progressivism needed was a compelling persona — which was precisely what it got in Theodore Roosevelt. Roosevelt was the real thing — cowboy, war hero, fierce foe of vested interests — but he was also a master at magnifying his popular appeal. Intuitively appreciating the possibilities of modern journalism, he cultivated the press, winning over reporters by the force of his personality and making them almost co-conspirators in his efforts on behalf of the American people. He showed off his family, the most boisterous bunch ever to occupy the White House. He christened the "bully pulpit" and preached from it regularly. His hunting trips (including the famous Mississippi bear hunt at which he spared what became the prototype for the teddy bear), his reunions with his Rough Rider comrades, his obvious delight ("Dee-lighted!" sprang from his mouth even more often than "Bully!") in mingling with farmers, loggers, miners, factory workers — all of this honestly reflected the person he was, but it also amplified the persona he adopted.

Roosevelt's appeal rested on his ability to bridge two eras. His heroic persona was a throwback to the 19th Century, which grew the more heroic the far-

America in 1900 consisted of the Lower 45. Still territories: Oklahoma, Arizona and New Mexico. Alaska, bought from Russia in 1867 for $7.2 million, was aswarm with gold rushers. And Hawaii, handed over by pineapple king Sanford Dole after he wrested the islands from Queen Liliuokalani, had been a U.S. possession for only two years.

ther it receded into romantic memory. Yet his progressive politics were solidly anchored in the 20th Century, and his ability to put across his persona relied on techniques unavailable to his predecessors.

The nation needed heroes — precisely because heroes, as it had known them, were unsuited to what the nation was becoming. Pierpont Morgan, the marshal of finance, was more characteristic of the new century than Teddy Roosevelt, the colonel of the First Volunteer Cavalry. At some level Americans understood this; after all, they had made Morgan and Carnegie and Rockefeller rich. But Americans didn't like what this said about them as a people. Roosevelt represented traditional values and tested truths, items always in demand in America, and never more in demand than during the unnerving first decade of what promised to be a most unsettling century.

H.W. Brands is the author of 14 books, including T.R.: The Last Romantic *(1997)* and Masters of Enterprise *(1999). He is Thomas Professor in Liberal Arts at Texas A&M University.*

MAJESTIC TWILIGHT

As the 20th Century dawned, the four rulers pictured here governed three out of every five human beings alive. Their world was less populous (1.6 billion versus almost six billion now) and divided into fewer sovereign states (some 50 versus today's 190 plus). But their kingdoms, so dominant for centuries, were about to be engulfed by a global quest for independence. Revolutions swept out the Chinese and the Russian dynasties. The Ottoman Empire crumbled after World War I. And in 1997, when Hong Kong reverted to China, the sun finally set on the British Empire.

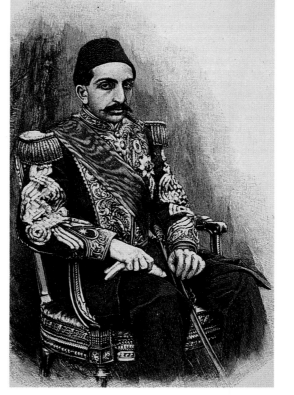

<
ABDUL HAMID II

The Ottoman sultanate he inherited in 1876, at age 34, was just a husk of the mighty Islamic empire that in the 16th Century, under Sulayman the Magnificent, reached from eastern Europe to Persia and down to Arabia. Abdul Hamid II ruled erratically from the seclusion of his Istanbul palace until deposed in 1909 by the reformist Young Turks. He died in 1918, at about the same time as the 600-year-old Ottoman Empire, which was dissolved by various World War I peace treaties.

ARCHIVE PHOTOS

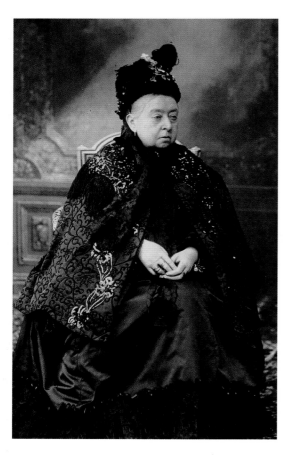

<
VICTORIA

In 1837, one month after her 18th birthday, she became Queen of the United Kingdom of Great Britain and Ireland. Hers was a prosperous realm thanks to the ongoing Industrial Revolution, which England had launched. Hers was also the greatest colonial empire of the 19th Century, which she expanded even farther, taking in 1876 the title of Empress of India. By her achievements and her length of reign — 63 years, the longest in English history — Victoria rightly lent her name to an age.

TIME INC.

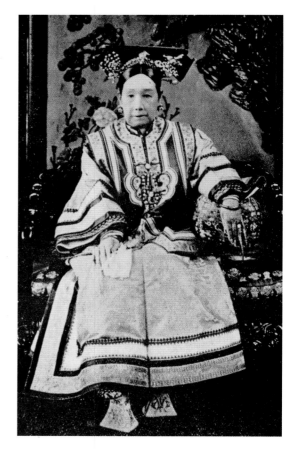

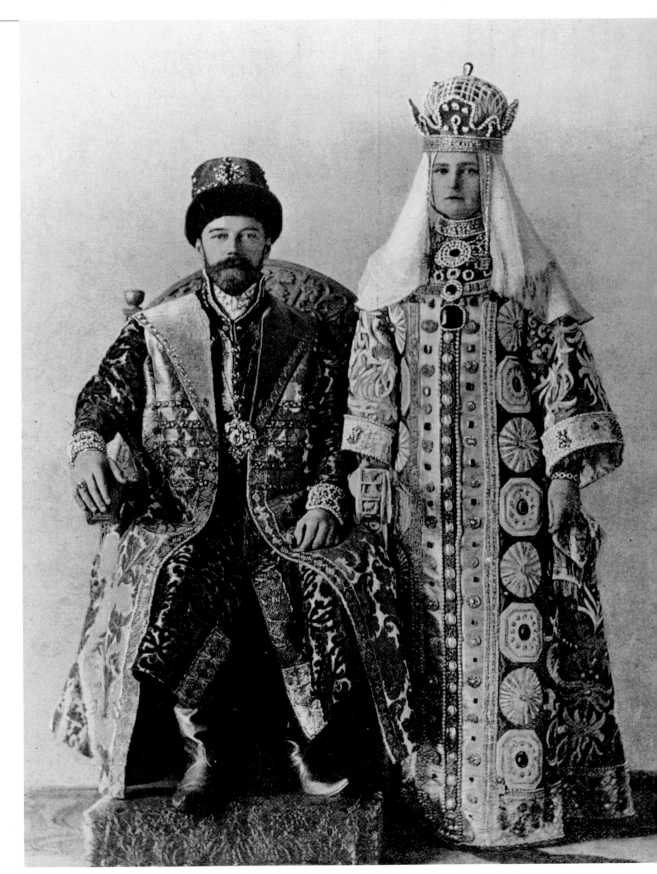

On becoming, at 26, the 18th in the Romanov line to rule Russia since 1613, Nicholas immediately took as his czarina Alexandra (right), a granddaughter of Queen Victoria. He proved a better husband than monarch. Comfortable only with his family and inner court, Nicholas was easily swayed by advisers like the semiliterate faith healer Rasputin. Isolated from his subjects, he had no grasp of the vast unrest that would lead to the Russian Revolution of 1917 — and to the violent end of the Romanov succession (see page 58).

TIME INC.

<

TZ'U-HSI

No other concubine ever amassed the influence of China's notorious Empress Dowager. Tz'u-hsi began ruling the country in 1862, when her six-year-old son by Emperor Hsieng-feng ascended to the throne. Then 27, she remained in power even after his death and the failure of the Boxer Rebellion, the 1900 anti-Western uprising she encouraged. Nor did Tz'u-hsi ever stop scheming. In 1908, from her sickbed, she ordered that the then emperor — her nephew — be poisoned. He died a day before she did.

TIME INC.

1900–1913: ACROSS THE THRESHOLD 7

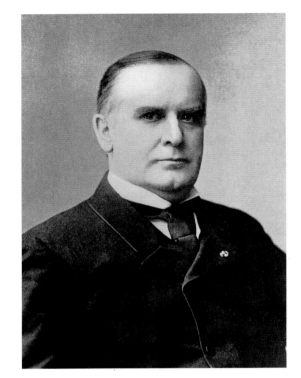

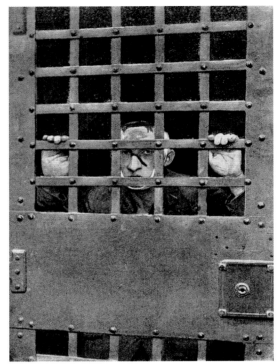

IN THE LINE OF DUTY

Having overseen the U.S.'s 1898 vanquishing of Spain (the victor's spoils: Cuba, Puerto Rico, Guam, the Philippines), William McKinley (near right) easily won a second term. He served only six months of it. On September 6, 1901, while visiting Buffalo, the 25th president became the third to be shot (after Lincoln and Garfield). McKinley, 58, lived eight more days; his assassin, 28-year-old anarchist Leon Czolgosz (far right), another 53 until he was sent to the electric chair.

RIGHT AND FAR RIGHT: TIME INC.

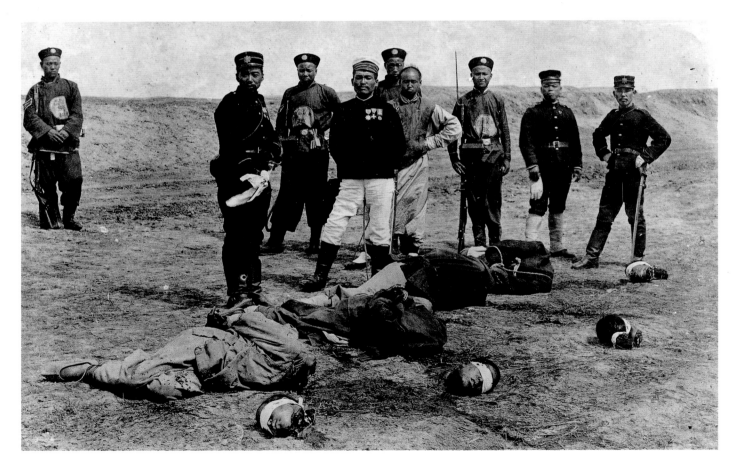

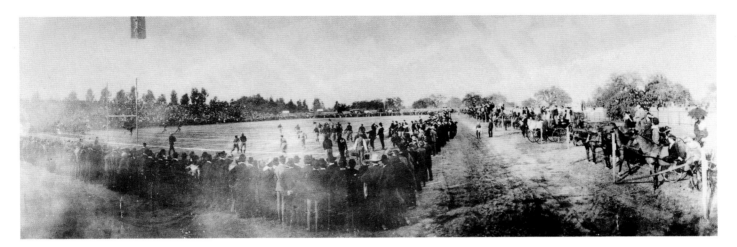

BIRTH OF A CLASSIC

On New Year's Day, 1902, 8,500 college football fans — some on horseback — watched the inaugural Rose Bowl in Pasadena, California. Every play on offense was a run; forward passes were illegal until 1906. And touchdowns and field goals both counted five points. Under any rules, it was a blowout: University of Michigan 49, Stanford 0.

BENTLEY HISTORICAL LIBRARY

<

ULTIMATE SACRIFICE

Four warriors of China's Righteous Harmony Fist movement were put to the sword in 1900 by the Japanese officer wiping clean his blade. The so-called Boxers were encouraged by the Empress Dowager to purge the Middle Kingdom of meddlesome foreigners and Christians. Their fatal mistake: attacking Western legations in Beijing. Eight nations quickly sent firearm-toting troops to crush the sword-wielding rebels.

AMERICAN MUSEUM OF
NATURAL HISTORY

TOUCHES OF CLASS

Though blind, deaf and mute before age 2, Helen Keller (near right) was, by 22, enough of a celebrity to pose with renowned actor Joseph Jefferson (far right) in 1902. She was then attending Radcliffe College, from which she graduated cum laude. Keller's real teacher was Anne Sullivan (center), the partially blind "miracle worker" only 14 years older than the pupil she had drawn into the world. Sullivan also interpreted for Keller at college and later accompanied her on world tours to promote rights for the disabled.

TIME INC.

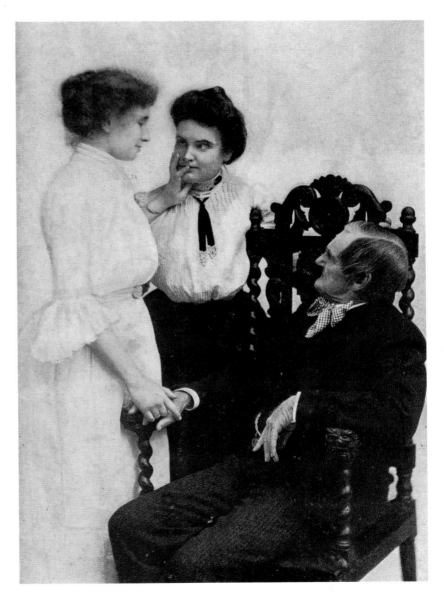

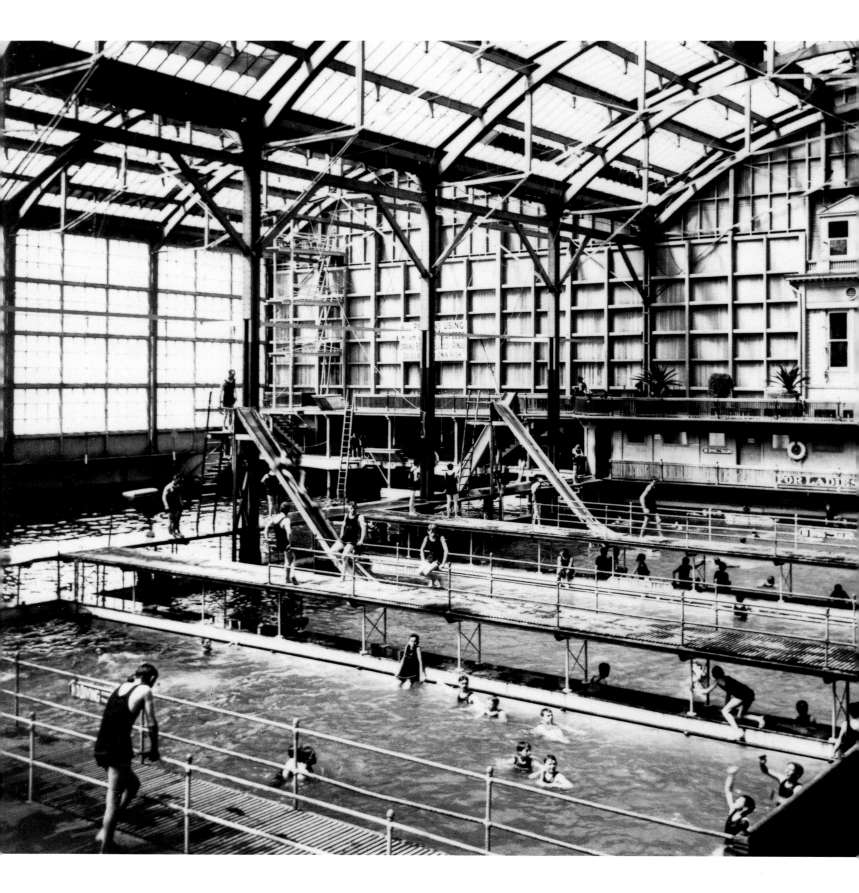

> TALE OF THE TAPE

Dot-dot-dot (Morse for the letter *S*) was what the 27-year-old Guglielmo Marconi (near right) and aide G.S. Kemp received on December 12, 1901. The moment was thought historic enough to restage for this photo because the two had been in Newfoundland — and the code sent from Cornwall, England, 1,800 miles away. The Italian-Irish Marconi won the 1909 physics Nobel for his contributions to the infant medium of radio.

PIX INC.

<

ALL WASHED UP

Fifty years after Millard Fillmore stunned the nation by having a tub put in the White House, many U.S. cities boasted public facilities (few as grand as San Francisco's Sutro Baths). The aim: to improve the hygiene of the working class (fees were typically a dime). At the turn of the century, however, even the homes of the rich usually lacked running water.

NATIONAL ARCHIVES

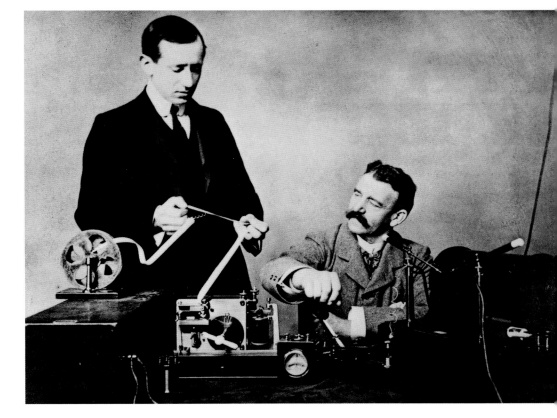

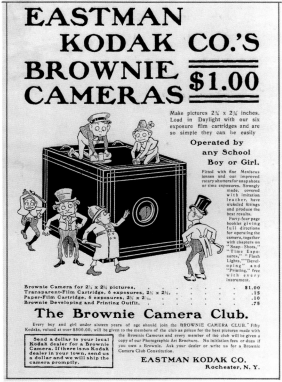

SAY CHEESE . . .

What does *Kodak* stand for? Nothing; the trade name was fabricated by George Eastman in 1888 because he liked the letter *K*. The ex–bank clerk, then 26, went on to invent ever-better film and cameras. No Kodak product had more impact than his 1900 box Brownie, which fulfilled Eastman's wish to make "the camera as convenient as the pencil."

EASTMAN KODAK CO.

THE WRIGHT STUFF

Yes, the brothers Wright were inventors — but they were also businessmen. After all, it was in their bicycle shop in Dayton, Ohio, that Wilbur and Orville fabricated their flying machines. They did have the foresight to position a photographer to document *Wright Flyer*'s first journey. But after extensively testing *Flyer No. 2* in the summer of 1904, they shunned the limelight to work out improvements — and to patent their designs. Not until 1908 did they go public by way of field trials for the U.S. Army (a $25,000 contract) and for the French (who paid them $100,000).

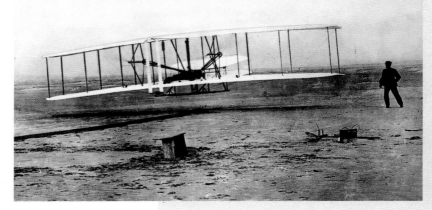

WE HAVE LIFTOFF
After rolling down a 60-foot track, Orville Wright, 32, soared past Wilbur and into history. That first powered flight, on December 17, 1903, at Kill Devil Hills, North Carolina, ended after 12 seconds and spanned all of 120 feet. But the last of the day's four trials covered an impressive 852 feet.

TIME INC.

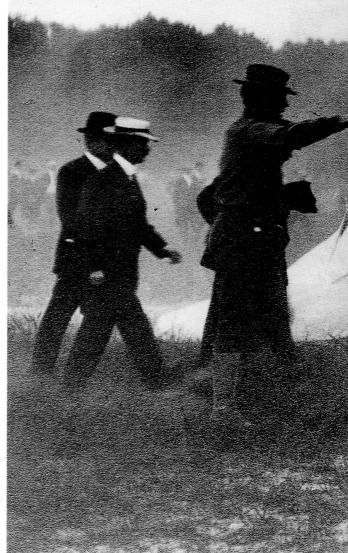

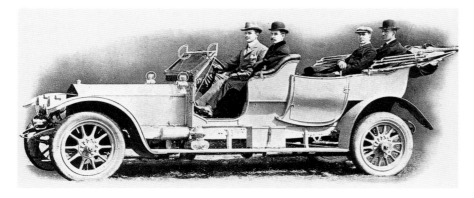

KNIGHTS OF LAND AND AIR
On a 1909 tour of Europe to promote their invention, the Wrights met automaker — and flying enthusiast — Charles Rolls (at the wheel of a six-cylinder Rolls-Royce; others pictured are, from left, Orville, patent agent Griffith Brewer and Wilbur). The next year Rolls became the first to fly across the English Channel and back nonstop. A month later he crashed and became, at 32, Britain's first air fatality.

TIME INC.

FATAL LANDING

Observers at the 1908 Army trials of the Wrights' two-man plane in Virginia hoisted the wreckage of the downed craft to free pilot Orville, who emerged with a broken leg, hip and ribs. The men at far right were tending to his passenger, who was not so fortunate; Lieutenant Thomas Self-ridge died of head injuries, the first victim of the air age. Cause of the crash: One of the new extra-long wooden propellers split. Though the Wrights had made flights as long as 70 minutes, the Army was more interested in speed. To pass these trials, the plane had to average a dangerous 40 mph.

SMITHSONIAN INSTITUTION

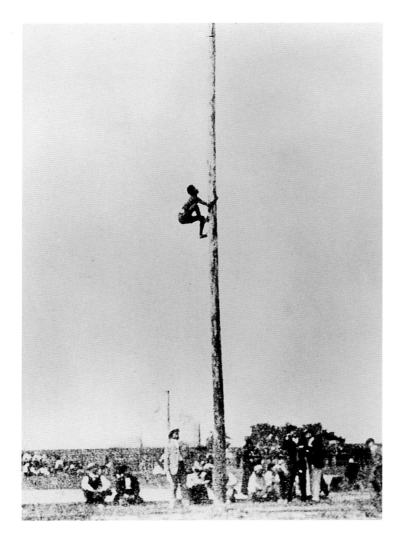

STRANGE OLYMPICS

As part of the world's fair in St. Louis, the 1904 Olympic Games included such embarrassing events as this pole climb (and mud fighting too) designed to showcase the talents of "indigenous" people, including American Indians and African pygmies. Only 12 countries and fewer than 700 athletes bothered to compete. The Olympics remained a sideshow until the Paris Games of 1924.

IOC ARCHIVES

MEET ME IN ST. LOUIS

Anchoring the 1904 Louisiana Purchase Exposition were 10 ornate palaces scattered across a 1,200-acre site in downtown St. Louis. Never mind that this world's fair, to mark the centennial of a real-estate deal even sweeter than that for Manhattan, opened a year late. Sixty-two nations and 43 states mounted exhibits, among them the actual log cabin in which Abraham Lincoln was born. The Expo's best innovation: the ice-cream cone.

TIME INC.

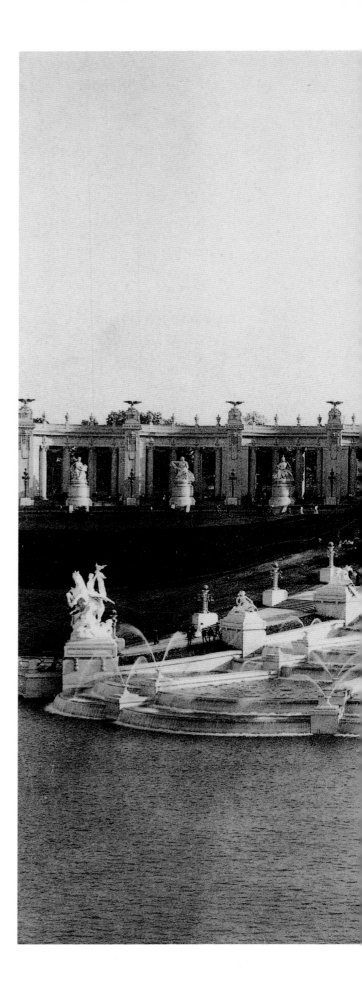

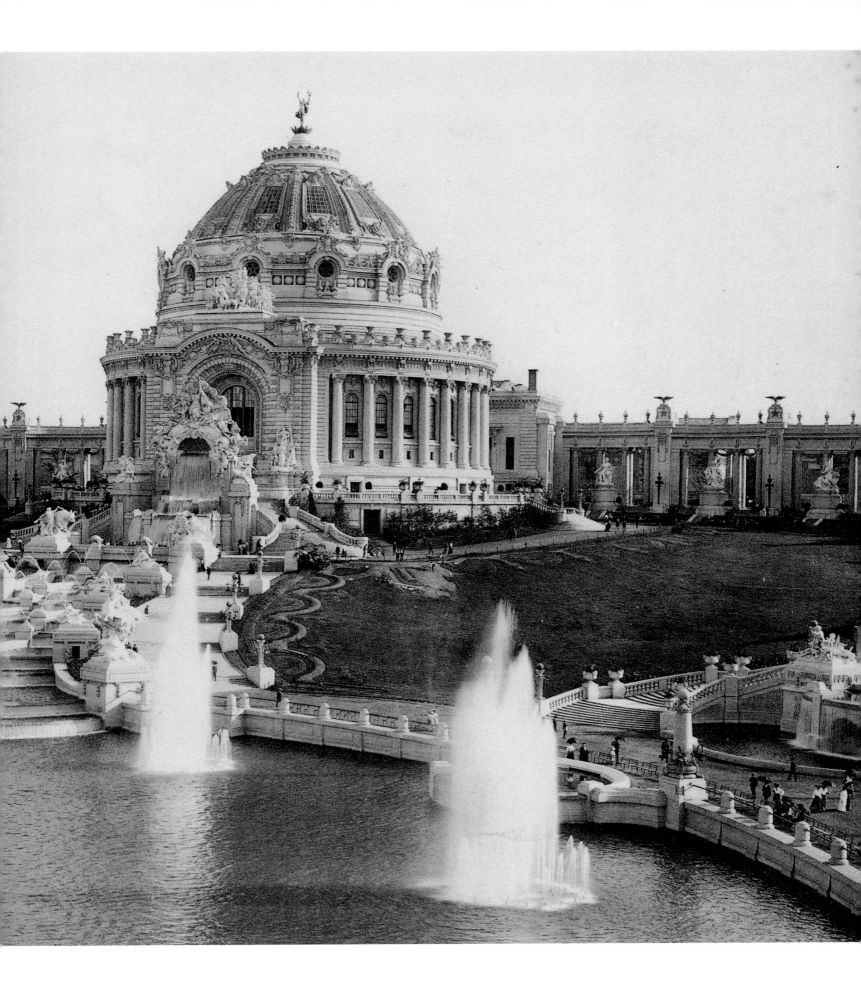

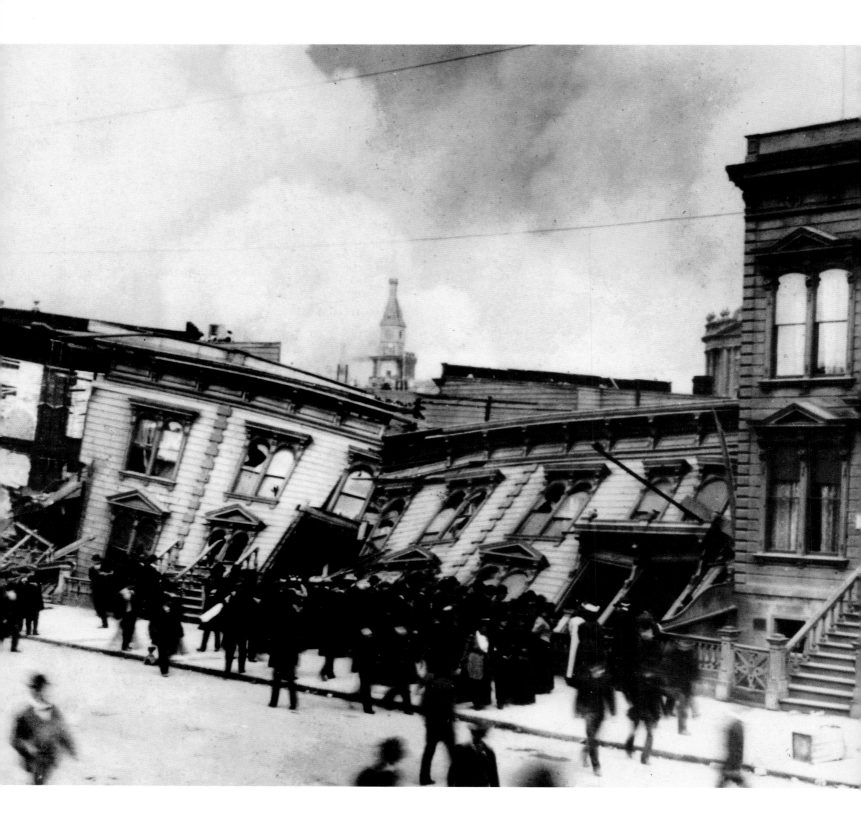

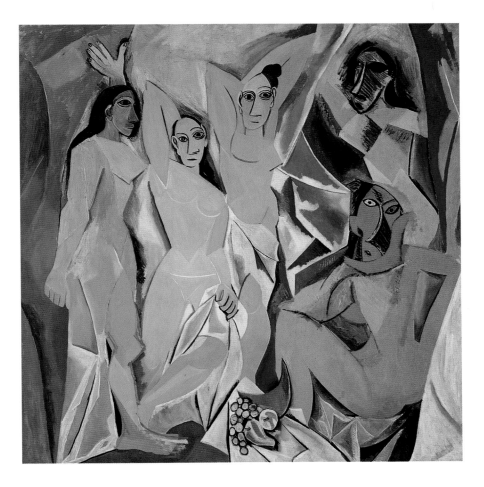

ART TAKES A NEW SHAPE

Western painters were searching for new directions when a 26-year-old Spaniard set on canvas a radical, form-fracturing vision. From 1907's *Les Demoiselles d' Avignon* sprang Cubism — though for years Pablo Picasso, unsure of what he had wrought, showed the work only to close friends. Nor was it put on public exhibition until 1916.

MUSEUM OF MODERN ART

A CITY TUMBLES DOWN

Thirty-five years after Mrs. O'Leary's cow was blamed for the Chicago Fire, the Quake of 1906 totaled San Francisco. The main tremor on April 18 lasted less than a minute but was thought to have neared 8.3 on the Richter scale (invented in 1935, with a top value of 10). Worse was the blaze that began shortly after this photo was taken. When the last flames were put out three days later, as many as 3,000 were dead or missing, and 225,000 — more than half the city's residents — were homeless.

NOAA / EDS

FOOL FOR LOVE

At 16, Pittsburgh-born chorus-liner Evelyn Nesbit took as her sugar daddy New York architect Stanford White (whose works include the Washington Square Arch). At 19, she married mining scion Harry Thaw. He couldn't handle Nesbit's tales of rough sex with White and so in 1906 shot her former lover dead. America's first Trial of the Century ended with Thaw adjudged insane.

RUDOLF EICKEMEYER / SMITHSONIAN INSTITUTION

THE GERM SPREADER

Irish-born Mary Mallon easily found work in New York as a cook. Alas, the wealthy families she fed often took ill. In 1907, public health officials found Mallon, then 38, to be infected with typhoid while remaining herself unaffected. Dubbed Typhoid Mary by the press, she used aliases to keep cooking until 1915, when the state institutionalized her for life.

CORBIS /BETTMANN-UPI

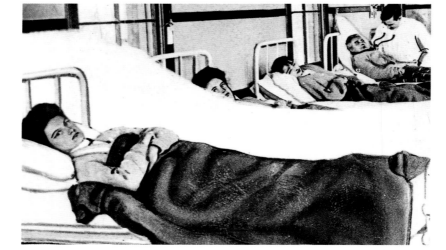

UPTOWN, DOWNTOWN

By 1902, New York City's 3.4 million citizens were no longer well-served by the rackety, sunlight-blocking elevated transit lines (right) that had begun sprouting in the late 1870s. The solution: Follow the example of London (1863), Budapest (1896), Boston (1897) and Paris (1900) by going underground (left). Manhattan's first subway opened in 1904 with a nickel fare. By 1940, there were 462 stations along a 230-mile route (93 miles of it aboveground) criss-crossing every borough.

LEFT: GEORGE P. HALL & SON /
NEW YORK PUBLIC LIBRARY
RIGHT: LEWIS W. HINE /
NEW YORK PUBLIC LIBRARY

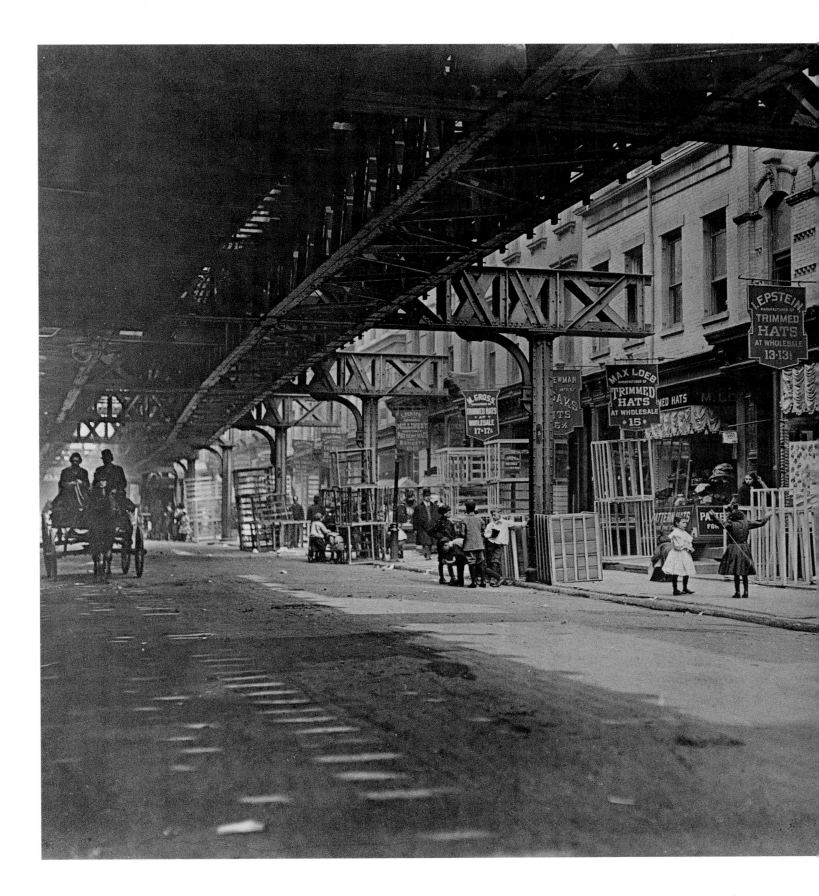

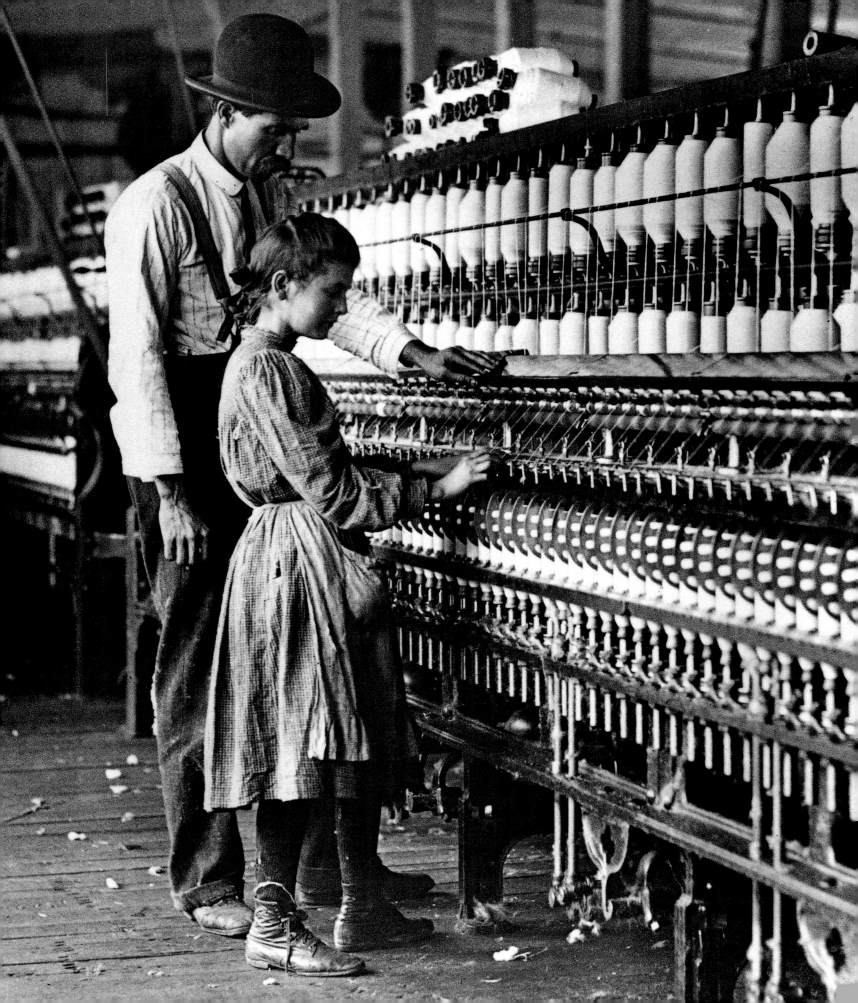

AN AGONIZING CHOICE

Panicked seamstresses who escaped burning alive by leaping from 10 stories lay beneath a New York sweat-shop in 1911; the Triangle Shirtwaist Company bolted its exits until quitting time. Of 500 workers (mostly immigrant women aged 13 to 23), 146 perished. Factory owners had to pay 23 families $75 each but were acquitted of manslaughter.

COURTESY OF ILGWU

<

WASTING THEIR YOUTH

Her name is unknown, as is the age of this young cotton spinner from Newton, South Carolina. What is certain: In the 1900s, one-eighth of the South's textile workers were under age 12 (and most tobacco- and cotton-field workers under 10). Industries relying on child labor fended off reforms until 1938 — when unemployed Depression adults coveted those jobs.

LEWIS W. HINE /
NEW YORK PUBLIC LIBRARY

>

THE FORD IN OUR FUTURE

In 1907, he hadn't solved where to put the spare tire (held by a worker at right); yet Henry Ford, 44, was proud to show Detroit the mock-up of his new horse-less buggy. The next year he put the Model T on sale for $825. By the time the Tin Lizzie gave way to the Model A, in 1927, Ford had sold 15 million worldwide — and pioneered modern assembly-line production.

HENRY FORD MUSEUM

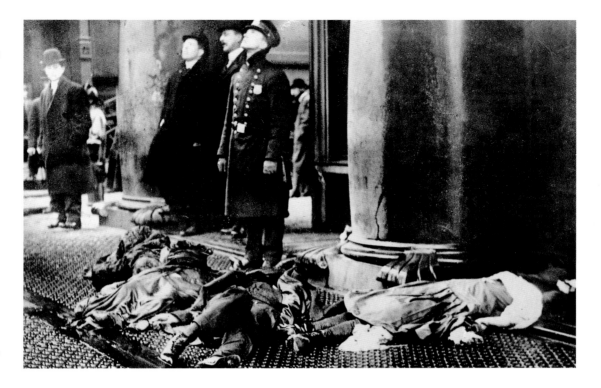

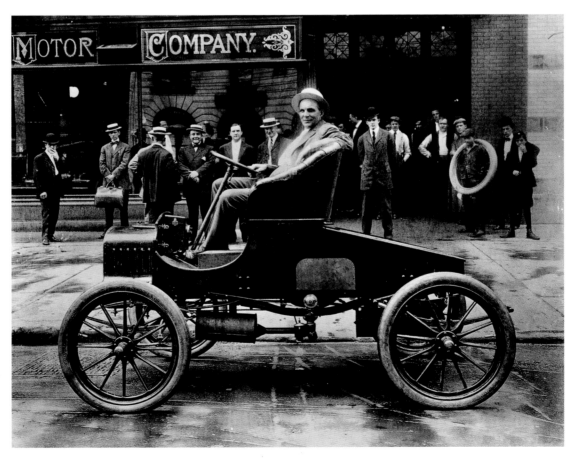

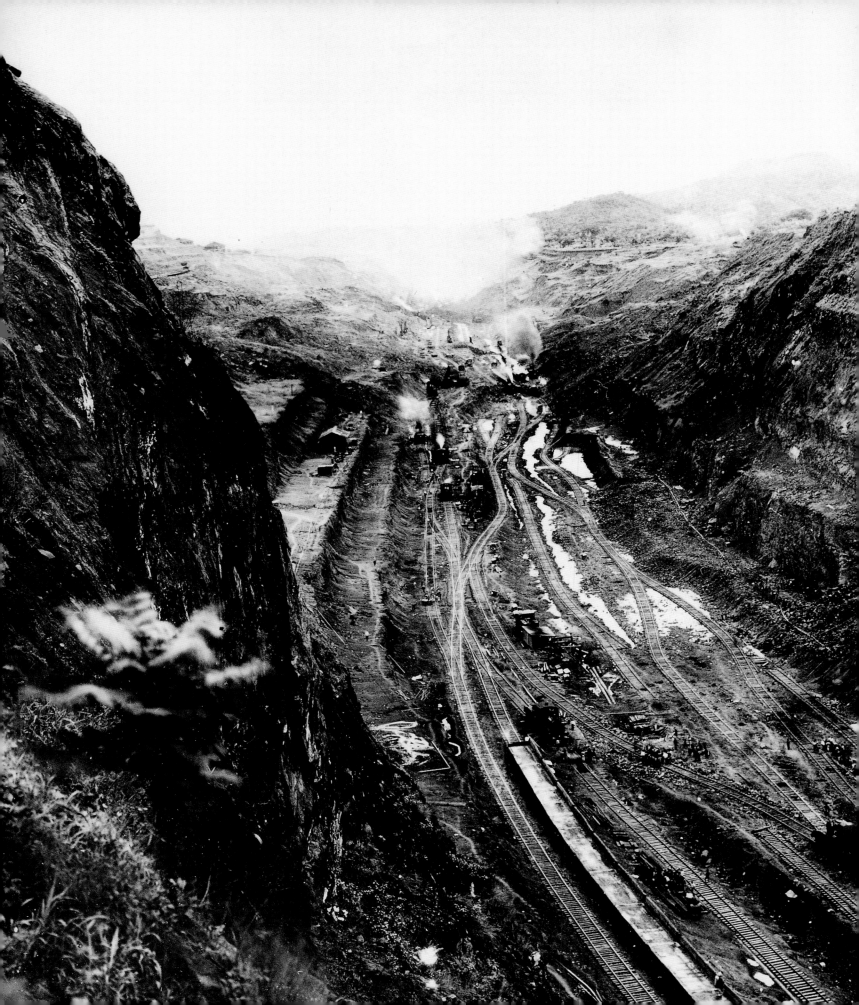

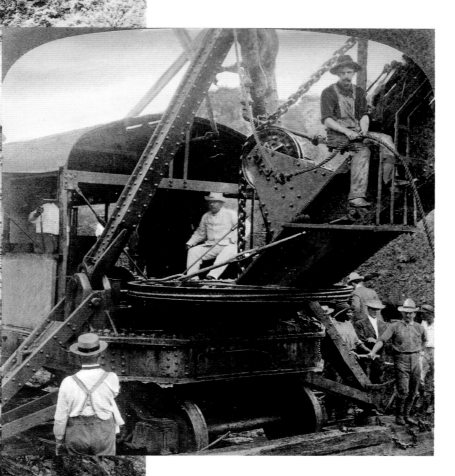

The Path Between the Seas

Mariners had long dreamed of channeling through Colombia's narrow Isthmus of Panama to link the Atlantic and Pacific oceans, thereby sparing themselves the 7,000-mile haul around Cape Horn. In the 1800s, a French consortium began digging but ran out of money. In 1902, Teddy Roosevelt petitioned Bogotá to let a U.S. team try. Rebuffed, he encouraged a group of Colombians to form their own country — and then promptly accepted from this new Republic of Panama a sea-to-sea right-of-way in perpetuity. When TR went in 1906 to inspect the Big Ditch (as well as the cab of a steam shovel, above), he became the first sitting president to travel beyond America's borders. The 40-mile-long, 500-foot-wide, 40-foot-deep Panama Canal opened for traffic in 1914 after 10 years; it cost $352 million and some 5,600 lives, mostly victims of tropical diseases.

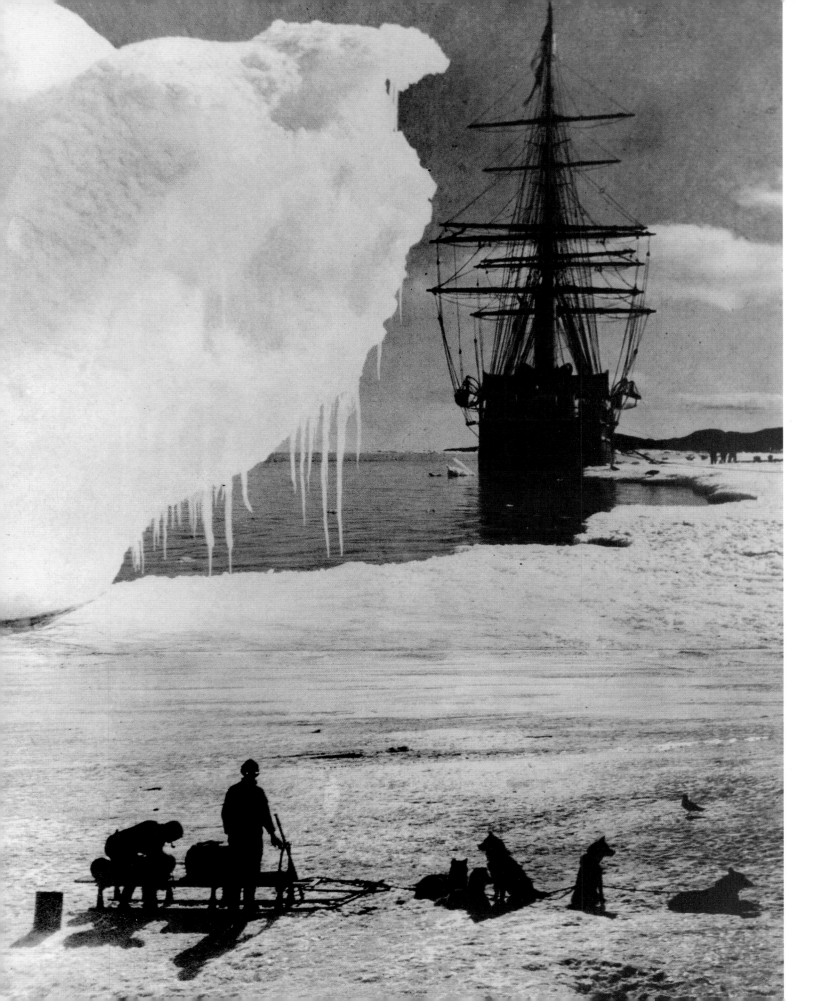

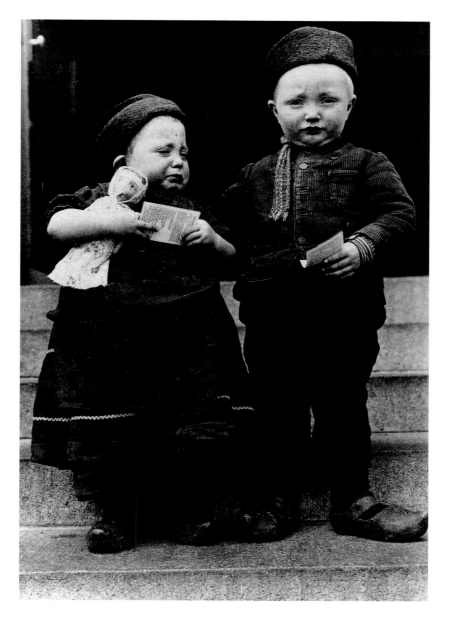

THE CRUELEST CONTINENT

A year after America's Robert Peary became the first to stand at the North Pole, a British team under Robert Scott sailed *Terra Nova* to Antarctica hoping to win the race to the South Pole. They reached it on January 18, 1912 — only to find a note left 35 days earlier by Norway's Roald Amundsen. Scott, 44, and his men starved to death on the trek back.

TIME INC.

NEW WORLD, NEW LIVES

Bravely emerging from the processing hall at New York's Ellis Island, two tots entered the U.S. Between 1899 to 1907, immigration quadrupled as the vibrant American economy demanded ever more workers. Ellis Island was the main portal because 90 percent of the newcomers sailed from Europe; racially inspired bans on Asians (primarily the Chinese) were lifted only in 1943.

AUGUSTUS FRANCIS SHERMAN /
NEW YORK PUBLIC LIBRARY

OTHELLO WITH GLOVES

A black titleholder was unthinkable until Jack Johnson (far right) won the heavyweight crown in 1908, at age 30. Instead of praise, he was reviled for openly courting white women. Ex-champ James Jeffries, 35 (near right), came out of retirement in 1910 to challenge the man he had called a "coon." Bad move: Johnson tattooed him for 14 rounds before dropping him in the 15th.

PHOTOGRAPHER UNKNOWN

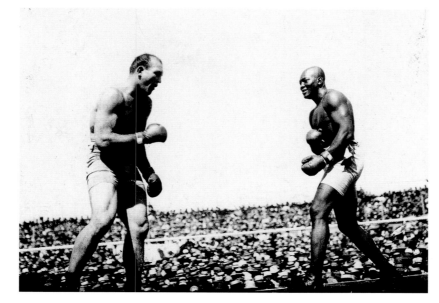

25

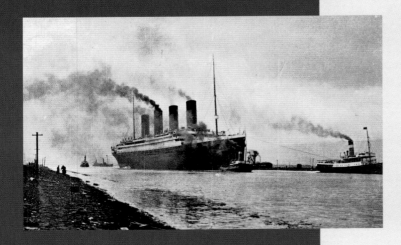

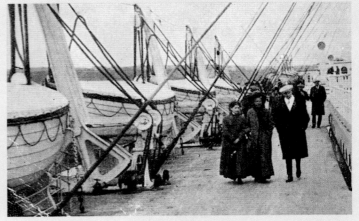

Tragic Maiden

Since at least the time of Homer, storytellers have preferred tales of adversity and doom. The 20th Century's prime cautionary fable, of course, concerns a state-of-the-art ocean liner and an iceberg. Other shipwrecks have resulted in calamitous losses (the Mississippi sidewheeler *Sultana* burned in 1865, killing 1,500); yet it is RMS *Titanic* that haunts us. Why? Because the disaster contradicts the mantle of techno-infallibility that has defined our age. *This ship is virtually unsinkable*, wrote a trade journal. The claim was echoed by its builders, its owners, its captain, even its awed passengers. Similar boasts have since issued from designers of bridges, zeppelins, space shuttles and PC software. The Greeks had it right: The hardest lesson to learn may be the cost of hubris.

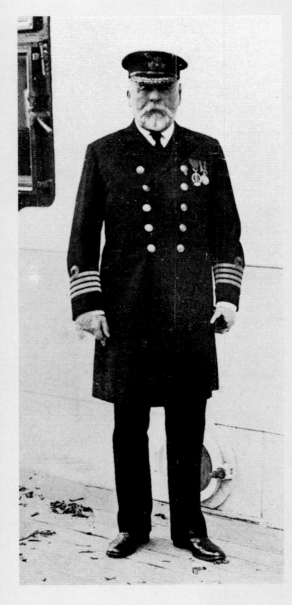

PRIDE OF AN EMPIRE

Towed by tugs to its sea trials on April 2, 1912 (left), *Titanic* was, along with sister ship *Olympic*, the largest liner yet built. England's White Star Line spent some 439 million in today's dollars on each. Promenading passengers (above) who hiked from bow to stern walked 882½ feet — longer, the company's literature boasted, than New York's Woolworth Building, then the world's tallest skyscraper, was high.

TOP LEFT AND ABOVE: TIME INC.

MASTER OF THE SHIP

To mark Captain E.J. Smith's 43 years at sea, White Star gave its retiring top skipper a farewell gift: command of *Titanic*'s first crossing to New York. The ship left port April 10 and soon began picking up radioed warnings of icebergs ahead — including seven on April 14. Yet Smith, 62, never ordered speed to be trimmed.

TIME INC.

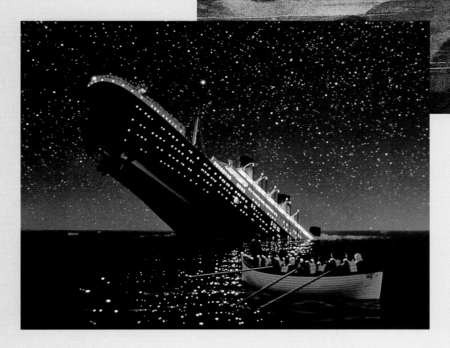

LUXE ON THE HIGH SEAS

The "electrical camel" above was just one amenity of first-class passage ($4,350 for a Parlour Suite; steerage ran from $32). *Titanic* also had a squash court, 30-foot swimming pool, gym and Turkish bath.

BROWN BROTHERS

DEATH OF A LINER

At 2:18 a.m. on April 15, 1912, a shade more than two-and-a-half hours after hitting the iceberg, the bow-flooded *Titanic* began its plunge to the bottom of the North Atlantic. Seven hundred aboard escaped. Fifteen hundred did not.

KEN MARSCHALL /
MADISON PRESS

"ICEBERG RIGHT AHEAD!"

A contemporary British rendition of *Titanic*'s glancing collision with an iceberg also showed the ship's immensity. The top seven of its decks were for passengers, the bottom four levels for machinery, provisions and cargo.

TIME INC.

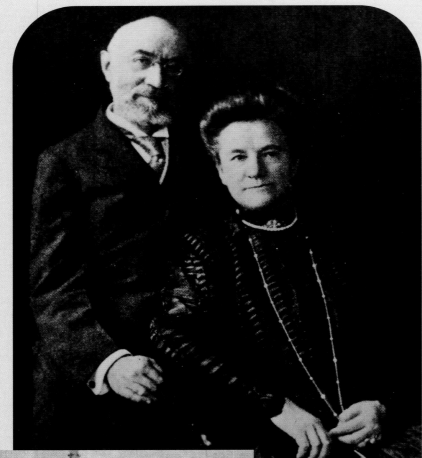

VALOR AND DISGRACE

When Macy's co-owner Isador Straus, 67, refused a lifeboat seat, so did his wife, Ida, 66. Not all first-class passengers were so gallant. British aristocrat Sir Cosmo Duff Gordon and his wife objected to plucking survivors from the sea, though there was room for 28 more in their 40-person boat.

COURTESY OF STRAUS HISTORICAL SOCIETY

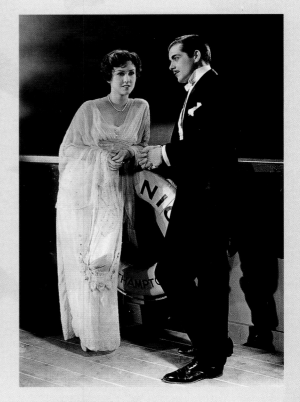

THE FIRST PICTURE SHOW

In 1933's *Cavalcade*, lovers Margaret Lindsay and John Warburton booked passage aboard the you-know-what (note life buoy). Far quicker off the mark were the makers of *Saved from the Titanic*, a silent one-reeler that hit nickelodeons one month after the sinking.

CULVER PICTURES

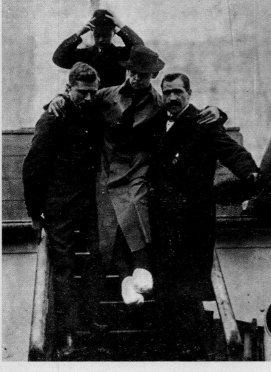

HE TOLD THE WORLD

Carried off rescue ship *Carpathia* was injured *Titanic* junior tele-graphist Harold Bride, 22. He had helped send the standard distress call, CQD, and a new code, SOS. First on land to receive them: New York–based operator David Sarnoff, 21, who in 1926 founded the NBC radio network.

TIME INC.

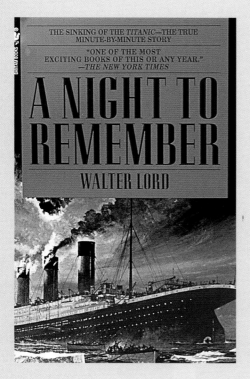

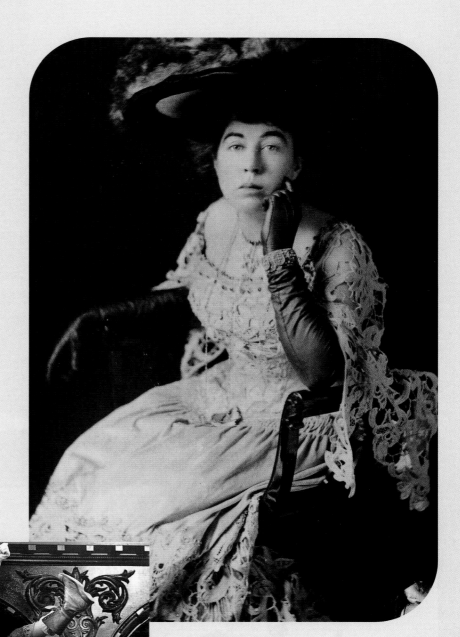

FRESH SEA LEGS

Titanic-mania was reignited in 1955 by veteran journalist Walter Lord's minute-by-minute retelling of the disaster. The hardcover edition was a best-seller for six months and the paperback (above) is still in print. The next year NBC dramatized it in a high-ratings special; the movie version came out in 1958.

JOHN MEYER

A LIFE UNINTERRUPTED

Before becoming, at 44, *Titanic*'s most celebrated survivor, Molly Brown (above) knew both rags and riches; born to a Missouri ditch-digger, she headed west and married a successful gold miner. Her social-climbing life was memorialized in a 1960 musical that went Hollywood in 1964, with Debbie Reynolds (left) as *The Unsinkable Molly Brown*.

ABOVE: COURTESY OF COLORADO
HISTORICAL SOCIETY
LEFT: CULVER PICTURES

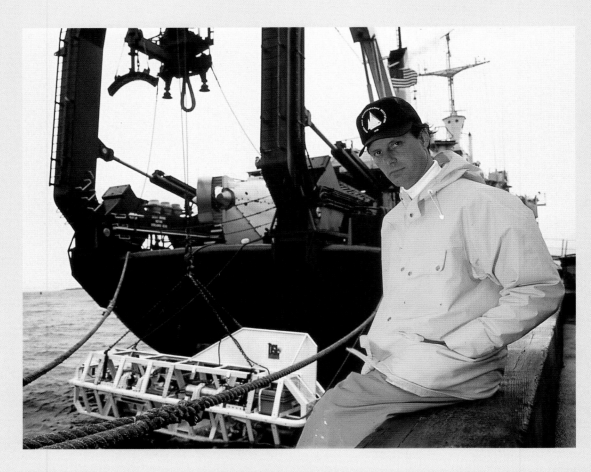

LOST AND FOUND

Titanic's remains lay beyond human reach, 2½ miles below the North Atlantic, until 1985. That's when American oceanographer Bob Ballard, 43, and his French partners borrowed experimental deep-sea search gear from the U.S. Navy. Others had mounted high-tech expeditions, but Ballard's was the first to find the liner on the ocean floor, split almost in half lengthwise.

MICHAEL O'NEILL

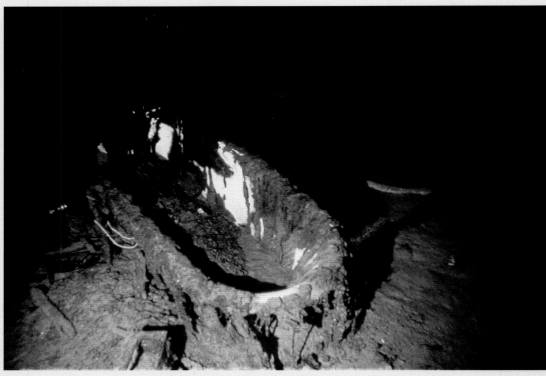

GRAVE SECRETS

The rust-draped prow (right), as well as the rest of *Titanic*'s exterior sitting atop the muddy seabed, was documented by the Ballard team on videotape and 53,000 stills. Remote-operated cameras also snaked inside the superstructure to capture items like a bathtub (left), dishes and utensils, leather shoes, and a bottle of champagne, cork still intact.

LEFT: WOODS HOLE
RIGHT: EMORY KRISTOF / NGS
IMAGE COLLECTION

STANDING PROWED

Straddling a mock-up of the bow, Leonardo DiCaprio, 23, and Kate Winslet, 22, stirred teenage hearts in 1997's *Titanic*. But their charisma alone could not account for the $1.8 billion worldwide gross of the century's No. 1 blockbuster. Director James Cameron, 43, descended in a Russian submersible to film the wreck. More important, he scripted the affecting love story, and oversaw the special effects, which humanized a night that will long be remembered.

PARAMOUNT PICTURES

HER LIPS ARE SEALED

In 1914, Italian house painter Vincenzo Perugia (above) was convicted of stealing the *Mona Lisa* from Paris's Louvre. It was an open-and-shut case: He was caught trying to fence the 16th Century Da Vinci masterwork. The crime was actually directed by scam artist Eduardo de Valfierno — who didn't even care about the painting. In the two years it was missing, he sold six forgeries, five to nouveau U.S. collectors, at $300,000 per copy. (Louvre officials insist they got back the original.)

LEFT: ERICH LESSING / ART RESOURCE
ABOVE: HARLINQUE COLLECTION

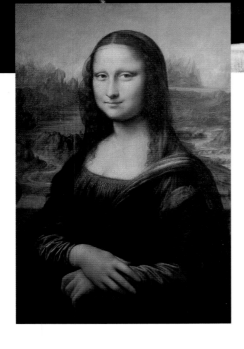

PARIS JEERS A MASTERPIECE

Parisian first-nighters expected the new ballet, created by a trio of fiery Russian émigrés, to be different. Then Igor Stravinsky's dissonant score began, and the curtain rose on wildly costumed members of Serge Diaghilev's troupe executing Vaslav Nijinsky's athletic choreography. The shocked audience jeered loudly enough to drown out the orchestra but not enough to stop the 1913 debut of the modern-dance classic *Sacré du Printemps*, or *Rite of Spring*.

PIERRE BOULAT /
COLLECTION OF BAIER KOCHN

HE WROTE THE SONGS

By 15, the Russian-born orphan of a cantor had quit school and was a singing waiter on New York's Lower East Side. By 19, though unable to read or write music, Irving Berlin was publishing his own songs (which he plunked out on the piano). The first of his 800-plus oeuvre to hit it big was 1911's "Alexander's Ragtime Band." Others: "Blue Skies," "Puttin' on the Ritz," "There's No Business like Show Business," "God Bless America" and one of the top-selling 45s of the century, "White Christmas."

BROWN BROTHERS

REQUIEM

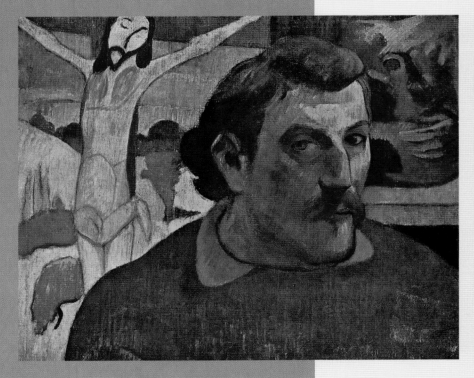

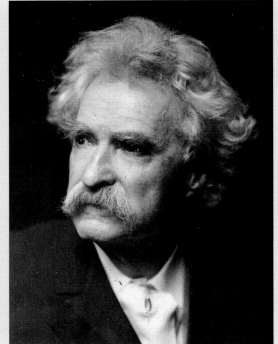

PAUL GAUGUIN
1848–1903

He forfeited, at 35, a career as a stockbroker in Paris to become an Impressionist painter. He then forfeited family and France to move, at 43, to Tahiti. Alas, recognition for his fusing of European technique with native energy — as in the late 1880s self-portrait above — came posthumously.

TIME INC.

MARK TWAIN
1835–1910

On America's centennial he gave the country a charming young hero: Tom Sawyer. Eight years later he created Huck Finn. Samuel Langhorne Clemens of Hannibal, Missouri, was blessed with a vernacularist's ear and a skeptic's eye. He used both to become a master storyteller.

TIME INC.

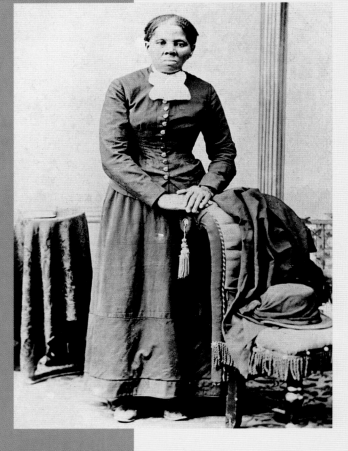

HARRIET TUBMAN
1821–1913

Born on a Maryland plantation into slavery, she fled north in 1849. Yet Tubman kept going home to help other blacks (among them, her parents) board the Underground Railroad to free states or Canada. And during the Civil War, she posed as a menial in her native South to spy for the Union.

LIBRARY OF CONGRESS

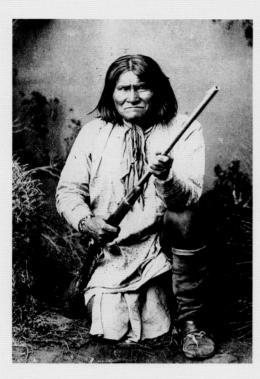

<
GERONIMO
1829–1909

Broken treaties consigned his Chiricahua Apaches to a corner of Arizona with neither water nor game, so Geronimo led one of the West's last major Indian uprisings, finally surrendering in 1886. A rebel with a cause? Yes. But he was a guest of honor at Theodore Roosevelt's 1905 inauguration — and ended his days as a farmer in Oklahoma.

CORBIS / BETTMANN

>
LEO TOLSTOY
1828–1910

By age 50, he had published two canons of Western literature: *War and Peace* and *Anna Karenina*. Then the Russian nobleman took up religious asceticism and renounced his land and earthly goods. Although estranged, his family all hurried to the remote town of Astapova to be at his bedside when he succumbed to pneumonia.

TIME INC.

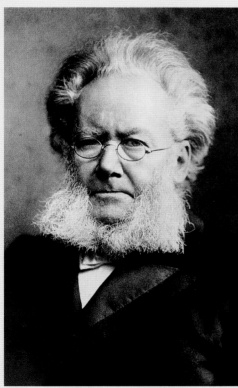

<
HENRIK IBSEN
1828–1906

Between 1879 and 1890, his country's greatest playwright crafted three social dramas so timeless they still need no updating: *A Doll's House*, *An Enemy of the People* and *Hedda Gabler*. But they were written abroad. A commercial and artistic flop at home, Ibsen spent his most productive years in Italy and Germany before returning to Norway.

ROYAL MINISTRY OF FOREIGN AFFAIRS, PRESS AND CULTURAL RELATIONS DEPARTMENT, OSLO

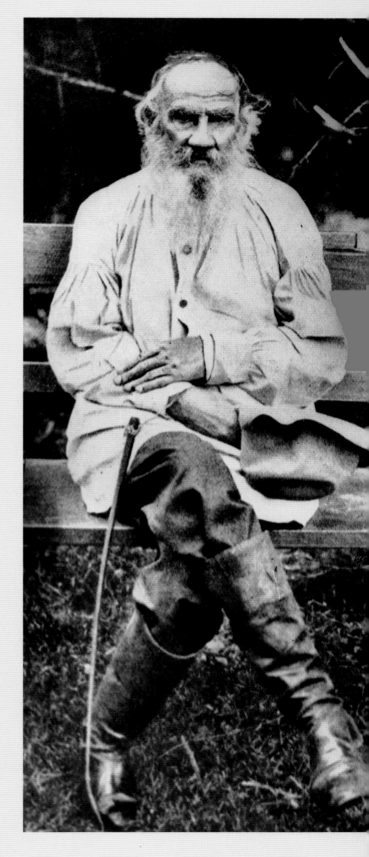

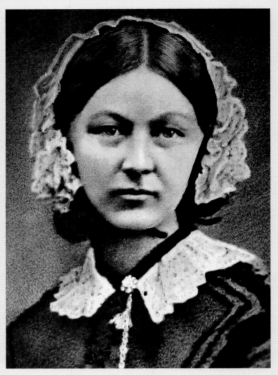

FREDERIC REMINGTON
1861–1909

Born in upstate New York, this Yalie (he attended the college's art school) went west to become America's best-known interpreter of the vanishing cowboy life. Whether in magazine illustrations, oil paintings or, most famously, his visceral bronzes, Remington's celebrations of frontier machismo were anything but tenderfooted.

FREDERIC REMINGTON MUSEUM

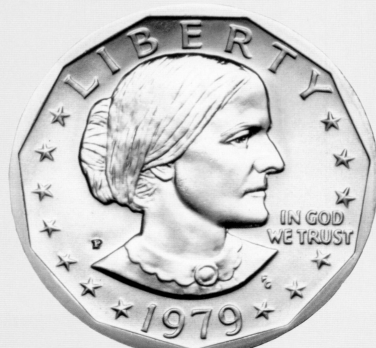

SUSAN B. ANTHONY
1820–1906

Angry that her teaching pay was one-fifth a male's, she protested by quitting and joining the temperance movement. Then, at 32, Anthony began to champion female suffrage. U.S. women would not get to vote in a national election until 1920. But for her groundbreaking crusade Anthony was, in 1979, the first native-born woman to be commemorated on an American coin.

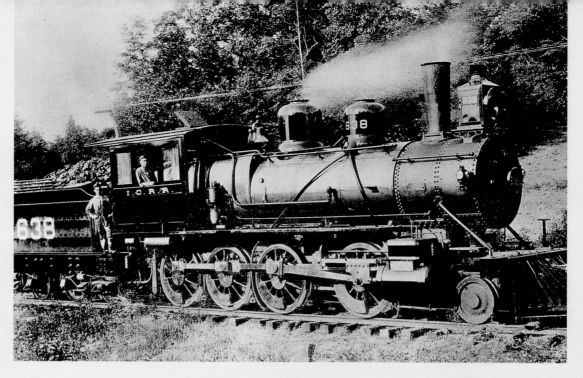

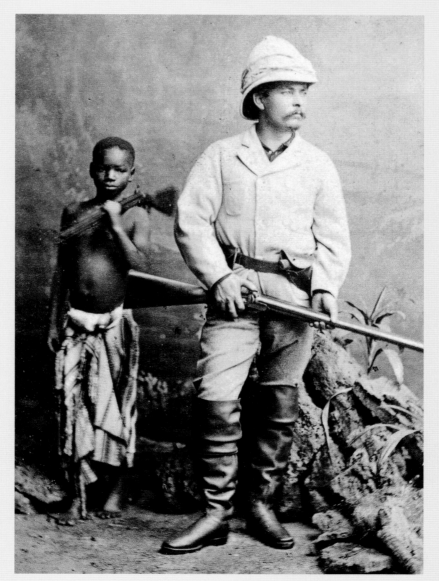

FLORENCE NIGHTINGALE
1820–1910

She led 38 nurses to the Crimea in 1854 to tend wounded troops, only to be cursed by British army doctors for her meddling. But the men adored their "Lady of the Lamp" for making nightly rounds; she sailed home a hero. Nightingale founded the world's first school of nursing in 1860 and in 1907 became the first woman honored with Britain's Order of Merit.

CAMERA PRESS

CASEY JONES
1864–1900

The Illinois Central engineer in the cab was known for a heavy hand on the throttle, so naturally his *Cannonball* express was steaming full tilt. Near Vaughan, Mississippi, he was warned that the track was blocked. Ordering his fireman to jump, he hit the brakes. Passengers and crew walked away but not the man whose heroics are retold in the ballad "Casey Jones."

ILLINOIS CENTRAL RAILROAD

HENRY MORTON STANLEY
1841–1904

Arriving in the U.S. at 18, the Welsh bastard John Rowland took a new name and became a reporter. In 1869, the New York *Herald* sent Stanley after a Scottish explorer who had vanished in Africa while searching for the headwaters of the Nile. Two years later, in what is currently Tanzania, his hunt ended with "Dr. Livingstone, I presume?"

TIME INC.

The tanks, the troops, the caissons, the cavalry, the
supply wagons: American. The place: France. The year:
1917. The enemy: somewhere beyond the horizon.

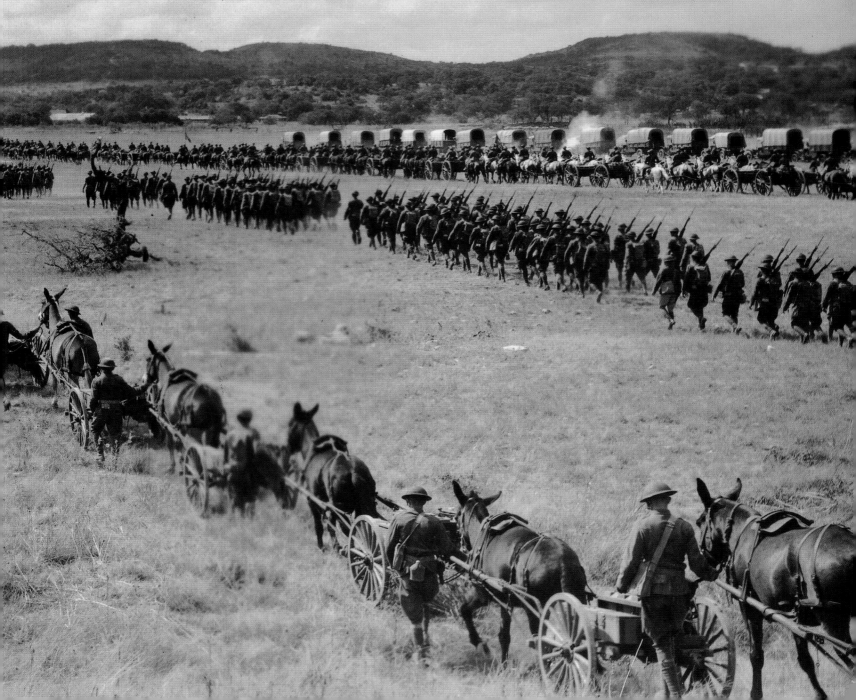

1914–1919

THE WAR TO END ALL WARS

Victory Proved Easier Than Peace

BY DAVID M. KENNEDY

T 8:20 ON THE evening of April 2, 1917, President Woodrow Wilson left the White House, stepped into a waiting automobile and motored through the rain up Pennsylvania Avenue toward Capitol Hill accompanied by a clattering troop of cavalry that cantered alongside his car. Minutes later, after composing himself briefly in a Capitol anteroom, the President strode through the swinging doors of the House chamber to face an extraordinary joint session of Congress. The packed hall erupted in emotional applause, but Wilson's manner was solemn and burdened. For only the fourth time in American history, a president was about to ask Congress for a formal declaration of war.

The Imperial German government, Wilson explained, desperate to bring its adversaries in the three-year-old European War to their knees, had for the last two months been violating international law by waging unrestricted submarine warfare against neutral shipping bound for Britain and France. "American ships have been sunk, American lives taken," said Wilson, and the United States had no choice but to "accept the status of belligerent which has thus been thrust upon it." Four days later, with 50 dissenting votes in the House and six in the Senate, Congress granted Wilson's request. The United States had now entered the Great War.

"It is a fearful thing to lead this great peaceful people into war, into the most terrible and disastrous of all wars," Wilson said. Fearful indeed. Since the bark of Gavrilo Princip's pistol in Sarajevo on June 28, 1914, had shattered the peace of the Old World, millions of young Europeans had perished. In the east, the Czar's armies had absorbed more than one million casualties in the war's first year alone. Russian officers then resorted to herding unarmed peasants into battle and certain slaughter — helping to kindle the seething popular resentments that would soon revolutionize Russia and extinguish the Romanov dynasty. On the western front, once the scything sweep of the German armies had been stopped at the River Marne in September 1914,

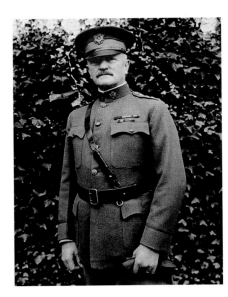

He fought out West (with a Negro unit, thus the nickname Black Jack), in Cuba, in the Philippines, in Manchuria, in Mexico. At 56, John J. Pershing was ready to shape an American Expeditionary Force and lead it to France in 1917 to fight alongside the Allies.

NATIONAL ARCHIVES

the fighting had congealed into the grisly and prodigiously bloody stalemate of trench warfare. The five-month-long siege of Verdun in 1916 butchered more than 300,000 Germans and an equal number of Frenchmen. A single battle along the Somme River in the same year killed 420,000 Britons; a year later another 245,000 died at Passchendaele.

To a degree that later generations would find baffling, some young American men — especially if they were well educated — greeted Wilson's war message with unbridled enthusiasm and uncritical patriotic fervor. William Langer, later a distinguished Harvard historian, recalled with some perplexity his generation's "eagerness to get to France and above all to see the front."

One would think that after almost four years of war, after the most detailed and realistic accounts of murderous fighting on the Somme and around Verdun, to say nothing of the day-to-day agony of trench warfare, it would have been all but impossible to get anyone to serve without duress. But . . . we men, most of us young, were simply fascinated by the prospect of adventure and heroism. Most of us, I think, had the feeling that life, if we survived, would run in the familiar, routine channel. Here was our one great chance for excitement and risk. We could not afford to pass it up.

Similarly, the 1916 Harvard graduate and future novelist John Dos Passos recollected that "we had spent our boyhood in the afterglow of the peaceful nineteenth century. . . . What was war like? We wanted to see with our own eyes. We flocked into the volunteer services. I respected the conscientious objectors, and occasionally felt that I should take that course myself, but hell, I wanted to see the show."

Harvard men may have volunteered, but the vast American Expeditionary Force (AEF) hastily mobilized in 1917–1918 was mostly built with conscripts. Their army mirrored the predominantly rural, sur-

prisingly backward and astonishingly polyglot society from which they were ladled. A farmer from Jackson County, Missouri, Captain Harry S Truman exemplified the agrarian background of a majority of World War I American servicemen. Yet in other ways he was an unusual doughboy. At five feet eight inches in height, Truman stood a full inch taller than the average recruit. As a high school graduate, he had almost twice as many years of schooling as the typical native-born white draftee, three times more than immigrant conscripts and four times more than most black soldiers, who were mustered into segregated units and assigned almost exclusively to noncombat duty. Some 25 percent of all draftees were illiterate; few had any knowledge of the world beyond their town or neighborhood or, more typically, beyond their isolated rural county or even beyond the farthest furrow of their own farm.

Truman was also an old-stock American, while one in five draftees had been born abroad. They were the children of the great European diaspora that had brought more than 17 million migrants to American shores in the quarter century before the war's outbreak. The AEF's censors had to scan letters penned in 49 languages. A wartime joke had it that when one officer called his unit's roll, not a single soldier recognized the pronunciation of his name; but when the officer sneezed, 10 men stepped forward.

Among the reasons Wilson had hesitated for so long to lead his country into the war was his anxiety about the loyalties of those great immigrant communities. One in every three Americans was foreign-born in 1914 or had at least one foreign-born parent; more than 10 million of them came from Germany or from Germany's ally, Austria-Hungary. They were freshly arrived and still largely unacclimated; indeed, many had not yet committed themselves to remaining permanently in America. Most men will fight for their country, Mark Twain once remarked, but few will fight for their boarding-

house. The immigrants' allegiance to the United States, and especially their willingness to shoulder arms, often against their own cousins, could hardly be taken for granted.

Neither could the fighting spirit of millions of other Americans, who were historically isolationist and largely indifferent to the fate of the Old World. "We never appreciated so keenly as now the foresight of our forefathers in emigrating from Europe," the Wabash, Indiana, *Plain Dealer* had editorialized in 1914. President Wilson understood the depths of that isolationism and indifference. "It was necessary for me," he wrote to a friend just two days after delivering his war message, "by very slow stages indeed and with the most genuine purpose to avoid war to lead the country on to a single way of thinking."

Now that the United States was at war, Wilson deployed all of his formidable oratorical gifts to nurturing that "single way of thinking." He turned to the great task of persuading the American people of the war's justice and necessity. Holding aloft the torch of his idealism, he preached about the high purpose of the war to end all wars and the crusade "to make the world safe for democracy." His government organized monster war-bond rallies, featuring popular silent-film stars like Douglas Fairbanks and Mary Pickford, as much to sell the war as to sell bonds. His Administration propagandized housewives to conserve food by observing "meatless Tuesdays" and "wheatless Wednesdays" and by planting "victory gardens" where they could hoe their way to glory. Apple-eating children were urged to be "patriotic to the core." The war-born Committee on Public Information

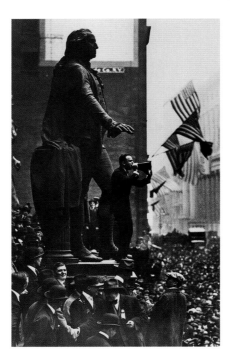

plastered the country with war posters and dispatched some 75,000 "Four-Minute Men" to deliver rousing speeches in schools, churches, movie houses and vaudeville theaters. The committee also produced inflammatory hate-the-Hun films, including *The Kaiser, the Beast of Berlin* and *To Hell with the Kaiser*.

Wilson's labors bore fruit — though some of it quickly went rotten. The U.S. mobilized for war, but a destructive mood of hyperpatriotic hysteria swept the country. German-Americans, historically among the nation's most esteemed immigrant groups, found themselves the targets of sometimes mindless fury. German terms like *hamburger* and *sauerkraut* were replaced by *liberty sandwich* and *liberty cabbage*. Playing German music and teaching — even speaking — the German language were prohibited. One German-American in St. Louis was stripped, bound with an American flag and lynched by a mob of 500 people. Whether of German background or not, anti-war protesters were dealt with harshly. Several war critics were beaten and many arrested. The noted Socialist leader Eugene V. Debs received a 10-year sentence for a speech questioning the legality of the military draft.

Numbering fewer than 130,000 men at the war's onset, the U.S. Army enlisted some four million men by war's end. Nearly half of them made it to France with the AEF, and about 1.5 million tasted combat, most in the prolonged and largely inconsequential battle of the Meuse Argonne, fought in the war's last six

The year after America joined the war, movie swashbuckler Douglas Fairbanks asked Wall Street workers to show their patriotism by investing in Liberty Bonds ($50 and up).
NATIONAL ARCHIVES

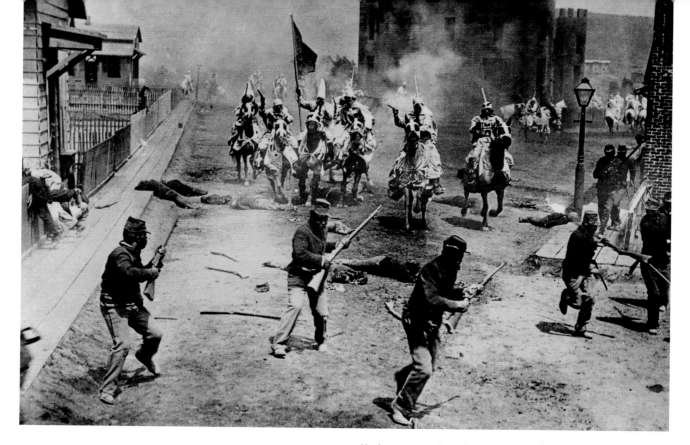

Movies were a crude art form in the Teens, but one transcended the times: 1915's *The Birth of a Nation*. Director D.W. Griffith, 40, grew up in post-Reconstruction Kentucky. The heroes of his restaging of the Civil War and its aftermath: the Ku Klux Klan. On its debut, the 158-minute epic was cheered as cinemagic and jeered as racemongering. Both true.
CULVER PICTURES

weeks. More than 100,000 of those who went to France never returned. Fifty-three thousand died in battle, and another 63,000 fell to accident and disease — especially to the 1918–1919 killer influenza epidemic that also swept away more than 500,000 civilians in the U.S. alone.

If American troops did not contribute heavily to victory, Wilson nevertheless hoped to play a major part in shaping the postwar settlement. Attended by extravagant hopes and greeted with massive outpourings of popular acclaim, Wilson arrived in Paris in December 1918 to hammer out the peace treaty. His cardinal goal was the creation of a new body, the League of Nations, which would work to heal the wounds of war and build a permanent regime of international peace. Returning to the United States in 1919, Wilson once again put his impressive powers of persuasion to work to convince his countrymen that the treaty signed in the Hall of Mirrors at Versailles on June 28, 1919, should be approved.

To no avail. The Senate repudiated Wilson's treaty, the United States refused to join the League of Nations, and in the war's aftermath Americans retreated ever more deeply into their historic isolationism — even as former lance corporal Adolf Hitler began to brew a vastly more destructive war to avenge Germany's defeat. As for Woodrow Wilson, crippled by a stroke in October 1919, shattered in body and spirit by his futile effort to usher America into the family of nations, he muttered from his sickbed on February 2, 1924, "I am a broken piece of machinery," and quietly died the next morning.

David M. Kennedy, Donald J. McLachlan Professor of History at Stanford University, is the author of Over Here: The First World War and American Society *(1980) and* Freedom from Fear: The American People in Depression and War, 1929-1945 *(1999).*

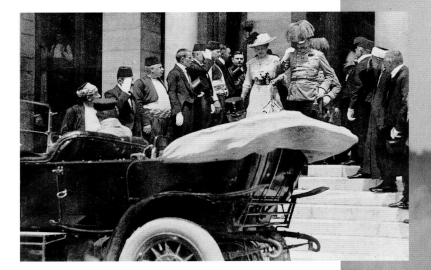

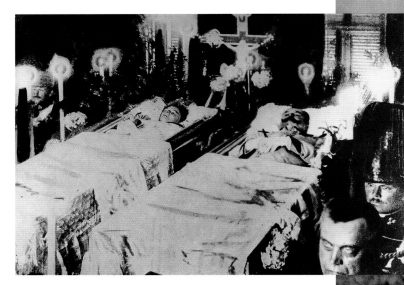

SETTING FLAME TO TINDER

Europe had enjoyed an uneasy peace for 44 years when on June 28, 1914, Archduke Franz Ferdinand (top), heir to the Austro-Hungarian Empire, left city hall in Sarajevo, provincial capital of Bosnia and Herzegovina, with his wife. Their car was just under way when Serbian nationalist Gavrilo Princip, 19, began shooting; Duchess Sophie was 46, the archduke 50. In less than 10 weeks, nine nations had mobilized and launched the Great War.

TIME INC. (2)

AN ARMY IS BLOODED

Some 30,000 British troops had just arrived to defend Mons, a dreary Belgian mining town when, on August 23, 1914, the Germans attacked, 160,000 strong. The British held — but not the large French force on their right flank. Retreat was sounded. The Germans followed deep into France. Thoughts of a quick Allied triumph vanished.

TIME INC.

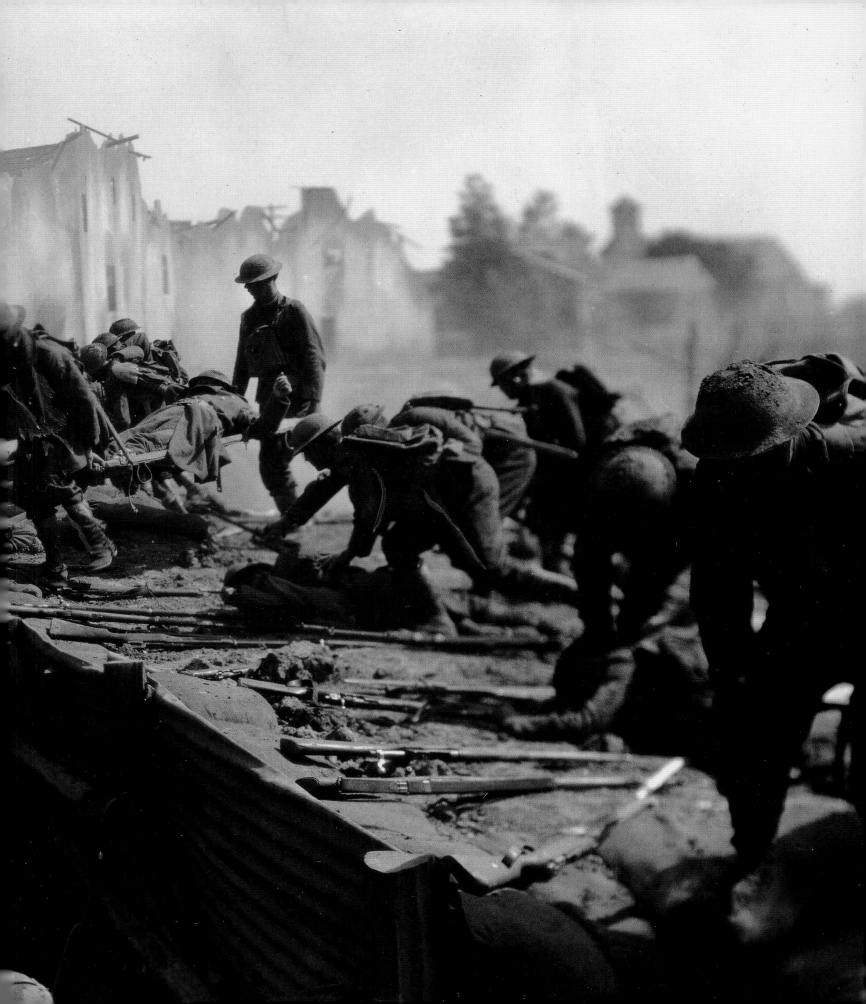

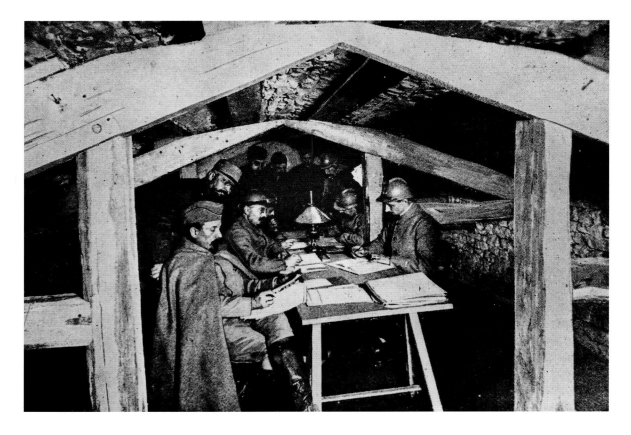

THE WAITING GAME
Trench warfare, directed from underground bunkers like this French command post, soon came to characterize the combat between the vast but immobile armies of the Allies and the Central Powers. Valiant charges "over the top" into hostile fire resulted in nightmarish casualties but little territory gained. Both sides adopted the same strategy: victory through attrition.
TIME INC.

ROAD TO NOWHERE
The jauntiness with which British troops had steamed across the English Channel to take on the Hun faded on the killing fields of France. Between 1914 and 1919, 6.2 million Englishmen were mobilized (out of an adult male population of 20.5 million). More than 744,000 did not make it home.
TIME INC.

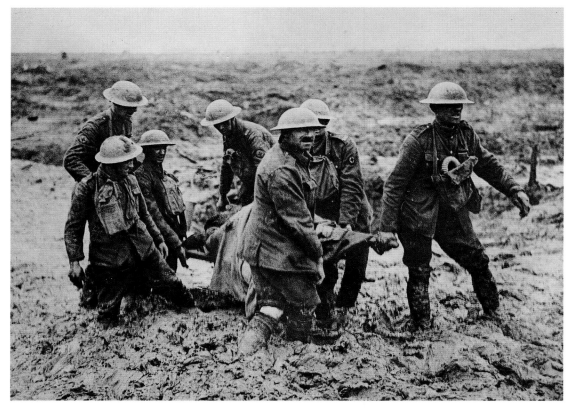

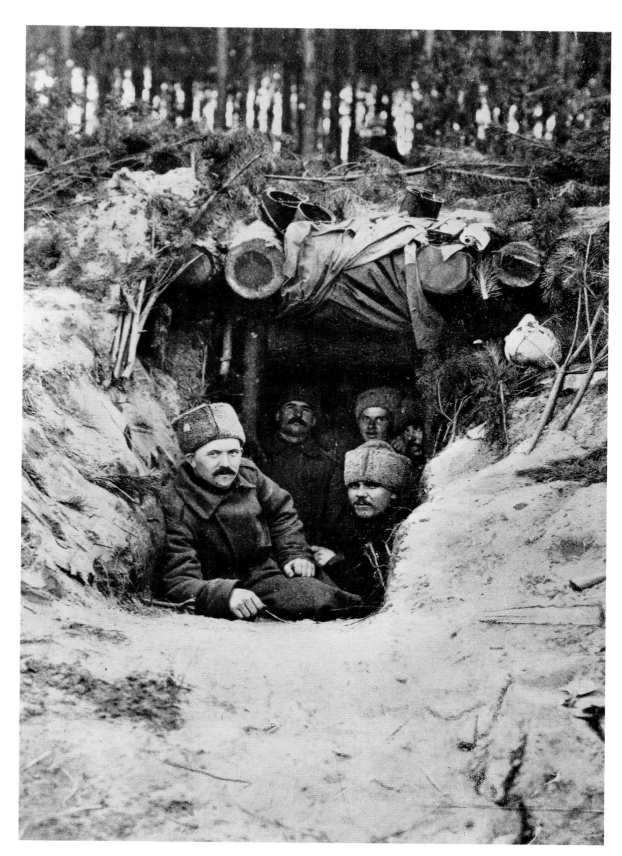

ST. PETERSBURG RULES

All was mercifully quiet on the eastern front for Russian officers guarding the Carpathians, the mountains between their motherland and Hungary. Manpower was not an issue — in 1914, after 125,000 Russians were captured by the Germans at Tannenberg, Czar Nicholas II just ordered more serfs drafted — but firepower was: One-third of the men lacked guns. By the end of the war, Russia's dead, wounded or captured exceeded nine million troops.

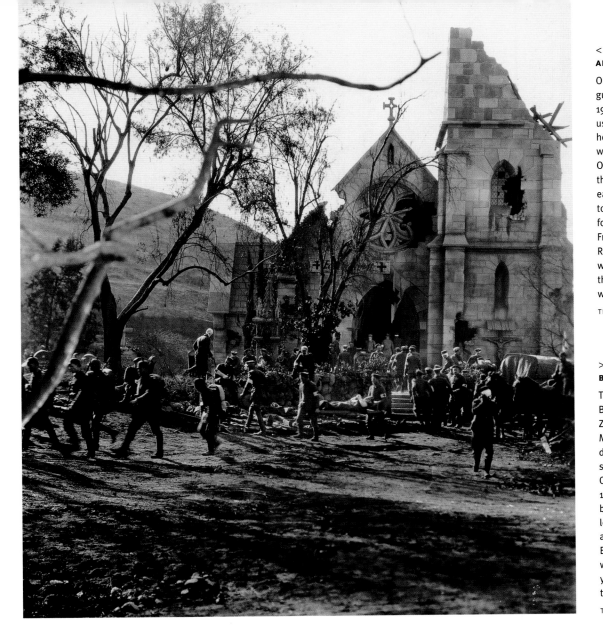

AN INVASION BLUNTED

One month after the first guns sounded in August of 1914, German troops (here using a parish church as a hospital) had pushed to within 25 miles of Paris. Overconfident generals thereupon sent two corps east to fight Russia — only to see their drawn-down forces checked by the French and the British at the River Marne. The Germans were still stuck there when the second battle of Marne was waged four years later.

TIME INC.

BOTCHED CHANCE

The goal: Land 75,000 British, Australian and New Zealand troops on Turkey's Mediterranean coast and drive up the Gallipoli Peninsula to Istanbul, seat of the Ottoman Empire. The April 1915 invasion went well — but then Commonwealth leaders chose to slow their advance. The Turks rallied. By mid-May, 25,000 Allies were dead or wounded; by year's end, the surviving troops were evacuated.

TIME INC.

REVENGE FOR FERDINAND

A Serb assassinated their archduke, so Austro-Hungarian soldiers had no qualms about executing Serbian POWs. The violence spread geographically too. In 1915, Italy and Bulgaria ended their neutrality, raising to 11 the number of warring nations.

NATIONAL ARCHIVES

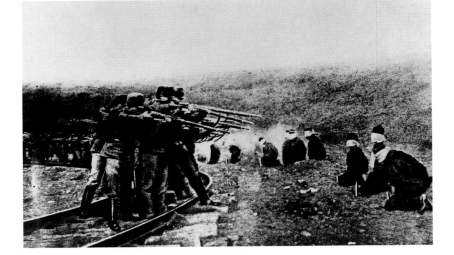

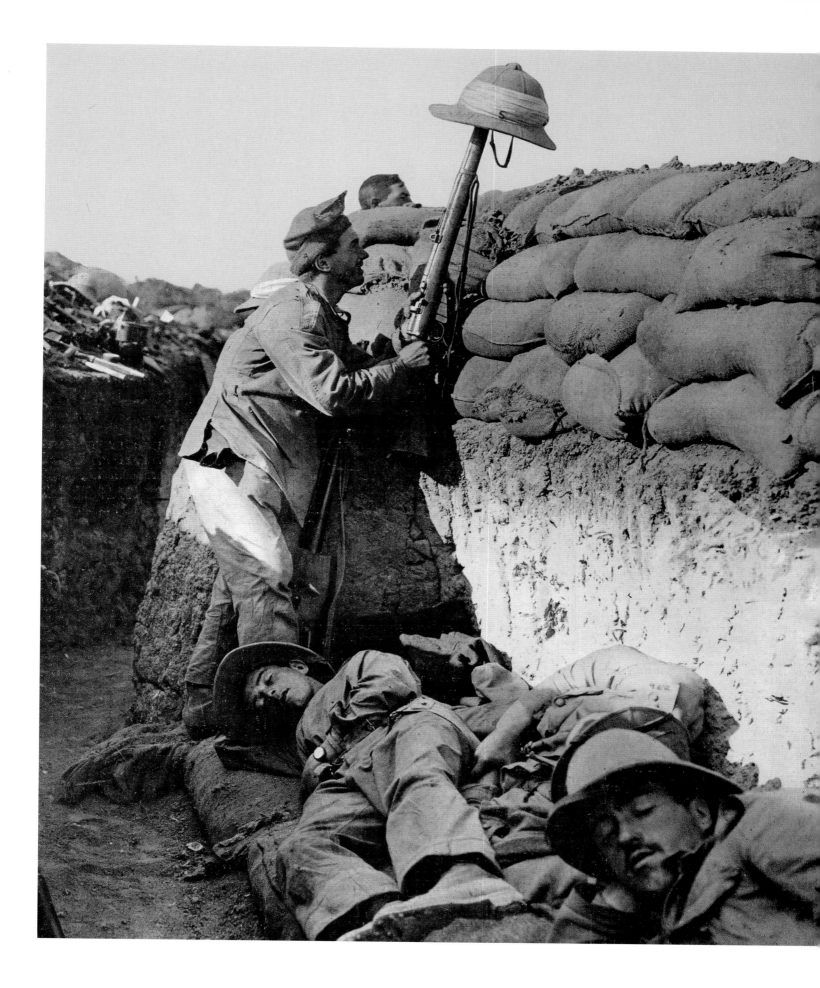

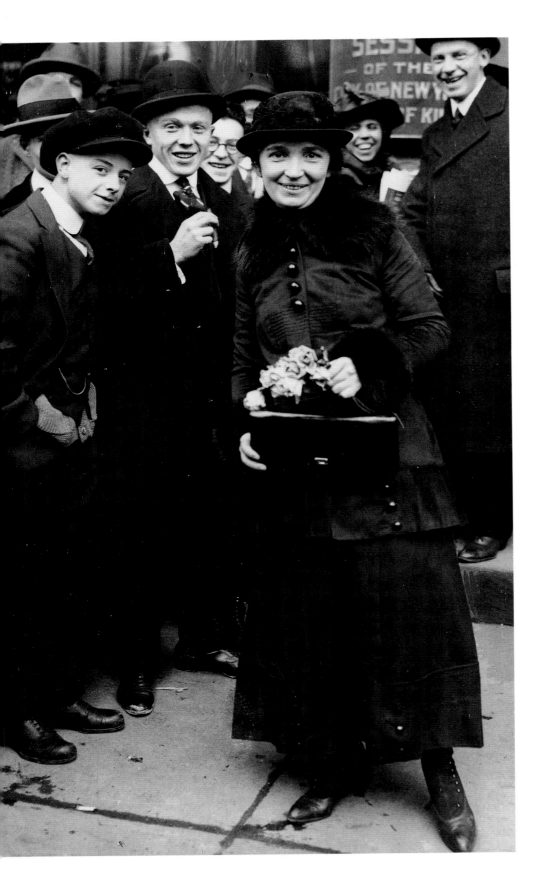

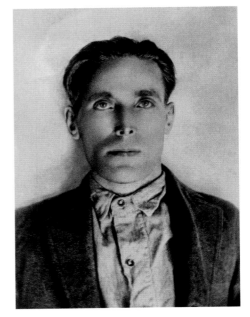

I DREAMED I SAW . . .

. . . Joe Hill on almost his last night, in Salt Lake City, where the Swedish-born labor organizer and troubadour awaited death by firing squad in 1915. He had been convicted of a double killing on evidence so flimsy even President Wilson protested. Brash to the end, Hill, 36, asked to be buried elsewhere: "I don't want to be found dead in Utah."

CORBIS / BETTMANN

PLANNING PARENTHOOD

Twice in 1916 Margaret Sanger landed in New York courts for preaching contraception. First the ex-nurse, 36, was charged with obscenity for mailing pamphlets that described techniques; the case was dismissed. Later she drew 30 days for opening, in Brooklyn, the nation's first clinic to advise on birth control (a term coined by Sanger).

CORBIS / BETTMANN-UPI

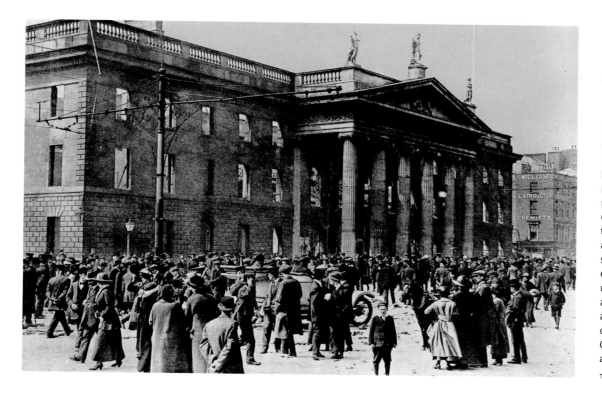

RUE, BRITANNIA

On Easter Monday, 1916, Dublin's tranquillity was broken when Irish nationalists seized key sites to protest British rule. The empire struck back, shelling the main post office (left) and forcing a quick surrender. The British then executed 15 leaders of the uprising. That blunder aroused dormant patriotism and led to the 1922 creation of the predominantly Catholic state now known as the Republic of Ireland.

TIME INC.

ACROSS THE RIO GRANDE

The last foreign troops to invade the Lower 48 were led by Mexico's Pancho Villa. After helping oust the dictators Porfirio Díaz and Victoriano Huerta, he fell out with fellow insurgents. In 1916, Villa, 38, and his loyalists shot up Columbus, New Mexico. John Pershing and 4,000 U.S. soldiers chased him for a year across northern Mexico in vain.

TIME INC.

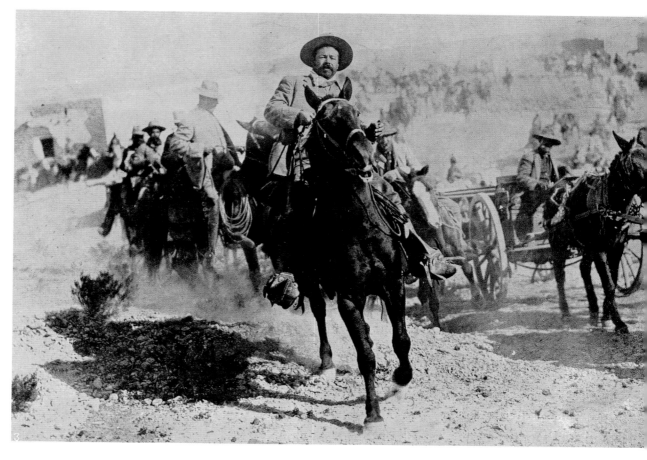

Enter Singing

In 1900, in an unruly part of Manhattan's West Side, impresarios were building theaters to hold a stupefying 1,500. For years, minstrels and vaudevillians had taken their acts to the remotest burgs. Now the best found a home on Broadway. In this Great White hothouse, melodists and bards joined to beget a uniquely American art form, in which songs, and later dance, advanced the story — a formula copied worldwide. Rival mass entertainments soon emerged. Nickelodeons grew into Hollywood, radio into TV, sports into neo-religion. Broadway (whose biggest house still holds just 1,933) has often read its own closing notice. Each has been premature.

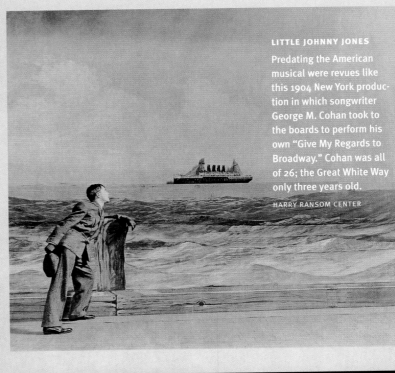

LITTLE JOHNNY JONES
Predating the American musical were revues like this 1904 New York production in which songwriter George M. Cohan took to the boards to perform his own "Give My Regards to Broadway." Cohan was all of 26; the Great White Way only three years old.
HARRY RANSOM CENTER

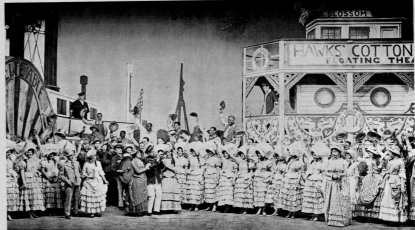

SHOW BOAT
Novelist Edna Ferber's 1926 best-seller was about entertainers who plied the Mississippi in a paddle wheeler. Jerome Kern and lyricist Oscar Hammerstein II took 14 months to craft from it a drama laced with complex social issues — a first on Broadway — and a score that, like "Ol' Man River," jus' keeps rollin' along.

ROGERS AND HAMMERSTEIN ORGANIZATION

VERY GOOD EDDIE
Jerome Kern and Guy Bolton created, in 1915, a show with one plot, two acts and, most important, seven songs that advanced the story. The first American musical told of the confusion that beset two honeymooning couples. Among those who saw it: a teenage aspiring composer named Richard Rodgers.

HARRY RANSOM CENTER

RALPH MORSE / LIFE

PAL JOEY

Pittsburgh native Gene Kelly broke through in a 1940 musical by Richard Rodgers and Lorenz Hart that married, as never before, story (or "book") and music. More audacious yet was the plot, drawn from a set of John O'Hara stories: Kelly, 28, portrayed a sleazy rake. The dark play bewitched audiences even as it left them bothered and bewildered.

OKLAHOMA!

Sure, the corn was as high as a elephant's eye. But to a nation gone from Depression to war, this first tuneful collaboration of Rodgers and Hammerstein, in 1943, was like a wind sweepin' down the plain. Based on the play *Green Grow the Lilacs*, it was the first musical to use choreography (by the ballet-trained Agnes de Mille) to advance the story.

GJON MILI / LIFE

SOUTH PACIFIC

War memories were still fresh when Mary Martin, 34, leaped to stardom in 1949 as a Navy nurse in the Pacific. The bittersweet Rodgers and Hammerstein show, based on James Michener's tales, was disturbingly topical (pointing out that even in paradise there was racism). And in a steal from Hollywood, the orchestra played beneath the dialogue.

PHILIPPE HALSMAN

MY FAIR LADY

George Bernard Shaw's 1913 stage hit, *Pygmalion*, had stumped all attempts at musicalization until Frederick Loewe and Alan Jay Lerner took a shot. Their 1956 show — seamlessly melding book and song — starred Rex Harrison (above, right) and an ingenue with a four-octave voice, Julie Andrews, 20.

LEONARD MCCOMBE / LIFE

WEST SIDE STORY

From Romeo and Juliet to Tony and Maria? Composer Leonard Bernstein and choreographer Jerome Robbins originally planned an innovative, dance-driven update of Shakespeare set on New York's turn-of-the-century Lower East Side. By 1957, the other side of town was hotter, and whites versus Puerto Ricans had supplanted Catholics versus Jews. Only in America....

HANK WALKER / LIFE

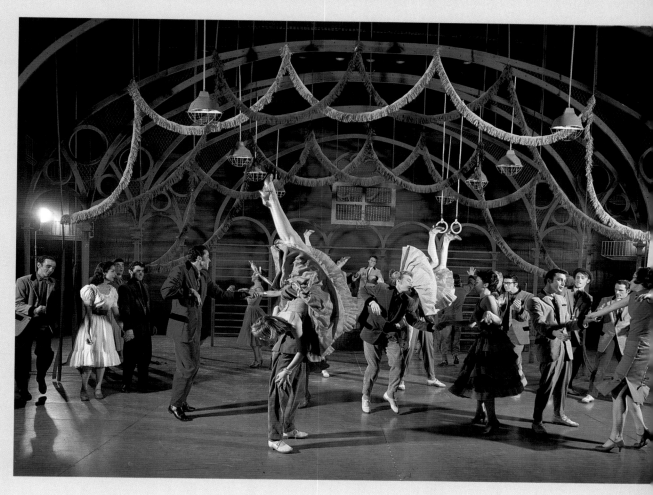

HAIR

Wasn't 1967 about time for baby boomers to see their (counter)culture take center stage? Well, good morning, sunshine.... Gerome Ragni and James Rado set the karma from that year's "Summer of Love" against the increasingly bad vibes from a place called Nam. And for their "American tribal love-rock musical," they picked a title sure to rile the geezers.

RALPH MORSE / LIFE

A CHORUS LINE

In a drafty rehearsal hall, gypsy dancers like Pamela Blair confided their showbiz dreams while trying out for bit parts in a Broadway extravaganza. The Michael Bennett–Marvin Hamlisch show, as austere as the traditional musical was gaudy, opened in 1975 and ran for a then-record 15 years.

MARTHA SWOPE / TIME INC.

AIN'T MISBEHAVIN'

Sixty-five years after black musical revues were consigned uptown to Harlem, Broadway decided the most important color was green. Richard Maltby Jr.'s groundbreaking 1978 tribute to the ebullient pianist-composer Fats Waller sparked a run of hits that mined black song and dance, among them *Jelly's Last Jam* and *Bring in da Noise, Bring in da Funk*.

MARTHA SWOPE / TIME INC.

<

FOLLIES

Nobody had accused Broadway of being too cerebral — until 1971, when in rode Gene Nelson. The vehicle, courtesy of Stephen Sondheim and Harold Prince, probed the memories of two aging Ziegfeld girls by way of a nonlinear (and virtually nonexistent) plot. The "concept musical" proved a format that few besides Sondheim could adroitly handle.

MARTHA SWOPE / TIME INC.

>

RENT

Broadway was ruled by the British megahits of Lloyd Webber and by pricey revivals when Jonathan Larson arrived in 1996. His protean rock opera reset Puccini's *La Bohème* in New York's East Village and fused a cornucopia of musical genres: electric rock, Motown, reggae, salsa, even gospel. Three weeks before opening night, Larson died unexpectedly of an aortic aneurysm; he was 35.

JOAN MARCUS

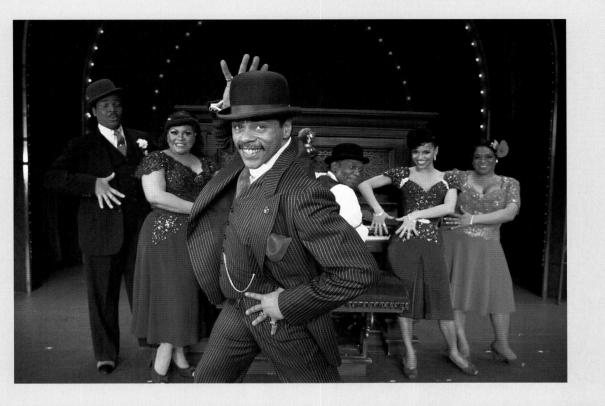

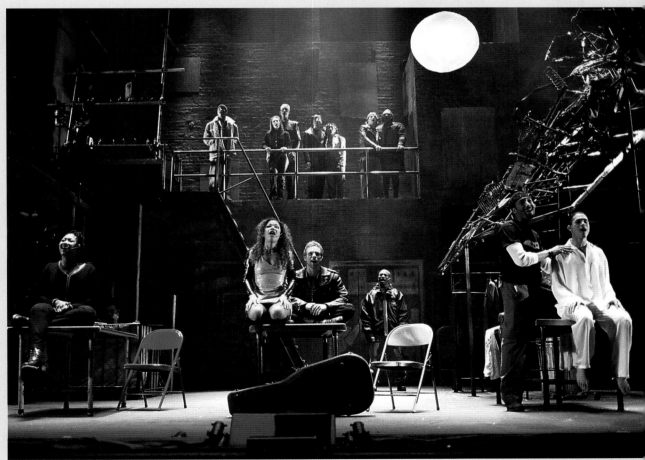

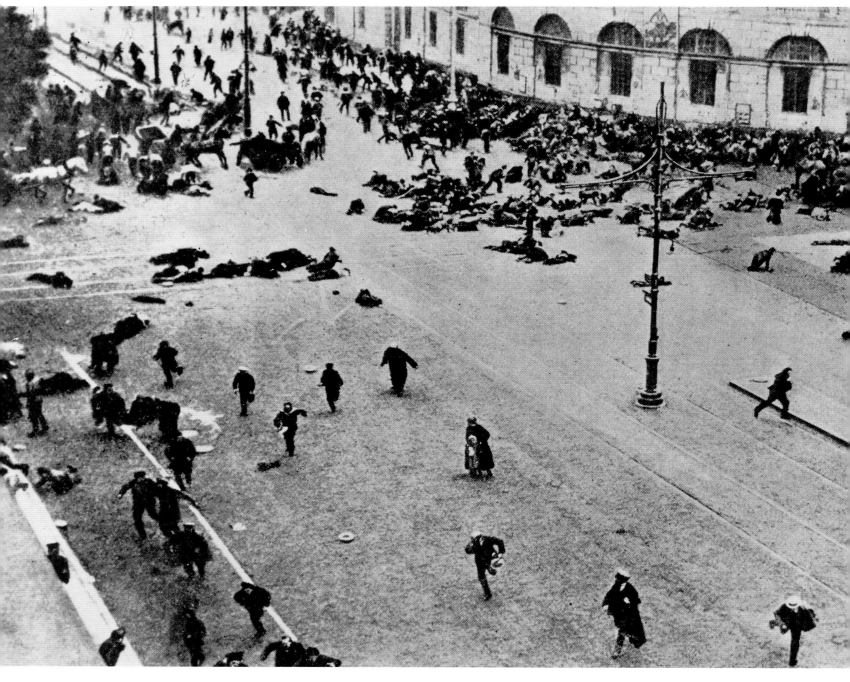

TEN DAYS THAT SHOOK THE WORLD

In early 1917, with their country's scant food and fuel diverted to a futile war, Russians began to riot, most notably in the newly renamed capital of Petrograd (above). The czar had barely survived an uprising in 1905. Now Nicholas abdicated. A provisional government soon fell to the Reds (Communists), who were counterattacked by the Whites (the czar's loyalists). The Russian Revolution was on.

TIME INC.

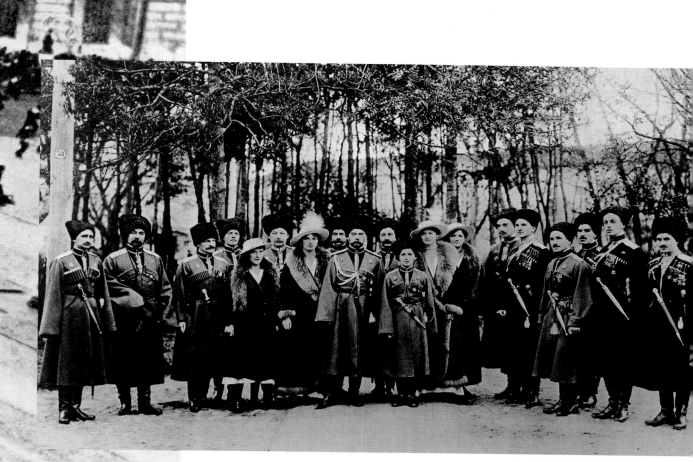

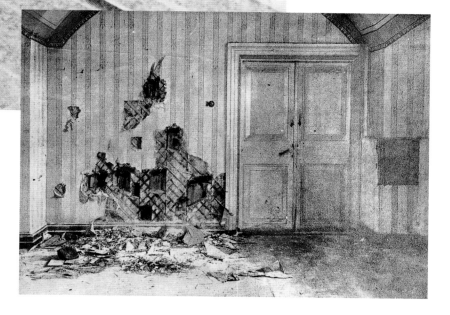

A MASSACRE — AND A MYSTERY

The imminent turmoil seemed not to faze Nicholas (above, center, with heir apparent Prince Alexis, 14; his four daughters, ages 17 to 23; and palace guards). The imperial family soon surrendered to the Reds and was taken to an estate in the Ural mountains to await a show trial. But on July 16, 1918, as the White Army neared, the czar and czarina, the five young Romanovs, plus four servants were slain with guns and bayonets. The 11 corpses were removed from the bullet-pocked room (left), doused with acid and tossed in an unmarked grave. Yet Soviet officials exhuming the remains in 1991 found only nine bodies.

ABOVE AND LEFT: TIME INC.

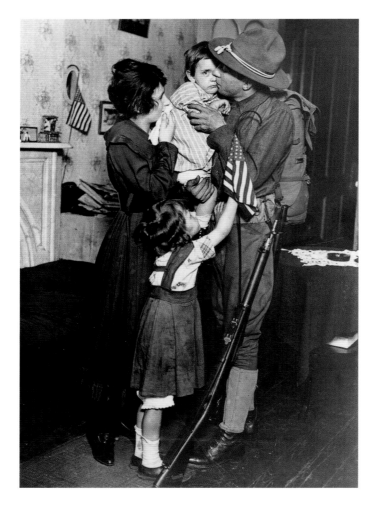

THE YANKS ARE COMING

Private T.P. Laughlin of the New York National Guard said goodbye in 1917 after being called to active duty. Reacting in part to German submarine attacks on U.S. merchant ships, America ended its neutrality despite having an army with fewer than 130,000 men. But the first doughboys (slang for troops since Custer's time) were in France by June and in combat by October.

NATIONAL ARCHIVES

NEXT, THE RHINE

American troops mounted their first major offensive in September 1918, 15 months after the Yank vanguard reached France. The battlefield — Saint-Mihiel, in German hands for four years. Aided by thick fog, the U.S. First Army, now 1.4 million men strong, punched through. It then joined with French forces to win back the Argonne Forest. The German retreat was under way.

U.S. SIGNAL CORPS

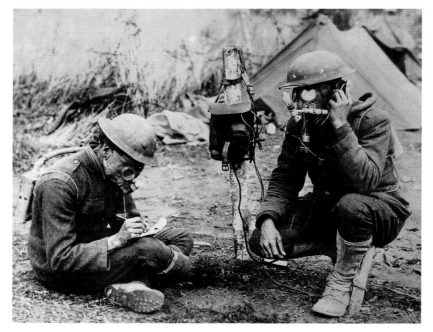

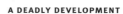

A DEADLY DEVELOPMENT

Two U.S. Signal Corpsmen were braced for a weapon new to World War I: poison gas. Though the 1899 Hague Convention banned chemical warfare, Germany began using gas in 1915. At first, Allied and German soldiers alike (the yellow clouds turned with the wind) had no protection beyond a wet hankie. It took a year to develop a working mask.

CULVER PICTURES

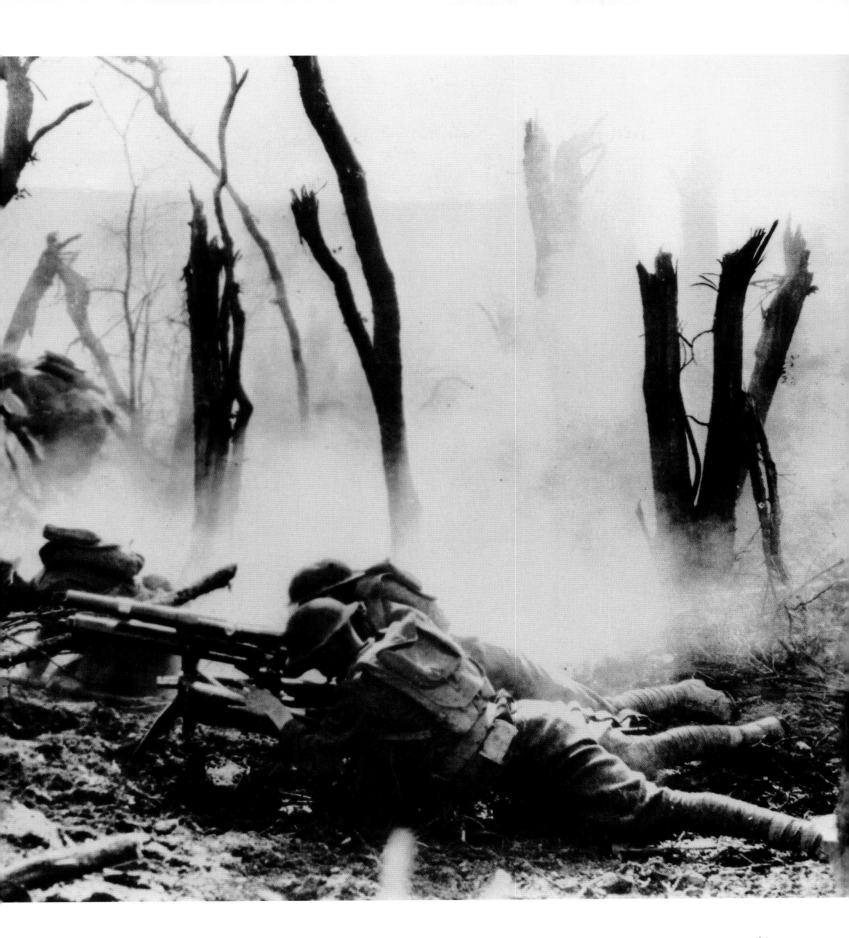

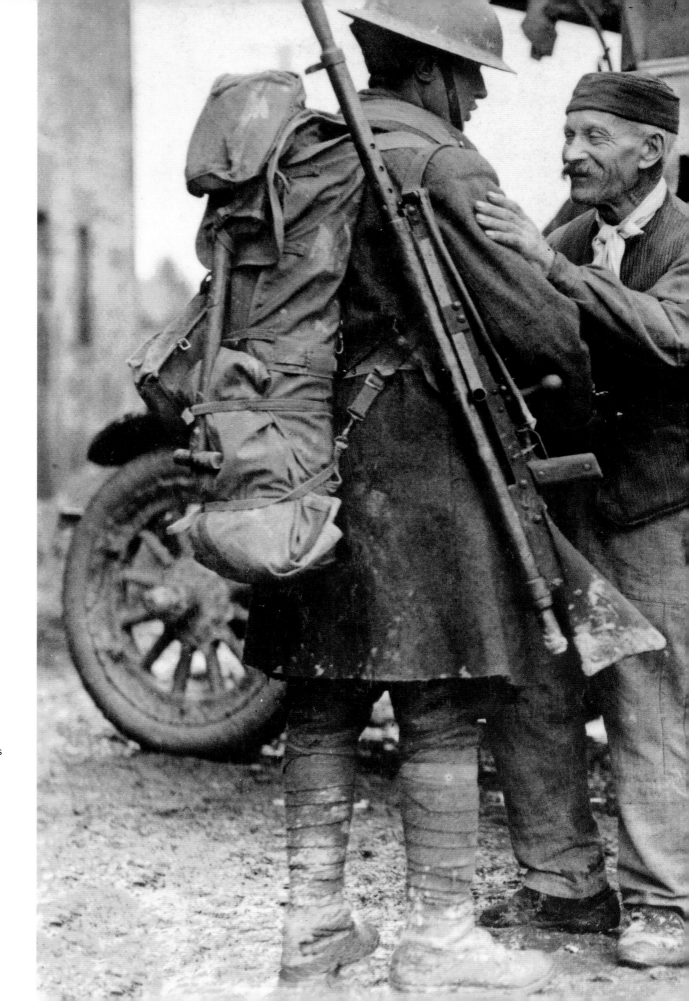

MERCI, MES AMIS

The gratitude of M. and Mme. Baloux, *anciens* from Breuilles-sur-Bar, toward a couple of Yanks in 1918 was palpable. Doughboys had helped liberate their hamlet, occupied by Germans for four years. Battle casualties in France claimed 1.4 million native sons, as well as half the 112,500 Americans who died during the war.

NATIONAL ARCHIVES

THEY ALSO SERVED

Unlike the Civil War a half century earlier, no troops cowed America's citizenry, no battles scarred its towns and cities. Yet World War I demanded real sacrifices on Homefront, USA. Four million men (of an adult male population of some 52 million) donned uniforms. Only half made it Over There, but all were separated from family and jobs. Picking up the slack: women. Traditionally male occupations (below) were filled by a gender that quickly proved itself neither weak nor lesser. Empowerment would soon translate into enfranchisement.

PITCHING PATRIOTISM

Give me your dollars (rather than your tired, your poor) was the gist of a 1918 ad posed by New York debutante Francis Fairchild. Its blunt slogan: "Save Her from Hun — Buy Liberty Bonds." When another New Yorker, Harry Cohn, launched Columbia Pictures six years later, the catchy image was re-created for his studio's logo.

NATIONAL ARCHIVES

BEYOND THE MELTING POT

Earlier in their lives, the women sewing an oversized Stars and Stripes had owed allegiances to five different European countries (Hungary, Galicia, Russia, Germany and Romania). At war's start, a third of America's almost 100 million citizens were foreign-born or had at least one parent who was an immigrant.

NATIONAL ARCHIVES

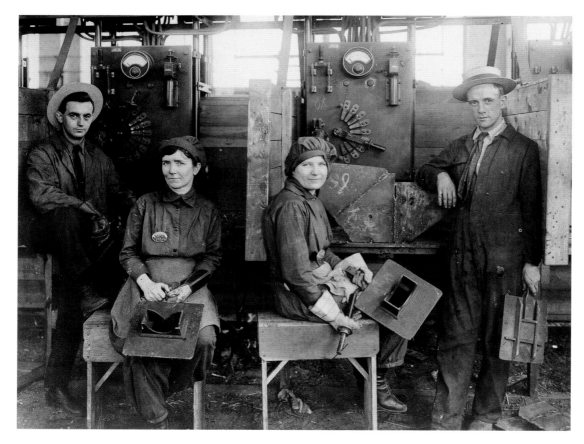

STAND THE HEAT? SURE

Rosie the Riveter was still two decades and one war in the future when these groundbreaking women signed on as welders at a shipyard on Hog Island, near Philadelphia. The only way American women could help out in France was as nurses. In hopes of so doing, some 10,000 enlisted in the American Expeditionary Force.

NATIONAL ARCHIVES

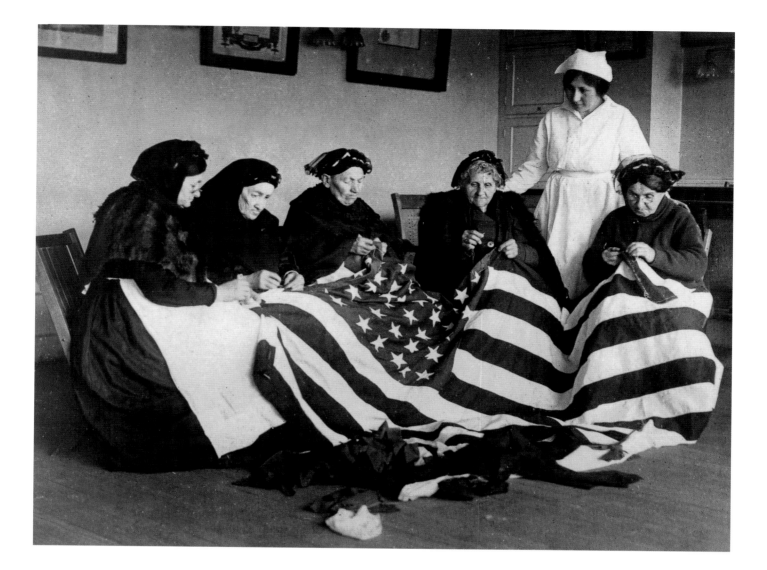

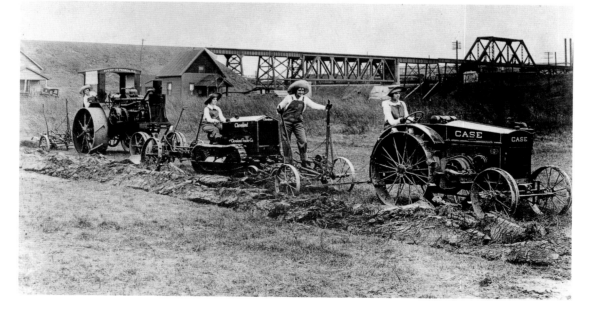

SPEED THE PLOW

Hardest hit by mobilization were U.S. farms. The 1910 census classified only 50 percent of the nation as urban. (Los Angeles's population was 319,198; that of Houston and Dallas combined, a mere 170,904.) Yet for the 19-month duration of the war, America's farm women made sure no countryman went hungry.

NATIONAL ARCHIVES

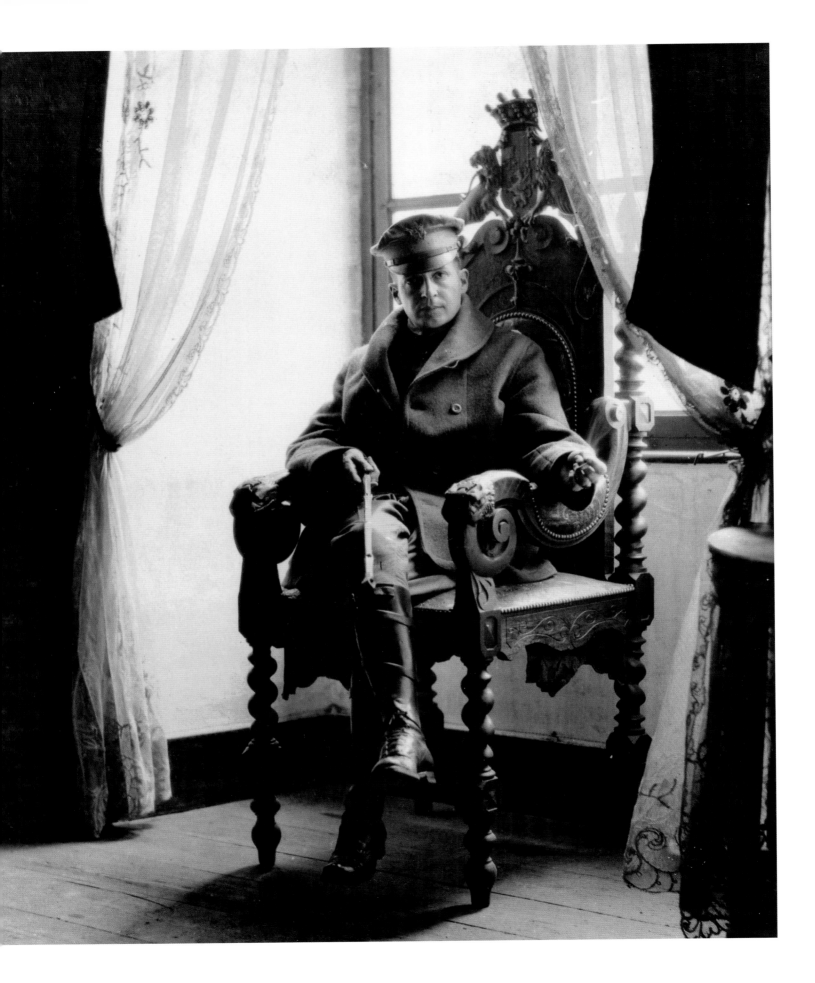

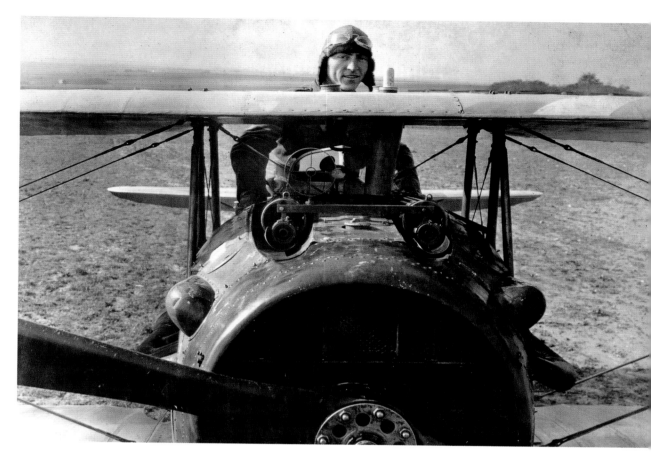

<

HE WOULD RETURN

Newly minted Brigadier General Douglas MacArthur, 38, was at ease in a chair belonging to the lord of a French manor repatriated by the Allies. A son of former Army chief of staff Arthur MacArthur, he would gain the same post in 1930. His retirement, in late 1937, was brief: MacArthur was recalled five months before Pearl Harbor.

NATIONAL ARCHIVES

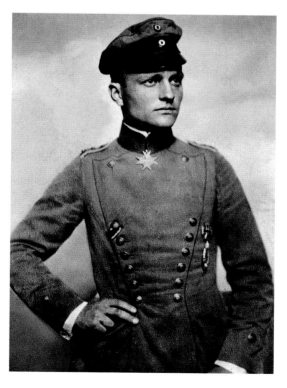

GERMANY'S TOP GUN

His fighter plane was indeed red, Manfred von Richthofen was indeed a baron, and for 20 months, the Prussian ace indeed owned the skies over France, downing an average of one Allied plane per week. On April 21, 1918, his streak ended. Hit by fire from either ground troops or Canadian pilot Roy Brown, Richthofen, 26, died when his Fokker fell to earth near Amiens.

PHOTOTHEK

OVER THERE, IN THE AIR

When America joined the war, Eddie Rickenbacker, 27, ranked as one of its top race drivers. Soon he was in France chauffeuring members of General Pershing's staff. Rickenbacker then earned his wings and before Armistice Day shot down 26 German aircraft. From 1932 to 1963, he helped develop America's commercial aviation industry.

NATIONAL ARCHIVES

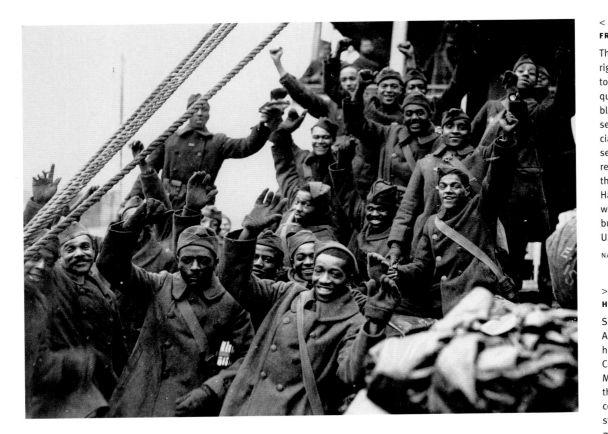

FREE AT LAST

The 369th Infantry was rightly jubilant sailing back to New York in 1919. Three-quarters of the 200,000 black men in uniform served as menials or musicians — black women seeking to be nurses were rejected out of hand — but the 369th was different. The Harlem Hellfighters not only went toe-to-toe with Jerry but also became the first U.S. unit to reach the Rhine.

NATIONAL ARCHIVES

HOME IS THE HERO

Safely back in Tennessee, Alvin York, 32, showed Mom his Medal of Honor and Croix de Guerre. In 1918's Meuse-Argonne campaign, the blacksmith, denied conscientious-objector status, charged a German machine-gun nest alone. He killed 25 and captured the rest; then, returning to HQ, York accepted more surrenders. Total POWs he delivered that day: 132.

VITAGRAPH, INC.

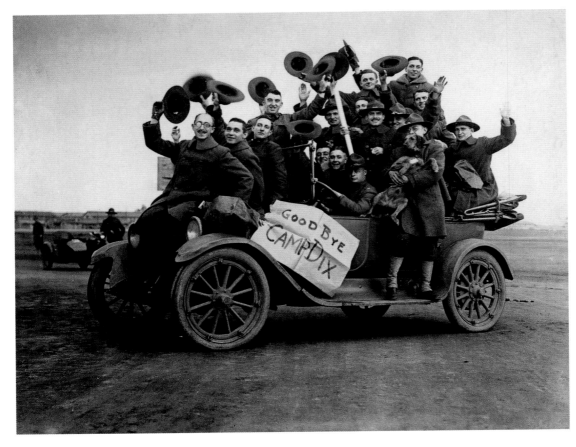

A FAREWELL TO ARMS

Were these troops happy to leave their New Jersey demobilization center in late 1918? More so than the four-legged souvenir of war clutched by the doughboy on the running board. All told, 2.1 million Yanks went Over There. Some 122,500 ended up in graves or missing; another 237,135 returned wounded.

NATIONAL ARCHIVES

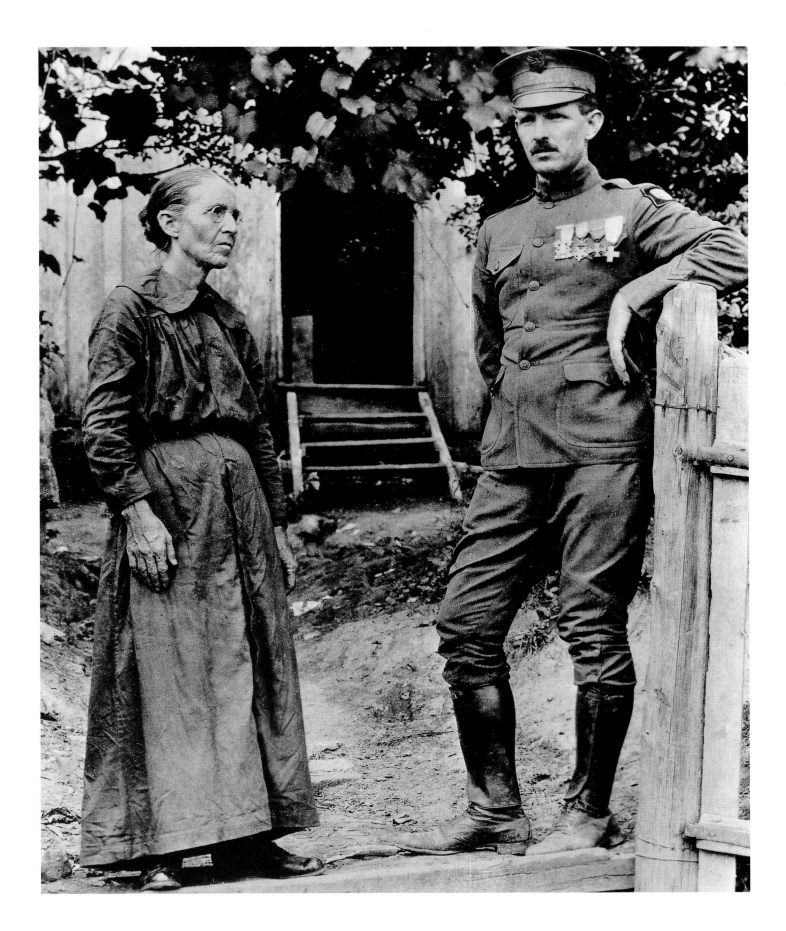

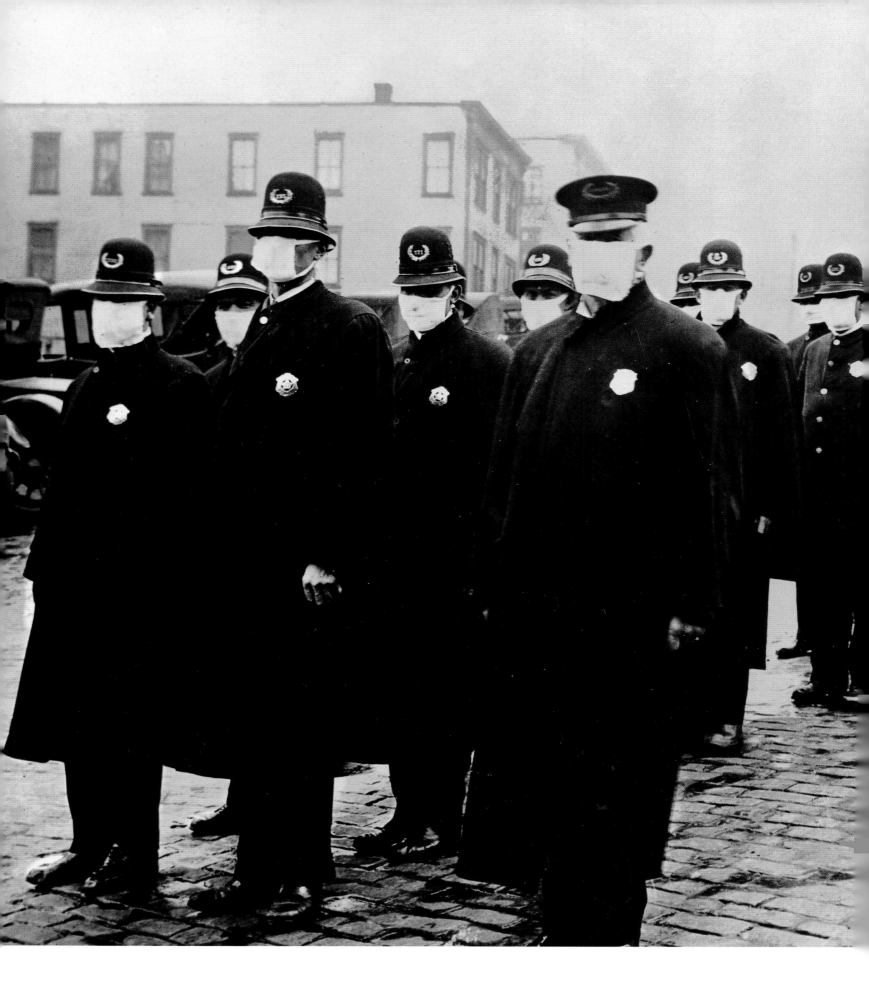

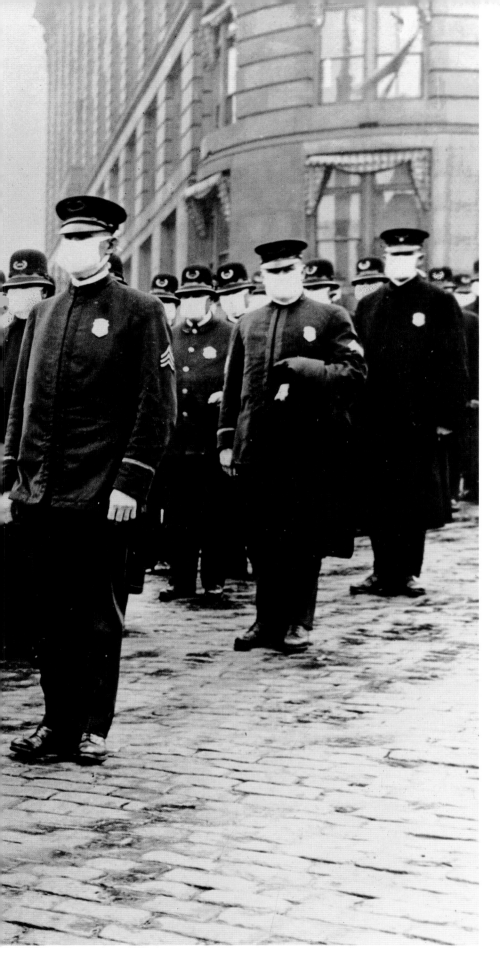

DIAMOND SCANDAL

In 1919, Joe Jackson, 31, had another All-Star year (.351 average, 96 RBIs) to lead his White Sox to the World Series. But when the underdog Cincinnati Reds won, he and seven team-mates were charged with fixing the outcome on behalf of gamblers. Shoe-less Joe said it wasn't so, and the jury agreed. But baseball banned him and the rest of the Chicago Black Sox for life.

CORBIS / BETTMANN

INVISIBLE ENEMIES

Near war's end, two fevers swept America. Seattle cops wore masks in 1918 to guard against Spanish flu, a strain targeting those aged 20 to 40. Borne across oceans by transiting soldiers, it killed a half million in the United States, 20 million worldwide. The other virus — the Red Menace of Bolshevism — would take far longer to run its course.

NATIONAL ARCHIVES

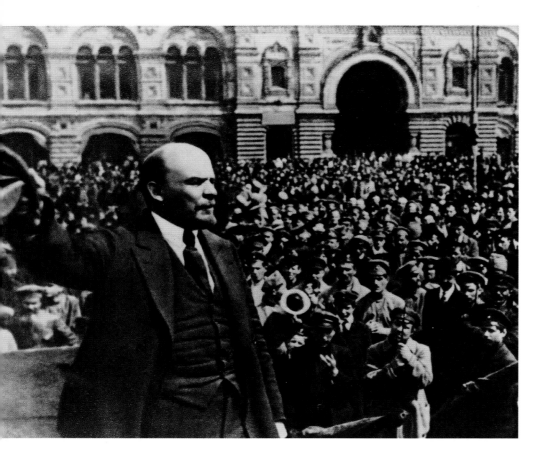

RUSSIA TURNS RED

Two years earlier, this 49-year-old revolutionary preaching communism in Moscow's newly renamed Red Square was sneaking back to Mother Russia inside a boxcar. Czar Nicholas had vacated his throne — and in chaos, Vladimir I. Lenin saw opportunity. Rightly so. By 1919, the civil war had been won, and power cemented, by his Bolsheviks.

TIME INC.

WAS THIS TRIP NECESSARY?

They rolled out the carpet for Woodrow Wilson in Dover, England, one month after the armistice ending World War I. The president, 61, was sailing to peace talks in France. He would play a pivotal role in forging the Treaty of Versailles. Congress, blind to issues beyond America's borders, rejected not only the pact but also U.S. membership in the League of Nations.

NATIONAL ARCHIVES

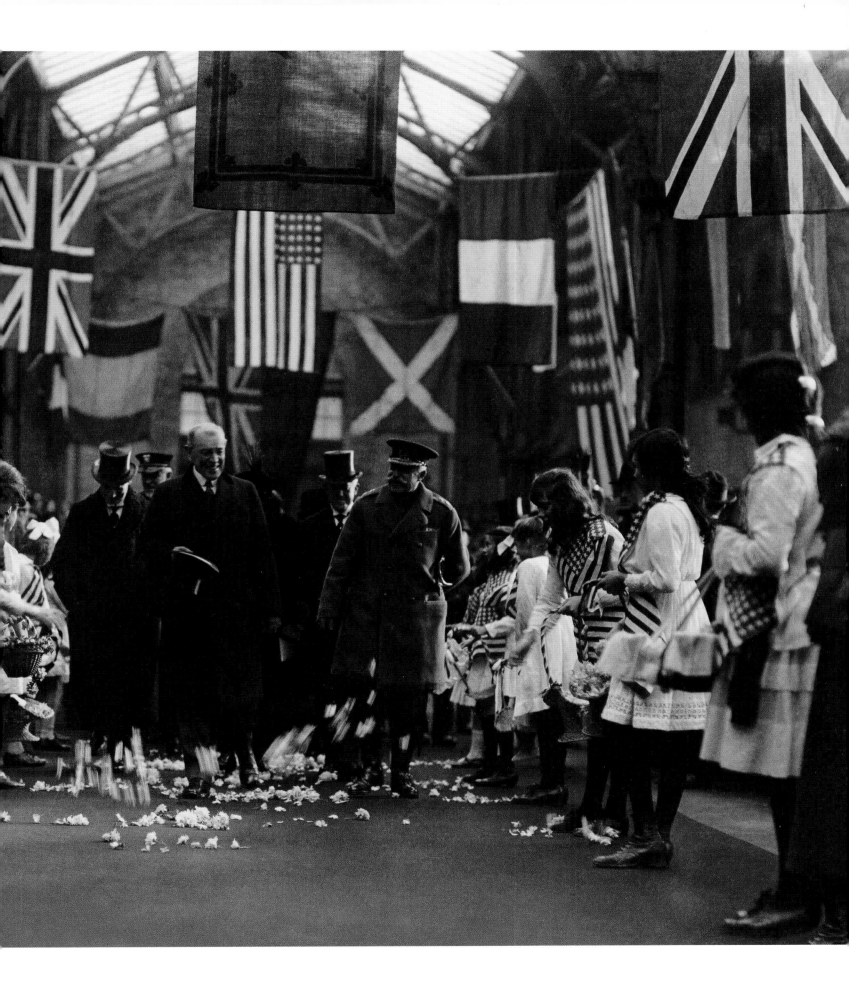

REQUIEM

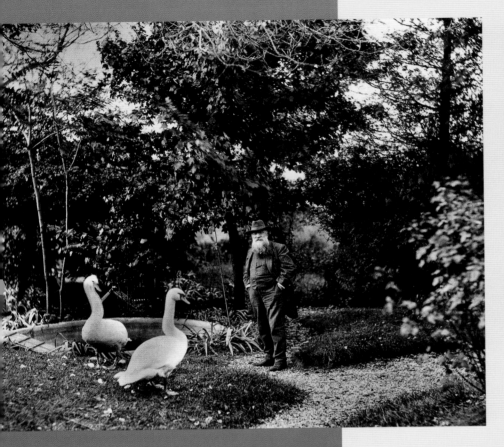

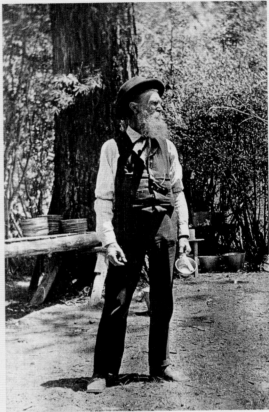

AUGUSTE RODIN
1840–1917

The sculptor renowned for outsized nudes began by executing fussy decorative works for established artists. Not until his mid-30s did Rodin find a style of his own: an au naturel realism in bronze ("The Thinker") and marble ("The Kiss") that startled the art world. And titillated it: The nubile female smoocher was his pupil and lover, Camille Claudel.

AKG

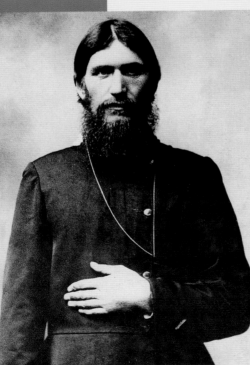

RASPUTIN
1872–1916

The illiterate Siberian won entrée to the court of Czar Nicholas II in 1907 as a holy man who could cure the crown prince of hemophilia. Rasputin accrued so much power that he weakened the throne. Nor did he give it up easily. On December 31, 1916, foes fed him poison, then shot him — repeatedly. He was still alive when they dumped him in the Neva River to drown.

TIME INC.

JOHN MUIR
1838–1914

When his family left Scotland for Wisconsin, young Muir was delighted: a chance to explore America. The adult naturalist's articles about his wilderness treks spurred Washington to carve out 13 national forests safe from commercial exploitation. Muir then roughed it in Yosemite with a high-placed pal; soon, Teddy Roosevelt created the federal parks system.

SIERRA CLUB

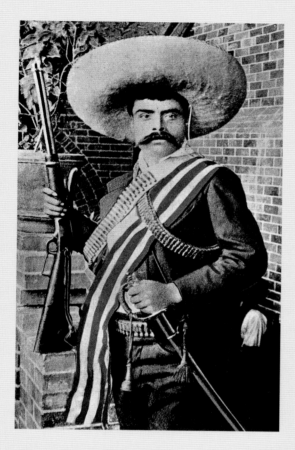

EMILIANO ZAPATA
1879–1919

As a teen, he began fighting the hacendados who stole land from Mexico's peasants, and he never stopped. If negotiations with owners failed, Zapata reclaimed property by force. Then Mexico City bushwhacked him. Seventy-five years later, when the mestizos of Chiapas State started a guerrilla campaign for land reforms, they styled themselves Zapatistas.

CORBIS / BETTMANN-INP

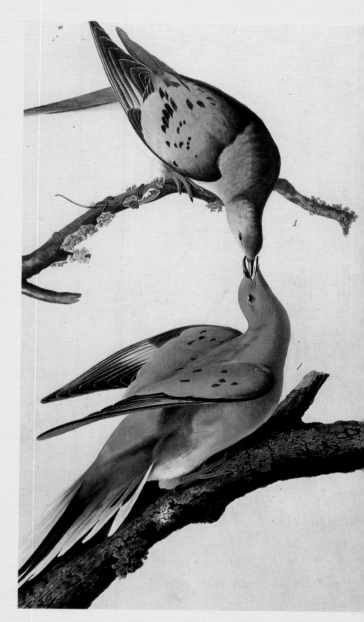

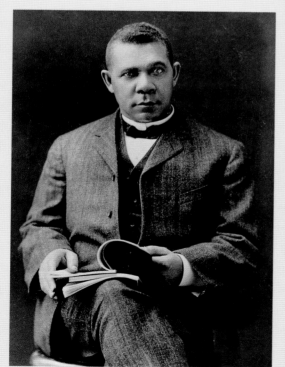

BOOKER T. WASHINGTON
1856–1915

Neither birth as a slave nor abject poverty dimmed his dreams. In 1881, in the belief that vocational skills were the fast track to racial equality, Washington founded a college, Tuskegee Normal and Industrial Institute. For his pragmatism and his friendships with influential whites, some rival black leaders deemed him an Uncle Tom.

LIBRARY OF CONGRESS

ECTOPISTES MIGRATORIUS
????–1914

In 1813, seeing a mile-wide flock take three hours to pass, ornithologist James Audubon calculated its congregants at one billion. America's most populous species was butchered for food and for sport in the 1800s, but scientists now blame its demise on deforestation and disease. The last known passenger pigeon, bred and raised at the Cincinnati Zoo, died at age 29. Her name was Martha.

COLLECTION OF THE NEW YORK HISTORICAL SOCIETY

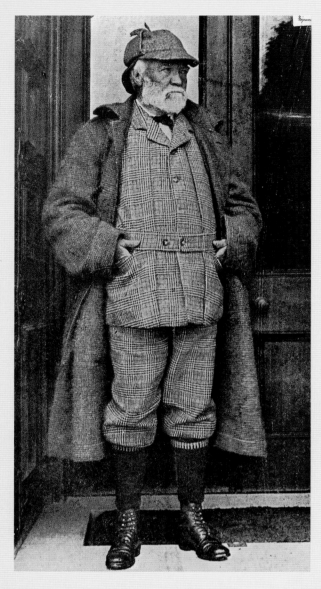

WILLIAM F. CODY
1846–1917

His exploits as an Army scout and buffalo hunter captivated novelists — but did Native Americans no good. Trading on his woolly reputation, Buffalo Bill launched his Wild West show in 1883; it featured cowboys and Indians (including Sioux Chief Sitting Bull) and even a cowgirl (Annie Oakley). Despite the barnstorming troupe's popularity, Cody died poor.

TIME INC.

<

ANDREW CARNEGIE
1835–1919

The young Scot's first job in America: bobbin boy at a cotton mill. He reached management at the Pennsylvania Railroad but quit at 38 to found the firm that became Carnegie Steel. J.P. Morgan paid him $250 million for it in 1901; Carnegie devoted the rest of his life to giving away money, much of it to underwrite public libraries across the country.

TIME INC.

>

HENRY JAMES
1843–1916

Born in New York, raised on both sides of the Pond, he chose to live and write in England. James therefore had a ringside seat to observe naive Americans adrift in fin-de-siècle Europe. While long on interior dialogue and short on action, novels like *The Portrait of a Lady* and *The Wings of the Dove* are wise meditations on character, class and manners.

CULVER PICTURES

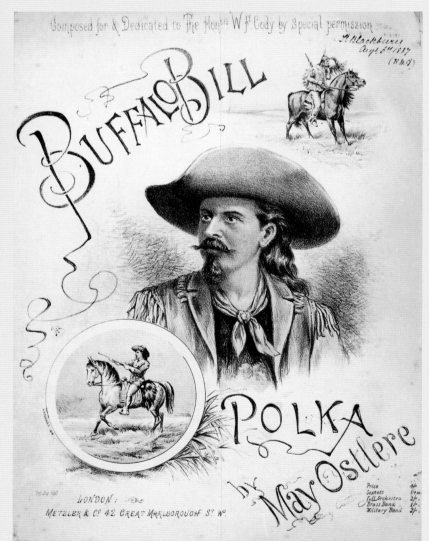

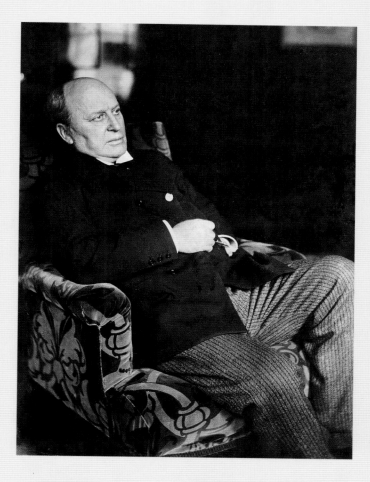

PIERRE-AUGUSTE RENOIR
1841–1919

A teenage job decorating porcelains and fans led him to study art. Then, with Claude Monet, he renounced academic tradition and hauled his easel outdoors. (Their peer Frédéric Bazille executed this 1867 portrait.) Unlike his fellow Impressionists, Renoir preferred to paint figures. When arthritis crippled his hand, he had brushes tied to his arm.

ERICH LESSING / ART RESOURCES

FRANK WOOLWORTH
1852–1919

Until he opened a store in Lancaster, Pennsylvania, in 1879 (right), Woolworth had failed to make low-price retailing work. He soon turned his concept into a Main Street staple; at its height, the chain had 8,000 locations worldwide. Competition from discounters nickeled-and-dimed the firm to death. Now the Venator Group, it sells sports gear.

BROWN BROTHERS

1920–1929

ALL THAT GLITTERS

In 1921, fair maidens from nine cities were in Atlantic City vying to be the first Miss America. The winner: Margaret Gorman, 16, of Washington, D.C. (third from left).

CULVER PICTURES

But Who Pays the Piper?

BY GENE SMITH

THE WAR, THEY DECIDED, was a long shriek of collective insanity. Why, they asked, had they ever sent The Boys to Over There? A final dividend was Bolshevik ideology and Great Red Scare bombs sent through the mail and loosed off in front of J.P. Morgan's in Wall Street to kill 40 people. The Americans turned away from Europe, and from Wilson and his League.

What they desired and what we needed, Woodrow Wilson's successor Warren G. Harding said, was return to normalcy. His dreamed-of normalcy, a word previously unknown to most students of the language, was the world of the 1890s: Protestant America of old pioneer stock on its farms and in its villages with house doors never locked, the paved street coming to an end at the edge of town where the trolley turned around, and after sundown a great peaceful silence, nothing to be heard but the bark of a distant dog. The real America. No urban mess. No radicalism. No foreigners of alien cosmopolitanism.

Perhaps they believed what President Harding said — for a little while. The past's last brief stand was mounted, with Prohibition's virtues at least publicly extolled, the doctrine of evolution often denounced, a resurgent Ku Klux Klan widely accepted for its application of the lash and the burning cross to blacks defined as uppity, Catholics, Jews, immi-

grants, labor leaders seen as agitators who had entirely too much to say about the 12-hour day and the 84-hour week. Soon enough such issues were pushed into disregarded background. They became like income taxes. One in 500 Americans paid — a good-earning family man taking down, say, 5,000 was assessed maybe 20 dollars. Issues? There *were* no issues.

No. Europe struggled with the war's bankruptcy, both financial and spiritual, but Americans had an enormous surplus of money flooding into a nation suddenly turned from debtor to creditor and great energies brought to a boil but left unfulfilled when Kaiser Bill ran off to Holland after losing the war. Energy met money, and both burst into a splurge of God's Own Country productivity that rapidly brought technological progress such as history had never known. All at once washing machines and refrigerators were available, and electric irons, vacuum cleaners, telephones, phonographs, waffle makers, running-water toilets, sewing machines — and you didn't have to pay! In the past of Puritan-like tradition, borrowing was for dire medical emergency, imminent foreclosure or burial expense, but now there

More than stocks were soaring in Manhattan. When work got under way on the 1,048-foot Chrysler Building in 1928, a rival syndicate quickly hatched plans to raze the original Waldorf-Astoria Hotel and put up a 1,250-foot skyscraper (right), the Empire State Building.
LEWIS W. HINE / NEW YORK PUBLIC LIBRARY

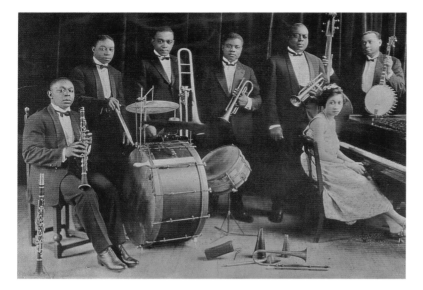

Imagine the Jazz Age without jazz. Imagine jazz without Louis Armstrong (center, with King Oliver's Creole band in 1922). The trumpeter extraordinaire's solo improvisations were the bridge from blues and ragtime to swing and beyond. He also invented scat; dropping the sheet music during a recording session, Satchmo ad-libbed nonsense syllables.

PHOTOGRAPHER UNKNOWN

was installment buying with a little down and a little every month, and with a twist of a switch you could accomplish what cost poor grim Grandfather and Grandmother a couple of hours of brutal labor and have things of which they could never dream.

Most of all, your car and your radio. In 1895, the country produced four internal combustion vehicles. By the mid-Twenties, automobiles directly or indirectly provided employment for five million Americans and were not colored just conservative old black, but available in Dawn Grey, Niagara Blue and Arabian Sand. Sales of radios were $1 million in 1920; five years later, $400 million. At the beginning of 1922, there were 28 licensed stations. At the end of the year, 576.

It became one's duty to buy things. Out along the lanes made into roads yesterday and where tomorrow exclusive new suburbs would be — ON THIS SITE WILL BE ERECTED — there sprang up the handmaid of installment buying, advertising billboards. Five thousand lined the Pennsy tracks between Washing-

ton and New York for the Limited roaring by with a long string of Pullmans carrying live-wire salesmen affirming that their products were strictly first chop. Thin newspapers and solemn magazines, which once carried only information and opinion, swelled to hundreds of pages, mostly ads. You bought.

Miraculously new ways and codes arrived, with country club golf courses suddenly in place for two million novices hacking about where in the past dull-eyed cows grazed and crops grew. Booze allegedly just off the boat was discreetly served in teacups to turn-of-the-century-born men whose fathers uniformly dressed in dark clothing but who themselves wore checkered and bulging plus fours and Argyle socks, and whose women did away with their mothers' crowning glory and fruit-tray hat for the bobbed cut reaching just below the ear under a cunning little cloche cap, with skirts up to the knee in place of what used to sweep the floor. And lip paint and powder. A whole new industry arose, that of the beautician. She had her shop in even the smallest town.

In 10 years the skyline of every city was wondrously transformed. The New Era's architectural symbol was perhaps less the skyscraper than it was the movie house. Palace, really. That was what they were called, representations in even minor population centers of ancient Spain, China, Egypt, or Versailles, soaring roof, statues in alcove, glittering chandeliers, marble stairs, great arch, plush carpet. The style and manners and ways of the star on the screen brought, along with radio and magazine, the new and stylish to Louisiana plantation and Montana ranch, and so eliminated the country bumpkin and the rube. They who had been such now knew along with the Manhattan sophisticate about Joe College, the sheik with his Betty Co-Ed of footlong cigarette holder, and of Clara Bow's possession of "It," and of Capone's settling Chicago bootlegging disagreements with a Thompson submachine gun, and of

Scott and Zelda's riding on top of taxicabs and jumping into fountains; they knew of Flaming Youth, the much-talked-of Younger Generation. And achievements of the Golden Age of Sports: Bobby Jones, Big Bill Tilden, Trudy Ederle's swimming the English Channel. And the Snyder-Gray murder case in which Mrs. Coiffed Peroxide Blonde Housewife puts paid to Dreary Husband with assistance from — who else — Traveling Salesman.

It all seems today, looking back, utterly distant from what we must think of as the real life of those whose blood flows in our veins. What on *earth* did it matter to Great-grandpa if Tunney beat Dempsey or vice versa. That a St. Louis mechanic did or did not fly the Atlantic — what was that to them? Yet these were the matters that all evidence says entranced those people of the tiny little face-the-sun-and-squint photos in our old albums. These trifles. Yes, yes, Sacco-Vanzetti was important to some and Dayton's Monkey Trial and Freud with his dicta about throwing off inhibitions — which filtered down as approval of rumble-seat necking parties — but it is not for nothing that the times were famously termed the Era of Wonderful Nonsense. The Jazz Age. The nights of saxophone and the Charleston, the Flapper Era, the Roaring Twenties in which not everyone heard the noise, and there were those whose ears the music but faintly reached, blacks, for instance, or the farmers, whose average family income was less than a thousand a year, $200 in the South. But generally it was like the race in *Alice in Wonderland* in which everyone wins.

Then calendars brought what is always recalled with *before* or *after* preceding its mention: Nineteen hundred and twenty-nine. It is a mistake to believe every shoeshine boy gave you stock tips throughout the reign of the Prince of Laissez-Faire, Cool Cal Coolidge. Playing the market was strictly for Wall Street buccaneers before real people took in that, as with installment buying, you could put down a dime

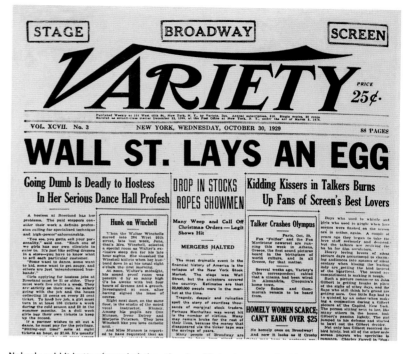

Nobody said it better (or ruder) than the showbiz trade paper: On Black Tuesday, America's securities lost 12.8 percent of their worth. Ironically, as hard times set in, the value of entertainment-industry stocks rose.
CULVER PICTURES

and get a dollar's worth of stock. By early 1929, new stock issues totaled $800 million a month at a time when the annual federal budget was under $4 billion. The Market became central to the culture, with the rise of, say, Radio Corporation of America from a 1928 low of 85 to a high of 428 seen as enthralling as the Babe's previous-year total of 60 homers.

Coolidge went away and Hoover came in, and the Great Bull Market reached in early September its Indian summer flood crest. Then of a sudden on October's Black Thursday and Black Tuesday the water crashed over the dam. Long and dreary party's-over years followed, and the Twenties became in painfully thin newspapers "the days of our prosperity," "the happier times" — "The Golden Decade."

Gene Smith is the author of the best-selling When the Cheering Stopped: The Last Years of Woodrow Wilson *(1964). He has also written books on President Herbert Hoover and General of the Armies John J. Pershing.*

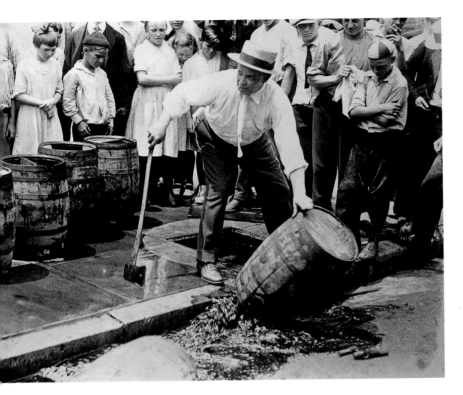

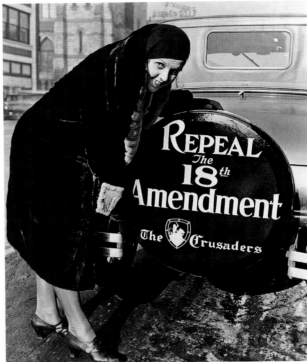

CLOSING TIME

America went dry on
January 29, 1920, as the
18th Amendment, banning
John Barleycorn, kicked in.
Revenuers (above) hunted
for stashes; flappers (above
right) hunted for speak-
easies. Before Prohibition's
repeal 13 years later, many
illicit bootlegging fortunes
would be made.

ABOVE: CULVER PICTURES
ABOVE RIGHT: LIBRARY OF
CONGRESS

YOU'RE ON THE AIR . . .

To boost its reach, KDKA of
Pittsburgh even tried
airborne antennae. The
nation's first radio station
debuted on November 2,
1920, with Election Night
coverage of the Harding-Cox
race. It soon added music.
In 1922, WEAF in New York
City sold advertisements,
completing the gestation of
commercial radio.

CORBIS / BETTMANN

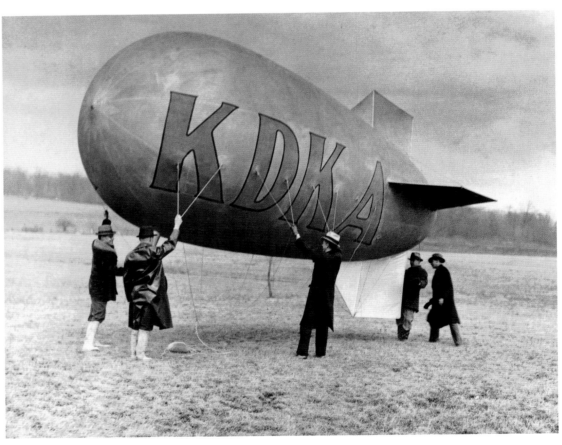

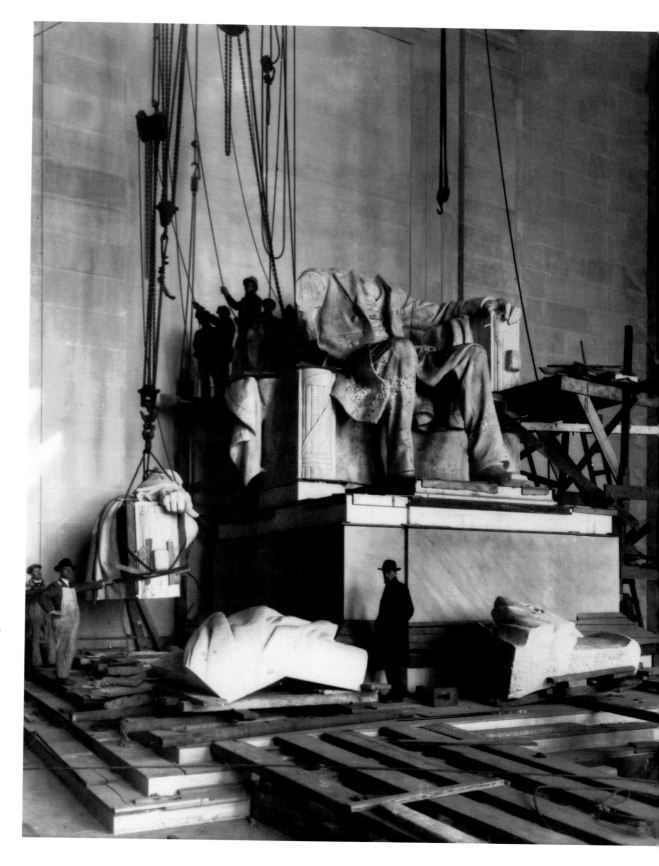

A STATUE DIVIDED

Ground had been broken for the Lincoln Memorial in Washington, D.C., 50 years after the 16th president's assassination in 1865. The 36-column building (one for each state of the Union at the time of the Civil War) was roofed before workmen began installing Daniel Chester French's 19-foot-high marble statue. The $2.9 million memorial was dedicated in 1922.

NATIONAL ARCHIVES

TURNING POINT:
CLOSING THE GENDER GAP

You Go, Girl!

The Founding Fathers didn't specifically preclude the Founding Mothers from a role in democracy. No need to: During the republic's early years, women largely endured second-class citizenship, a bias inherited from millennia of Western culture. Things began to change with the opening of the American West. On the frontier, gender counted for less than can-do spirit. By the late 19th Century, many states had rewritten laws allowing women to own property. Yet calls by early suffragettes for voting rights were met with hoots; in 1900, women could cast ballots in a national election only in New Zealand. World War I helped tip the scales in America (see pages 64–65). At century's end, women have achieved every major elected and appointed post in the country except the two highest. Can't stop thinking about tomorrow. . . .

(see pages 64–65)

ONE WOMAN, ONE VOTE

On August 20, 1920, when Tennessee became the required 36th state to ratify the 19th Amendment into law, Alice Paul lifted a glass (of grape juice, thanks to the 18th Amendment). The militant Paul, 35, didn't quit there. She later helped lobby gender-equality passages into the U.N. charter and the U.S. Civil Rights Act of 1964.

CORBIS / BETTMAN-UPI

NEW YORK STATE DENIES The VOTE To CRIMINALS LUNATICS, IDIOTS & WOMEN

<
IS ANYONE LISTENING?

The marchers' blunt message was true until 1917, when their state joined 14 others (out of 48) in granting women at least some voting rights. The U.S. House voted in 1918 to make it the law of the land, but Southern senators balked at enfranchising black women. Congress finally passed the 19th Amendment the next year.

CULVER PICTURES

>
USE IT OR LOSE IT

Members of the brand-new League of Women Voters prepared to entrain for the 1920 Democratic Convention in San Francisco. The organization, called the National American Woman Suffrage Association until the 19th Amendment was ratified, began life with an impressive two million members.

ARCHIVE PHOTOS

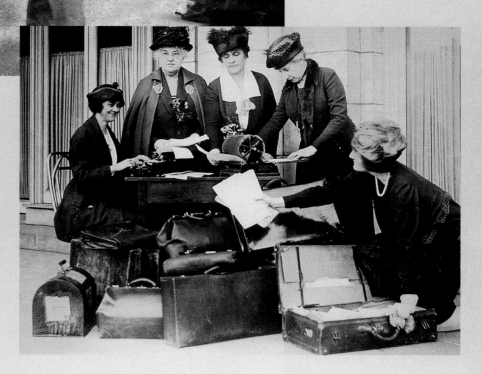

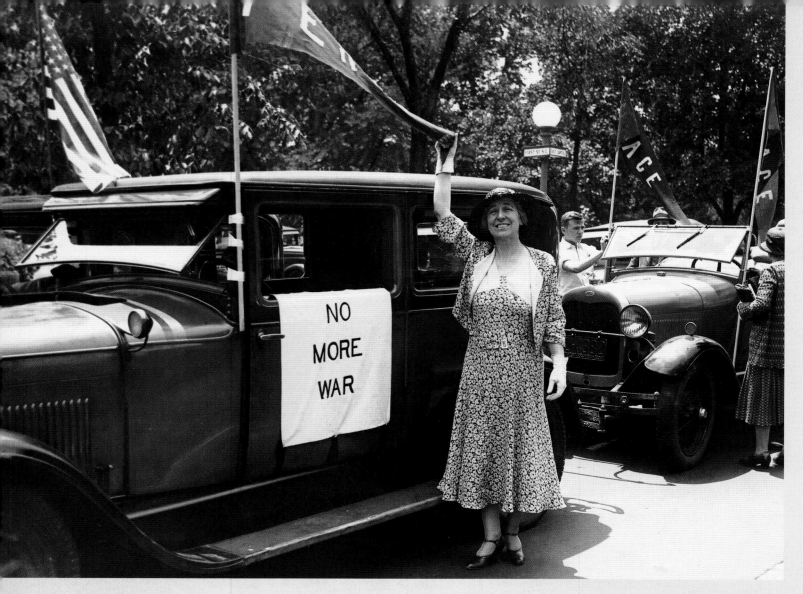

PEACE IN HER TIME

The first U.S. congress-woman (representing her native Montana) could vote for herself in 1916 but not for a presidential candidate. Jeannette Rankin lost her next run after opposing America's entry into World War I. Her continued pacifism (above, in 1932, at age 51) led to a second term in 1940; she thereupon became the lone legislator to vote against declaring war on Japan after Pearl Harbor.

AP

A PIONEER APPOINTEE

The 1933 Senate confirmation of Frances Perkins, 51, as Secretary of Labor made her the first female cabinet member. Though thought "soft" by both industry and labor, she helped craft New Deal laws on unemployment compensation, minimum wage, maximum workweek and Social Security. Perkins resigned in 1945, two months after the death of her mentor, FDR.

AP

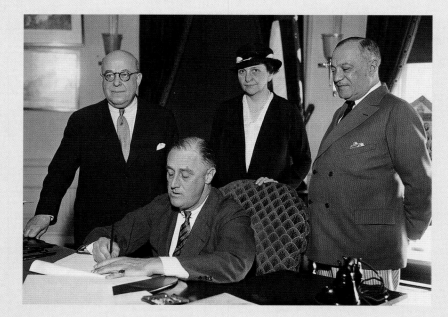

WELCOME TO "THE CLUB"

Exultant four-term representative Margaret Chase Smith, 52, of Maine won the GOP nomination for the Senate in 1948. By then capturing the election, she became the first woman to sit in both houses of Congress. Smith, whom Eisenhower considered for veep in 1952 before choosing Richard Nixon, served four terms in the Senate.

CORBIS / BETTMANN-ACME

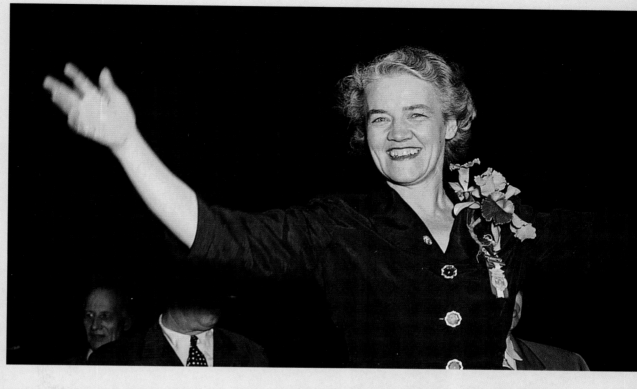

DON'T FENCE HER IN

"Unbought and unbossed" was the slogan of Brooklyn's Shirley Chisholm, who in 1968, at 43, became the first black congresswoman. She proved just as feisty on the Hill. Named to a subcommittee overseeing forestry, Chisholm asked aloud if that was because House leaders knew little about her home borough except that "a tree grew there." They caved. She won reelection six times.

FRED DE VAN

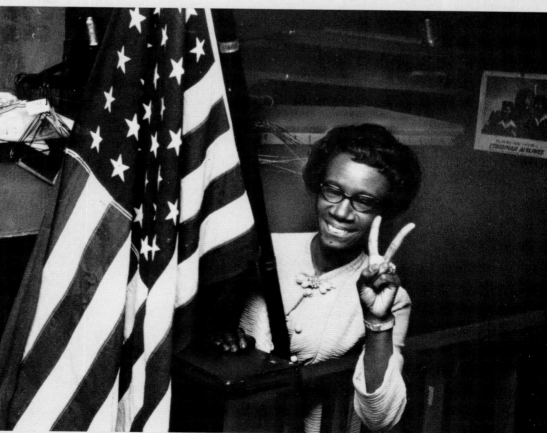

<

HERE COMES THE JUDGE (INTO HISTORY)

Fifty-one-year-old Sandra Day O'Connor was the surprise
nominee of Ronald Reagan to become the 102nd justice of the
Supreme Court. In 1981, the Arizona jurist became the first
woman confirmed to the High Court. Twelve years later, when
O'Connor was joined by Ruth Bader Ginsburg, both received
matching T-shirts that read "The Supremes."

DAVID HUME KENNERLY

<

MADAM GOVERNOR

America's first three women governors were wives of prior incumbents. Then, in 1974, Connecticut voted in Ella Grasso, 55, who had held various offices since 1952, including a seat in Congress. Her husband was a school principal. Grasso resigned partway through her second term, in 1979, a year before her death from cancer.

HENRY GROSSMAN

<

THE ANITA FACTOR

Until the 1992 election of Illinois's Carol Moseley Braun, 45, no black woman had ever sat in the U.S. Senate. She and three other freshwomen won a year after the gender- and race-charged confirmation hearings for Supreme Court nominee Clarence Thomas. Unlike the others, Braun was not reelected in 1998.

IRA J. SCHWARZ

>

RAINDROPS KEPT FALLING

An autumn shower in 1984 didn't dampen the spirits of Geraldine Ferraro, the first woman major-party candidate for vice-president, and ticket head Walter Mondale, 56. The ex-congresswoman, 49, held her own in a televised debate, but Election Day turned stormy: Reagan-Bush captured even Ferraro's home state of New York.

DIANA WALKER / TIME

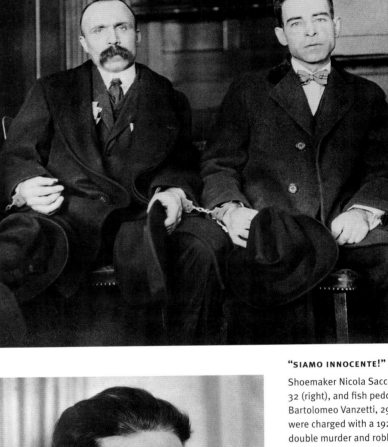

QUEEN OF COUTH

Stick a fork in it? Blue blood Emily Post told the rest of America precisely which fork to use (as well as how to handle every social occasion from birth announcement to condolence card). Post was 50 when her *Etiquette in Society, in Business, in Politics and at Home* was published in 1922; a million-plus copies later, the book remains in print.

CULVER PICTURES

16 JUNE 1904

James Joyce didn't set out to write the novel that changed 20th Century literature. Instead, *Ulysses*, completed in 1922, when he was 40, attempted to yoke the sacred to the profane, the eternal to the quotidian. Set in Joyce's native Dublin on the day he met lifelong companion Nora Barnacle (the template for Molly Bloom), its earthy passages led to global censorship. Americans first got to read it legally in 1934.

BERENICE ABBOTT / COMMERCE GRAPHICS LTD.

"SIAMO INNOCENTE!"

Shoemaker Nicola Sacco, 32 (right), and fish peddler Bartolomeo Vanzetti, 29, were charged with a 1920 double murder and robbery in South Braintree, Massachusetts. Despite flimsy eyewitness testimony and Sacco's corroborated alibi, the Italian-born anarchists were convicted. All requests for a retrial were denied — even after a local hood confessed to the crime in 1925. Their executions, in 1927, sparked worldwide protests.

CORBIS / BETTMANN-UPI

AN UNCOMMON FIND

In 1923, workers in Egypt (right) removed artifacts from an obscure pharaoh's tomb that had been sealed since 1323 B.C. British archaeologist Howard Carter, 50 (below, inspecting the royal coffin), found a trove of funerary art far more significant than Tutankhamen himself. (The king's reign had been abbreviated by regicide while he was still a teenager.)

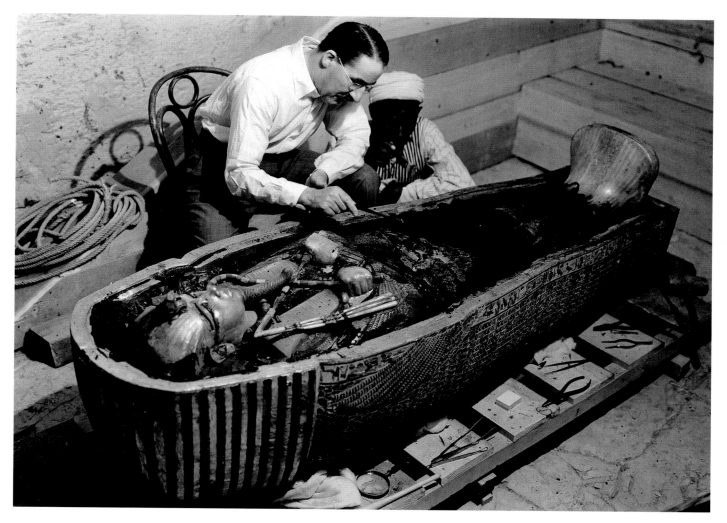

CUTTIN' LOOSE

It looked goofy (even when performed by Tempest Stevens and Swedish pole vault champ Charles Hoff at a 1926 contest in Los Angeles), but hey, giddy times spawned jazzy fads. In fact, the Charleston sprang from traditional dances of West Africa and Trinidad as transformed by Southern blacks. And it survived the Roaring Twenties: Remember such Charleston-reminiscent rock steps as the Hully Gully, the Watusi and the Mashed Potato?

CORBIS / BETTMANN-UPI

> ## THE RISING SUN

Japan's 124th emperor — Hirohito, installed in 1926 at age 25 — named his reign Showa, or Enlightened Peace. But over the next decade he did little to curb his nation's military adventures in China. Nor, as he was about to mark his 15th anniversary on the throne, did Hirohito balk at plans for an air attack on an American naval base at Pearl Harbor, Hawaii.

TIME INC.

A SOUND BARRIER FALLS

"You ain't heard nothin' yet!" bragged Al Jolson, segueing into "Toot, Toot, Tootsie!" Audiences for 1927's *The Jazz Singer* flipped over the first movie with synchronized speech. Jolson, 41 (above, with Eugenie Besserer and Warner Oland), played a cantor's son torn between religion and showbiz. Unlike many silent-era stars, he would thrive in the talkies.

FRANK DRIGGS COLLECTION

DARWIN ON TRIAL

At 65, his three runs for the White House long past, William Jennings Bryan (right) agreed in 1925 to help the state of Tennessee prosecute John T. Scopes, 24, for teaching evolution. Opposing counsel Clarence Darrow called on Bryan to defend the Bible's version of creation. He could not. Five days after Scopes was found guilty (a verdict later overturned), Bryan died of a heart attack.

CORBIS / BETTMANN-UPI

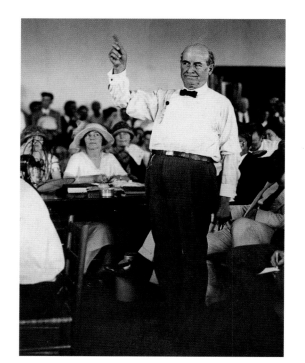

> ## HITLER DOES TIME

His 1923 coup against the government of Bavaria a flop, Adolf Hitler, 34 (near right), had to serve eight soft months at Landsberg Fortress. Among his visitors: Rudolf Hess (in tan suit), to whom Hitler dictated *Revenge*, the first half of *Mein Kampf (My Struggles)*, his best-selling encomium to Aryan superiority.

TIME INC.

REVOLUTIONARY EPIC

Sergei Eisenstein, 27, had directed only one feature when Moscow asked him to make a film marking the 20th anniversary of the abortive 1905 uprising against the czar. He delivered *Potemkin* — and forever altered cinema. Eisenstein's tale of mutiny aboard a battleship docked at Odessa was driven by rapid-fire montages. Many have copied the device; few have employed it better.

MOVIE STILL ARCHIVES

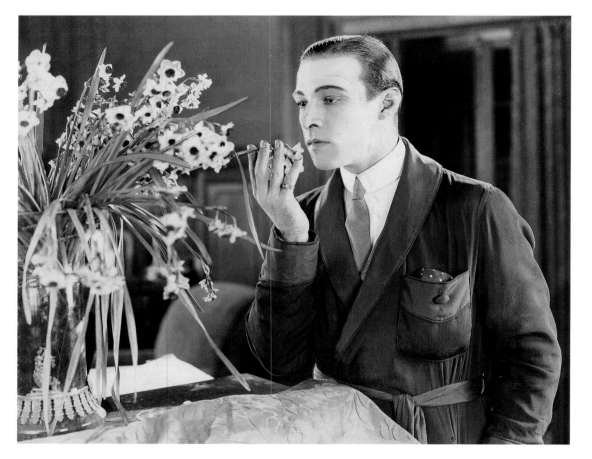

THOSE LIPS, THOSE EYES

He emigrated from Italy at 18 to work as a laborer, broke into movies at 23 — and wound up Hollywood's first hunk. Rudolf Valentino never got to see if his smoldering eroticism *(The Sheik, Blood and Sand)* would play in the sound era; he died in 1926, at 31, of a perforated ulcer. Thirty thousand women, led by first wife Jean Acker (far right), mobbed the funeral home.

ABOVE: TIME INC.
RIGHT: ARCHIVE PHOTOS

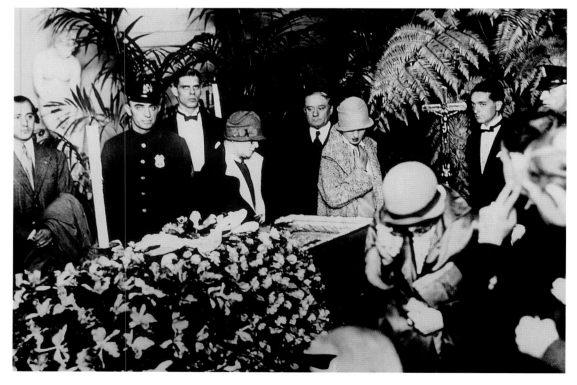

LET THE GAMES BEGIN

When his pay hit $80,000, George Herman Ruth was asked why he merited a salary larger than President Hoover's. Cracked the Babe, or so it was reported, "I'm having a better year." Before World War I, the most renowned and rewarded athletes were boxers, whose prizefights were described in every newspaper. Then came the infant but insistent medium of radio. How to fill hour upon hour of empty airtime? Well, sporting events were cheap to broadcast. An America flush with leisure time and pocket cash responded, transforming mere diversion into an industry. The Twenties were a time for heroes to emerge and profit. Some, like the Babe, did.

<
SWIMMING TO TINSELTOWN

Romanian-born, Chicago-reared Johnny Weissmuller quit ninth grade to focus on swimming. In addition to setting 67 world marks, he won three Olympic golds in 1924 and a pair more in 1928. Weissmuller then went Hollywood and vine, playing Tarzan 12 times before ending his acting career as big- and small-screen hero Jungle Jim.

JANZTEN, INC.

GOING, GOING, GONE . . .

The Baby Ruth candy bar was in fact named for President Cleveland's infant daughter. All other tales about the Yankee slugger are true. He played hard, lived harder. More to the point, by repeatedly swatting the new "live" ball over fences — 60 times in 1927, 714 times in a 21-year career — Babe Ruth helped his sport escape the long shadow of its 1919 Black Sox scandal.

CORBIS / BETTMANN-UPI
<

>
DESPERATION PLAY

It was third-and-long for the five-year-old, 13-team National Football League when the Chicago Bears paid an All-America halfback from the University of Illinois $100,000 to turn pro. Red Grange (with ball) earned every dime. In 1925, the Galloping Ghost packed the house for 18 games, including exhibitions, and made the NFL viable.

CORBIS / BETTMANN-INP

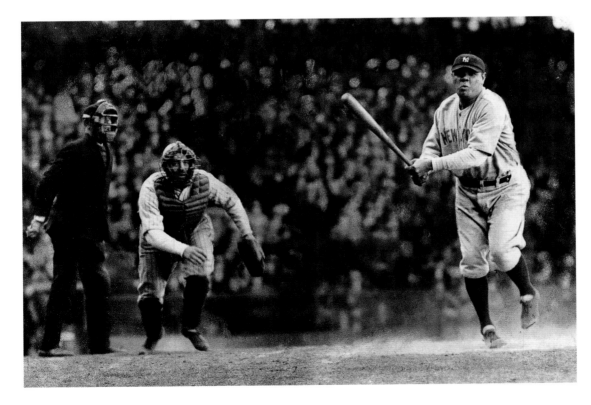

TWO TENNIS TERRORS

There was no country-club politeness about the games of Helen Wills and Bill Tilden: Each crushed foes with raw power. Wills won her first U.S. Open in 1923, at 18, and added six Opens and eight Wimbledons over the next 15 years. From 1927 to 1932, she lost not one set of singles. Tilden was almost as dominant, capturing seven U.S. and three Wimbledon titles between 1920 and 1930. But his fortunes declined after he retired in 1937, at 44. Back then, his homosexuality was little tolerated: Tilden died in 1953, poor and alone.

TOP LEFT: CULVER PICTURES
TOP RIGHT: CORBIS /
BETTMANN-ACME

LET THE GAMES BEGIN

THEY SWAPPED LEATHER

Jack Dempsey (above) was 24 when he rode a string of savage KOs to the heavyweight championship in 1919. Called the Manassa Mauler, he kept the crown until 1926, when ex-Marine Gene Tunney, 29, took it away. Their rematch the next year became the most controversial bout in ring history. Dempsey battered Tunney to the canvas but was slow to move to a neutral corner. The delay gave his foe more than 10 seconds to recover; aided by the "long count," Tunney won the fight.

ABOVE AND TOP RIGHT:
CULVER PICTURES

A CHANNEL CROSSING

Two years after winning a gold and a pair of bronzes at the 1924 Paris Olympics, Manhattan-born Gertrude Ederle, 19, became the sixth person — and first woman — to swim the English Channel. Her time for the grueling 35 miles was the fastest yet by nearly two hours. But Ederle's 14½-hour effort aggravated an ear problem that later rendered her deaf.

CULVER PICTURES

THE ICE PRINCESS

Figure skating was as dull as a compulsory figure eight until Sonja Henie. The Norwegian used her ballet training to create fluid and exciting freestyle programs; at 15 she won the first of 10 straight world titles, to which she added three Olympic golds. Henie went on to star in an ice revue and a dozen lame but popular movies (e.g., *Sun Valley Serenade*).

CORBIS / BETTMANN-UPI

FIRING AT THE PIN

It wasn't his exquisite game that made Bobby Jones an idol nor his run of 13 major titles in eight years. Instead, it was the wonder of an amateur (and full-time lawyer) repeatedly besting the top pros. After winning the Grand Slam in 1930, Jones, 28, withdrew from competitive golf to help found and nurture the Masters tournament in his native Georgia.

HUTLON DEUTSCH / LIAISON

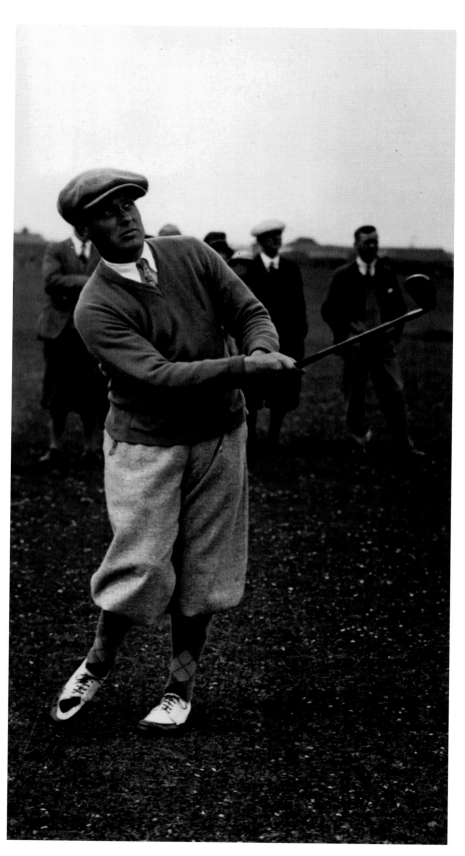

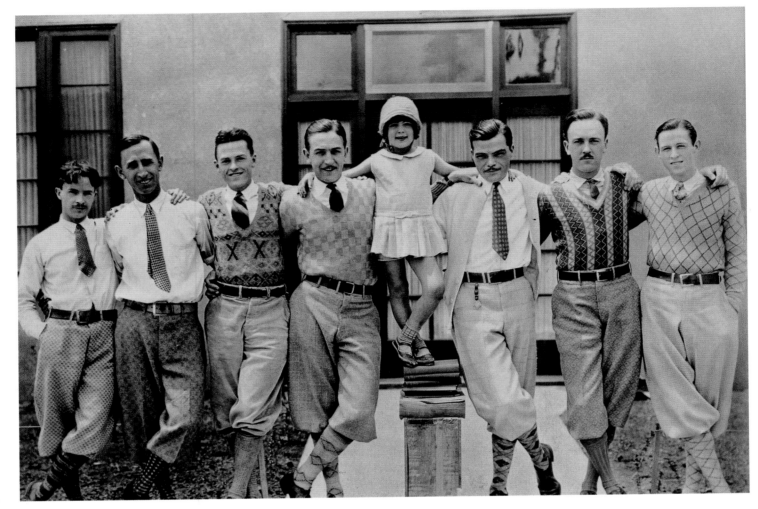

THE ORIGINAL WORLD OF DISNEY

In 1926, animator Walt Disney, 25 (fourth from left), posed with his entire staff and Margie Gay, the star of his *Alice in Cartoonland* series. At the time, Disney's studio was rodentless — and struggling. Two years later, however, along came *Steamboat Willie* and a mouse named Mickey (whose pip-squeak voice was provided by Walt himself).

PHOTOGRAPHER UNKNOWN

YOU LIKE ME! YOU REALLY LIKE ME!

First time around, they just ate and drank; this time they also gave out gilded statuettes. Winners included *Wings* (best production), Emil Jannings (best actor) and Janet Gaynor (best actress). In 1931, the statuette was dubbed Oscar. In 1943, they cut out the food and wine. In 1953, the rest of us got to tune in and giggle through the acceptance speeches.

ACADEMY OF MOTION PICTURE ARTS & SCIENCES

REQUIEM

WYATT EARP
1848–1929

An authorized biography burnished his reputation as a fearless lawman. But many in Tombstone, Arizona, wanted to hang its deputy marshal and his pal Doc Holliday for slaughtering members of the Clanton Gang at 1881's O.K. Corral shoot-out. The next year, accused of murdering two men suspected of killing his brother Morgan, Earp escaped farther west.

KANSAS STATE
HISTORICAL SOCIETY

LIZZIE BORDEN
1860–1927

They never found the ax with which she allegedly gave her mother 40 whacks (and, went the chant, her dad 41), so the jury acquitted the 33-year-old Sunday school teacher of the 1892 homicides. Though the target of critical whispers, Borden never moved from her native Fall River, Massachusetts.

FALL RIVER HISTORICAL SOCIETY

ANNIE OAKLEY
1860–1926

As a young girl in Ohio, the future trick-shot artist got her gun and hunted small game to help pay the family mortgage. Next Oakley set her sights on larger prey: noted marksman Frank Butler, whom she outshot in a match and then married. When the high-caliber couple joined Buffalo Bill's Wild West show, the Peerless Lady Wing-Shot got top billing.

PHOTOGRAPHER UNKNOWN

ISADORA DUNCAN
1877–1927

Inspired by classical Greek art, the terpsichorean from San Francisco promoted free movement and flowing costumes. Her lifestyle was equally avant-garde: She bore children out of wedlock to three different fathers. Although none of Duncan's dance schools survive, her style and unconventional musical choices reignited interest in all forms of the art.

TIME INC.

SARAH BERNHARDT
1844–1923

The convent-educated daughter of a French courtesan gave up thoughts of the nunnery for the stage. Her Parisian debut, at 18, drew little notice. But by the 1870s, Bernhardt was a star with a reputation for quirkiness (she slept, it was said, in a coffin). Despite losing a leg at 71 to gangrene, she continued touring Europe and America.

TIME INC.

CORNELIUS COLE
1822–1924

On May 16, 1868, this U.S. senator from California, then 43, joined 34 others in pronouncing Abraham Lincoln's successor, Andrew Johnson, guilty of "high crimes and misdemeanors." But 19 voted to acquit and thus spared, by one ballot, the first president to be impeached. Cole was the last senator who voted in that historic trial to die, 74 years before the Senate had to sit in judgment of the second.

ARCHIVE PHOTOS

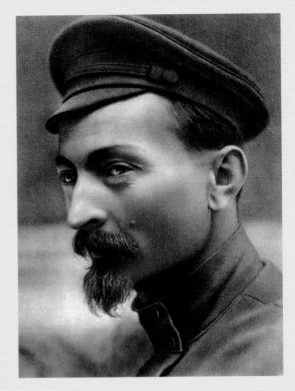

FELIKS DZERZHINSKY
1877–1926

The Polish-born socialist joined Russia's anticzarist Bolsheviks and, with their triumph in 1917, won a key post: internal security. Cheka, the ruthless secret police he founded, would later go by OGPU, NKVD and KGB. Fittingly, Lubyanka, the notorious prison in Moscow where "enemies of the state" were tortured, sat on Dzerzhinsky Square.

TIME INC.

<

JOSEPH CONRAD
1857–1924

Two decades at sea gave the son of a Polish patriot exotic settings for novels that relentlessly explore the corrosive impact of greed and corruption. Conrad Anglicized his name and wrote — in English — *Heart of Darkness*, *Nostromo* and *The Secret Agent*. Yet shortly before his death, the naturalized British subject refused knighthood.

CORBIS / BETTMANN

ALEXANDER GRAHAM BELL
1847–1922

Teaching elocution to the hearing impaired led the audiologist to experiment with the electric transmission of sound. While the telephone, invented when he was 29, could not help his favorite deaf pupil, Mabel Hubbard, she married him anyway. Bell also devised a kite to carry people and bred sheep more likely to bear twins.

TIME INC.

FRANZ KAFKA
1883–1924

An assimilated German Jew who was both a distinct minority in his native Prague and a misfit within his family, Kafka supported himself as a lawyer. Nights were spent crafting grimly humorous fiction like *The Trial*, in which capricious powers persecute the innocent. He died of tuberculosis; his sisters perished in the Holocaust.

PHOTOGRAPHER UNKNOWN

ENRICO CARUSO
1873–1921

Music lessons were out of reach for a poor Neapolitan with 19 siblings. He made up for lost time. At 21, with only three years of training, Caruso debuted in his hometown. Soon the tenor's prodigious voice and dramatic delivery won worldwide acclaim. But a prodigious appetite for food and tobacco shortened the career — and life — of opera's biggest star.

FRANK LERNER

EMPTY POCKETS

To farm folk fleeing the Dust Bowl engulfing the Southwest, anything beat what they had left behind — even makeshift quarters on the road west. The most popular destination of these internal immigrants: California.

AP / WIDE WORLD

One Depression, Two Remedies

BY ROBERT S. McELVAINE

THE THIRTIES CONSTITUTED the most unusual decade — and, in many respects, the most important — in the 20th Century. A century whose motto might well be the single word *progress* and that had been marked in the industrialized portions of the world by increasing material prosperity for larger segments of the population suddenly shifted from the highest forward gear into reverse. The decade began in the early stages of the worst economic collapse in modern history and ended in the early stages of the worst war in modern history.

That decisive armed struggle between democracy and dictatorship had only just begun as the Thirties ended, and its outcome would not be determined until the middle of the Forties. But democracy might not have been in a position to contest with dictatorship had it not been for its ability to respond, albeit with far less than complete success, to the economic collapse of the Thirties. And the horrors of mass slaughter of civilians that would characterize the first half of the Forties were heralded in the fascists' destruction of the Basque town of Guernica in 1937 and the Nazi invasion of Poland in 1939.

It was a decade of many faces, including thousands of anonymous — yet personal — faces captured in the haunting black-and-white images created by such photographic geniuses as Dorothea Lange, Walker Evans, Eudora Welty and Horace

Bristol. We think of the Thirties in black and white because of those photographs, the movies of the era and the general impression that it was a drab, colorless time best expressed in shades of gray. But that perception is only partially correct.

It was, in another sense, a decade whose significance can be seen in just two faces, both of them vivid with color: the cheerful, optimistic countenance of Franklin D. Roosevelt and the hate-filled, smirking visage of Adolf Hitler. The careers of these two men as national leaders coincided almost exactly. Hitler came to power in Germany less than five weeks before Roosevelt was inaugurated in 1933. In 1945, FDR died less than three weeks before Hitler. Over the intervening dozen years, these two men represented diametrically opposed visions for the world. Both were highly effective in moving masses of people, but they employed very different approaches in doing so. FDR often began his radio "fireside chats" with the words "My friends . . . ," while Hitler stirred his listeners by attacking those he told them were their enemies.

Faith in marketplace economics, democracy and the very idea of progress was shaken in the Thirties as at no other time in the 20th Century. The collapse of the economy in the period after 1929 discredited acquisitive, consumption-centered values — such as extreme individualism and defining happiness and self-worth in terms of material possessions — that

had become so widespread in the Twenties. More co-operative values were resurgent among a large portion of the American populace during the Depression. Roosevelt's New Deal did not cause this shift in the popular mood; it reflected it.

Roosevelt was a democratic politician par excellence; his leadership was of the sort that gives voice and form to the sentiments already present among the people. What FDR did so well is similar to the description Zora Neale Hurston gave of the oratorical skills of Janie, the protagonist in her 1937 novel, *Their Eyes Were Watching God*: "She put jus' de right words tuh our thoughts." At its best, the New Deal put the right programs and policies to the thoughts and values of the American people in the Thirties.

By the time Roosevelt replaced Herbert Hoover in 1933, one-fourth of the American workforce was unemployed. Even Mother Nature seemed to join the assault on normal life as severe drought transformed the Great Plains into the Dust Bowl, forcing farmers in the region to pack their families and portable belongings onto dilapidated trucks and head west to what usually proved to be the false promised land of California.

Yet many people do not remember and did not experience these years in nearly as bad a light as those bare facts might lead one to believe. If it was — and it was — a decade of depression, despair and dictatorship, it was

Did this filling station in Los Angeles pump Flying "A" gasoline? Nope, its owner just wanted to beat the hard times — and the cost of building an office. He had also learned the Hollywood art of self-promotion.

ALFRED EISENSTAEDT / LIFE

also a decade of compassion, community and cooperation. There was something refreshing about the collapse of the ultramaterialistic culture of the Twenties. In his literary chronicle of the era, *Shores of Light*, Edmund Wilson recalled such feelings of the Thirties.

To the writers and artists of my generation, who had grown up in the Big Business era and had always resented its barbarism, its crowding-out of everything they cared about, these years were not depressing but stimulating. One couldn't help being exhilarated at the sudden, unexpected collapse of that stupid gigantic fraud. It gave us a new sense of power to find ourselves still carrying on, while the bankers, for a change, were taking a beating.

And take a beating the bankers and business leaders, so respected in most other periods in the 20th Century, certainly did. "The bank is something more than men, I tell you," John Steinbeck wrote in *The Grapes of Wrath* (1939). "It's the monster. Men made it, but they can't control it." From the veiled equation of business with crime in the 1930 film *Little Caesar* through the blatant 1939 portrayals of a banker as a criminal in John Ford's *Stagecoach* and a greedy businessman as evil incarnate in Frank Capra's *Mr. Smith Goes to Washington*, American popular culture bashed capitalists in the Depression decade to an unprecedented degree. And as businessmen were seen as criminals, some thieves were cast in the popular imagination as Robin Hoods. Many robbers, including Bonnie Parker and Clyde Barrow, were romanticized in the

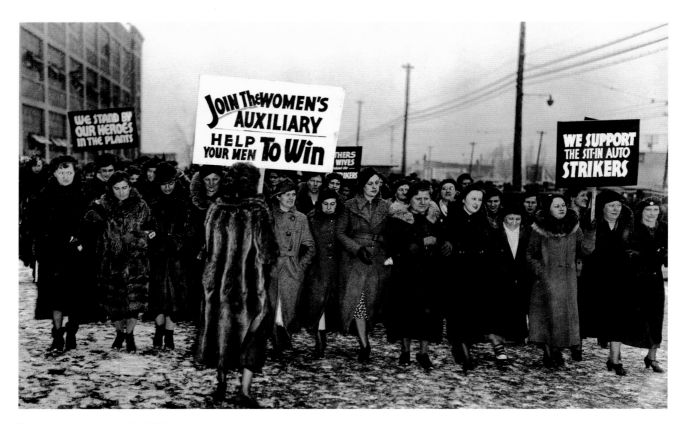

Before 1937, union wives (and kids) were sometimes roughed up when they supported their men's strikes. But at a Chevy plant in Flint, Michigan, management and labor decided to give peace a chance (page 141).

CORBIS / BETTMANN-UPI

Thirties, none more than Pretty Boy Floyd, an outlaw made over into a hero by popular mythology and a 1939 Woody Guthrie song that painted Floyd as an armed redistributor of wealth.

There were many signs of a leftward tilt in American thinking in the Thirties. One was the rise of unionism in the mass production industries. The Congress of Industrial Organizations, personified by John L. Lewis, was the beneficiary of militant cooperative attitudes bubbling up from the workers below. In this respect, the CIO leaders were in a position analogous to Roosevelt's — they were able to echo and articulate the desires and beliefs that had developed among their constituents under the impact of the economic collapse. Workers, not union leaders, launched the first of the highly effective sit-down strikes that forced General Motors to agree to recognize the United Auto Workers in 1937.

Although a substantial majority of African-Americans were sufficiently impressed with the New Deal that they shifted their allegiance to the Democrats, it was not a good decade for minorities in the United States. "Repatriation" programs forced many Mexican-Americans out of the country. Blacks were frequently fired as whites were constrained to take jobs they had previously considered "beneath" them. Sports played a significant role in racial matters in the Thirties. Heavyweight boxer Joe Louis became a huge hero to blacks. His 1938 victory over Germany's Max Schmeling, a defeat of an "Aryan" by a man identified in Nazi propaganda as belonging to an inferior race, was similar in its impact to what had happened two years before when the Olympics were held in Berlin. African-American Jesse Owens threw Hitler's beliefs back in his face by winning four gold medals.

Eleanor Roosevelt was far more concerned about racial injustice than her husband was. She became America's leading voice for compassion and for the rights of minorities and women, and did almost as much as her husband did to define a new place for government.

The Depression severely disrupted the traditional roles of men and women. Unemployed men felt cast adrift when they could not be providers. The desperate desire of many men for the restoration of the old order was perfectly captured in the song "Remember My Forgotten Man" from the movie *Gold Diggers of 1933*: "Ever since the world began, every woman needs a man." During the Thirties this axiom was put in question. The same point is evident in Walt Disney's 1937 film *Snow White*. The comatose woman who needs to be given life by a man is the embodiment of the male reaction to the gender-role reversal in the Depression. The starving man in the closing scene of *The Grapes of Wrath* who needs to be kept alive by Rose of Sharon's breast milk is as appropriate a metaphor for the reality of the Depression as Prince Charming's life-restoring kiss is for the wishful thinking of men in the decade.

The ending of Steinbeck's novel and his casting of Ma Joad as the leader of the family also symbolize the new relationship between the government and the American people that arose in the Thirties. The New Deal's approach is best characterized as "maternalism." The creation of a partial welfare state, particularly through the establishment of Social Security in 1935, put the federal government in the position of life sustainer for those in need of assistance.

There is, however, no doubt that the era was and always will be remembered as the Depression decade. To vastly oversimplify, the main significance of these years can be stated as follows: Under the impact of the collapse of the world economy, Germans abandoned their brief experiment with democracy and accepted

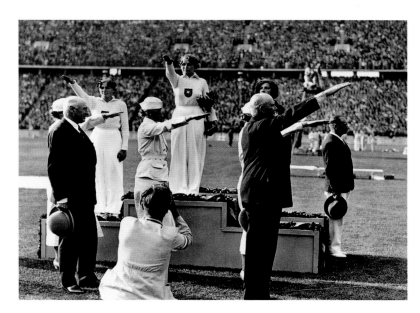

Berlin had been awarded the 1936 Olympics three years before Adolf Hitler's ascension. For all the pomp and Sieg Heils, the entire German men's track and field squad collected fewer medals than the 13 taken home by the 10 black athletes on America's team. The Games set for 1940 and 1944 were canceled because of World War II.
TIME INC.

a dictator who divided their society and comforted the majority by providing them with a scapegoat in the form of a minority within the nation. Under the same stimulus, Americans came together in a spirit of cooperation, found a leader capable of shaping their inchoate feelings into a political program, placed a few modest restraints on the marketplace economy, formed a rudimentary welfare state and renewed their faith in democracy. By the decade's end, these alternate visions, molded in the crisis of the Thirties, were poised to confront one another in a monumental struggle over the direction the world would take for the remainder of the century.

Robert S. McElvaine is chair of the department of history at Millsaps College in Jackson, Mississippi, and author of three major books on the Depression. In 2000, he will publish a book on the influence of sex in human history, titled Eve's Seed: Sex and the Shaping of History.

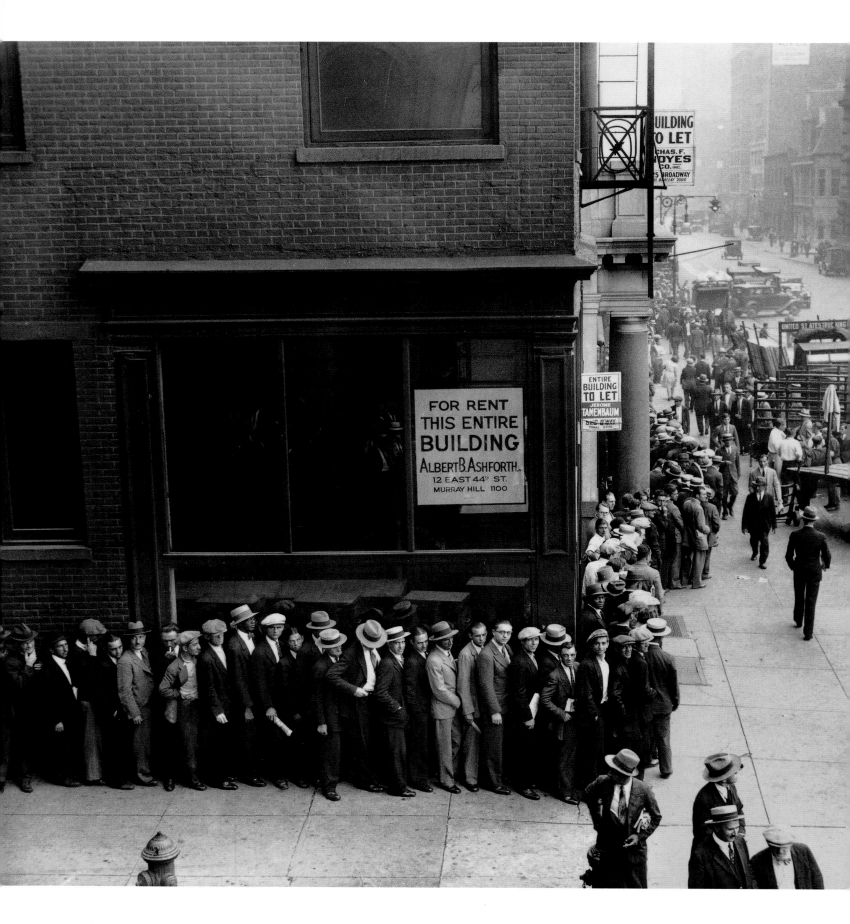

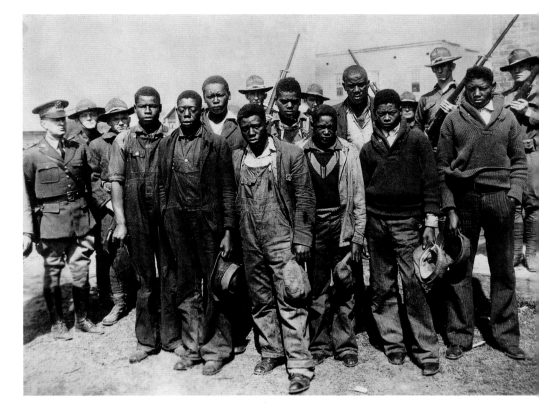

>
LOOK AWAY, LOOK AWAY

In 1931, Alabama cops caught 11 itinerants on a freight train. Two were white women who claimed the others, black youths aged 13 to 20, had raped them. Doctors found no evidence; yet eight of the "Scottsboro Boys" (after the town where they went on trial) were convicted and sentenced to die. The Supreme Court ruled against Alabama twice before the state gave up. Still, Clarence Norris (second from left) remained in prison until 1946.

CORBIS / BETTMANN-UPI

<
TAKE A NUMBER

On a summer day less than 10 months after the Great Crash of 1929, 6,000 New Yorkers from varying economic stations queued at a state employment agency; 135 found jobs. It would soon get worse. By 1932, almost 30 percent of America's labor force was looking for work.

CORBIS / BETTMANN-UPI

>
ON THE DOLE

Four days before Christmas, 1932, families in Grand Rapids, Michigan, picked up milk and bread at a fire station–cum–food bank. By this point in the Depression, industrial output had slumped 54 percent and more than 40 percent of the nation's banks had gone under or were on the verge.

AP / WIDE WORLD

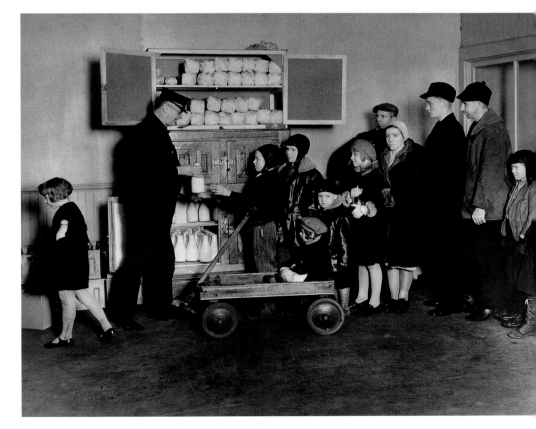

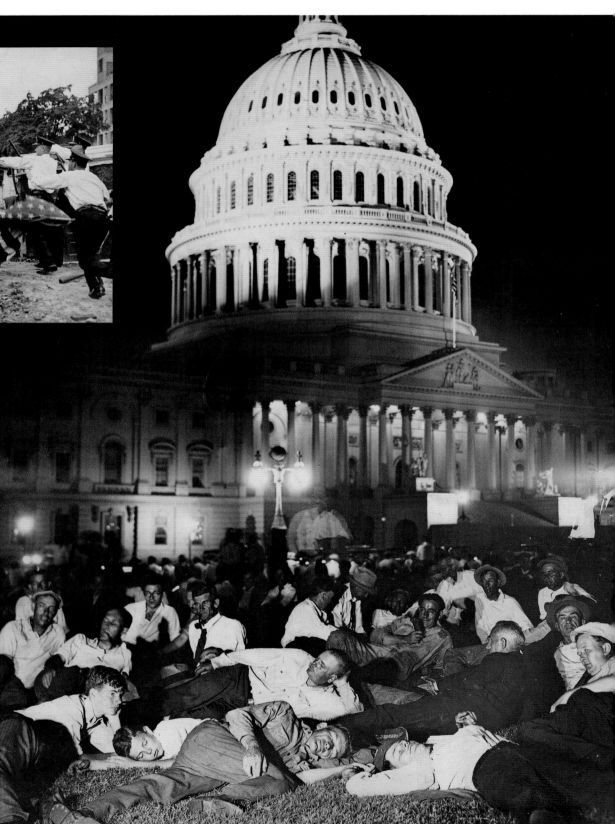

POTOMAC FEVER

The capital was occupied in the summer of 1932 by some 15,000 World War I vets. In 1924, Congress had voted them a small bonus — payable in 1945. The Depression-battered men wanted their money now. A series of skirmishes with police (above) led President Herbert Hoover to call in the Army. General Douglas MacArthur's troops quickly routed the protesters and burned their tents. But the public backlash doomed Hoover's reelection bid.

RIGHT: CORBIS / BETTMANN-UNDERWOOD
INSET: NY DAILY NEWS

THE WINNING TICKET

Two-time New York governor Franklin D. Roosevelt, 50 (right, with running mate John Nance Garner, 63), was the 1932 Democratic candidate for the White House. In public, he used leg braces to hide his polio. His boilerplate speech (as in Goodland, Kansas, below) vowed "a new deal" and Prohibition's repeal. Plus, he wasn't Hoover; FDR's victory was a landslide.

RIGHT: CORBIS / BETTMANN-ACME
BELOW: AP

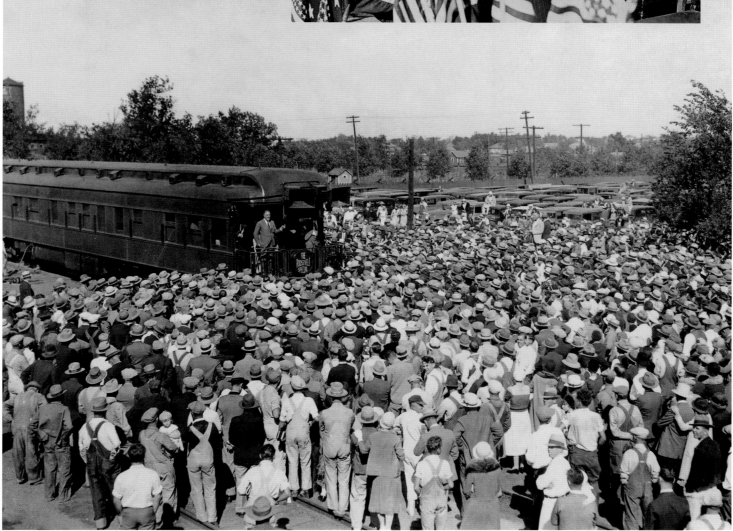

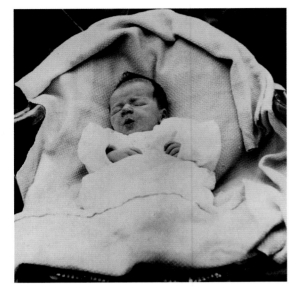

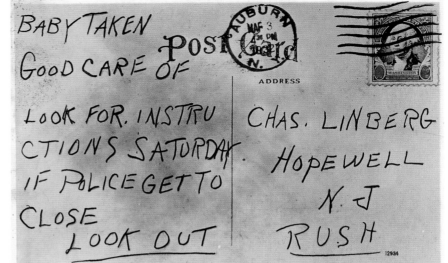

BABY TAKEN
GOOD CARE OF

LOOK FOR. INSTRU
CTIONS SATURDAY.
IF POLICE GET TO
CLOSE
LOOK OUT

CHAS. LINBERG
HOPEWELL
N. J.
RUSH

POST Card ADDRESS

THE KIDNAPPED BABY

Charles Lindbergh Jr. was 20 months old when he was taken from a second-floor bedroom of his hero father's rural New Jersey mansion on March 1, 1932. The nation was transfixed. Clues abounded (a ransom note, a ladder), as did cruel hoaxes (above right). On April 8, the Lindberghs paid $50,000 in marked bills for a fruitless tip. On May 12, their son's body was found just five miles from home. Three years passed before a German-born carpenter spent part of the $50,000. Bruno Hauptmann was electrocuted in 1936.

ABOVE: CORBIS / BETTMAN
ABOVE RIGHT: AP

AN EXPERIMENT ENDS

Jeepers, creepers! Booze was legal again! One Clevelander (lower right) couldn't wait! Prohibition was repealed in 1933 after Utah, of all states, ratified the 21st Amendment. Not until 1970 did America try more social engineering, when Congress outlawed marijuana.

NEW YORK TIMES /
ARCHIVE PHOTOS

A LEAGUE OF HER OWN

America's woman athlete of her time (perhaps of all time) took the gold in the javelin and the hurdles at the 1932 L.A. Olympics and lost the high jump only because the judges didn't like her unorthodox style. Babe Didrickson also starred in hoops and baseball before focusing on golf in 1934. She won 50-plus titles, including a third U.S. Women's Open at 40 despite recent cancer surgery. Babe died 26 months later, in 1956.

CORBIS / BETTMANN-UPI

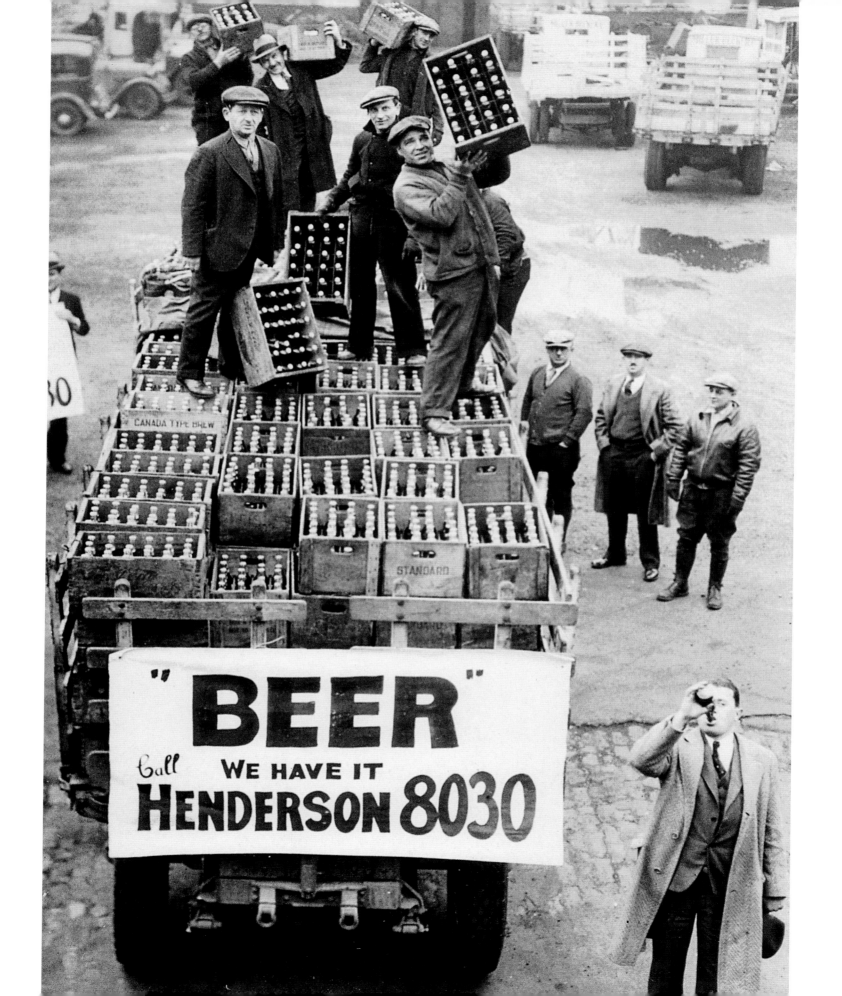

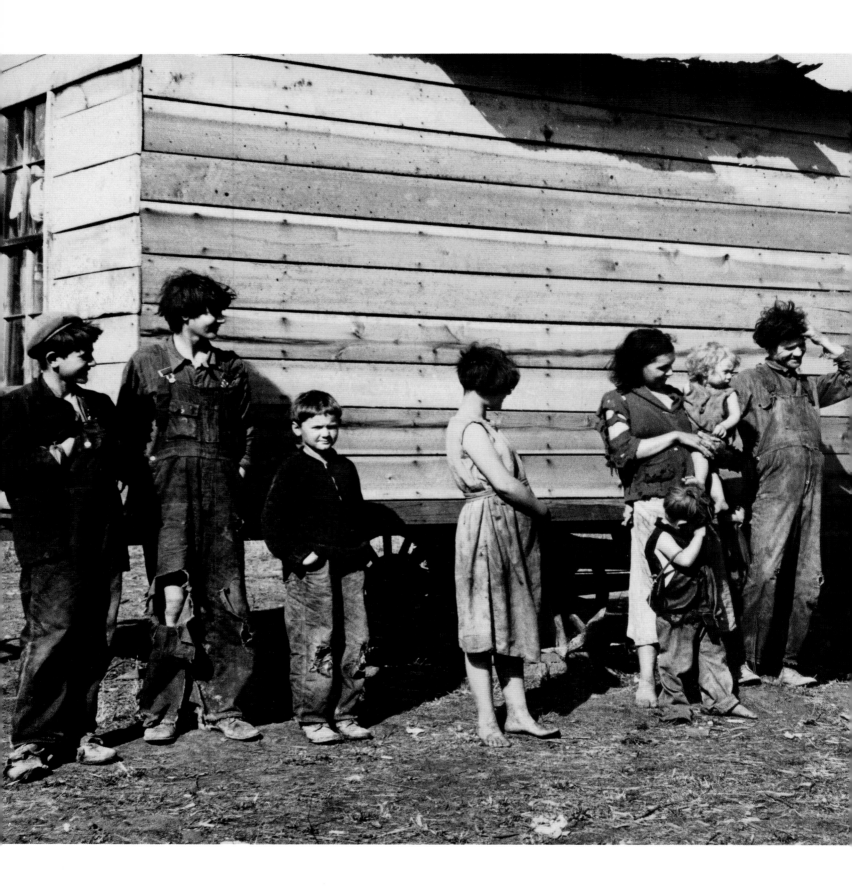

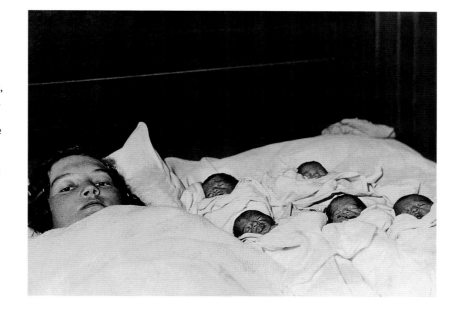

> ### THE FAB FIVE

On May 28, 1934, Elzire Dionne, 24, of Callendar, Ontario, gave premature birth to her seventh, eighth, ninth, 10th and 11th babies. Émilie, Yvonne, Cécile, Marie and Annette were the first quintuplets to survive, thanks to recent advances in neonatal care. Hucksters so badly exploited the family that the tots were wards of the state until they reached seven.

KEYSTONE VIEW CO.

< ### IN NEED OF A NEW DEAL

Rural America was especially devastated by the Great Depression. In 1935, a federal relief worker (near left) visited a threadbare Tennessee family to gauge its eligibility for help. From 1933 to 1941, FDR's domestic-aid programs channeled billions to those on the brink.

CARL MYDANS / FSA

> ### DIMPLED DYNAMO

Before Shirley Temple turned eight, she was earning $2,500 per week for singing, dancing and charming in such hit movies as *Little Miss Marker* and *The Little Colonel*. Unlike many child stars before and since, Temple's life had a second act: a durable marriage and public service that included two years as U.S. ambassador to Ghana.

CULVER PICTURES

GRAPES OF WRATH

A bad drought in the Thirties teamed with bad farming practices to turn 150,000 square miles of the Great Plains into the Dust Bowl. In 1935, the well had not yet run dry on two Colorado girls (far left). But in New Mexico (above) and four other states, families called it quits and caravanned west. By decade's end, California's population had grown by 22 percent. Meanwhile, federal workers were teaching the farmers who had stayed behind better techniques for conserving topsoil.

CLOCKWISE FROM FAR LEFT: PHOTOGRAPHER UNKNOWN; DOROTHEA LANGE / FSA; LIBRARY OF CONGRESS

Beloved Badmen

A society is shaped by its laws but often defined by its outlaws. Americans bridle against authority, be it King George III or a speed-limit sign, so it is not surprising that we have long doted on a certain breed of raffish crook. The larcenous spirit of the James Gang and Billy the Kid, retailed in dime novels of the 1800s, didn't die with the Old West; it rode into the new century alongside Butch and Sundance. A rogue jaunty enough to stop while on the lam to pose for a portrait? Why, that's the stuff of folklore, not to mention Hollywood, which has lionized almost all these felons on film.

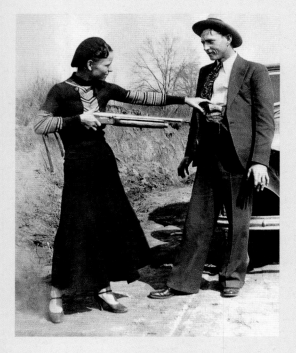

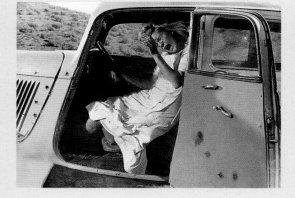

THIEVES LIKE US

In 1934, Bonnie Parker (top) was 23 and her prisoner of love, Clyde Barrow, was 25. The Dust Bowl couple indeed robbed banks, gas stations, etc. — 13 in 21 months. The law soon sprang an ambush near Gibsland, Louisiana, as deadly as the one depicted in 1968's *Bonnie and Clyde*, starring Warren Beatty and Faye Dunaway (above).

FROM TOP: CORBIS / BETTMANN-UPI; WARNER BROTHERS

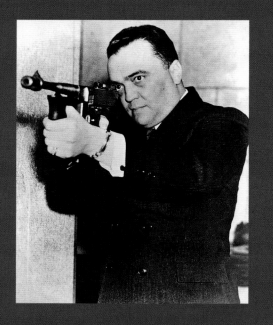

DEAD AIM ON CRIME

The criminologist in J. Edgar Hoover (left) led him to modernize the FBI, which he took over in 1924, at age 29. The spin doctor in him invented the Public Enemy (usually some hood his G-men were set to nab). Hoover swore until the 1960s that there was no organized crime in America, yet kept his post through eight presidencies, until his death in 1972.

TIME INC.

Robert Parker, 34 (seated, near left), went by Butch Cassidy. Harry Longbaugh, 30 (seated, far left), went by Sundance Kid. Their Wyoming-based Hole in the Wall gang of robbers and rustlers was also called The Wild Bunch (but that's another movie). Butch and Sundance did flee to Bolivia in 1901. But where did they die? Butch near Spokane in 1937, claim some, and Sundance in Casper, Wyoming, circa 1957.

WESTERN HISTORY COLLECTION / UNIVERSITY OF OKLAHOMA LIBRARY

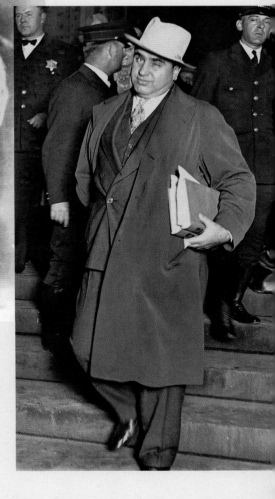

HE FOUGHT THE LAW — AND THE LAW WON

As a kid in Brooklyn, Al Capone practiced crime. He perfected it in Chicago, a city thrown wide open by Prohibition. The cops couldn't nail him for the cunning massacre of rival bootleggers on St. Valentine's Day, 1929. But two years later the Feds sent him to the slammer as a tax cheat. Capone died horribly of syphilis in Miami at age 48.

CORBIS / BETTMANN-ACME

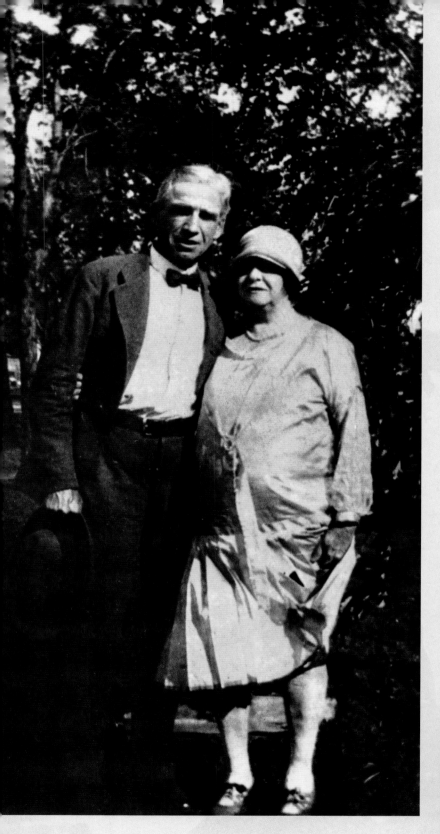

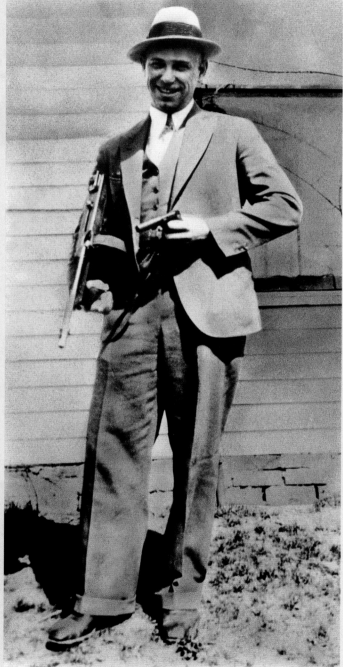

<

AND THEN THERE WERE NONE

Having left the father of her four sons (two in prison, another dead battling Kansas cops), crime mistress Arizona "Ma" Barker, 60, met George Anderson (left). Family baby Fred objected and in 1932 killed George. In 1935, the FBI shot Fred and Ma. In 1939, son number 3, Arthur, died trying to flee Alcatraz. And in 1947, the last of Ma's boys, Lloyd, finished his 25 years in Leavenworth — only to be slain by his wife.

CORBIS / BETTMANN-UPI

<

THE MONEY . . . PLEASE

He entered jail at 21 a two-bit thief and emerged at 30 far wiser. Over the next 11 months, the always polite, always dapper John Dillinger robbed at least 10 banks. Twice cops caught him; twice he escaped, hiding once at his dad's house (left) while G-men scoured the nation. In 1934, a Romanian madam in Chicago sold him out for a green card; Dillinger was 32 when he was ambushed and killed by the FBI.

AP / WIDE WORLD

<

ONE QUOTABLE CROOK

After doing time for safe-cracking, Willie Sutton tried wearing disguises to pull holdups. That didn't work either: He spent 15 of the next 17 years in prison. A bust as a thief, Sutton still caught America's fancy. Asked why he robbed banks, he was famously quoted as replying, "That's where the money is."

BILL STAHL /
CORBIS / BETTMANN-INP

BOZOS ON PARADE

Anthony Pino (below left) and 10 Boston pals rehearsed for two years. In January 1950, they finally hit a Brink's depot and took $2.7 million. Commies, cried J. Edgar Hoover, but his FBI nabbed zip. Weeks before the statute of limitations ran out, one hood squealed. In 1980, *The Brink's Job* (with Peter Falk, below, as Pino) played it right: for yuks.

BELOW LEFT: FBI
BELOW: MOVIE STILL ARCHIVES

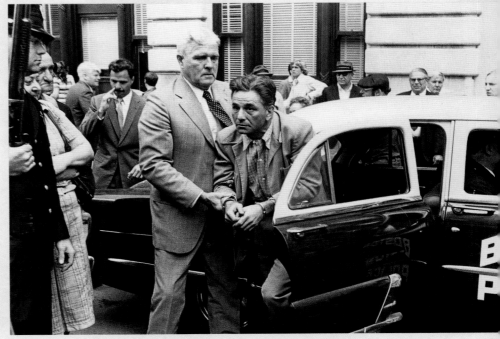

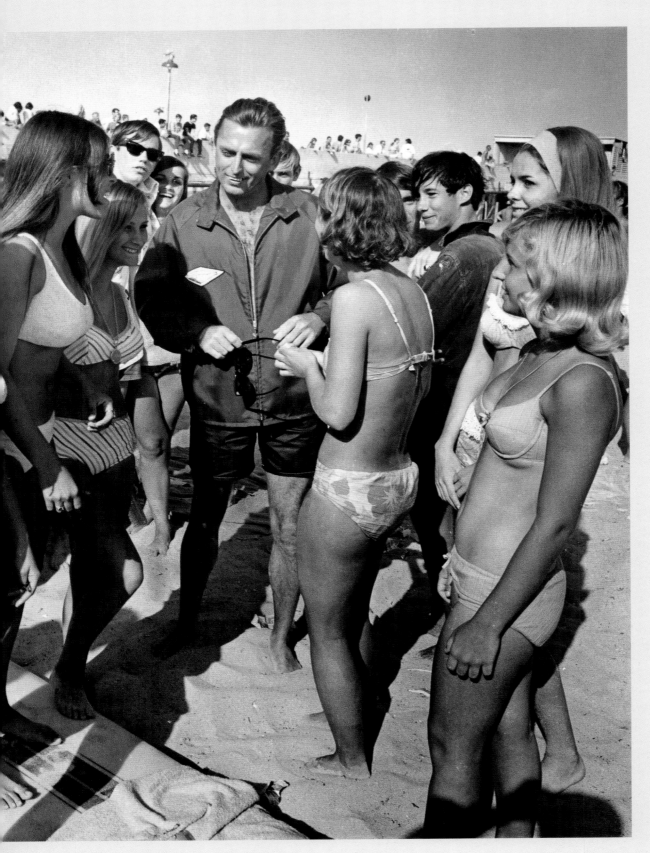

GLITTERING PRIZES

Six weeks after the caper movie *Topkapi* opened in 1964, Florida beach bum and petty crook Jack Murphy, 26, aped the plot by climbing with a pal into New York's Museum of Natural History through a fourth-floor window. Pick of the 22 gems they grabbed: the golf-ball-sized Star of India sapphire, a gift from J.P. Morgan. Murph the Surf was an instant suspect, but until the pal finked two months later, he toyed with cops (and, right, with Gidget wannabes).

ALBERTO COYA / MIAMI HERALD

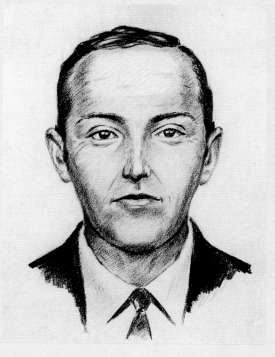

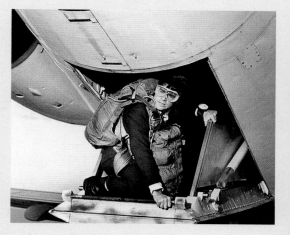

WINDFALL RICHES

In 1971, a Northwest passenger (sketch, top) flashed an apparent bomb and demanded $200,000 and four parachutes. After the jet took off again, he bailed out with the loot (as did actor Treat Williams in 1981's *The Pursuit of D.B. Cooper*). Some $5,800 was found — but not the thief who inspired a cult.

FROM TOP: FBI SKETCH; MOVIE STILL ARCHIVES

IN THE GENES

At 45, John Gotti vaulted atop New York's Gambino crime family by having capo Paul Castellano whacked. The publicity-loving "Dapper Don" smirked at Feds until a pal ratted. In 1999, serving life, Gotti, 58, learned that the heir to his mob, son John Jr., 35, was joining him behind bars.

BILL SWERSEY / GAMMA LIAISON

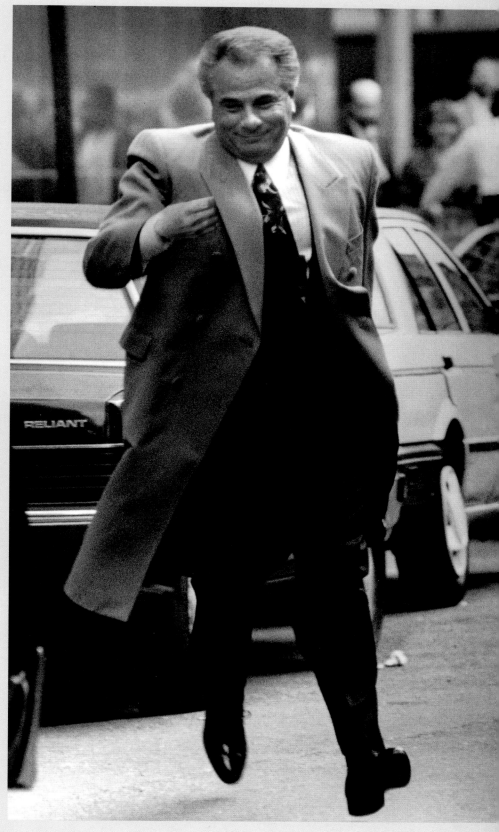

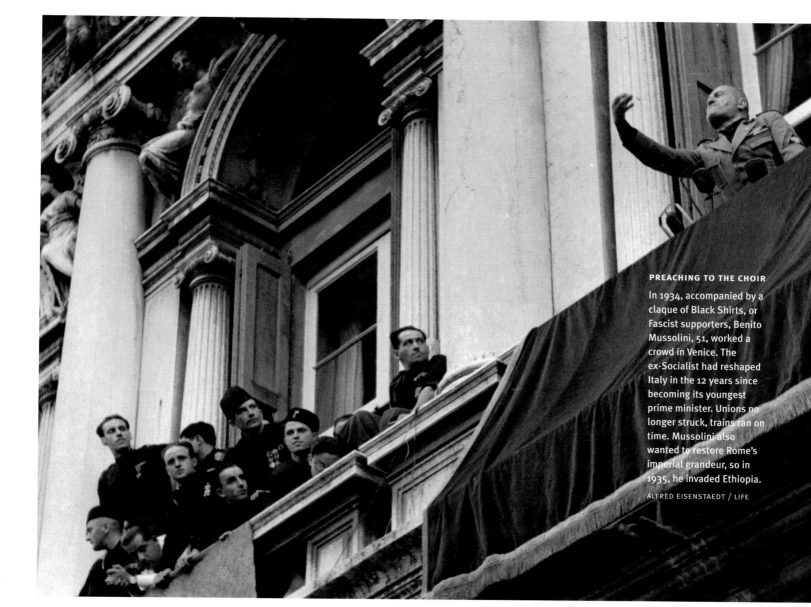

PREACHING TO THE CHOIR

In 1934, accompanied by a claque of Black Shirts, or Fascist supporters, Benito Mussolini, 51, worked a crowd in Venice. The ex-Socialist had reshaped Italy in the 12 years since becoming its youngest prime minister. Unions no longer struck, trains ran on time. Mussolini also wanted to restore Rome's imperial grandeur, so in 1935, he invaded Ethiopia.

ALFRED EISENSTAEDT / LIFE

THE GREAT ESCAPE

Mao Tse-tung, 41 (near left), and Chou En-lai, 37, had reason in 1935 to be proud. A year earlier, facing military defeat by the government, they had retreated north with 100,000 guerrillas. After 6,000 miles, 24 rivers and 18 mountain ranges, 8,000 reached safety in Yenan. In 1949, Mao's Communists won control of China; Long March veterans retained power until 1997.

LATTIMORE FOUNDATION / COURTESY OF PEABODY MUSEUM

ELIMINATING RIVALS

Many of Joseph Stalin's evil deeds in the Thirties went unreported in the USSR. Grabbing Lenin's mantle in 1926, at 47, he collectivized farms; the ensuing famine may have killed 10 million. In 1934, with Leon Trotsky banished, Stalin had his last rival, Sergey Kirov, murdered. Still ahead: the Great Purge of 1936–1938, which claimed up to 10 million more.

PHOTOGRAPHER UNKNOWN

WELCOME TO CATFISH ROW

Porgy and Bess was termed a folk opera by its composer, George Gershwin, 37. Before adapting the DuBose Heyward novel, he summered in South Carolina to absorb black music. The result: Charleston's tenement life, as evoked in a fusion of musical genres. Audiences in 1935 preferred the frothier Gershwin of *Strike Up the Band* and *Girl Crazy*; *Porgy* closed after 16 weeks.

VANDAMM STUDIO

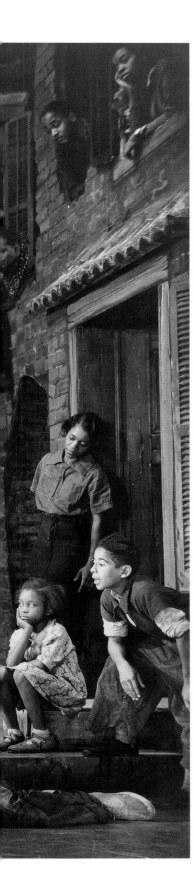

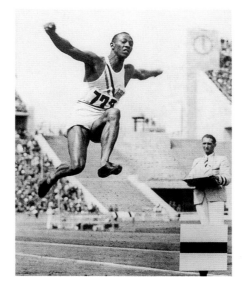

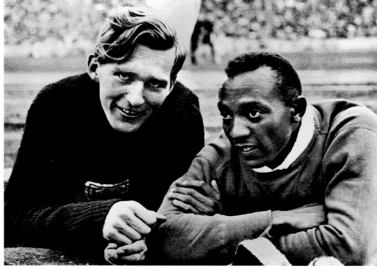

LEAPING INTO HISTORY

By winning a record four events at the 1936 Berlin Olympics, Jesse Owens, 22 (above), foiled Adolf Hitler's dream of showcasing Aryan superiority. Ironically, he qualified for the long jump only after a tip from Luz Long of Germany (above right). Owens went on to take gold, Long the silver. The two stayed in touch until Long was killed in Italy during World War II.

ABOVE: POPPERFOTO / ARCHIVE
ABOVE RIGHT: CIO

BLACK HUMOR

By the mid-Thirties, as radio networks grew, upwards of 40 million Americans got their nightly laughs from *Amos 'n' Andy*. Few minded that the broad dialect jokes were courtesy of two white minstrels (Freeman Gosden, near right, and Charles Correll). The show had such legs that in 1951, CBS hired TV's first all-black cast to turn it into a high-Nielsen sitcom.

TIME INC.

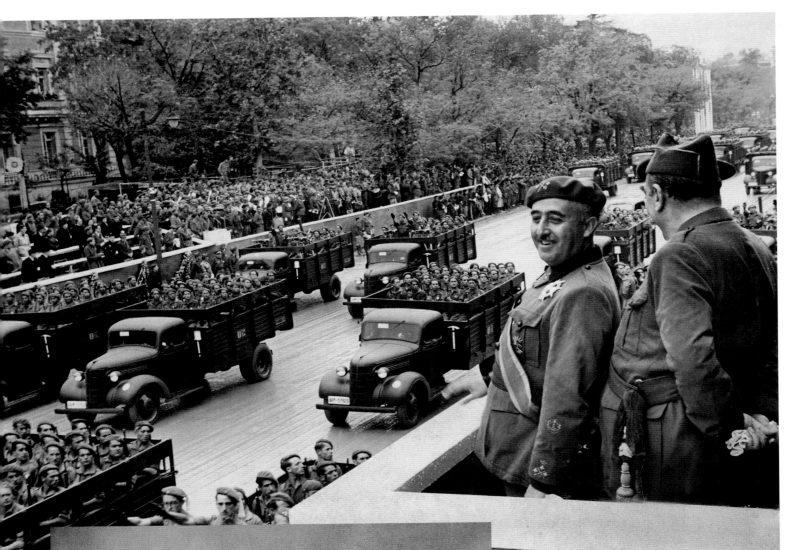

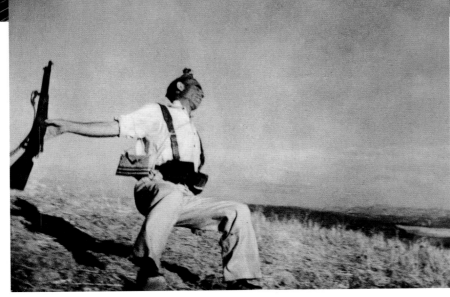

A Hard New Regime in Spain

Three years after his assignment to a remote post in the Canary Islands for being a trouble-maker, General Francisco Franco, 46, stood in Madrid as head of state (above). The price of power: a brutal civil war. In 1936, Franco, backed by Italy and Germany, led army units that helped right-wing Nationalists oust a shaky liberal government. The leftists, with Soviet aid, fought back (right, armed Loyalist women; left, Robert Capa's famous photo of their dying comrade). The advantage in weapons was Franco's. As caudillo — leader — he ruled Spain despotically until his death in 1975.

CLOCKWISE FROM TOP LEFT: DEVER; TIME INC.;
ROBERT CAPA / MAGNUM

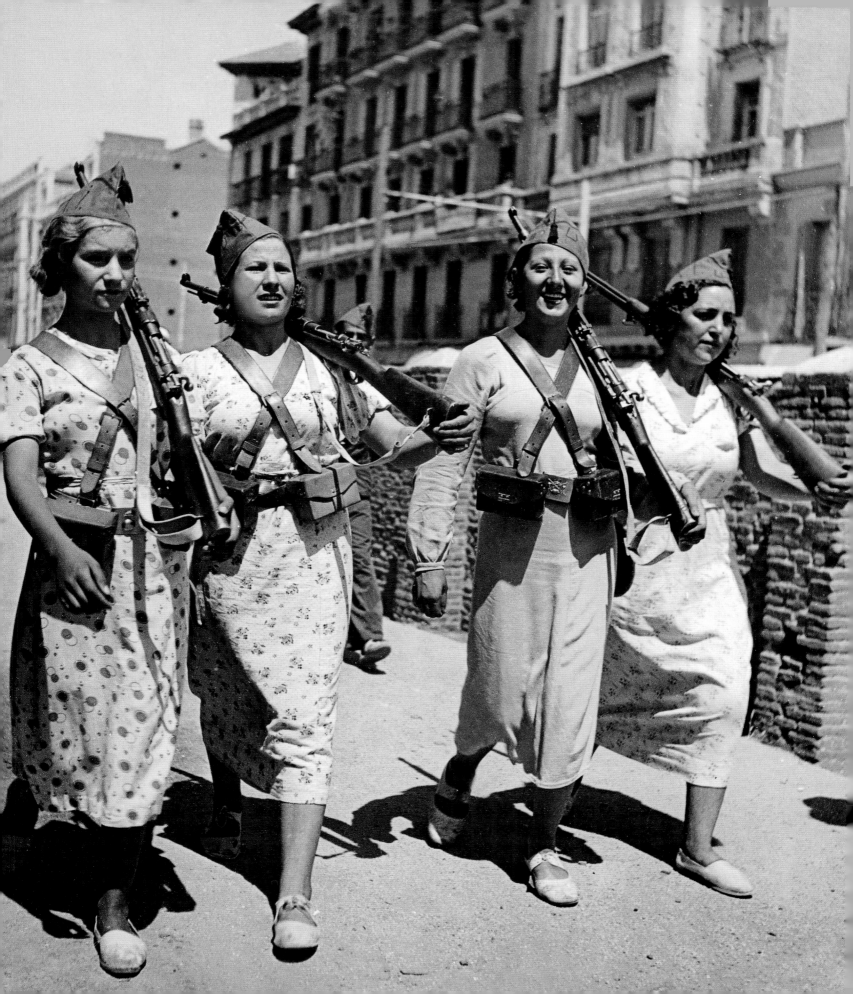

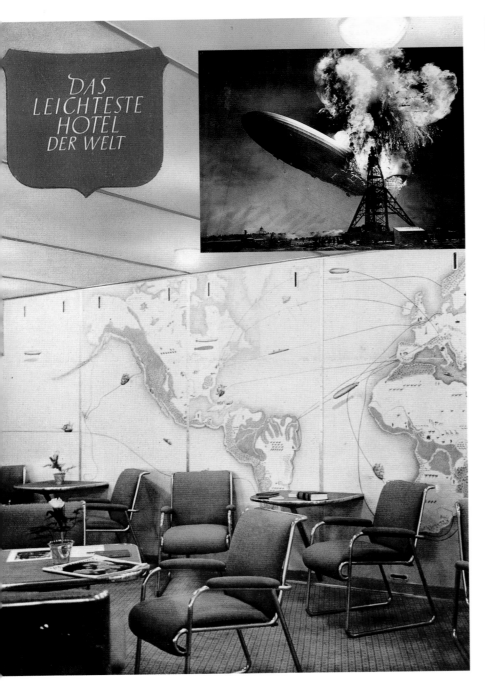

FLIGHT INTO TERROR

The elegant lounge of "the lightest hotel in the world" (above) was for passengers making the 52-hour transatlantic trip aboard *Hindenburg*, pride of the German zeppelin fleet. The rigid airship, whose frame was only 76 feet shorter than *Titanic*'s, relied for lift on highly flammable hydrogen. It was docking at Lakehurst, New Jersey, in 1937 when fire broke out (inset). Miraculously, 61 of the 97 aboard survived.

TIME INC.; INSET: WARD-BALDWIN / CORBIS / BETTMANN

<

THE FUTURE DALAI LAMA

A four-year search ended in 1937 when monks identified B'stan-'dzin-rgya-mtsho, age 2, as Tibet's next spiritual ruler. In 1940, the boy was installed as Dalai Lama (the 14th since 1391). He was 15 when China overran his kingdom. The Dalai Lama escaped into exile in 1959; in 1989, he won the Nobel Peace Prize for his gentle campaign to win freedom for his homeland.

A.T. STEELE

>

A ROYAL COMEDOWN

The Paris mansion was nice but no match for multiple castles in Britain. That was, however, the choice of Edward VIII, the man who would not be king without "the woman I love." He abdicated his throne in 1936, at 42, to marry American divorcée Wallis Simpson (who liked to say, "One can never be too rich or too thin"). The Duke and Duchess of Windsor lived out their years partying.

WILLIAM VANDIVERT / LIFE

<

READ ALL ABOUT IT

Having fled to Mexico City to escape a wrathful ex-comrade, Soviet theorist Leon Trotsky, 58, and his wife, Natalia, reviewed their plight in a new weekly titled *Life*. His sin was to vie with Joseph Stalin for power after Lenin's death. Mexico proved not far enough: In 1940, a Soviet agent sent by Moscow assassinated Trotsky with an ice pick.

FRANCIS MILLER / LIFE

LABOR PAINS

"The chief business of the American people is business," said Calvin Coolidge in 1925. Left out of the equation: blue-collar workers, whose efforts to organize were often bloodily suppressed (Haymarket Square, Pullman, Ludlow). Management was still using goons to bust strikes (Harlan County, River Rouge) when FDR's New Deal leveled the playing field. Collective bargaining was enacted in 1935, a minimum wage in 1938. What organized labor did not — could not — anticipate was America's evolution into a service economy in which the workers' collars were white.

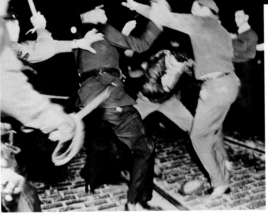

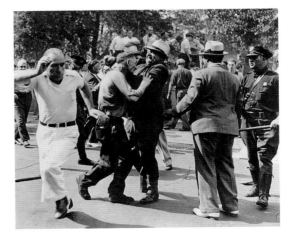

DOING IT THE HARD WAY

Violence was common at strikes in the Thirties. At a Pennsylvania steel mill, picketers learned firsthand that the man trying to cross their line, the Reverend H.L. Queen, was indeed a management mouthpiece (above). Less amusing was the behavior of cops at an Ohio rubber factory (left) and a machinery plant in New Jersey (below left).

ABOVE AND BELOW LEFT: CORBIS / BETTMANN-ACME
MIDDLE LEFT: CORBIS / BETTMANN-INP

ORGANIZATION MEN

When GM fired five men for wearing prolabor buttons, co-unionists in Flint, Michigan, refused to leave their plant. In launching the first large-scale peaceful sit-down strike, on December 31, 1936, they came prepared (right). After 44 days, GM gave in (below) by recognizing the United Auto Workers union.

RIGHT AND BELOW: CORBIS / BETTMANN-UNDERWOOD

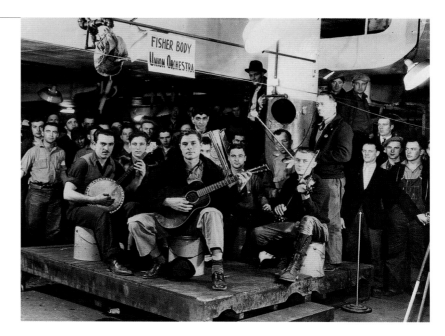

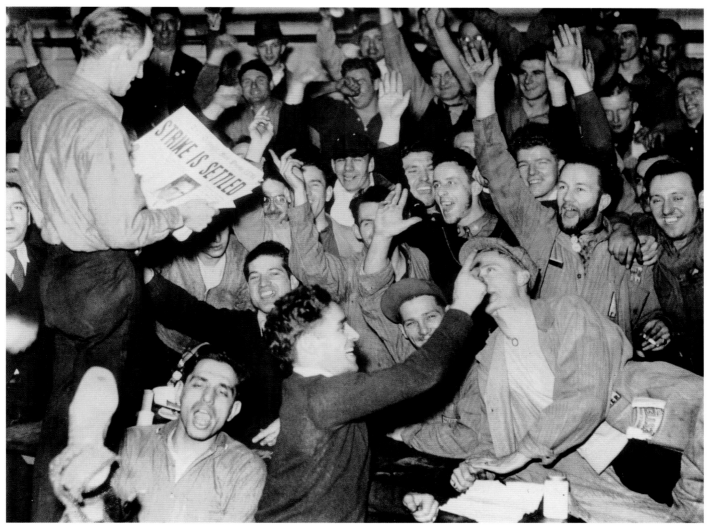

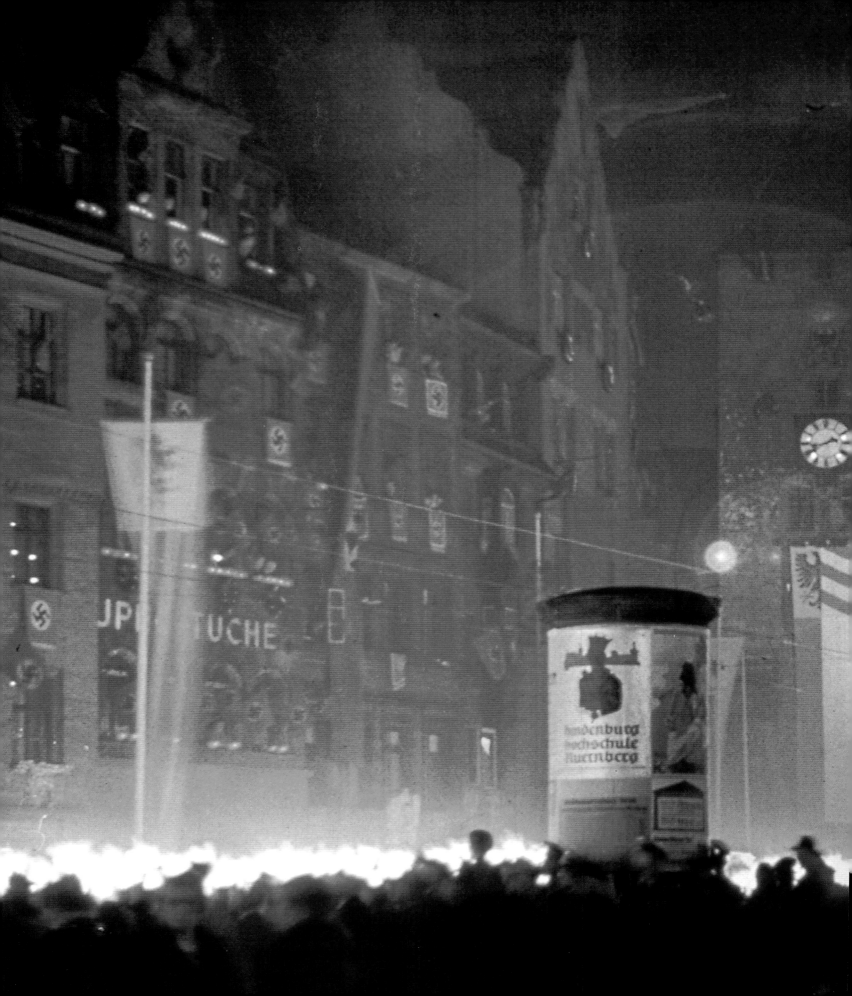

TOMORROW, THE WORLD

In 1938, Germany's Nazi
Party staged its ninth late-
summer rally in Nuremberg.
The faithful had good rea-
son to Heil their Führer
(above). At 49, Adolf Hitler,
the nation's chancellor and
president since 1934, had
just annexed Austria with-
out a single shot. Next up:
Czechoslovakia. This was
the final party conclave; the
next year, the Third Reich
was about to invade Poland.
HUGO JAEGER / LIFE (2)

FALSE PROMISE OF PEACE

After three diplomatic shuttles to Germany (right), British prime minister Neville Chamberlain, 69, returned home (inset) on September 30, 1938, to say he had secured "peace in our time." The cost: ceding Czechoslovakia to Hitler without a fight. His policy, labeled appeasement by critics, staved off war for just 11 months.

HUGO JAEGER / LIFE
INSET: CORBIS / BETTMANN-UNDERWOOD

THE BROWN BOMBER

Joe Louis, here with
manager John Roxborough,
had punched his way to the
heavyweight crown in 1937,
suffering only one loss —
to Max Schmeling, a
German ex-champ who
hobnobbed with Hitler.
Their 1938 rematch (above)
was hyped in both coun-
tries as a test of national
superiority. The main event
didn't last long. Louis, 24,
dropped Schmeling, 32, in
2:04 of Round 1.

GJON MILI / LIFE
INSET: CORBIS / BETTMANN-UPI

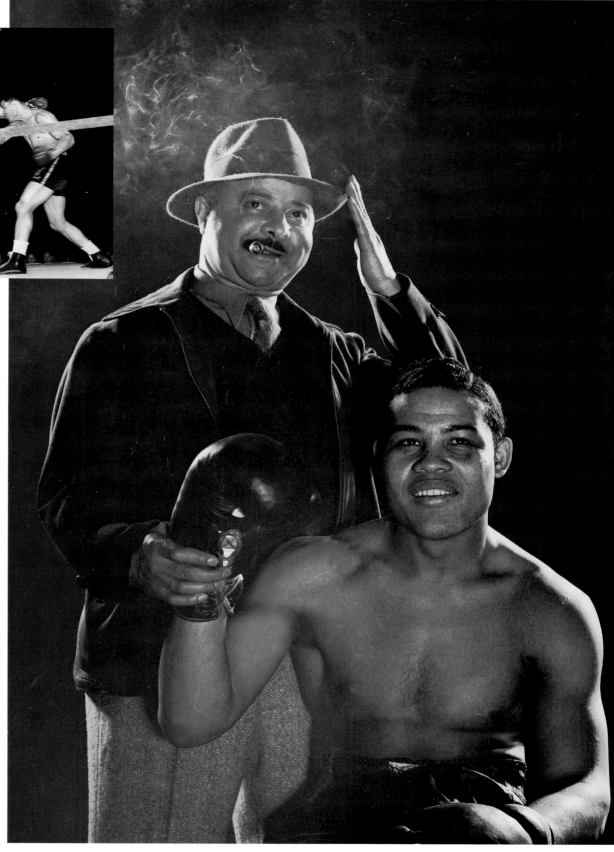

A PRE-JURASSIC FISH

Paleontologists studying fossils knew
the coelacanth began swimming the
world's seas 150 million years before the
first dinosaur. They thought the species
died out circa 70 million B.C. — until a
live one was caught in 1938 off southeast
Africa. Why the big fuss, wondered
Comoro Islanders, who had long been
throwing back the five-foot, 100-pound
fish as not especially tasty.

AMERICAN MUSEUM OF NATURAL HISTORY

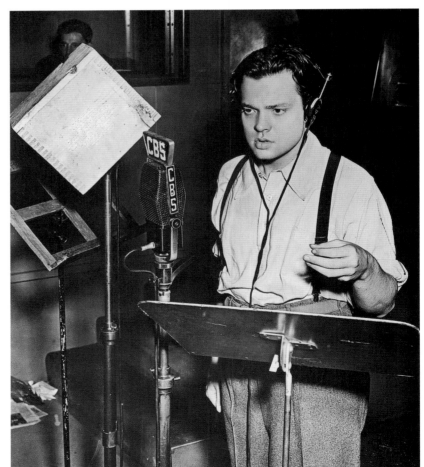

<
GROVER'S CORNER, N.H.

Thornton Wilder, 41, played the role of Stage Manager (center, conducting a wedding) in a 1938 production of his new play, *Our Town*. This look at daily life in a fictitious Granite State village used no sets and few props (a concept borrowed from Japan's Noh plays), and the actors often directly addressed the audience. The innovative drama won a 1938 Pulitzer.

RALPH MORSE / LIFE

>
THE BREATH OF LIFE

Ten years after Harvard physician Philip Drinker invented an artificial respirator in 1928, this massive iron lung kept alive paralyzed young polio victims in Cambridge, Massachusetts. The viral disease struck more than 20,000 a year in the U.S. alone (including FDR, in 1921). Another 350,000 Americans would contract it before an effective vaccine was developed.

HANSEL MIETH / LIFE

<
A TRICK, NOT A TREAT

Halloween Eve, 1938, saw Orson Welles, 23, play a brash radio prank: an hourlong show interrupted by "news bulletins" of Martians attacking New Jersey. The broadcast warned four times that it was fiction, a reworking of H.G. Wells's *The War of the Worlds*; yet police switchboards were jammed coast-to-coast, and some Princeton profs went hunting for ETs.

CULVER PICTURES

THE GREATEST YEAR IN HOLLYWOOD — EVER

The Thirties failed to depress the motion picture industry, which averaged more than 13 new releases every week of the decade. Sure, the stars moaned about being treated like chattel by the studios. Yet they were paid royally (James Cagney, $12,500 per week; Bette Davis, $4,000 per week) in an era when a steelworker earned $1,720 per year. And in 1939, the first generation of American moviemakers seemed to come of age at once. Never before, and never since, has Hollywood produced such a magical crop of entertaining, intelligent and enduring features in one calendar year.

DRUMS ALONG THE MOHAWK

In a rare John Ford Eastern, Henry Fonda played a New York settler turned reluctant Revolutionary Warrior. In the same year, and for the same director, the 34-year-old actor also starred as *Young Mr. Lincoln*. When not busy attending premieres, Fonda and Ford found time to film 1940's *The Grapes of Wrath*.

MOVIE STILL ARCHIVES

GUNGA DIN

At 35, Cary Grant (far left, with Victor McLaglen and Douglas Fairbanks Jr.) was still known for screwball comedies (*The Awful Truth*, *Bringing Up Baby*) and for adventures like this shoot-'em-up in India loosely based on Kipling. His emergence as a romantic lead would come shortly.

MOVIE STILL ARCHIVES

AT THE CIRCUS

The Marx Brothers' world was topsy-turvy enough even without trick camera work. But how else could Groucho, 49, tango on the ceiling? Taking it in stride: Eve Arden, 27, who went on to radio and TV fame as the blasé *Our Miss Brooks*.

MGM

THE HUNCHBACK OF NOTRE DAME

A face not even a mother could love was left off the movie poster but not the beastly body of Charles Laughton's Quasimodo, who ended up sweeping down from a cathedral belfry to rescue a Gypsy beauty (18-year-old Maureen O'Hara).

MOVIE STILL ARCHIVES

THE WOMEN

The comedy based on Clare Boothe's Broadway hit was set long before the invention of the cellular phone. So bubble bathee Joan Crawford, 31, burned while Rosalind Russell, 32, fiddled on the line.

MOVIE STILL ARCHIVES

THE GREATEST YEAR IN HOLLYWOOD — EVER

WUTHERING HEIGHTS

Emily Brönte's wild moors were in Yorkshire, England. For budgetary reasons, though, Laurence Olivier, 32, and Merle Oberon, 28, had to film their roamin's in the gloamin' nearer Hollywood — even if that meant planting part of the San Fernando Valley with heather.

MOVIE STILL ARCHIVES

INTERMEZZO

Hollywood sent for Sweden's breathtaking Ingrid Bergman to re-create the role that had made her a star back home: a young pianist who falls for a married violinist. Bergman, 24, daringly left her lush eyebrows unplucked. Leslie Howard, 46, obviously didn't mind, nor did U.S. audiences.

MOVIE STILL ARCHIVES

<

DESTRY RIDES AGAIN

In her 12th Stateside movie, Marlene Dietrich, 38, portrayed an Old West chantoosie who wants to know what the boys in the back room will have. And what did Frenchy herself fancy? The pacifist lawman played by James Stewart.

UNIVERSAL PICTURES

THE WIZARD OF OZ

Judy Garland proved her moxie at 16 by playing a 12-year-old from Kansas. Each day her breasts had to be painfully taped flat. But she and co-stars (from left) Bert Lahr, Jack Haley and Ray Bolger ended up smiling down the Yellow Brick Road to showbiz immortality.

MOVIE STILL ARCHIVES

DARK VICTORY

She thought those vicious headaches were from dates with martini-swilling boors like Ronald Reagan, 28. In fact, they were signs of a brain tumor that would all too quickly dim Bette Davis's 31-year-old eyes.

WARNER BROTHERS

THE GREATEST YEAR IN HOLLYWOOD — EVER

THE ROARING TWENTIES

James Cagney, 40, was top-billed as a quick-fisted mobster. Humphrey Bogart, also 40, was the second banana — a not unfamiliar role. Not until 1941, in *The Maltese Falcon*, would Hollywood begin to exploit the romantic nihilism that became Bogie's trademark.

MOVIE STILL ARCHIVES

MR. SMITH GOES TO WASHINGTON

Thirty-one-year-old James Stewart's aw-shucks decency was perfect for his role as a new senator standing up to vested interests. Director Frank Capra went to Washington to show off his movie to the Capitol Hill crowd. Reviews were not kind.

COLUMBIA PICTURES

GONE WITH THE WIND

It ate up 10 writers, three directors, a cast of almost 2,500 and an inflation-adjusted budget of $48 million. Yet the 220-minute Civil War epic (intermission not included) turned out to be engrossingly intimate, thanks mostly to the star power of Vivien Leigh, 26, and Clark Gable, 38.

MGM

STAGECOACH

The vehicle was creaky — strangers joined on a perilous journey — but not John Ford's masterly direction. He reinvigorated the horse opera while making stars of John Wayne and of Arizona's scenic Monument Valley.

WALTER WANGER PRODUCTIONS

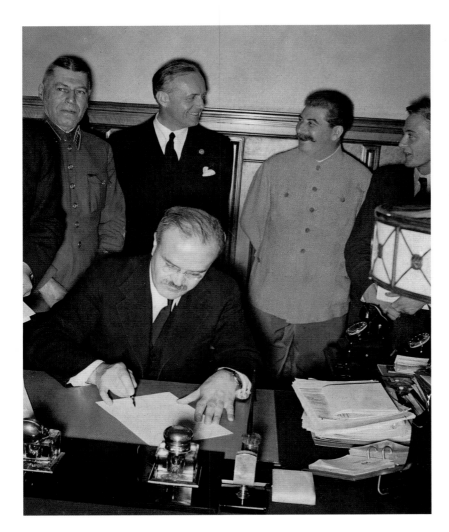

PLAYING FOR TIME

As Joseph Stalin and Nazi diplomat Joachim von Ribbentrop traded smiles in Moscow on August 23, 1939, Soviet foreign minister V.M. Molotov signed a nonaggression pact between the two archrivals that stunned the world. Nine days later (bottom left), the German army rolled into western Poland. On September 3, Ribbentrop honored a secret protocol and invited the USSR to breach Poland from the east; Stalin didn't have to be asked twice. The Soviet-German accord would last 22 months, until Hitler changed his mind.

LEFT: DEVER
BOTTOM LEFT:
HEINRICH HOFFMAN / LIFE

>
FUTURE SHOCK

Where was George Washington inaugurated? New York, of course, and in 1939, to mark the event's sesquicentennial, the city opened a world's fair stuffed with high-tech dreams (direct-dial long distance, TV). Over two summers, 45 million fair-goers gawked at this World of Tomorrow — while the real world was dissolving into war.

DAVID E. SCHERMAN / LIFE

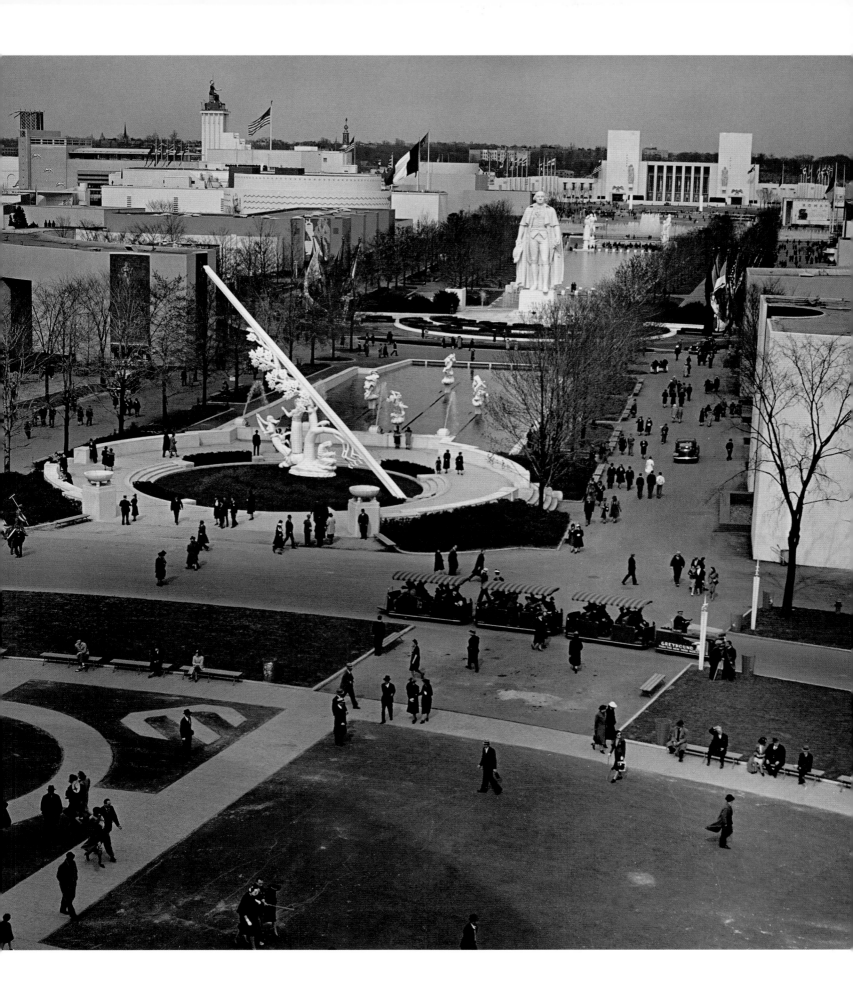

REQUIEM

<

WILL ROGERS
1879–1935

He never met a man (or an audience) he didn't like. After launching his career in South Africa, the Oklahoman lassoed Americans with his ability to twirl and crack topical jokes. A movie and radio star, he also wrote a column and served as Beverly Hills's mayor; Rogers died in Alaska flying to an Asian vacation.

CULVER PICTURES

>

JEAN HARLOW
1911–1937

Harlow went platinum long before LPs and credit cards. Hollywood's first blonde bombshell got her break in 1930's *Hell's Angels*. Later, MGM teamed her with Gable, Tracy and William Powell and honed her knack for comedy. She died from uremic poisoning after filming *Saratoga*, her 29th movie in eight years.

BEN CARBONETTO COLLECTION

>

AMELIA EARHART
1897–1937

In 1928, she was the first woman to fly the Atlantic — as a passenger. Four years later she repeated the trip — as the pilot. Earhart was also the first of either gender to solo from Hawaii to California, but her 1937 attempt to circumnavigate the globe fell short somewhere over the Pacific.

TIME INC.

SIGMUND FREUD
1856–1939

Sometimes a cigar is just a cigar; but thanks to the Austrian neurologist, we'll always wonder. Freud altered our understanding of behavior with his revolutionary theory that most human actions stem from unconscious desires. The father of psychoanalysis could have used some counseling himself. His smoking habit led to an agonizing death from mouth cancer.

TIME INC.

ARTHUR CONAN DOYLE
1859–1930

To improve his frail fiscal health, the University of Edinburgh–trained physician wrote an unlikely Rx: a detective story. It was a hit, so the decision to quit medicine was elementary. Doyle had less control over Sherlock Holmes. Tiring of the sleuth in 1893, he killed him off, but public outrage led to a resurrection and 35 more tales.

RADIO TIMES HULTON

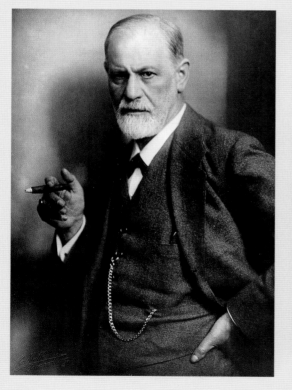

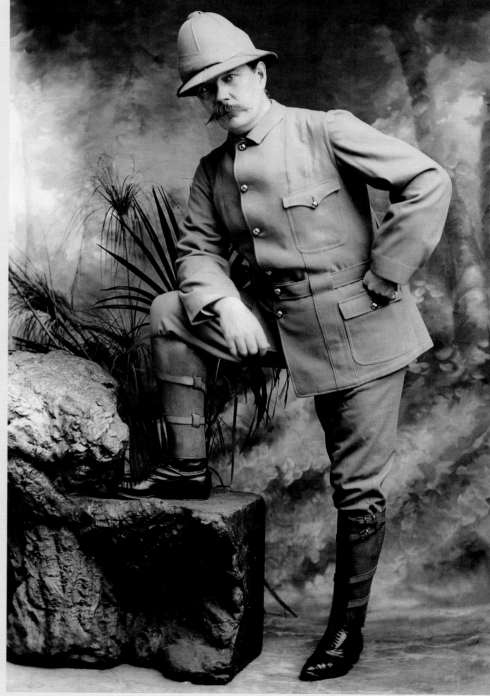

THOMAS ALVA EDISON
1847–1931

Deafness made him a misfit at school, so he educated himself. The boy began conducting chemistry experiments at 10 and never really left the lab. Over the next 74 years, Edison won an unprecedented 1,093 patents. Among his inventions: the record player, the incandescent lamp, a gizmo that became the ticker tape and the motion-picture camera.

NATIONAL PARK SERVICE

<

FLORENZ ZIEGFELD
1869–1932

Beefcake was scarce in the Broadway shows mounted by the impresario (here with second wife Billie Burke). His annual musical revue, a sanitized version of Paris's Folies-Bergère, featured long-stemmed chorines, lavish costumes and top talent. W.C. Fields, Fanny Brice and Eddie Cantor all rose from the Ziegfeld Follies.

CORBIS / BETTMANN-INP

MUSTAFA KEMAL ATATURK
1881–1938

A childhood teacher called him Kemal, "the perfect one." Atatürk, "father of Turks," was his own invention when Turkey's first president ordered his people to adopt surnames. He also secularized government, banned traditional Islamic attire and emancipated women, starting with Latife Hanm, his Westernized (and shockingly unveiled) wife.

TIME INC.

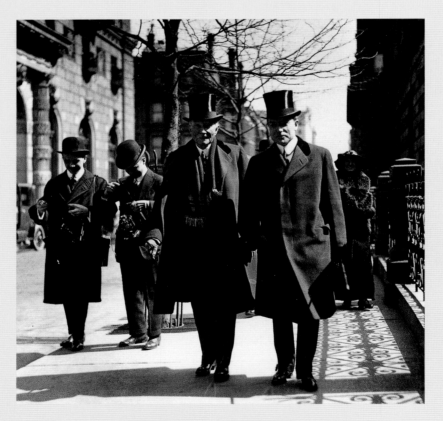

<

JOHN D. ROCKEFELLER
1839–1937

Owning Standard Oil, a refining monopoly for 30 years before the Supreme Court broke it up in 1911, made Rockefeller (here with John Jr.) not only one of the world's richest men but also a magnet for the era's paparazzi (far left). After 1897, the billionaire spent his time on philanthropy, chasing young women and image-buffing (he dispensed new dimes to children).

CORBIS / BETTMANN-UPI

JAMES NAISMITH
1861–1939

The game of hoops he devised in 1891 at a YMCA in Springfield, Massachusetts, was meant to amuse kids between football and baseball seasons. The first peach baskets went up with bottoms intact; someone had to fetch the ball after each goal. Naismith, who set them 10 feet off the floor, would no doubt be astonished by how much of today's game is played above the rim.

CORBIS / BETTMANN-UPI

GEORGE GERSHWIN
1898–1937

Freely mixing popular and classical idioms, America's most versatile composer developed an unrivaled musical vocabulary. Gershwin wrote symphonically *(Rhapsody in Blue)*, then crossed over to Broadway, collaborating with lyricist brother Ira on 1924's *Lady, Be Good* and 10 other shows. Two years after writing his folk opera, *Porgy and Bess*, though, he was dead of a brain tumor.

EDWARD T. STEICHEN

Chungking, China's provisional capital, fell under savage
Japanese bombing in July 1941. Japan had begun nibbling at
China a decade earlier; it was time for the main course.

CARL MYDANS / LIFE

1940–1945

WORLD ON FIRE

The Last Casualty Is Innocence

BY PAUL FUSSELL

MARTHA GELLHORN, war correspondent and third wife of Ernest Hemingway, was quite correct when she said, "War was our condition and our history, the place we had to live in." A lot more than total war went on in those years, but the struggle against Germany and Japan thoroughly permeated domestic life, dominating all other activity and inducting America into a grown-up and nasty world.

The disheartening thing was that we had fought it once before, at least against Germany, some 20 years earlier. But if the First World War was one that could be entered with some enthusiasm and innocent hope, this one was different. The book and film *All Quiet on the Western Front*, Hemingway's *A Farewell to Arms* and Robert Graves's *Good-bye to All That* helped feed the cynical atmosphere, and the news was out that only fools could celebrate war anymore or enter it with high patriotic excitement. Rather, the war now seemed a filthy procedure that simply had to be endured and won. No more sabers and Sam Browne belts, no more centuries-old habits of chivalry, no more leaving civilians safely out of it. The booby trap was significantly a weapon not of the First World War but of this one. Engineering and heavy manufacturing had to replace swank and spirit. Poet Louis Simpson writes of one World War II artillery exchange in Germany, "For every

shell Krupp fired / General Motors sent back four." And other novelties made the war unlike any other, such as the concomitant systematic torture and murder of millions for "racial" reasons and the mass bombing of civilians to terrorize them, or at least, in Churchill's word, to *de-house* them. A hitherto unheard-of feature of this war was the new definition of infantry combat implicitly provided by Japanese troops, whose defense of ground included killing not the enemy but themselves.

Because of the resoundingly successful end of the war — Germany and Japan humbled and in ruins — it is not easy or pleasant for Americans to recall its inept and embarrassing beginning. There was the shameful failure of U.S. intelligence at Pearl Harbor and the shocking mass sinking of Allied ships by German U-boats, some visible to the vacationers on Florida beaches. Author Bernard De Voto spoke for most Americans when in April 1942 he declared, "We are perilously close to being licked." From that moment on, Americans began to face the awful truth and, despite "war jitters" (a popular ailment in 1942), resolutely put themselves into gear.

In his address to Congress declaring war on Japan, President Roosevelt had delivered this stirring prediction: "No matter how long it may take us . . . the American people in their righteous might will win through to absolute victory." The word

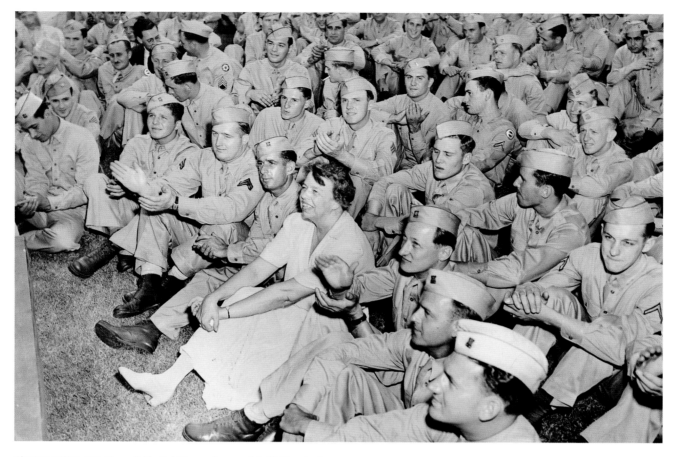

Glamorous? No. Happily wed? No. But Eleanor Roosevelt (with GIs, short for "government issue," on the White House lawn in 1942) was smart and caring. She fought fearlessly for the have-nots until her death in 1962, at 78, and, in so doing, redefined the role of First Lady.

CORBIS / BETTMANN-ACME

victory took hold and instantly became the propaganda keynote of the war. The accidental similarity between the Morse Code's letter V (. . . –) and the first four notes of Beethoven's Fifth Symphony opened up a whole new area for morale-lifting and self-righteousness. An ad for a concert featuring Beethoven's Fifth designated it "a grand piece, with victory emphasized throughout." Soon backyards were dug up and transformed into Victory Gardens, and taxicabs, especially those plying near military camps, became Victory Cabs. Of course government bonds were Victory Bonds, and the spread two-finger gesture enrolled the body itself in the Victory campaign. The standard three-cent stamp deployed the American eagle as an emblem but now depicted it with wings spread upward in the V-sign. There was even a Victory Flower Vase, with two bifurcated arms forming the V for Victory sign. The technique of photographic reduction, which enabled troops to write home conveniently, resulted in V-mail. By 1943, there was no holding back or skepticism about every American's duty, and factory workers as well as students and the formerly privileged joined in singing, "Now we're in it, we have to win it."

Actually, we had been virtually in it for some time, as a result of Roosevelt's shrewd evasions and redefinitions of former neutrality laws and such provocative gestures as assisting the British in dealing with U-boats in the Atlantic and the Caribbean, not to mention supplying England with copious planes and armor. At my college, the ROTC unit marched with ridiculous wooden simulacra of rifles because we had sent our World War I Springfields to Britain to help them repel a feared German invasion.

Mortgage bankers were pushovers next to the volunteers who in 1943 made up the federal Ration Board in Bristol, Connecticut. Scarce commodities requiring coupons: sugar, coffee, gas, meat and flour.
HERBERT GEHR / LIFE

Pearl Harbor was essentially Japan's answer to American embargoes on oil and steel, imposed because of Japanese aggression in China and elsewhere in the Far East, although the attack had to be presented to this country as an outcrop of unmotivated and unanchored Japanese wickedness. During the war, the home front was deluged with new forces of disingenuousness, until by the end few critics and skeptics expected the government to adhere strictly to the truth. The brutality required for winning the war would have been so shocking to the customary American sense of national virtue that devices had to be found to soften or entirely misrepresent evidence of it.

The country was prepared already with a flourishing publicity and advertising profession, which was called on immediately to serve the war effort. Well before the country was actually engaged in the shooting war, the euphemism operation was in ac-

tion, with *draft* or *conscription* replaced by *selective service* and *conscript* by *inductee*. But the outbreak of painful physical hostilities required intensified efforts of this kind, resulting in *collective burial* for *mass grave* and *battle fatigue* for *temporary insanity*. Because the war was overwhelmingly recognized as necessary and just, the press behaved itself, abandoning for the moment its customary role of faultfinder and critic and, under the "guidance" of the Office of War Information, becoming a virtual arm of the government.

Many today would be astonished to hear of the amount of regulation and repression people then accepted as necessary to win the war, the only thinkable objective at the time. Indeed, from 1942 to 1946, there was something like a Socialist America, which few seemed to mind since what was at stake was the successful end of the war with quick returns home of sons, brothers and husbands. For example, because of federal regulations, civilian objects made of steel practically disappeared, and there were no new automobiles after 1942. Even if you had a car,

tires for it were strictly limited and ordinary people could buy only four gallons of gasoline per week. Tobacco was in such short supply — most cigarettes went to the troops — that smokers learned to roll their own or turned to substandard brands like the now-forgotten Spuds or Wings. Desirable foodstuffs were available only if you presented correct ration tickets, and most housewives obeyed the laws seriously restricting their purchases of fats, coffee, meat and sugar. Of course there grew up black markets in all these commodities, but there was a surprising degree of enthusiastic compliance by people who did not want their country run by the Germans and the Japanese — and in wartime, that was a fear that would have come instinctively to most minds.

When the war finally ended, the men who had fought it hardly rejoiced as expected. They had seen too much. Correspondent Ernie Pyle was killed by a Japanese sniper near the end of the war against Japan. In his pocket was discovered a summary of the war that he had intended to turn into a Victory Day column.

There are many of the living who have had burned into their brains forever the unnatural sight of cold dead men scattered over the hillsides and in the ditches along the high rows of hedge throughout the world.

Dead men by mass production — in one country after another — month after month and year after year.

Dead men in winter and dead men in summer.

Dead men in such familiar promiscuity that they become monotonous.

Dead men in such monstrous infinity that you come almost to hate them.

Even if they had not themselves been on the line to kill the enemy, it was not hard for most Americans to sense that the Age of Innocence was over. We had massacred civilians with the atrocious

During the war, servicemen appreciated the gallows humor of the cartoons in their daily, *Stars and Stripes* (above, a GI puts down his most trusted pal). In 1945, Sergeant Bill Mauldin, 24, won a Pulitzer for his work. As a civilian cartoonist, he received a second, in 1959.
BILL MAULDIN

atomic bomb, and soon it would be evident that Roosevelt had been naive in trusting the Soviet Union to keep its pledge to encourage postwar free elections in Europe. History-minded people had no trouble understanding that the year 1945 was the worst for all humanity since history began to be written. But even the least informed and imaginative could feel that the war years had brought a new world. We were ready now for the Cold War, with its Koreas and Vietnams.

Paul Fussell, an infantry lieutenant in World War II, was wounded in France. His books include The Great War and Modern Memory *(1975), which won a National Book Award. He is professor emeritus of English at the University of Pennsylvania.*

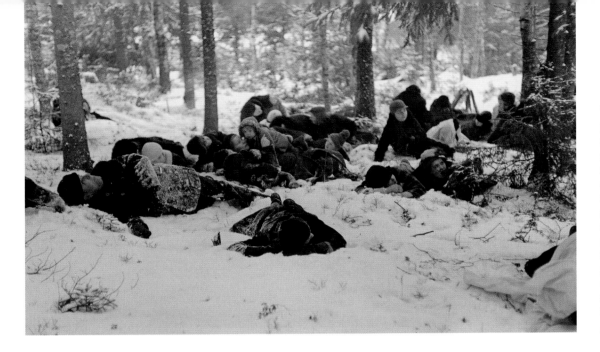

THE RUSSIANS ARE COMING

Finnish civilians took to the woods in early 1940 to wait out another Soviet air raid. Stalin, despite his non-aggression pact with Hitler, remained deeply suspicious of Germany's intent and sought to buffer his northern flank with a chunk of Finland. That nation of 3.8 million resisted with surprising ferocity; it staved off the Red Army for more than three months.

CARL MYDANS / LIFE

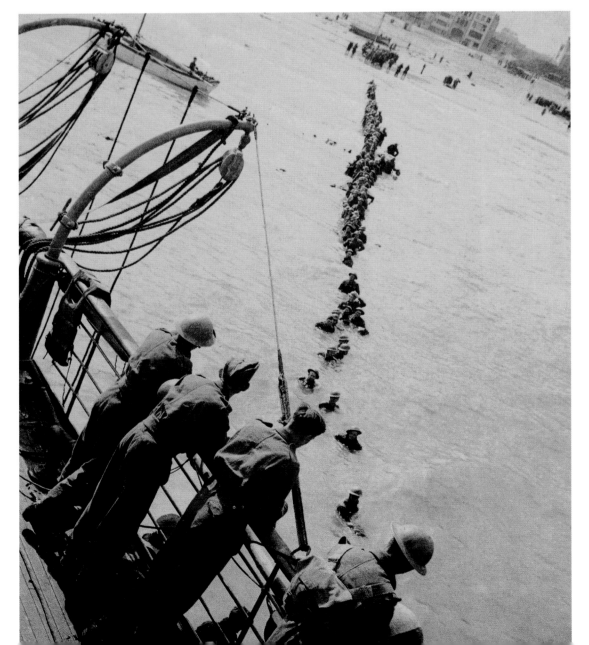

THIS EMBATTLED ISLE

Abject retreat (left) ended Britain's first attempt to repel Hitler. In mid-1940, 200,000 of its troops, plus 140,000 French and Belgian allies, were cornered in the Channel port of Dunkirk. The Brits mustered a 1,000-vessel fleet (ranging from warships to fishing boats) that, protected by the Royal Air Force, repeatedly made the 100-mile crossing. Over 10 days, all but 2,000 men were evacuated. A month later, Germany began air strikes on military sites in England in preparation for a cross-Channel assault. A retaliatory British bombing of Berlin so enraged Hitler that he ordered his Luft-waffe to pulverize London (right). Not only was the Blitz beaten back by the vastly outmanned RAF, but the 40,000 civilian lives it claimed also stiffened British resolve. Hitler shelved the invasion set for September 15, 1940.

LEFT: TIME INC.
RIGHT: WILLIAM VANDIVERT / LIFE

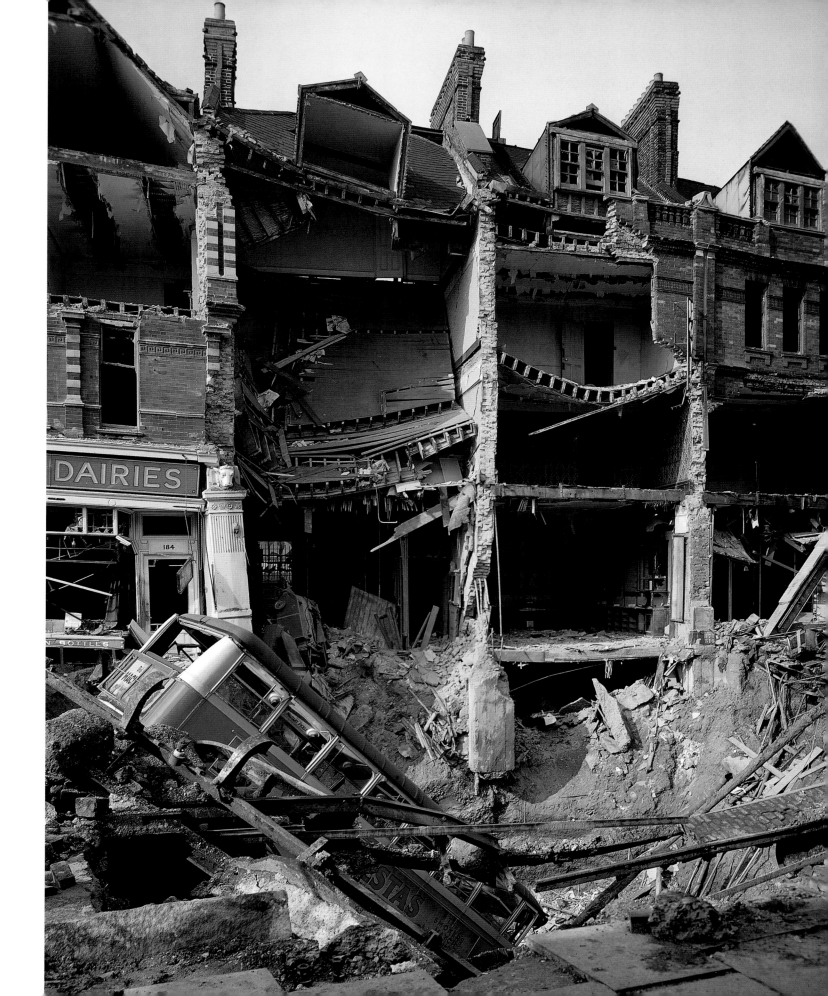

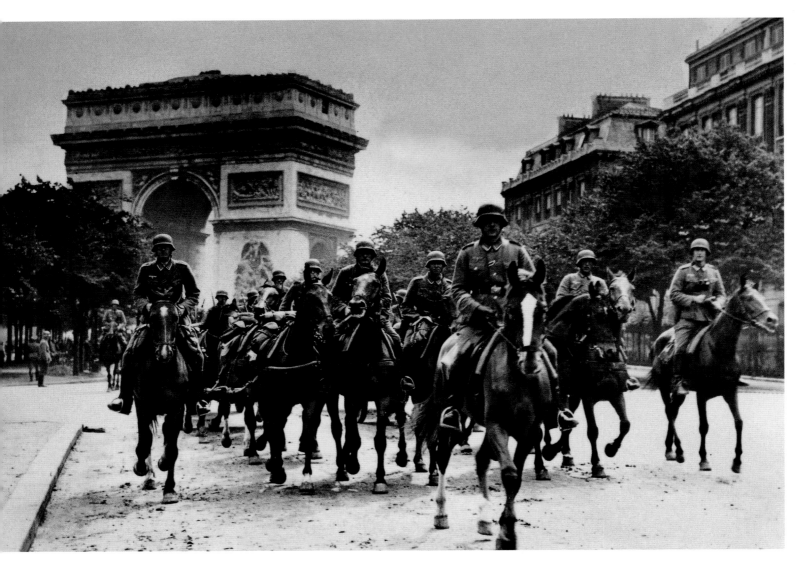

VICTORY LAP IN FRANCE

Six weeks too late to enjoy April (1940) in Paris, German soldiers paraded past the Arc de Triomphe (above). In 32 days, they did what their World War I countrymen could not do in four years: occupy the French capital. To skirt the Maginot Line — a 200-mile French defense on its border with Germany — they had swept through the Low Countries, displacing thousands (like the Belgian kids, left). One 11-year-old at another refugee center: Audrey Hepburn.

ABOVE: HEINRICH HOFFMAN / LIFE
LEFT: CARL MYDANS / LIFE

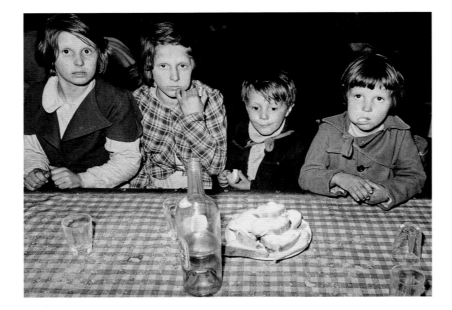

ANYBODY FEEL A DRAFT?

In October 1940, the U.S. was still technically neutral, so these men at Fort Slocum, New York (right), became part of the nation's first peacetime draft. The armed forces were in sore need of bolstering: They totaled just under one million. At that time, much of Europe was Hitler's, the Battle of Britain raged on, and Germany, Japan and Italy had just formed the Axis alliance.

RALPH MORSE / LIFE

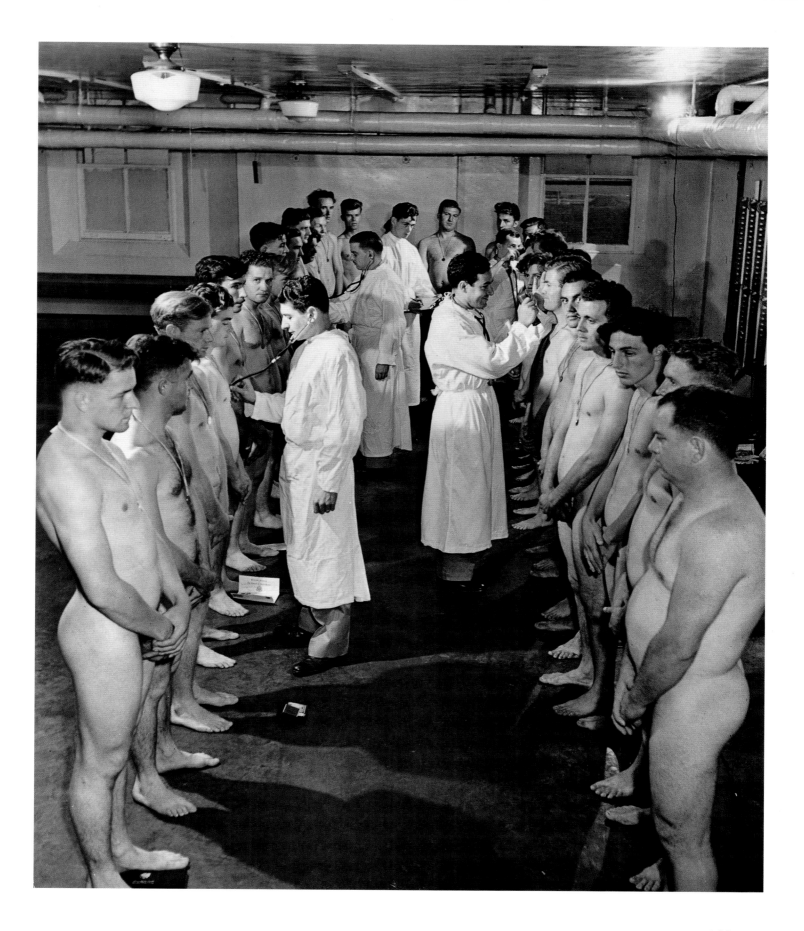

SPRINGTIME FOR HITLER

The early Forties were the best years of his wretched life. Since 1933, Adolf Hitler had pieced together an empire to rival ancient Rome's with little loss of German life. Such power invited adoration. Starstruck socialites (left), awed Austrian schoolgirls (right), enchanted wives of Nazi lackeys (far right) — all were part of the Führer's *schatzifreude*. From the evidence, Hitler believed in looking but not touching; he had never fallen in love again after young Geli Raubul committed suicide in 1931 to escape the attentions of her half-uncle Adolf. Hitler did, though, live abstemiously with Eva Braun (below right, at his Berchtesgaden chalet) from 1932 on. He would finally end 56 years of bachelorhood by marrying her on April 29, 1945, their next-to-last day on earth.

HUGO JAEGAR / LIFE (3)
BOTTOM RIGHT:
PHOTOGRAPHER UNKNOWN

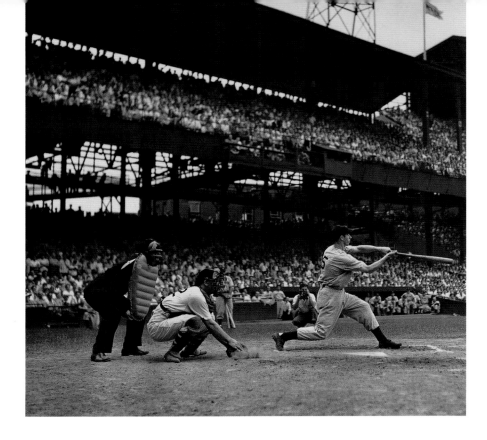

< 42 DOWN, 14 TO GO

With this single on June 29, 1941, outfielder Joe DiMaggio, 26, broke George Sisler's modern mark of hitting safely in 41 straight games. The Yankee Clipper would extend the streak to 56 (and lead New York to a World Series title). But Boston's Ted Williams, 23, did even better at the plate, becoming the century's last big leaguer to average above .400. (He finished the year at .406.)

> OPERATION BARBAROSSA

On June 22, 1941, Adolf Hitler reneged on his non-aggression pact with Stalin and sent 3.2 million Axis troops into the Soviet Union (inset). Stalin quickly rejoined the Allies. Though Germany had better weapons, the USSR countered with more men (like the civilians digging an antitank ditch outside Moscow, right) and Mother Nature (the bitter Russian winter came early that year).

GATHER YE ROSEBUDS . . .

At 25, Orson Welles cowrote, directed and played the title role in the most influential American movie since *The Birth of a Nation*. Technically daring, wickedly insolent, it recaps the rise of a megalomaniacal press lord. A miffed William Randolph Hearst told his papers not to run ads for *Citizen Kane*, which on its 1941 release was a box-office bomb.

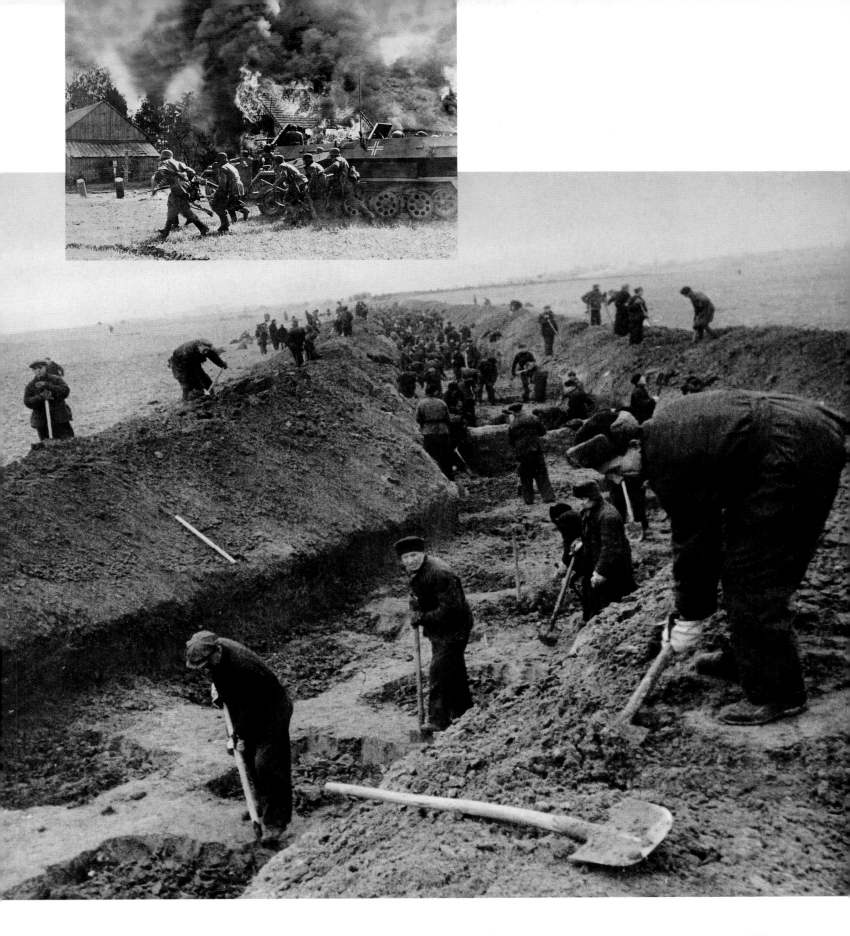

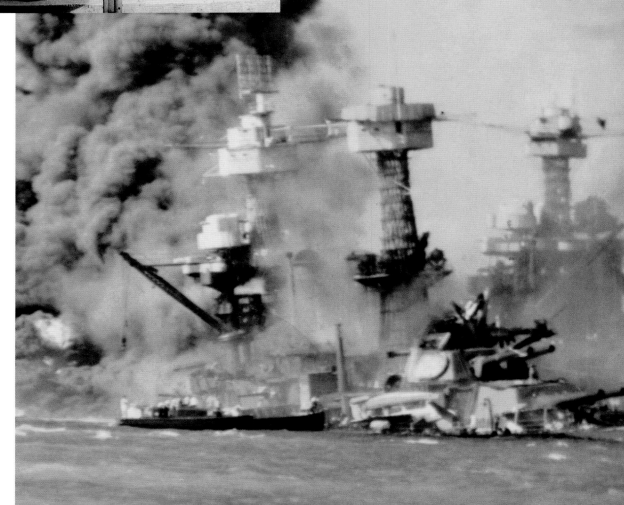

DECEMBER 7, 1941

At 7:55 that Sunday morning, sailors at the Pearl Harbor base in Honolulu, Hawaii, as well as pajama-clad civilians nearby (above), awoke to an infamous day. A Japanese fleet assembled by Harvard-educated Admiral Isoruku Yamamoto, 57, had crossed the West Pacific undetected. For two hours, 360 carrier-based attack planes pummeled Pearl (right). The U.S. lost 2,344 men, four battleships (14 other warships sustained major damage) and 200 fighter planes. Reason for the sneak strike: An American embargo of oil and steel was pinching the resource-poor nation's industries. It took Congress only 27 hours to declare war on Japan.

BALDWIN H. WARD / CORBIS / BETTMANN
INSET: KELSO DALY / LIFE

174

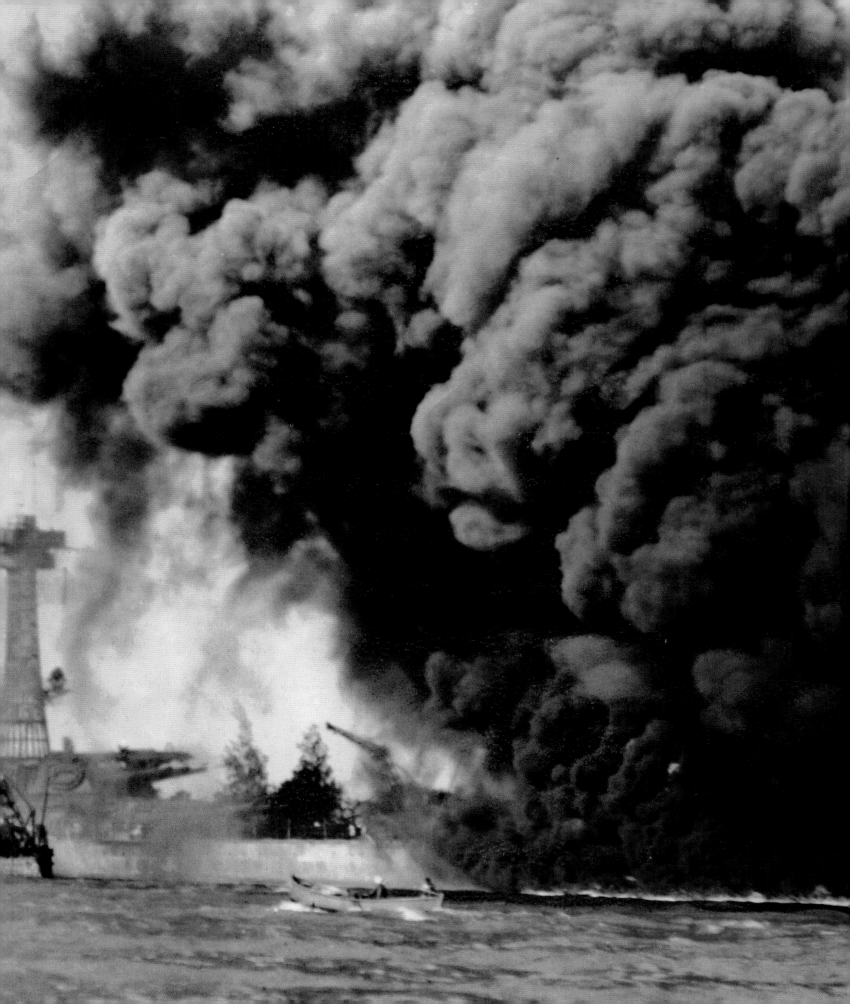

COMBAT: 1942

Early on, the bloody chessboard looked like this. Japan, after victories at Pearl Harbor and in Malaya and Siam, was consolidating its control of Southeast Asia and the South Pacific. Its Axis partners ruled Western Europe by force or by collaboration (France, Norway) and had the upper hand in North Africa, thanks to German panzer general Erwin Rommel. And Hitler's Wehrmacht had survived its first Russian winter to continue driving deep into the USSR.

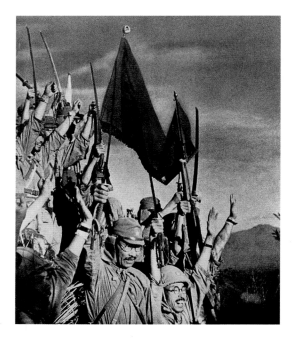

A CRUEL SUNRISE ON BATAAN

The Imperial Japanese troops above had earned their banzais by conquering the Philippines in five months. Surrendering at Bataan (right): 12,000 GIs and 64,000 Filipino soldiers. The Japanese forced their debilitated captives on a 65-mile trek. Some 10,000 escaped en route, but 5,600 did not survive the brutal Death March. Another 17,000 died in POW camps.

ABOVE: U.S. ARMY; RIGHT: TSUGUICHI KOYANGI

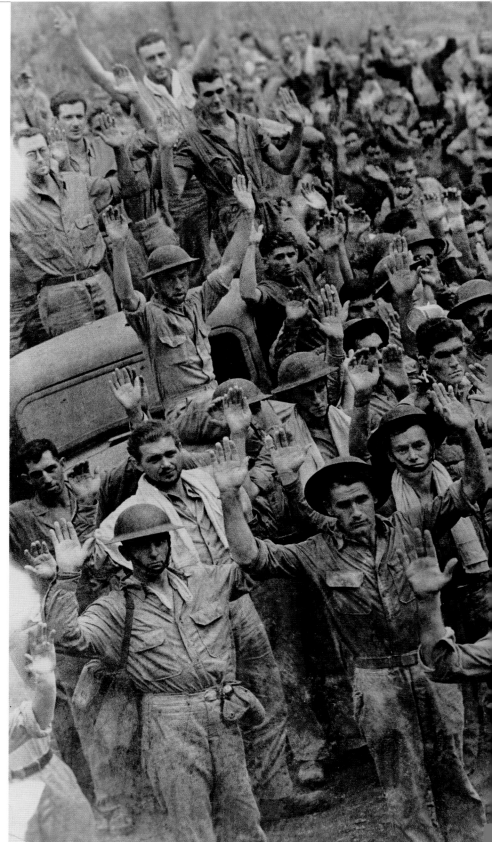

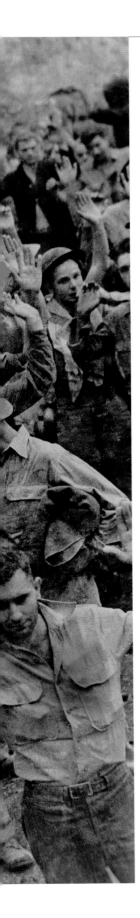

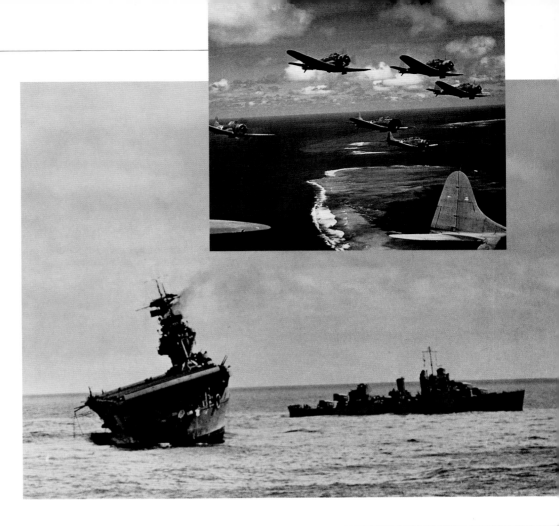

VICTORY AT SEA

Naval warfare took on a new dimension with two epic slugfests between the U.S. and Japan. Rather than exchange traditional broadsides, the foes sent torpedo bombers (top right) and fighters after each other's far-off warships. (By incredible luck, America's three Pearl Harbor–based aircraft carriers were at sea on December 7, 1941.) The fleets fought to a four-day standoff in May on the Coral Sea; then, on June 4, they met again off an island in the Central Pacific coveted by Japan as a base from which to menace Hawaii. The Battle of Midway began well for the U.S. as its planes sank three enemy carriers. That day, though, the flattop *Yorktown* was hit (above right; two days later, a Japanese submarine finished the job). American planes then bagged a fourth carrier and the cruiser *Mikuma* (below right). The Japanese, who also lost 332 planes, retreated west. The Pacific was America's.

FROM TOP:
FRANK SCHERSCHEL / LIFE;
U.S. NAVY (2)

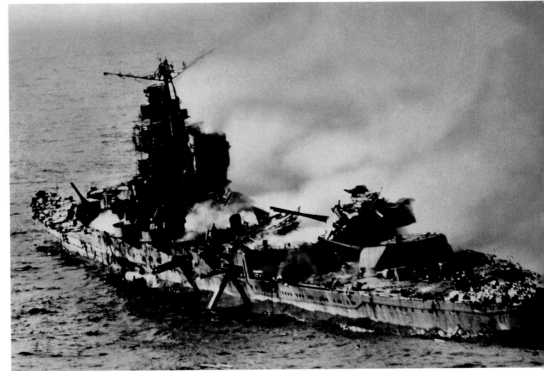

COMBAT: 1942

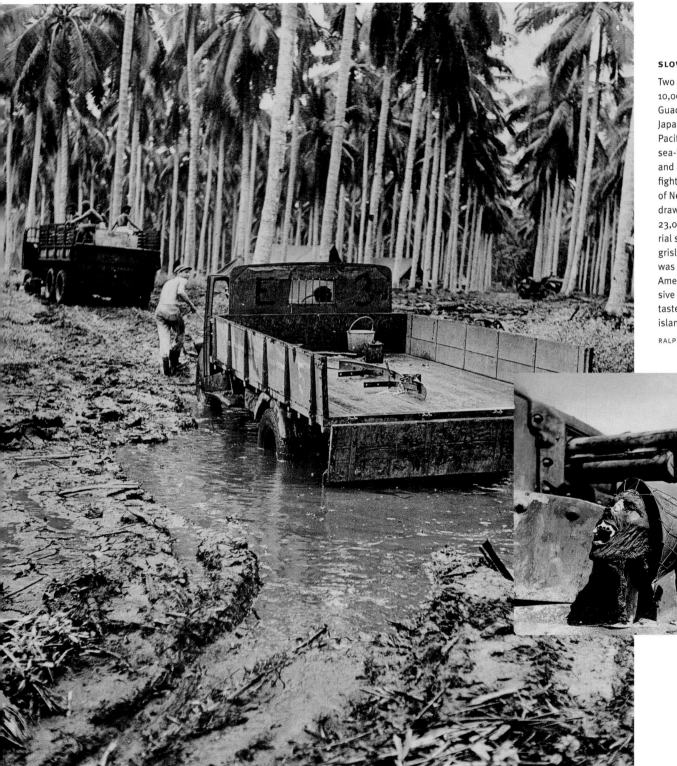

SLOW ROAD TO TOKYO

Two months after Midway, 10,000 Marines landed on Guadalcanal (left). The Japanese-held island in the Pacific was astride a key sea-lane between the U.S. and ally Australia, then fighting to hold the island of New Guinea. Before withdrawing, Japan absorbed 23,000 deaths. (The Imperial soldier below, in a grisly but famous photo, was a napalm victim.) America won its first offensive of the war — and got a taste of the difficulties of island combat.

RALPH MORSE / LIFE (2)

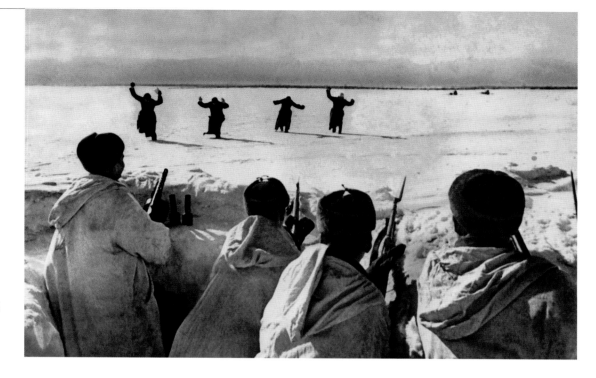

THE BIG CHILL

Deep inside Mother Russia, Wehrmacht officers in standard-issue greatcoats surrendered to winter-camouflaged Soviet troops. Like Napoleon 130 years before him, Hitler saw his army falter because of over-stretched supply lines and unsuitable garb and weapons (German rifles jammed in the cold). Yet he refused to call off the invasion.

TIME INC.

THE END WAS NEAR

A late-1941 Nazi edict requiring all Jews, like this Berlin couple, to wear yellow Stars of David in public was only the latest aimed at Germany's "unde-sirables." Jews, captured Slavs and others in the occupied countries were already being singled out for slaughter. Now Hitler impatiently demanded a "final solution." At a January meeting in Wannsee, high aides proposed using non-Aryans as slave laborers (see pages 202–203). Camps were built. And some were fitted with "showers" that sprayed the deadly gas Zyklon B.

AP

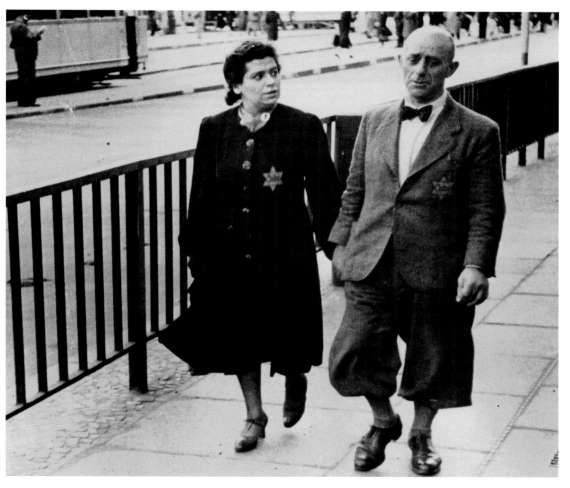

REWIND IT AGAIN, SAM

Of course it was hokum, Hollywood's 1942 version of a minor stage vehicle titled *Everybody Comes to Rick's*. But the Moroccan sets were exotic (if phony), the anti-Nazi sentiments timely, and Bogie, 43, and Bergman, 27, perfect. They'll always have Paris (if not each other).

PHOTOFEST

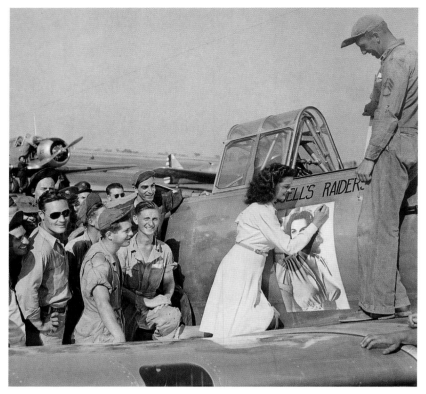

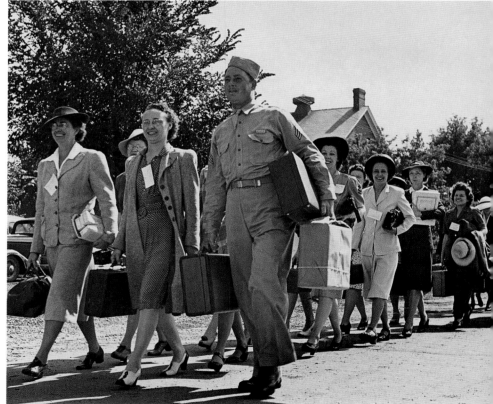

YOU'RE IN THE ARMY NOW

Newly sworn members of the Women's Auxiliary Army Corps marched into Fort Des Moines, Iowa, in July 1942. Two months earlier, by chartering the WACs (and the Navy Waves), Congress had made more than a third of America's population eligible for every military duty except combat. Before war's end, some 350,000 women had enlisted.

GORDON COSTER / LIFE

AN UPLIFTING MESSAGE

If pinup Betty Grable had million-dollar gams, Jane Russell, 20, cantilevered star of *The Outlaw*, had assets worth a zillion. Her 1942 visit to an air base was part of Hollywood's wish to do more than churn out anti-Axis agitflicks. Stars such as Bob Hope were entertaining troops at camp shows, which after Pearl Harbor often required hazardous travel to active theaters of war.

GLOBE PHOTOS

>

THE RACE CARD

For being born in the USA of a certain parentage, this child had to report, in April 1942, to a depot in California. After Pearl Harbor, a nervous nation forgot that there were far fewer Japanese-Americans than German or Italian hyphenates. Some 120,000 citizens of Japanese ancestry were shipped to barbed-wired camps in places like Minidoka, North Dakota. In 1989, Congress voted each surviving internee a reparation of $20,000.

DOROTHEA LANGE /
NATIONAL ARCHIVES

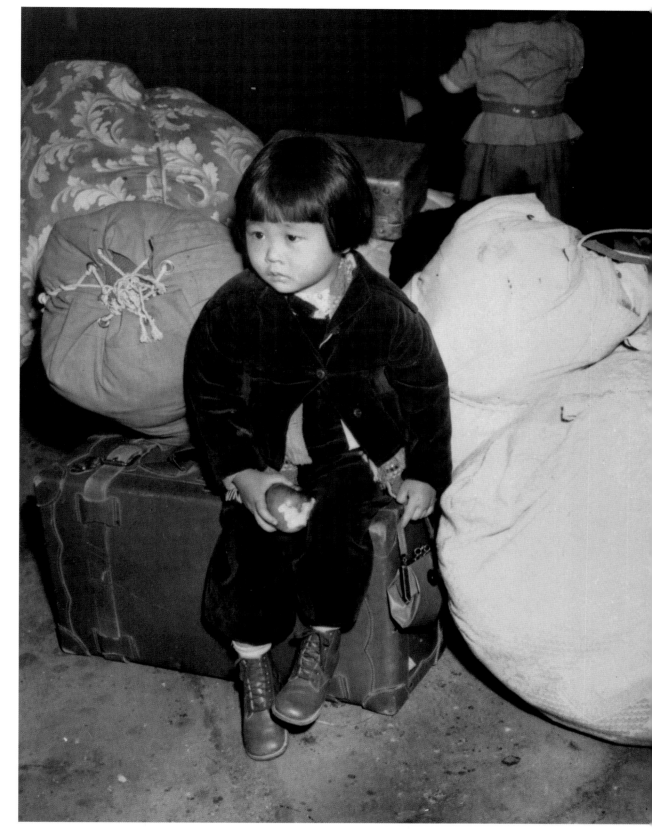

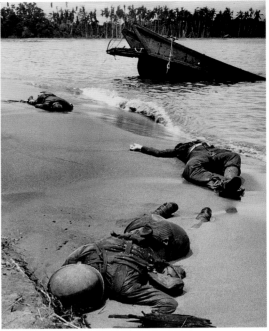

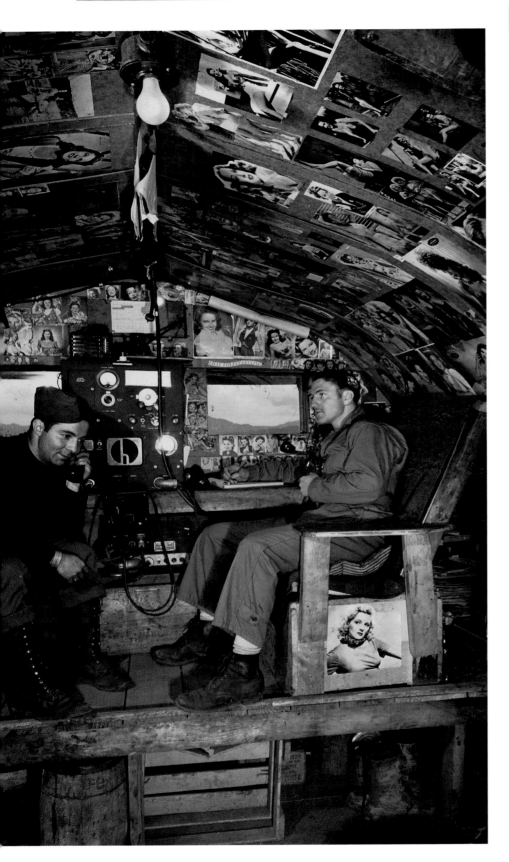

COMBAT: 1943

The year began with Allied and Axis forces still locked in deadly equipoise. In the Pacific, the U.S. was advancing west, island by island. In Europe, the Germans were busy in the USSR and quelling resistance in other occupied lands. But there soon came a breakthrough. An Anglo-American offensive launched in late 1942 seized North Africa. The Allies quickly hopped across the Med and invaded Sicily. Hitler now had to fight a war on two fronts.

NO PLACE WAS OUT OF HARM'S WAY

Bathing beauties may have seemed uppermost in the minds of U.S. airmen defending the Aleutians. But this was serious business; the war's only ground action on American soil was fought on this string of atolls in the North Pacific. In mid-1942, Japan landed troops on two islands; a year later, GIs evicted them. Peace reigned again. One Yank even wrote a third novel. His name: Walter Farley. His book: *The Black Stallion Returns*.

DMITRI KESSEL / LIFE

AN EYE FOR AN EYE
GIs paid dearly for their January amphibious landing on the island of New Guinea (left, one of the first photos of U.S. war dead to be cleared by government censors). So did Japanese defenders who had rushed down to the beach near Buna to press the fight (below). The Yanks were able to repel a Japanese advance on Port Moresby, a base on the island's south coast vital to the defense of Australia.

GEORGE STROCK / LIFE (2)

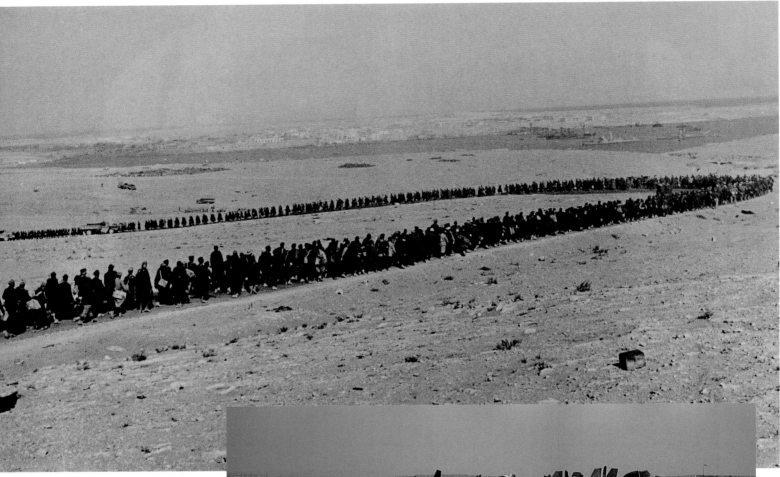

THE FIRST DESERT STORM

In January, Allied captors herded 19,000 Italian and 6,000 German POWs to the Libyan port of Tobruk (in the distance, above). The westward pursuit of Germany's crack Afrika Korps ended, in May, at Tunis (where, right, U.S. officers surveyed their damaged spoils of war). North Africa was now clear of the Axis.

ABOVE: BRITISH WAR OFFICE
RIGHT: HART PRESTON / LIFE

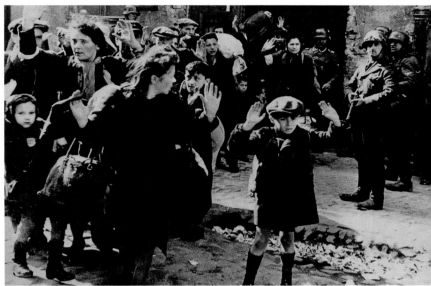

WHICH WAY TO ROMA?

What resistance GIs met in their July invasion of Sicily came from Germans; welcomes like that for Yanks entering Palermo (above) were routine. By then, a new government had replaced Mussolini.

ROBERT CAPA / MAGNUM

A TALE OF TWO CITIES

Soviet civilians returning to Stalingrad in February (right) found little still standing. The Wehrmacht attack, begun five months earlier, had ended in house-to-house combat. One German wrote home, "Animals flee this hell." But Hitler did win a siege in Poland (top right). In January, 65,000 Jews sealed off their Warsaw ghetto to avoid Nazi camps. They gave up in May — and were shipped to deadly Treblinka.

RIGHT: RUSSIAN NEWSREEL
ABOVE RIGHT: CORBIS /
BETTMANN

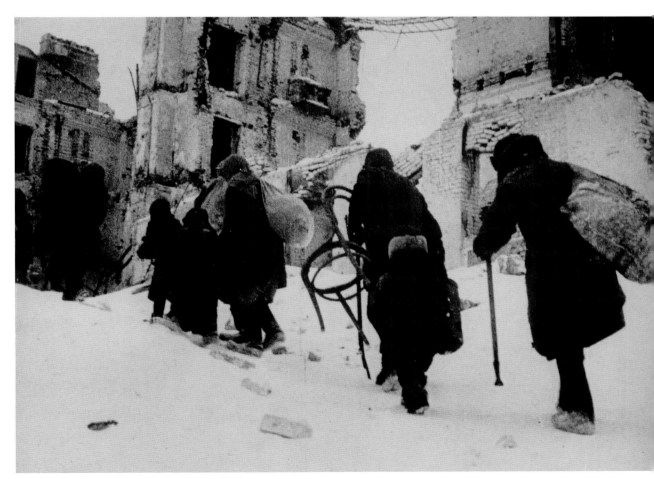

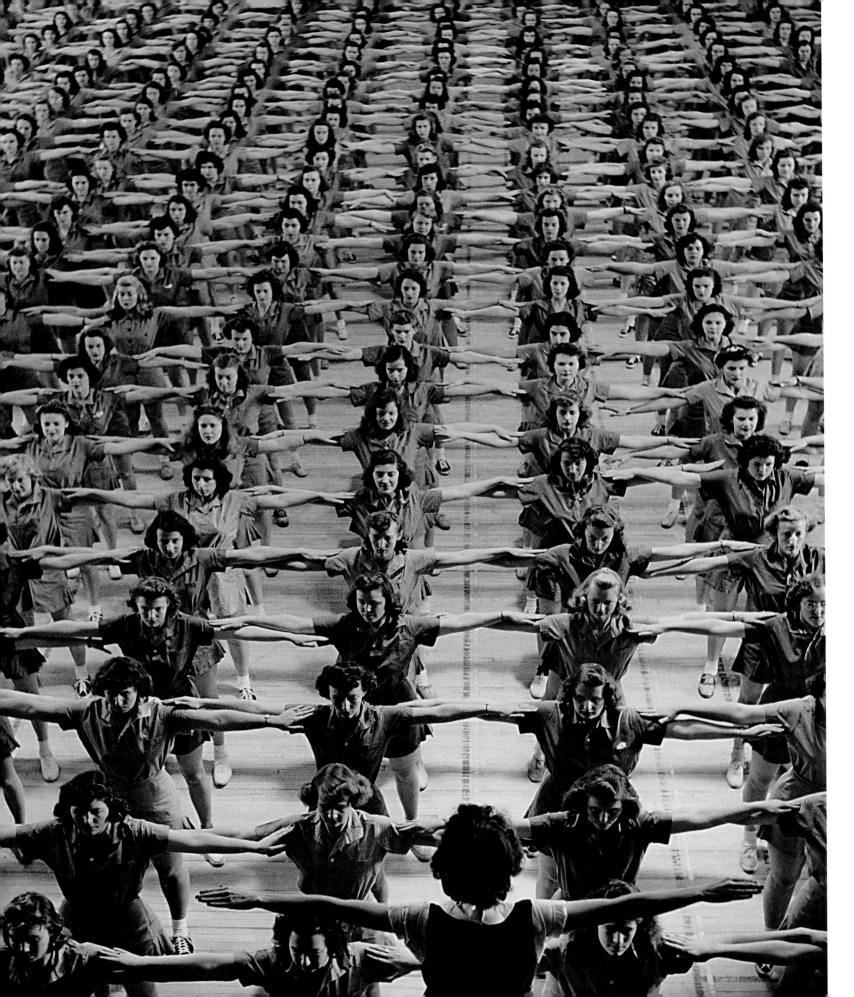

ANSWERING THE CALL

By early 1943, America's colleges were mobilizing. These students at the University of New Hampshire were obeying a War Manpower Commission directive that all students be physically fit in event of a call-up. But there would be a gender deferment; while women could enlist, the WMC promised that only "able-bodied male[s] are destined for the armed forces."

ALFRED EISENSTAEDT / LIFE

YOUNG BLUE EYES

Nights were spent at the Paramount in New York City acting as catnip to bobby-soxers and days at home in Hoboken, New Jersey, with a pair of Nancys (his first wife, 24, and their firstborn, 3). At 26, Frank Sinatra had the world on a string. The singer with the silver pipes and golden phrasing also acted and rat-packed before becoming chairman of the boored.

HERBERT GEHR / LIFE

AN AUSTERE NEW ART

It looked easy: a canvas, paint, a ruler. But Dutch-born Piet Mondrian had spent two decades paring his work down to grids, an abstract minimalism soon copied by other artists and designers. In 1940, at age 68 and fearing war, he fled Europe for New York. The city's energy inspired the pulsating blocks of primary colors that infuse late Mondrians such as (above) 1943's "Broadway Boogie Woogie."

MUSEUM OF MODERN ART

HIS MAJESTY, THE DUKE

Earlier in 1943, the sidemen jamming with Edward Kennedy Ellington, 44, had accompanied him downtown to play at the Carnegie Hall premiere of *Black, Brown, & Beige*, his suite to the African-American experience. Tagged Duke in high school for his suaveness, Ellington apprenticed at Harlem's Cotton Club before becoming the century's preeminent jazz bandleader and composer.

GJON MILI / LIFE

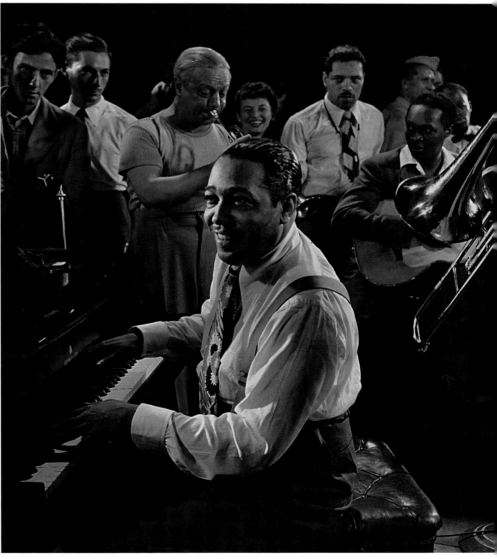

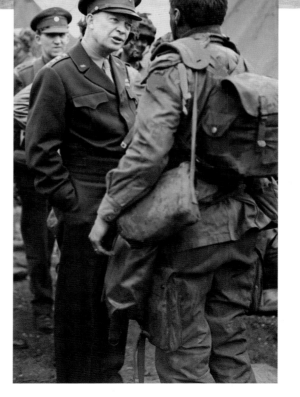

COMBAT: 1944

Like a leaky balloon, the Axis was contracting. In North Africa, its designs were history. In the Pacific, the Allies were taking back Japan's island conquests one by one, despite a chilling new enemy tactic. In Europe, Germany was exposed both to the east, where it had been repelled by the Soviet Union, and to the south, where erstwhile partner Italy was quite unresistant to invading Americans. It was time for the Allies to go for the jugular.

JUNE 6, 1944

Under General Dwight D. Eisenhower, 54 (left, on June 5), the Allies patiently marshaled in England the largest invasion force in history. The target: the Normandy coast of France. On D-Day (the randomly chosen *D* had no significance), 5,000 airplanes and ships bore 175,000 men across the Channel. The landings came under withering German fire (above).

ABOVE: ROBERT CAPA / MAGNUM
LEFT: U.S. SIGNAL CORPS

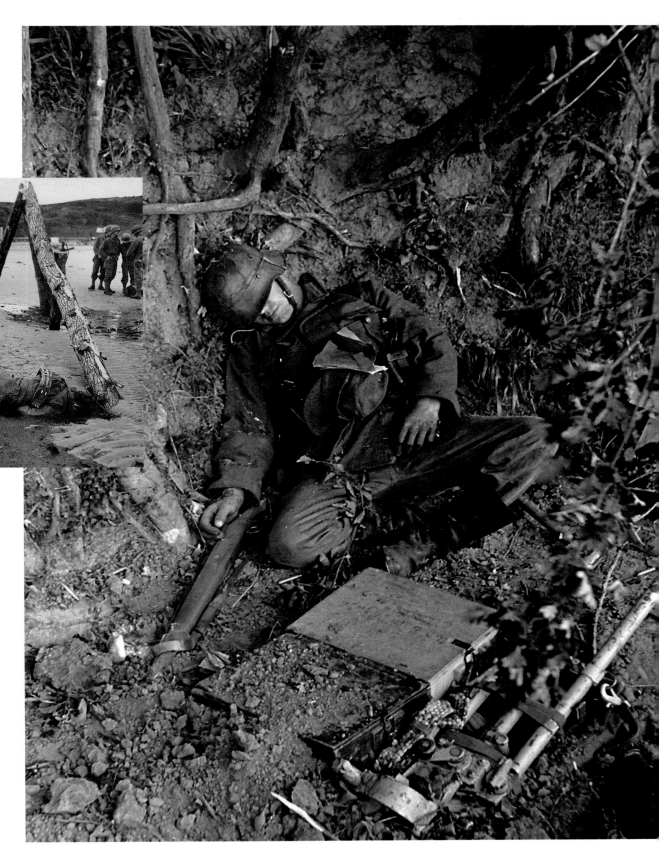

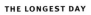

THE LONGEST DAY

Though the Germans had
been duped into thinking
the invasion would come
elsewhere, they held the
high ground at Normandy.
Some early Allied units
dashing ashore took 90
percent casualties (above).
To the rescue: air power. By
nightfall, the Allies had
battled up from the landing
zones and taken the fight to
the Germans (right). The
frontal assault on Nazi-
occupied Europe was on.

ABOVE: NATIONAL ARCHIVES
RIGHT: BOB LANDRY / LIFE

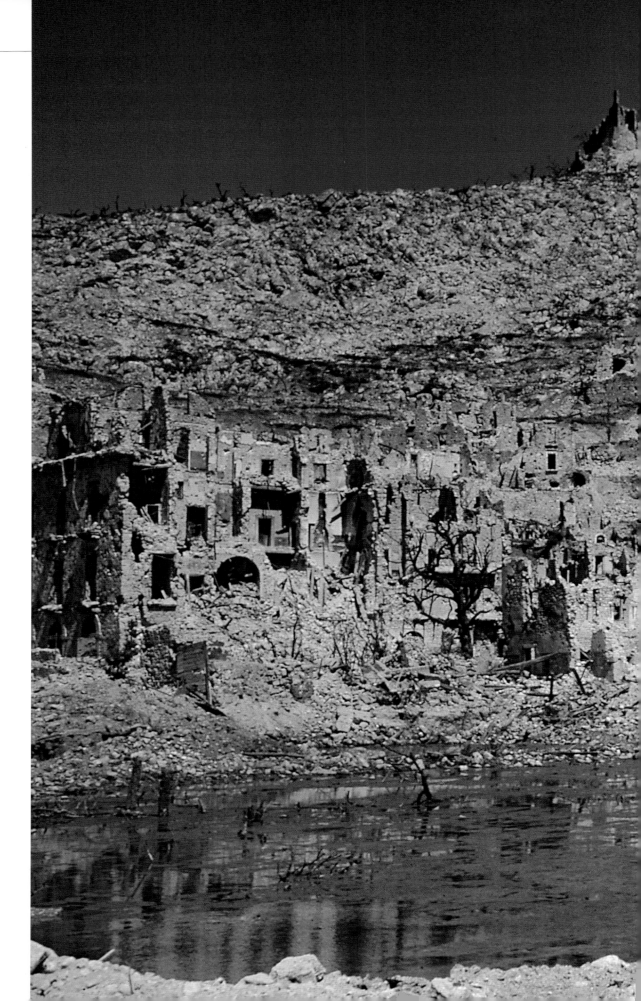

COMBAT: 1944

WRONG PLACE AND TIME

Pompeii had been hit by an act of nature; Monte Cassino was hit by U.S. bombers. The mountain southeast of Rome was crucial to the line set by Italy's German defenders against GIs fighting up the peninsula. Faulty intelligence led the Allies to target the summit monastery, built on the site where St. Benedict founded his first abbey in 529 A.D. A later raid on the base of the mountain destroyed a German-occupied town whose roots traced to pre-Roman times.

CARL MYDANS / LIFE

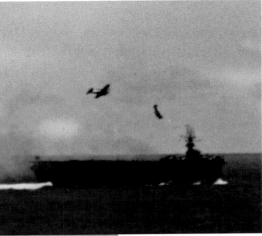

THE TICKET WAS ONE-WAY

Desperate to stem the tide, Japan in late 1944 began fitting fighter planes with 550-pound bombs; pilots were to plow them into U.S. warships (above). The gambit was called kamikaze, or divine wind, after a typhoon that repelled an invading Mongol fleet in 1274. Though the suicide flights sank or damaged some 300 ships, including the carrier *Belleau Woods* (left) most were shot down short of their target.

LEFT: EDWARD STEICHEN /
U.S. NAVY
INSET: CORBIS / BETTMANN

>

EVEN IN HELL, A TIME-OUT

In one of the Pacific's grisliest theaters, a Yank found a moment to offer rations, a drink and a smile. The U.S. hit the Mariana Islands in midsummer. Worse than the brutal combat was the sight of Japanese civilians on Saipan hurling their babies, then themselves, off cliffs rather than surrender. It took Americans two months to secure Saipan, Guam and Tinian.

W. EUGENE SMITH / LIFE

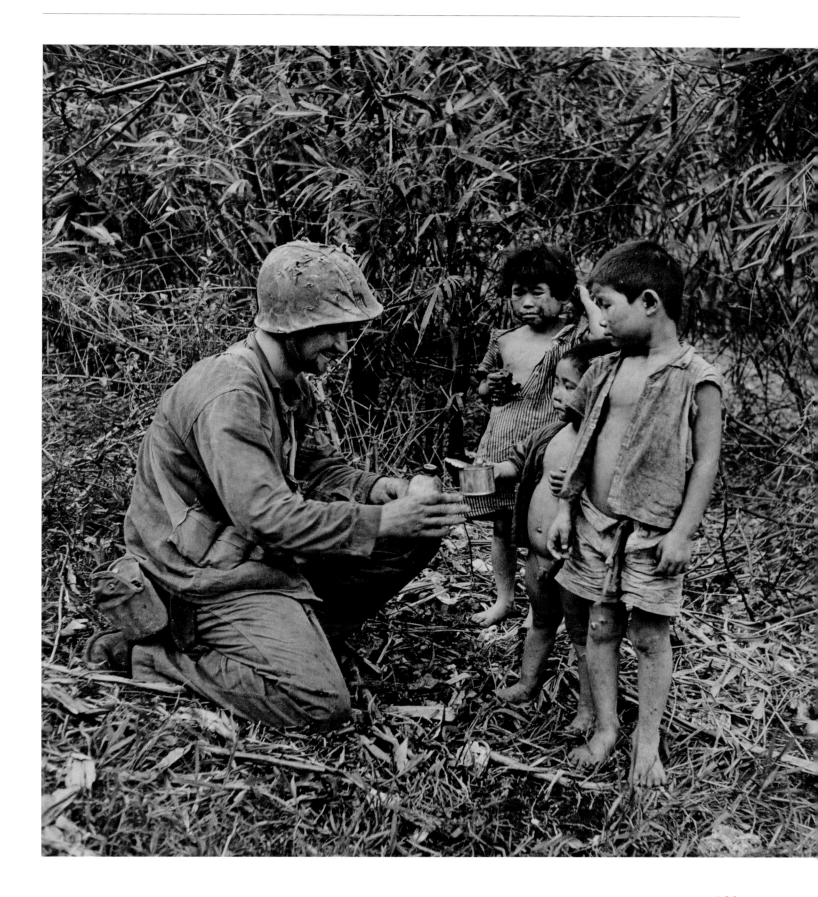

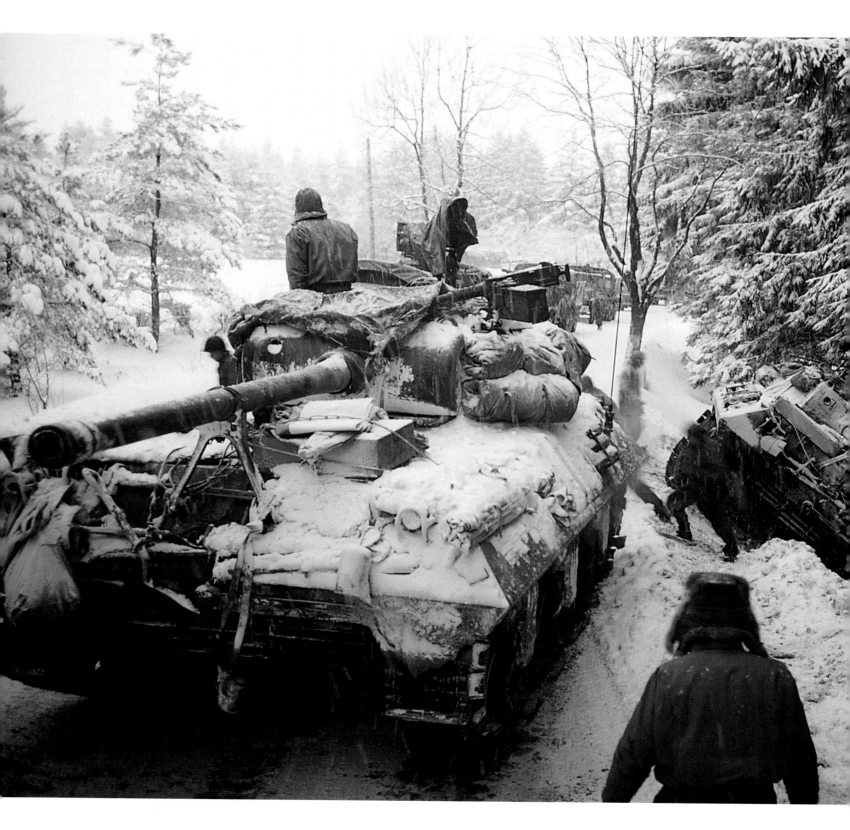

HITLER BETS THE FARM

Those were brave smiles in July 1944 (inset, left). Il Duce had been rescued 10 months earlier from house arrest in Italy by a daring German commando raid. The Führer had just survived a bomb — set by his own officers — that left one arm in a sling. But even a wounded Hitler was lethal. German buzz bombs, or self-guided missiles, had begun hitting London. And in December, he mustered a massive ground strike on the Ardennes, woodlands that sprawl across France, Belgium and Luxembourg. The GI defenders (above right), denied air support by bad weather, were mauled. U.S. armor (left) proved overmatched against the enemy's new Tiger tanks. Rather than concede the Battle of the Bulge, the U.S. inserted airborne divisions (like the 82nd, right) that helped blunt the attack until skies cleared on Christmas Eve and Allied planes regained the air. America's toll: 20,000 dead, 40,000 injured, 20,000 captured. The Germans fared worse. Hitler was now staring at Götterdämmerung.

LEFT: GEORGE SILK / LIFE
INSET: HEINRICH HOFFMAN / LIFE
RIGHT: U.S. ARMY (2)

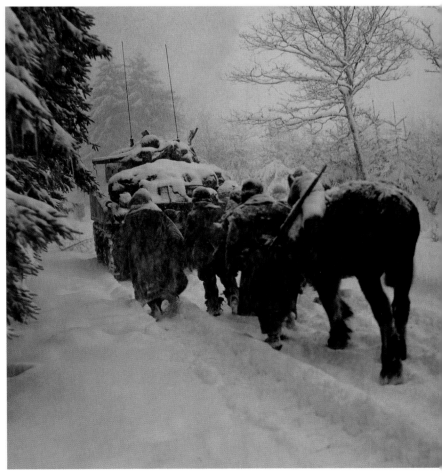

STRETCHING TO NEW HEIGHTS

Freed perhaps by the stirring strings that open *Appalachian Spring*, Aaron Copland's 1944 celebration of pastoral America, Martha Graham, 50, high-kicked loose of the jagged gestures she had championed for two decades. Drawn at 22 to modern dance, Graham's daring choreography and musical tastes prodded her art beyond its classical ballet origins.

JERRY COOKE / LIFE

NAME THAT TUNE

In 1944, Paul Robeson, 46, took the mike to sing: a) spirituals; b) "Ol' Man River"; c) the national anthem of an Allied nation. Answer: c ("Hymn of the Soviet Union"). A Rutgers football All-America who spurned the baby NFL to flex his magnificent bass onstage, Robeson in the mid-1930s grew sick of racism and embraced Communism. In 1950, the U.S. lifted his passport (and ruined his career). The singer-actor lived until 1976.

HERBERT GEHR / LIFE

AN EDDY OF ECONOMISTS

War still boiled on three continents, but envoys of 44 nations met during the summer of 1944 in quiet Bretton Woods, New Hampshire, to plan the rebuilding to come. Led by free-marketers John Maynard Keynes of Britain (near left) and U.S. Treasury boss Henry Morgenthau (taking notes), they devised a series of instruments — including the World Bank — to speed postwar recovery. For once, the science of economics wasn't dismal.

ALFRED EISENSTAEDT / LIFE

THE GAME MUST GO ON

In 1945, though minus an arm since a boyhood mishap, Pete Gray, 30, made the bigs. World War II had drained the rosters of the 16 major league teams. Thus Joe Nuxhall hurled for the Cincinnati Reds at age 15 and outfielder Gray hit .218 in 77 games for the St. Louis Browns (a sad-sack team that six years later sent Eddie Gaedel, a 43-inch-tall midget, to the plate to coax a walk).

AP

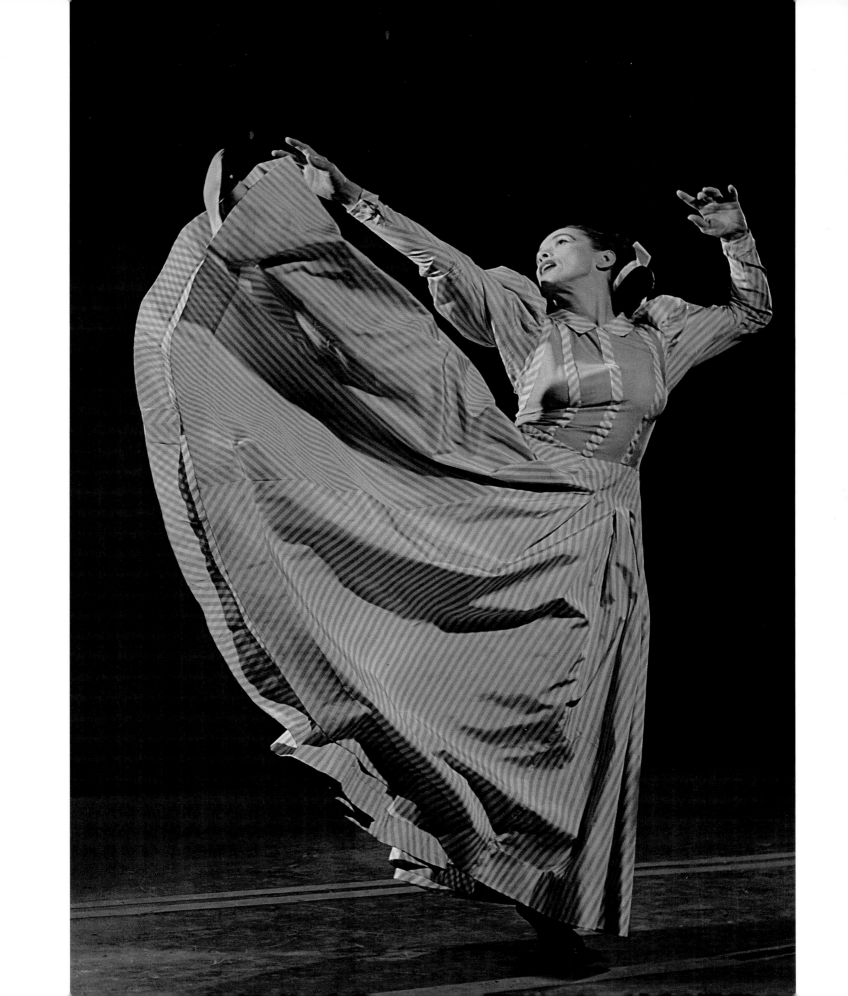

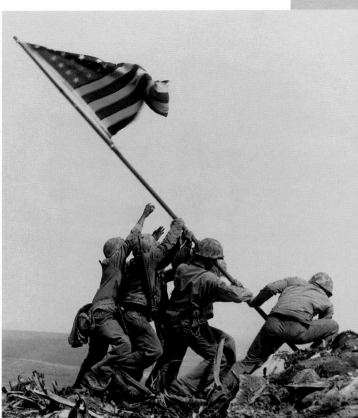

Prelude to Slaughter

In early 1945, five Marines and a Navy medic were fixed in time raising the Stars and Stripes on Iwo Jima — and the morale of war-weary Americans at home. Minutes after capturing probably the most memorable image of the Pacific conflict (above), AP photojournalist Joe Rosenthal, 33, recorded another (right) that is less famous but more haunting. The leathernecks were cheering because it had taken their unit just four days to conquer 500-foot Mount Suribachi, the highest point on this desolate, eight-square-mile volcanic atoll in the West Pacific. Forgotten in the joyous moment: the cruel lessons of island combat. Because Iwo sat within easy flying range of Japan's Home Islands, it was defended by 23,000 troops. The Imperial troops fought on for another month, until only 216 were alive to surrender. Of the 30,000-plus Americans who waded ashore, 21,000 were wounded and 6,800 killed. Among the dead: three of Rosenthal's flag raisers.

JOE ROSENTHAL / AP (2)

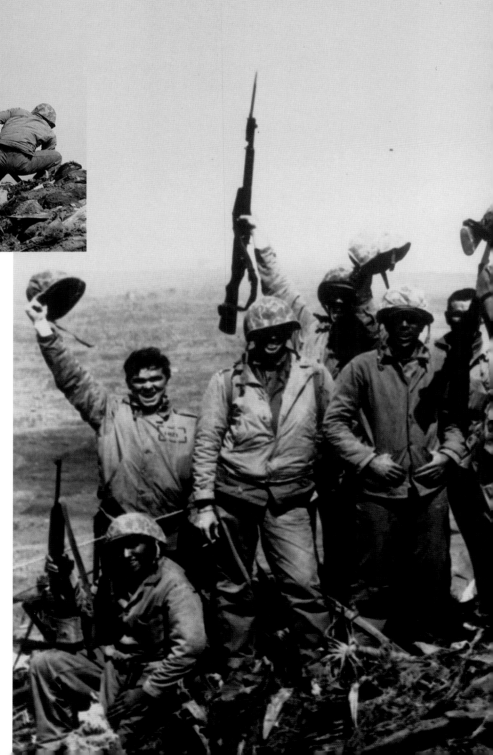

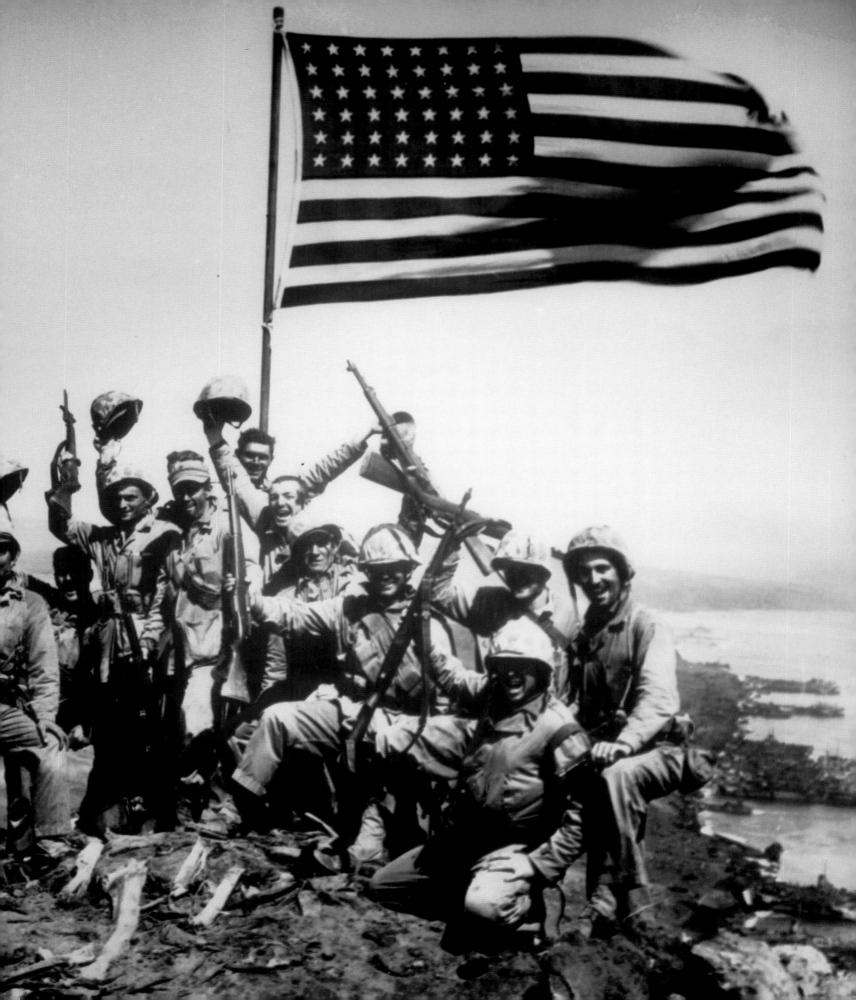

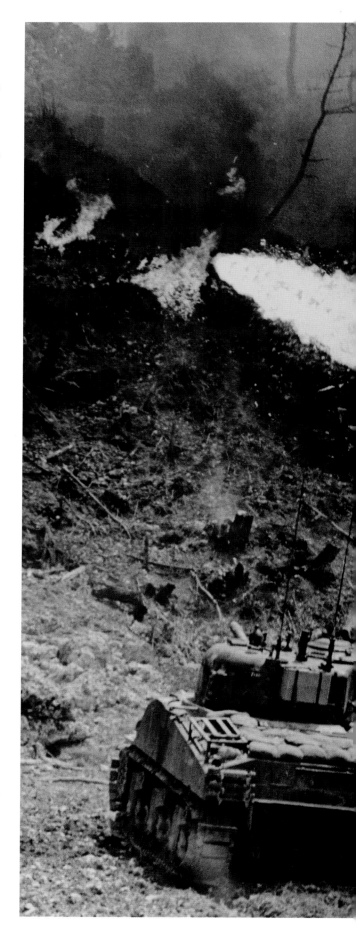

HELL IN THE PACIFIC

Okinawa was not a minor Pacific atoll but one of Japan's southernmost Home Islands. Its fortifications were exceptional (right). Joining the April invasion was journalist Ernie Pyle, 44 (inset), already a Pulitzer winner for his reporting from North Africa and Europe. He was killed by enemy fire on April 9. Fighting on Okinawa continued until August.

RIGHT: W. EUGENE SMITH / LIFE
INSET: U.S. SIGNAL CORPS

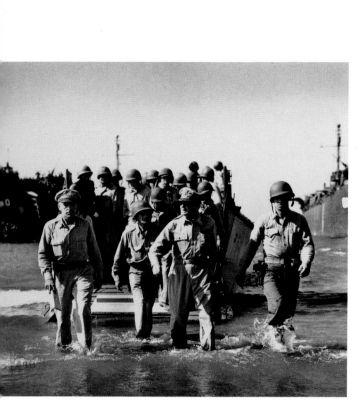

<

HE KEPT HIS WORD

In January 1945, almost three years after Douglas MacArthur, his wife and their son had been ordered to evacuate the Philippines ahead of the approaching Japanese, the general, 64, strolled back through the surf at Lingayen Gulf. He was fulfilling his pledge, "I shall return." MacArthur brought 68,000 U.S. troops. In July, he pronounced the islands liberated.

CARL MYDANS / LIFE

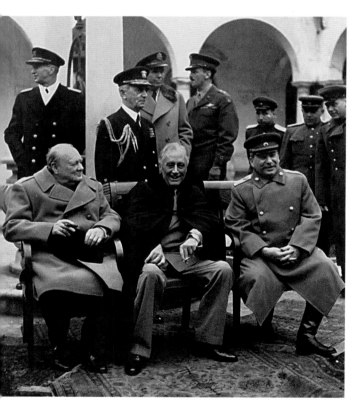

<

THE NEXT WAR BEGINS

February 1945: To Yalta, a Crimean resort, traveled Winston Churchill, 70 (far left); Franklin D. Roosevelt, 63; and host Joseph Stalin, 65. With no other Allied leaders present, they devised a strategy to checkmate the Axis and drew up a postwar map. Stalin came away with rights to Eastern Europe. The seeds of the Cold War were sown.

NATIONAL ARCHIVES /
U.S. ARMY

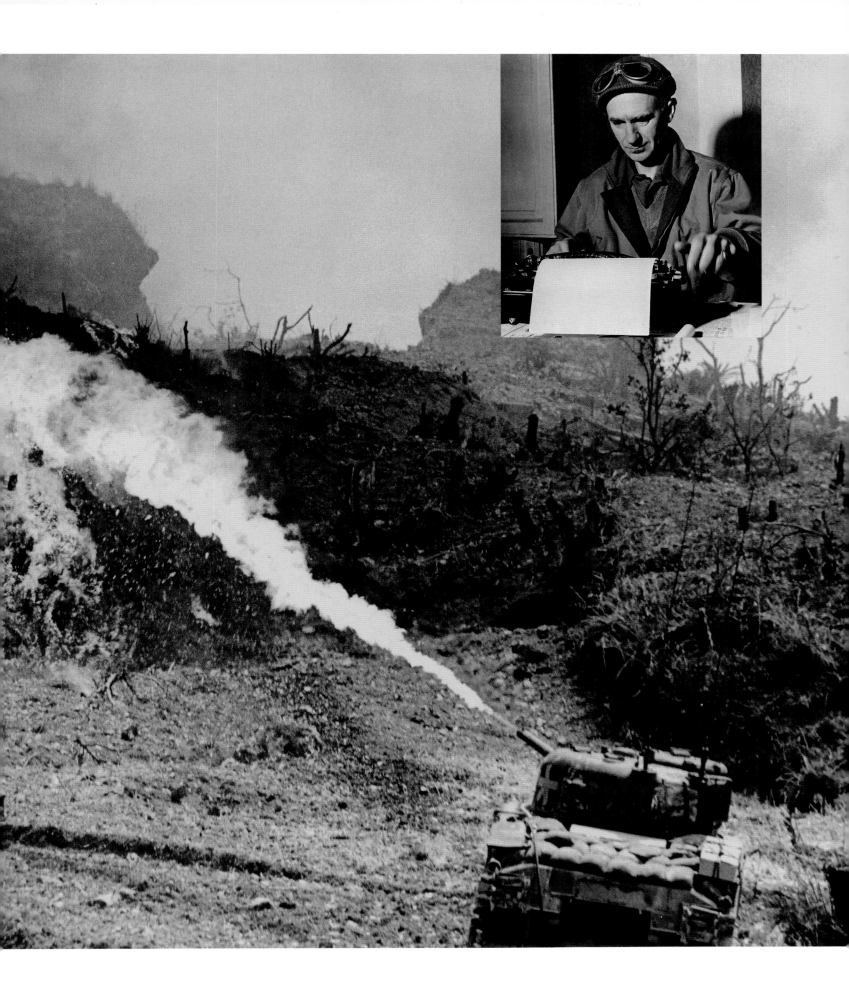

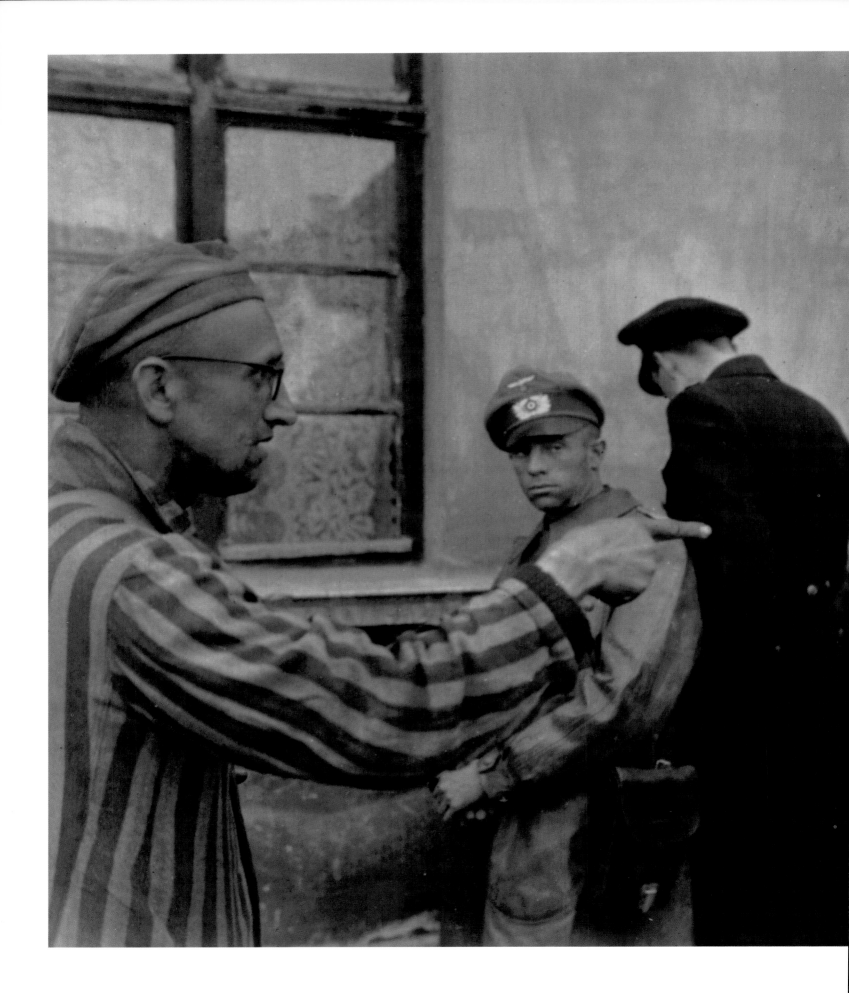

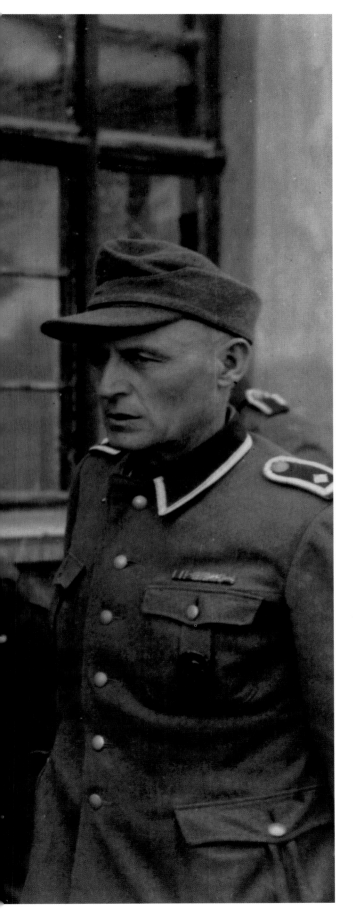

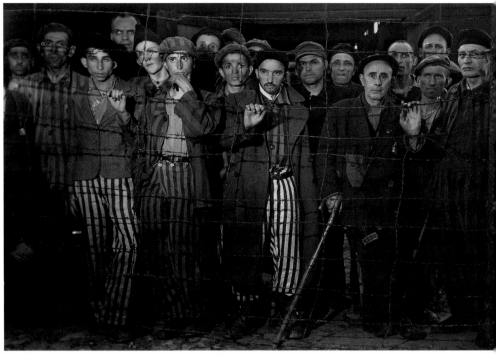

WHEN WORDS FAIL

The Russian POW fingering a Nazi tormentor (left) had survived slave labor until Allied troops liberated his camp. Some 11 million other inmates did not in the 100-plus compounds set up by the Third Reich in Germany and its captive countries. Allied leaders had known of a 1942 Nazi fiat to rid Europe of non-Aryans. Not until Germany's defeat, though, was the magnitude of Hitler's "final solution" apparent. The Allies rescued the gaunt inmates of Buchenwald (above) but were too late to aid the dead lining the road to Bergen-Belsen (right). The Holocaust claimed two-thirds of Europe's nine million Jews, as well as Slavs, Gypsies and gays. Many families lost three generations. Coming to grips with guilt — among survivors, butchers, bystanders alike — would require more than the next three generations.

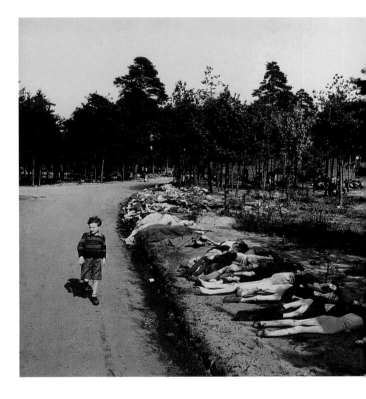

LEFT: NATIONAL ARCHIVES
ABOVE: MARGARET
BOURKE-WHITE / LIFE
RIGHT: GEORGE ROGER / LIFE

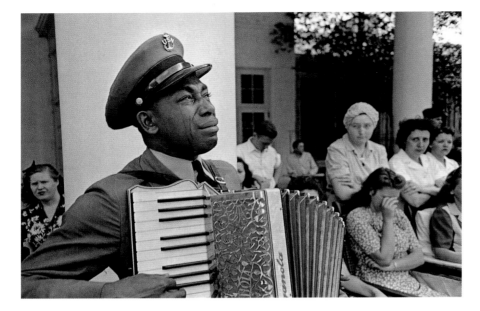

A CHIEF'S LAST HAIL

On April 12, 1945, polio patients at the Warm Springs spa (below), in Georgia, honored fellow victim Franklin D. Roosevelt, dead at 63 while there for therapy. Then, accordionist Graham Jackson, USN (left), began playing through his tears. FDR was the only four-time president; terms were capped at two in 1951. His successor: Harry S Truman.

EDWARD CLARK / LIFE (2)

HALFWAY TO PEACE

From New York — where a replica Lady Liberty greeted the masses gathering in Times Square — to Los Angeles, America partied on May 7, 1945, as word spread of Germany's surrender. It came 68 months and 50 million deaths after Hitler invaded Poland. But VE (Victory in Europe) Day jubilation was tempered; there was a war yet to be won in the Pacific.

TONY LINCK / LIFE

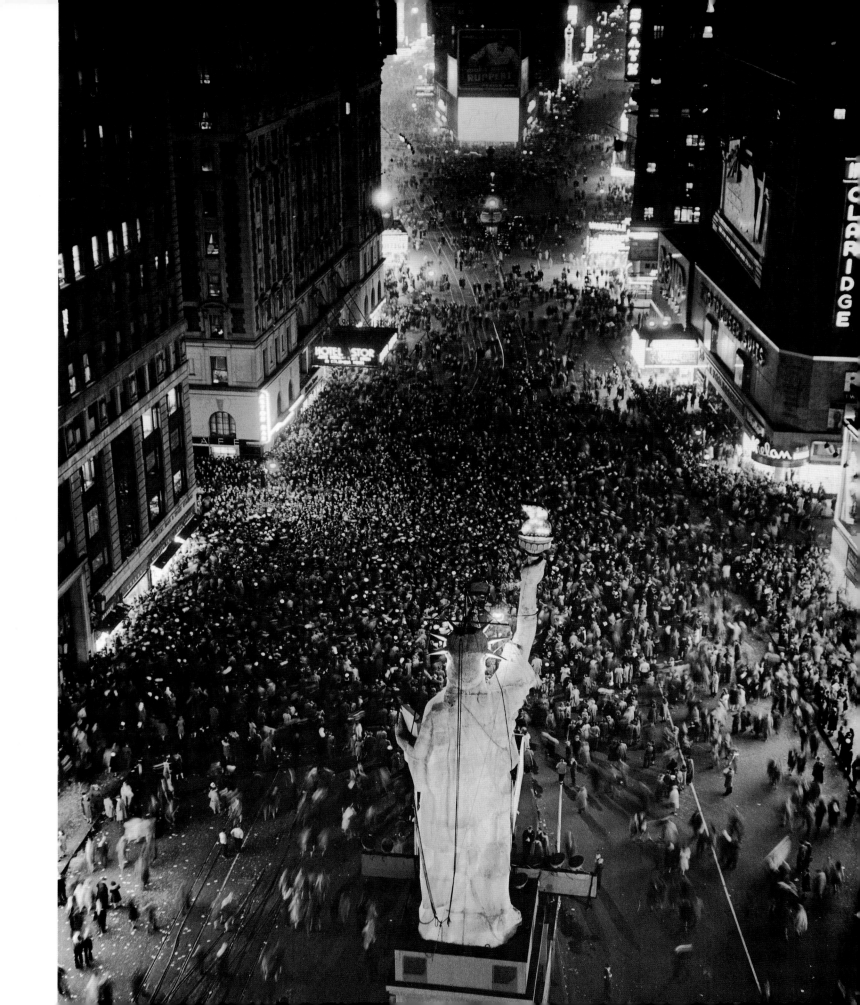

The silvery speck in the morning sky over Hiroshima, Japan, raised no alarms. What havoc could a lone U.S. B-29 wreak? From *Enola Gay*'s belly fell a single 9,000-pound bomb that detonated 2,000 feet above ground zero. The force of its fission-generated, 5,400-degree fireball killed 80,000 and leveled a four-mile-wide circle. The radioactivity spread by the mushroom cloud would claim an estimated 120,000 more lives by 1950.

BERNARD HOFFMAN / LIFE

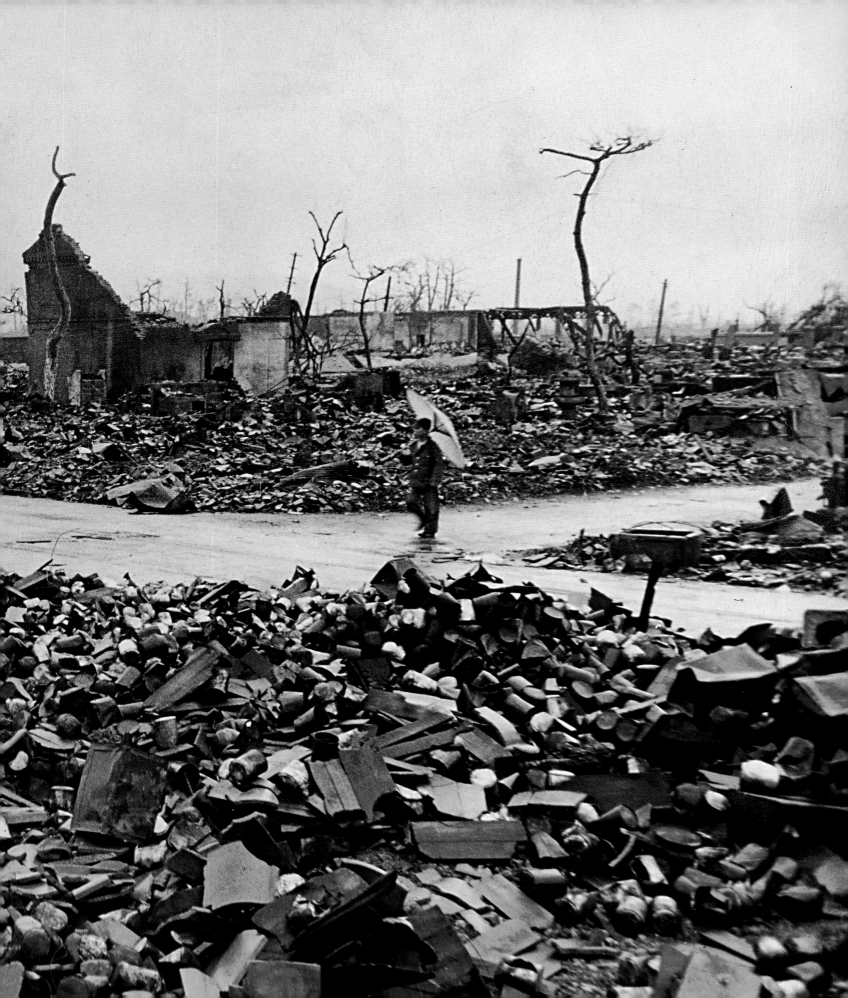

Pandora's Box

Though Shakespeare wrote of "atomies," not until the 1930s did anyone suspect that one of nature's tiniest building blocks harbored energy of undreamt scope. And then the atomic weapon — plausibly imagined in 1936's *The Dark Frontier* by Eric Ambler, father of the modern thriller — was soon a reality. War has a way of both hastening and mutating technology; Alfred Nobel cooked up dynamite to help farmers clear tree stumps. The fallout from the only two A-bombs dropped in anger will not dissipate. One casualty: nuclear energy, an industry undone by a string of accidental meltdowns. Another: our psyches. Forget disarmament. We know those early bombs are puny next to what now fits in a terrorist's valise. But like the genie, knowledge cannot be returned.

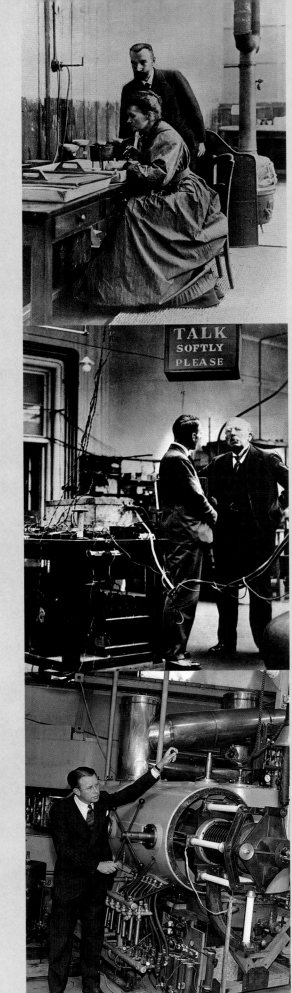

> ### ELEMENTARY DEDUCTIONS

For explaining a phenomenon first observed in 1898 — that the metallic element uranium radiates mysterious particles — Marie and Pierre Curie (top right) became, in 1903, the first husband-and-wife Nobel winners. The Polish-born Mme. Curie, 36, coined the word *radioactivity*. But handling radioactive samples led to pernicious anemia, from which she died in 1934. By then, a team at Cambridge University in England, led by Ernest Rutherford (center, with cigarette) had for the first time split an atom (of nitrogen). And later that decade, America's Ernest Lawrence (bottom right) had progressed from a crude 1930 prototype to an advanced model of his cyclotron, a particle accelerator essential to the new science called nuclear physics.

FROM TOP: TIME INC.;
CAMBRIDGE UNIVERSITY PRESS;
GRANGER COLLECTION

<
THE DOOMSDAY DEVICES

Replicas of the first two A-bombs sit in a science museum in Los Alamos, New Mexico. Little Boy (far left) was dropped on Hiroshima, Fat Man on Nagasaki four days later, killing 40,000. Why was Germany not also targeted? It had surrendered before the first successful test blast on July 16, 1945.

BEN MARTIN / TIME

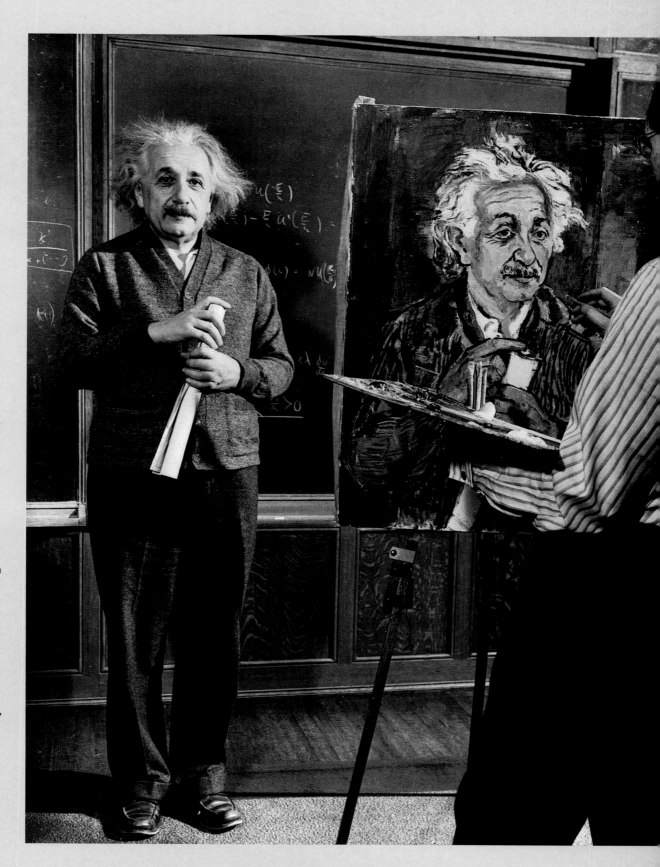

WHAT HIS MIND FORESAW

When Albert Einstein, 59, posed for this sketch in 1938, scientists in the U.S., England, France and Germany were racing to unlock the secrets of the atom. The next January, a German team came upon a process, fission, that could in theory transform uranium into a superbomb. When Einstein — a Jewish Nobel Laureate who upon Hitler's rise in 1933 had fled to the U.S. — learned of the news, he used his stature to alert the White House. In mid-1940, FDR responded by setting up the hush-hush Manhattan Project. Einstein, ironically, was not asked to join. The physicist, whose $E = mc^2$ fundamentally changed the way man understood his universe, was a known pacifist and Zionist, and thus deemed politically unreliable.

ELIOT ELISOFON

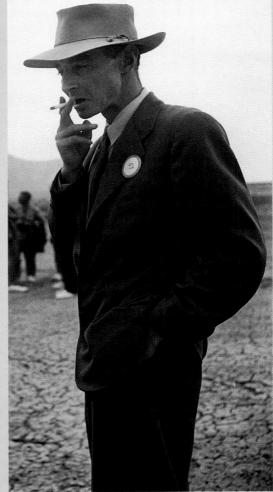

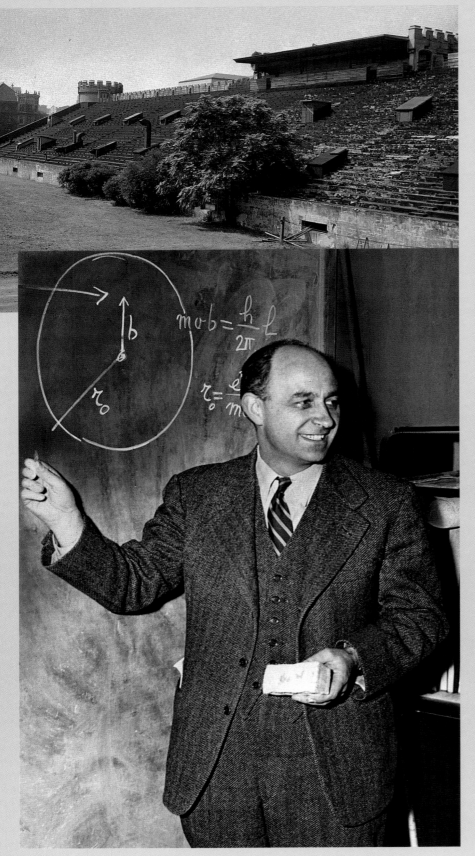

MANHATTAN TRANSFER

Who better in America to test the fission theory than Italian émigré Enrico Fermi (left), who had just won the 1938 Nobel for physics? He built a reactor beneath the decrepit University of Chicago football stadium (top left — the school had quit the Big Ten). On December 2, 1942, Fermi, 41, and his team achieved a sustained chain reaction. The superbomb was no longer just theory.

TOP LEFT: ARGONNE NATIONAL LABORATORY
LEFT: NEW YORK HERALD TRIBUNE

UNDER WESTERN SKIES

Even as Fermi was validating fission, physicist J. Robert Oppenheimer, 38 (above), and Army general Leslie Groves, who had just finished overseeing construction of the Pentagon, were turning 77 square miles of New Mexico mesa into a top-secret research complex. The army of scientists who came to work at Alamagordo needed almost 26 months to build the first A-bomb. Test date: July 16, 1945, over Trinity, New Mexico.

FRITZ GORO / LIFE

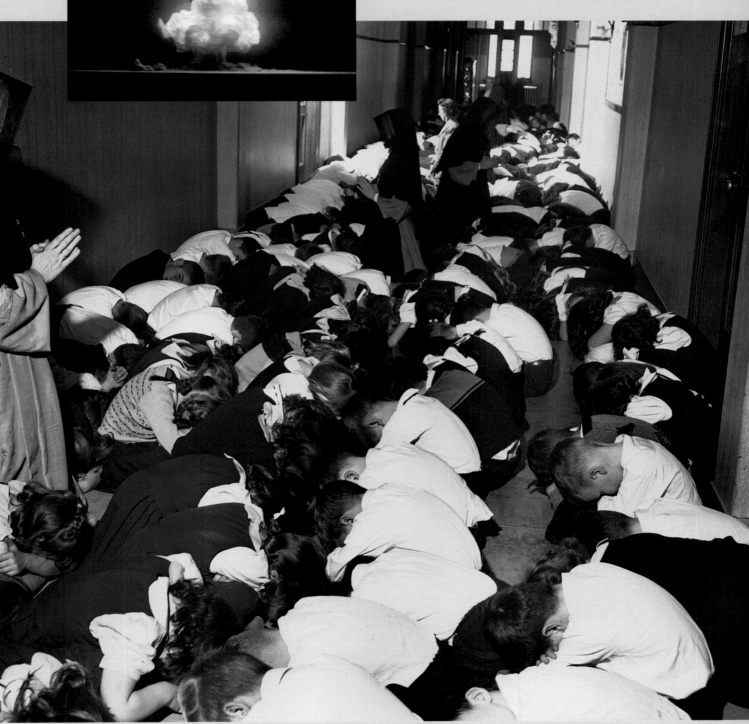

7/16/45: TRINITY, NM

A man-made sun usurped the desert dawn — the first A-bomb worked. The test site's name had a Biblical ring; yet it was a line from Hinduism's Bhagavad Gita that Robert Oppenheimer recalled: "I am become Death, the shatterer of worlds."

JACK W. AEBY / U.S. ARMY

IN EVENT OF ATTACK . . .

It was not to pray, but to survive a Red nuking that schoolkids at St. Joan of Arc in Queens huddled in a hall during a civil defense drill in 1951 (two years after the USSR unveiled its first atomic bomb). Also chic: backyard family fallout shelters.

NEW YORK DAILY MIRROR

MORE BANG FOR THE BUCK

A thermonuclear palette
vivified the night skies of
Hawaii on July 9, 1962.
Some 800 miles to the west,
the Pentagon had just
detonated another H-bomb
200 miles over Johnston
Island. The first hydrogen
bomb — 500 times more
powerful than the A-bomb
— had been triggered by
the U.S. in 1952. By the time
the heavens over Honolulu
turned green, Moscow
already had a working copy.

J.R. EYERMAN / LIFE

DEADLY CARGO

That white stalk being
transferred aboard a U.S.
nuclear sub at Holy Loch,
Scotland, in 1969 was a
Polaris intercontinental
ballistic missile with a 600-
kiloton payload and a
1,200-mile range. At the
height of the arms race, the
U.S. and the USSR had
more than 75,000 nukes
aimed at each other.

BILL RAY / LIFE

THE CHERNOBYL SYNDROME

Until April 28, 1986, it was a thriller movie plot, not a real concern among nuclear physicists: a runaway reactor that bores straight through the earth to China. Yes, there was that radioactive leak at Three Mile Island, Pennsylvania, but it was minor. Then came the meltdown at Chernobyl (right), a shoddily built, poorly run Soviet plant in Ukraine. Immediate dead: 31. Long-term dead: 125,000 — and counting.

SHONE / GAMMA LIAISON

TIME TO STAND DOWN

A Soviet sentry guarded ICBMs (below) slated to be scrapped under a 1987 disarmament treaty between the U.S. and USSR. Not affected: the 10 other nations known or thought to have such arsenals. The threat of thermonuclear warfare has eased — but it is far from ended.

AFP

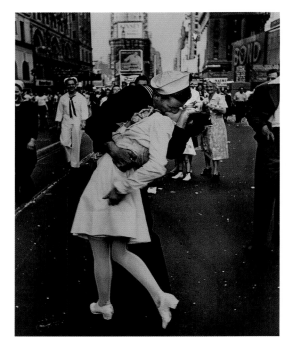

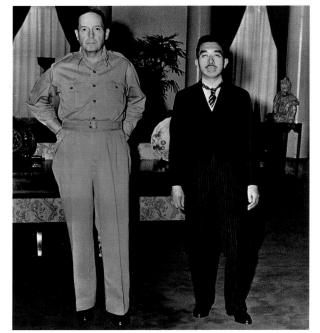

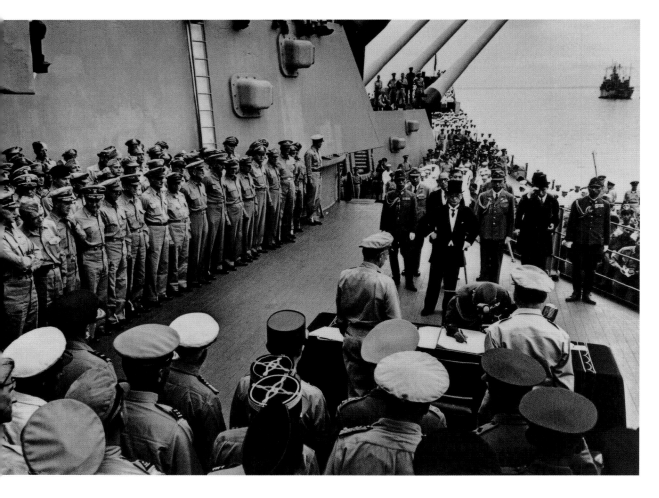

A SCORE IS SETTLED

On the 1,366th day after Pearl Harbor and the 27th after Hiroshima, Japan's leaders ferried across Tokyo Bay to formally surrender on the deck of the USS *Missouri* (below left). The news excited even strangers in Times Square (top far left). Yet a lasting peace was no sure thing. America had suffered 300,000 casualties in the Pacific; Japan had lost 4.2 million soldiers and civilians (six percent of its population). But on September 27, Hirohito called on U.S. commander Douglas MacArthur (top near left). The emperor, 44, until recently neither seen nor heard by subjects who thought him a divinity, volunteered to step down. The offer was declined. From this goodwill sprang a benign and mutually beneficial occupation that would last for seven years.

CLOCKWISE FROM BOTTOM:
CARL MYDANS / LIFE;
ALFRED EISENSTAEDT / LIFE;
CORBIS / BETTMANN

>
NOT WITH A BANG
BUT A BAA

May 1945: A Luftwaffe hangar in Leipzig — along with a quarter of the city where, two centuries earlier, Johann Sebastian Bach had composed the greatest cantatas of the Baroque era — lay flattened by Allied bombers. But fighting had stopped. The Third Reich had fallen 988 years short of its millennial vow. Sheep cared not of war and peace. Life resumed.

MARGARET BOURKE-WHITE / LIFE

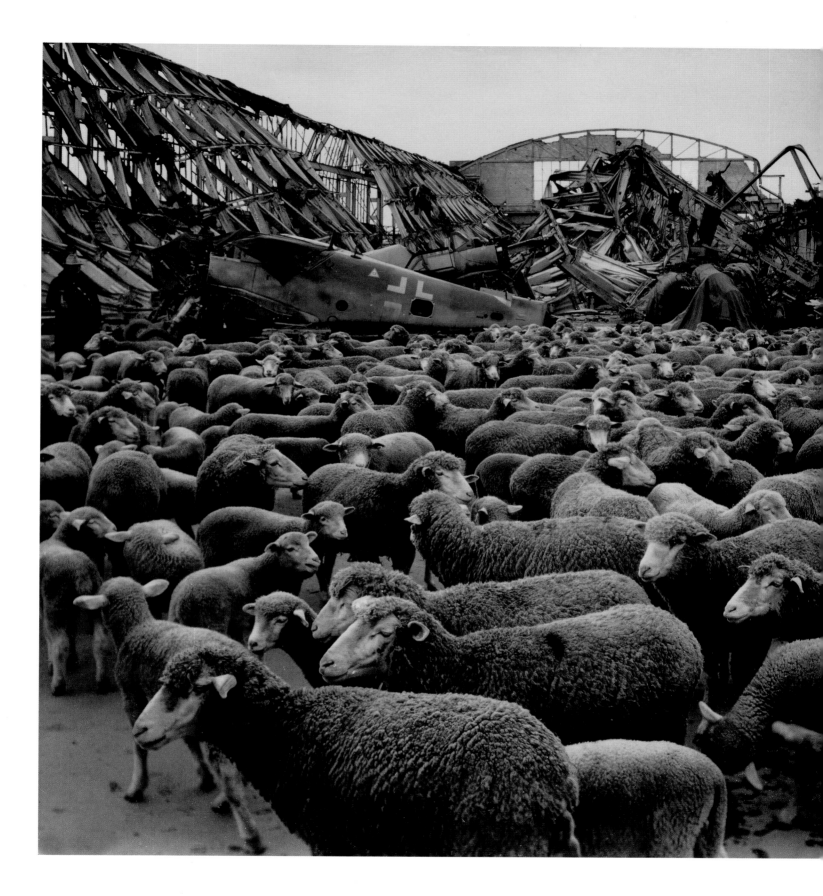

REQUIEM

GEORGE WASHINGTON CARVER, 1861–1943

Born a slave in Missouri, he set out at 12 in quest of an education. Two decades later, the agricultural chemist was at Tuskegee Institute, devising new uses for then-unpopular crops like peanuts. By promoting crop diversification, Carver altered farming worldwide.

CORBIS / BETTMANN-ACME

BEATRIX POTTER 1866–1943

Love of animals, starting with her own pooch, suffuses the British writer-illustrator's charming (yet never cloying) tales. Peter Rabbit debuted in a letter, graced with her own drawings, sent by the 27-year-old Potter to an ailing child. Later would come Squirrel Nutkin, Benjamin Bunny and Jemima Puddle-Duck.

ARCHIVE PHOTOS

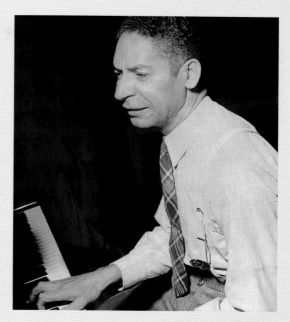

GLENN MILLER
1904–1944

Benny Goodman may have had more swing, but this bandleader's sweet renditions of "In the Mood" and "Tuxedo Junction" put his ensemble atop the charts in the early 1940s. Its signature piece was the Miller composition "Moonlight Serenade." He was touring with an Air Force orchestra when his plane from London to Paris disappeared over the English Channel.

CORBIS / BETTMANN-UPI

FERDINAND MORTON
1890–1941

Answering to "Jelly Roll" and flashing a diamond-studded front tooth, he liked to boast that jazz was his personal invention. The pianist, who had refined his chops by pounding ivory in the bordellos of New Orleans, wasn't totally off-key. By sketching out scores that allowed musicians room to riff, Morton helped push ragtime and Dixieland toward jazz.

CHARLES PETERSEN

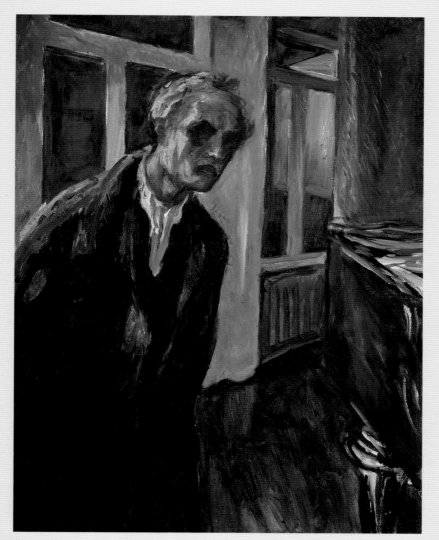

<
VIRGINIA WOOLF
1882–1941

To the salon she established with her siblings in London's Bloomsbury district went England's leading intellectuals. That hothouse atmosphere led to the essays and fiction that won her fame as a belletrist. Her pointed wit, affirmed in journals and letters published after her suicide, showed why many were afraid of Virginia Woolf.

MAN RAY

EDVARD MUNCH
1863–1944

The raw emotionalism of his most famous (and most parodied) painting, "The Scream," is also evident in this 1939 self-portrait. The Norwegian artist had reason to express an angst-tortured view of the world on canvas and in wood-cuts. Munch lost his mother, as well as his sister, to tuberculosis before he reached adulthood.

ERICH LESSING / ART RESOURCE

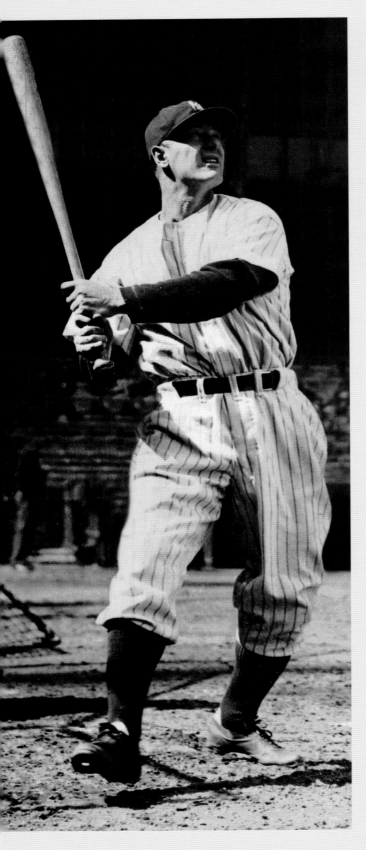

F. SCOTT FITZGERALD
1896–1940

Through novels about care-less strivers, the Minne-sotan earned the social and material success he craved. Fitzgerald and his writer wife, Zelda (above), were happy to be role models for flapperdom. But his master-piece, *The Great Gatsby*, foreshadowed the collapse of both the Jazz Age and the couple. She was institution-alized for schizophrenia; he drifted into alcoholism.

TIME INC.

<

LOU GEHRIG
1903–1941

Lured by the New York Yankees from Columbia University, the slugging first baseman (493 career homers) set an endurance mark thought untouchable: 2,130 straight games. It was broken in 1995 (by Cal Ripken Jr.), leaving only a sad medical legacy: Amyotrophic lateral scle-rosis, which ended his life, is usually referred to as Lou Gehrig's disease.

AP / WIDE WORLD

EMMA GOLDMAN
1869–1940

For urging Yanks to resist the draft in World War I, the Russian-Jewish anarchist was deported home in 1919. Red Emma soured on the Bolsheviks and became one of the first leftists to condemn the Soviets. Moving to Western Europe, she was soon railing against Hitler.

CHICAGO HISTORICAL SOCIETY

<

CAROLE LOMBARD
1908–1942

She went from junior high directly to silent-era Hollywood. There, Lombard enhanced her glamour with a sense of timing learned from slapstick master Mack Sennett and achieved stardom in screwball comedies like 1934's *Twentieth Century*. A happy second marriage, to Clark Gable, ended when her plane to a war-bond rally crashed near Las Vegas.

CORBIS / BETTMANN-INP

AIMEE SEMPLE MCPHERSON
1890–1944

The cross wasn't all that the flamboyant evangelist embraced. Three years after opening a $1.5 million temple in L.A., she vanished. Sister Aimee reappeared five weeks later claiming kidnappers had held her in a shack on the Mexican border. In fact, she had been shacked up with a married man. The faithful couldn't care less.

CORBIS / BETTMANN-INP

1946–1963

SPREADING THE WEALTH

In war, it had been guns or butter.
In postwar America, the choice
came down to baseball or piano.
(This 1962 recital was by Jimmy
Childs, 9, of Manchester, Iowa.)

An Age of Boom and Belief

BY ANN DOUGLAS

I WAS BORN during World War II, just before my father joined the Marines to fight in the Pacific. By the time I knew there was a larger world, America was engaged in a Cold War against the Communist Soviet Union that affected every household in the nation. One night in the late 1940s, listening to my heart beat against my pillow, I mistook it for the sound of marching feet and rushed into the living room to tell my parents, "The Russians are coming!"

When I joined the ranks of America's teenagers (a term new to wide usage), the most privileged and influential adolescents in history, I, too, fell in love with James Dean, Elvis Presley and Little Richard, whose crazed rhythms I tried in vain to imitate on my piano. In the 1960s, as a freshman at Harvard University, I wore blue jeans everywhere (except to class, where pants for women were still forbidden) and found a new hero in Martin Luther King Jr. I protested the Vietnam War, campaigned for Robert F. Kennedy and joined a feminist consciousness-raising group, whose idol, oddly enough, was the intensely macho Che Guevara.

In truth, the era in which I grew up was quite possibly the most momentous and exciting in American history. World War II reversed decades of official American isolationism. From now on, the U.S. would play a leading, stabilizing and permanent role in world affairs. The Bretton Woods Conference of 1944 ensured that the postwar global economy would be tied to the U.S. dollar and established the World Bank and the International Monetary Fund to prevent a repeat of the global depression of the 1930s. By 1965, direct corporate investment abroad was seven times greater than it had been in 1946. The United Nations, the first empowered organization of the world's nations, also a product of wartime planning, held its initial session in the United States in 1946 at its temporary headquarters in the gymnasium of New York's Hunter College. The U.N. originally had 51 members; by 1965, 67 more nations had joined, most of them newly independent former colonies from Africa and Asia.

The African-American writer James Baldwin complained that "all of Africa will be free before we can get a lousy cup of coffee," but by the late 1960s, the civil rights movement, led by Dr. King, Thurgood Marshall, Earl Warren's Supreme Court and Lyndon Johnson, had ended legal segregation, though it could not abolish racism. Before the protracted Vietnam War took its toll on the U.S. economy, America's astonishing, unprecedented wealth seemed to guarantee that Washington could spend billions in a Cold War abroad and still guarantee a better life to all its citizens at home.

Although the U.S. comprised only six percent of the world's population, it now produced and consumed more than a third of the world's goods and

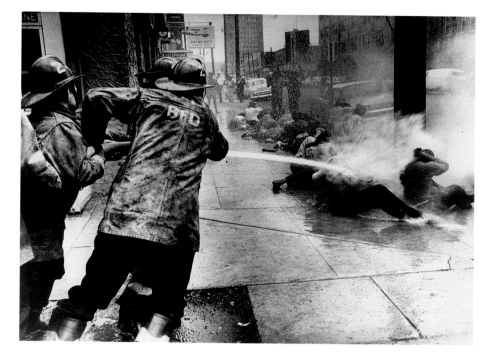

Some Deep South cities used clubs, others tear gas. In 1963, Birmingham, Alabama, tried fire hoses. Civil rights marchers were not deterred.

CHARLES MOORE / BLACK STAR

services. Average American life expectancy rose from 60 in 1940 to 70 in 1970. In 1956, the electronics industry, which had ranked 49th in 1939, was the fifth largest business in America. Television sets went on the market right after the war and TV watching quickly became the nation's primary leisure occupation. John Wayne declared that no form of entertainment had ever been so "available to the human race with so little effort since they invented marital sex."

The G.I. Bill, passed by Congress in 1944, extended its benefits, most notably in education, housing subsidies and business loans, to almost a third of Americans. Mass suburbanization was a U.S. phenomenon — few Europeans could afford the costs commuting to work entailed. Between 1950 and 1960, the number of Americans moving to suburbs doubled; yet blacks lived in increasing, disproportionate numbers in the country's fast-crumbling inner cities. Although anti-Semitism persisted, major Protestant theologians like Reinhold Neibuhr talked of the importance of the "Judeo-Christian" tradition; in 1955, Will Herberg published a much-discussed book about American religious identity boldly titled, *Protestant, Catholic, Jew*. President Harry Truman recognized the new state of Israel just minutes after its birth in 1948.

In 1953, Billy Graham, then beginning his half-century career as America's preeminent evangelical leader, urged his listeners to choose Christ because, "when you make your decision, it is America through you making its decision." Since America's archenemy, the Soviet Union, was officially atheistic, belief in God was part of waging the Cold War. To strengthen the Pledge of Allegiance, in 1954, Congress added the phrase "under God," and in 1956, In God We Trust became the official U.S. motto. Church membership in the U.S. hit an all-time high of 69 percent in 1960, though no comparable religious revival occurred in any other Western democracy.

Joseph Stalin's ambitions in Western Europe had been largely checked by the late 1940s, but when Britain announced in 1947 that it could no longer play its traditional policing role in Greece and the Middle East, President Truman widened the Cold War to include the support of "free peoples . . . resisting . . . subjugation" anywhere. China fell to Mao Tse-tung's Communist Party in 1949. The Cold War was displaced, in very "hot" form, from the First World to the Third, to Guatemala, Korea, Vietnam and later Angola, as Russia and America battled for control of the developing nations. The CIA, established in 1947, sometimes supported pro-U.S.

Third World dictators against their popular left-wing nationalist opponents, often suspected of Soviet sympathies.

The U.S. won World War II in part because of the atom bombs it dropped on Hiroshima and Nagasaki. Although a number of nuclear scientists protested that any nation with sufficient resources could develop nuclear weapons — Russia did so in 1949 — the bomb was declared the "property of the American people," and a culture of secrecy took hold at a depth and tenacity unparalleled in American history. An official language of doublespeak emerged; statesmen talked of "dual hegemony," "peace-keeping missiles" and "mutually assured destruction" (MAD for short).

Under Truman's loyalty program, instituted in 1947, 400 federal employees were fired and two thousand more resigned. The House Committee on Un-American Activities investigated citizens from every walk of life, including higher education, Hollywood and television, and Senator Joseph McCarthy terrorized the country with his claims of all-pervasive Communist infiltration. Even the Cal-Neva Casino in Reno required a loyalty oath from its employees. Some of those suspected or convicted of Soviet espionage, including Julius Rosenberg and, in all probability, Alger Hiss, were indeed guilty.

Gender roles became increasingly restrictive. The Soviet Union was organized in collectives rather than families, but in 1954 *McCall's* coined the word *togetherness* to express the new American domestic ideal. Americans married younger and had more babies than their parents had; contraception remained illegal outside of marriage until the early 1970s, while roughly one million women had illegal abortions every year. Feminism attracted less support than at any other time in 20th Century American history. Although women continued to join the workforce, in 1950 their wages were half those of their male peers. No major journal of sociology published an article about domestic abuse between 1939 and 1964.

Women stars had dominated movies in the 1930s and 1940s, but a new breed of surly, sexy male prima donnas, led by Marlon Brando and James Dean, eclipsed them in the 1950s. The actresses who did make it, like Marilyn Monroe and Anita Ekberg, demonstrated only one type of feminine beauty; in its 1951 catalog, Sears advertised 22 kinds of "falsies" for sale.

The Fifties are sometimes remembered as an era of tranquillity and order, but in fact, dissent from Cold War norms was pervasive, turbulent, much publicized and even feted. The pacifist theologian A.J. Muste headed a nuclear disarmament movement in the late 1940s. The Senate censured McCarthy in 1954; the Warren Court began dismantling the legal apparatus of state intrusion in the late 1950s. The charismatic Malcolm X, a leader in the Nation of Islam, advocated a bold program of defiant self-sufficiency for black Americans. Betty Friedan published her landmark book, *The Feminine Mystique*, in 1963. America's arts underwent an extraordinary revolution, turning individual subjectivity and free improvisation into a glamorous new form of rebellion. The conformist is "lost," popular author and psychiatrist

At 18, Billie Jean Moffitt (later King) already held a major title (doubles at Wimbledon). In later collecting 10 Wimbledon and U.S. Open singles crowns, the first woman athlete to earn $100,000 in a year (1971) proved to girls that sweat could be beautiful.
BRIAN SEED / SPORTS ILLUSTRATED

Robert Lindner announced in 1956; of all the animals, only man "assaults his prison."

In a series of huge canvases incandescent with energy, Jackson Pollock and Willem de Kooning liberated painting from any form but that of the artist's imagination; for the first time, American artists outshone the European avantgarde. Charlie Parker, Dizzy Gillespie and Thelonius Monk transformed jazz, America's premiere popular art, sending it back to Africa for fresh rhythms and emphasizing solo virtuosity over arranged or rehearsed ensemble work. Following Parker's sound, the Beat Generation writers Jack Kerouac and Allen Ginsberg invented "spontaneous bop prosody" and urged their readers to go "on the road," to travel into the unknown, bypassing or redefining the conventional masculine roles of husband, father and provider along the way. Poet Sylvia Plath eschewed "feminine frills" for the "terror" of primal myth. "Beware, beware," one poem counsels. "I rise with my red hair / And I eat men like air."

If a number of these artists pursued the ethos of liberation into alcoholism, drug addiction and self-destruction, they believed their times demanded an exaggerated insistence on self-expression as the American birthright, worth any price. They drew large followings not only at home but also abroad, even in countries sometimes opposed to America's Cold War policies. In Athens, in May 1956, although anti-American feeling was running high, a crowd gathered at the U.S. embassy to cheer the arrival of Dizzy Gillespie. With its ethnically diverse origins, its immense promise of abundance and freedom, America's new popular culture, from bebop and

He may have looked like a clean-cut product of the Eisenhower era, but in 1957, Allen Ginsberg, 31, was writing free-verse poetry (some of it a Beat Gen *Howl*).
ROME PRESS

Method acting to MacDonald's and the Twist, contributed massively to the dissolution of the Iron Curtain, attracting worldwide a passionate affection that military might could never command.

The stakes were always high in the postwar years. Everything meant so much; everything counted — a feeling that President John F. Kennedy's youthful confidence and jet-set glamour transmuted into a different, more cool and cosmopolitan style. Although our crusades abroad were not always well-advised, our idealism sometimes an obvious cloak for less worthy motives, whether we were rebels or conformists, we believed. Today, perhaps wisely, we live with multiple truths and narratives, a consumer's array of identities and attitudes with few final choices required, yet we continue to return, fascinated, to the voices and images of an earlier time — Elvis on the *Ed Sullivan Show*, a feckless white-trash sheik having more fun than the law allowed; Kennedy, grave-faced, elegant and masterful during the Cuban missile crisis; Martin Luther King transfigured by a dream before the Washington Monument — those electrifying moments when the whole world seemed to stop, then change forever.

Ann Douglas teaches American studies at Columbia University and is the author of The Feminization of American Culture *(1977) and* Terrible Honesty: Mongrel Manhattan in the 1920s *(1994). She is currently working on a book about Cold War culture in the U.S.*

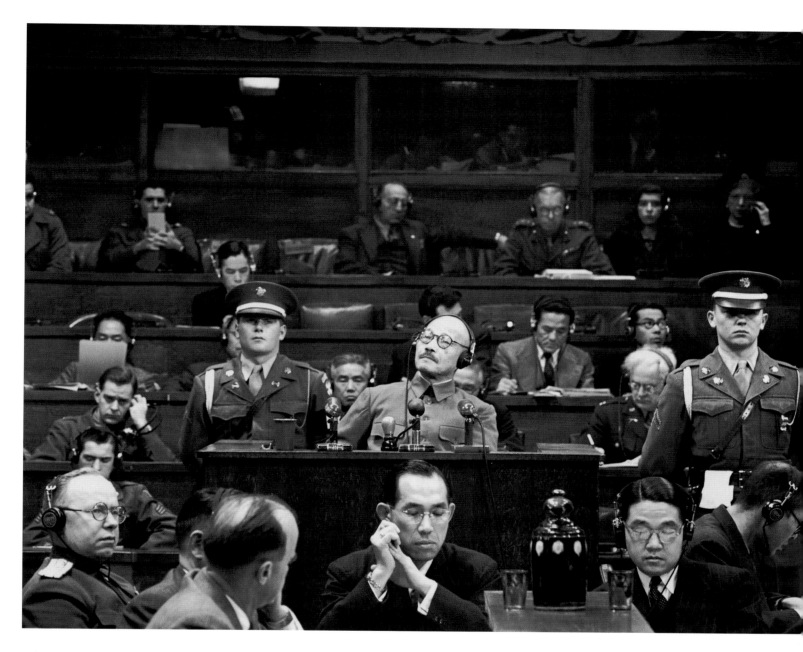

Crimes and Punishments

History being writ by the victors, in 1945 the Allies put on trial 24 Nazis (including Hermann Göring, left) and 27 Japanese leaders (including Hideki Tojo, in the dock, above). Beyond reach were Hitler, dead by his own hand, and Mussolini, shot sneaking back to Milan where his corpse was hung in public; Hirohito escaped judgment by using his vested majesty to ensure a peaceful U.S. occupation of his nation. At Nuremberg, Reichsmarschall Göring, 53, was condemned to death; on the eve of his hanging, he gagged down a smuggled cyanide capsule. At Tokyo, Prime Minister Tojo, 64 — who the previous September had shot himself in the chest but survived — received the same sentence; he climbed the gallows in 1948.

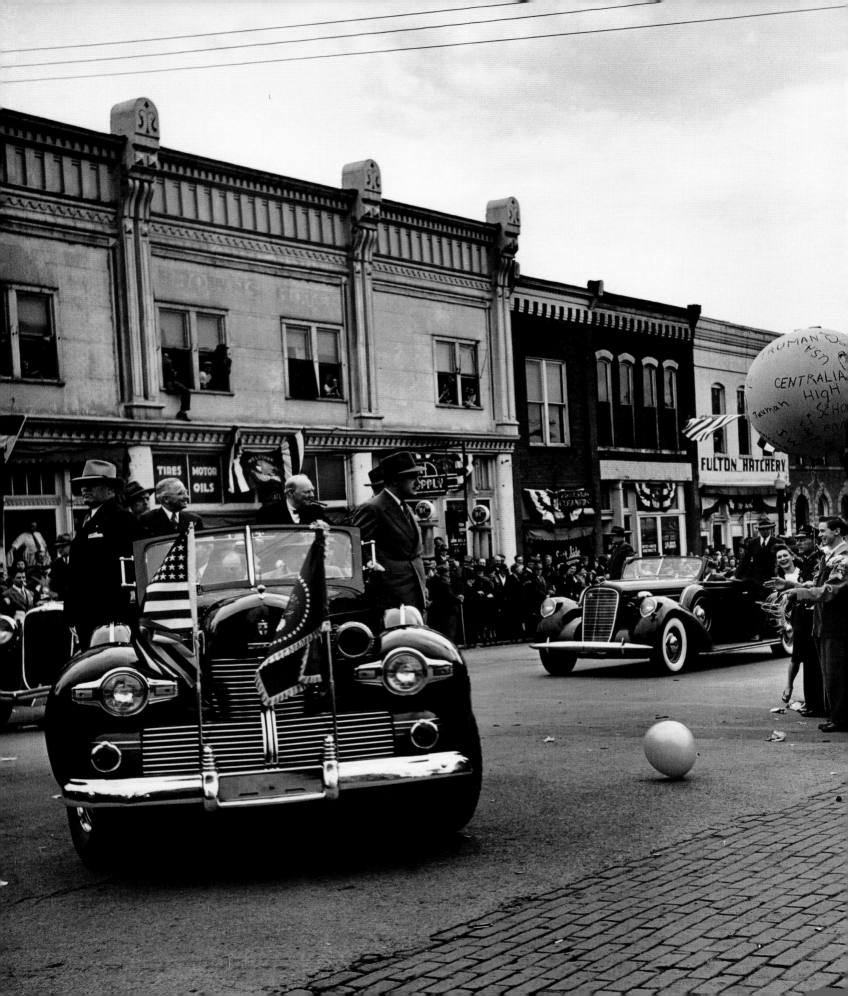

> A YOUNG DIARIST-TO-BE

A slim volume that appeared in Dutch bookstores in 1947 was by the girl who is second to right in this snapshot taken 10 years before. But in 1942, she and her family, which was Jewish, had to hide in Nazi-occupied Amsterdam. They were betrayed in 1944; she died, at 15, in Bergen-Belsen. The slim volume was Anne Frank's heartbreaking diary of those two years in hiding. (Three of her playmates survived the Holocaust.)

ILSE LEDERMAN

< TO COIN A PHRASE

To Fulton, Missouri, on March 5, 1947, came President Harry Truman, 62, and bestogied private citizen Winston Churchill, 72. The man who willed Britain through the war had stunningly been voted from office 11 weeks after VE Day. But he had not lost his grasp of geopolitics. In a speech that day, Churchill warned, "An iron curtain has descended across the Continent."

GEORGE SKADDING / LIFE

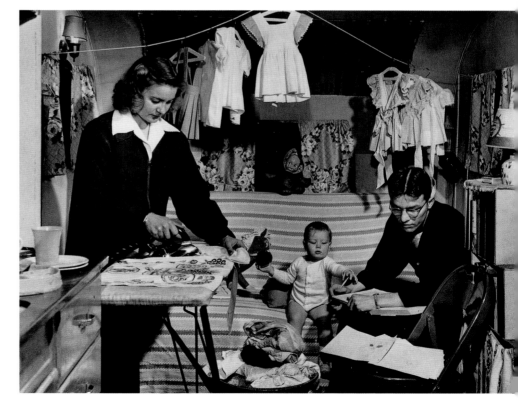

> A NATION'S THANKS

Charles Smayda wasn't like most fellow students at the University of Iowa in 1947. He was older, he had a family — and his bills were paid by Uncle Sam. The GI Bill of 1944 promised servicemen financial help. In just its first 20 years, the act, extended to cover Korea vets, enabled 10 million to go to school and 6.2 million to buy homes.

MARGARET BOURKE-WHITE / LIFE

MARSHALL'S PLAN

As a five-star general, he helped plot the Allied victory. In 1947, as Secretary of State, George C. Marshall, 67, toured Europe (right), then proposed a reconstruction plan that could run $20 billion over four years. Congress didn't blink and said yes.

THOMAS D. MCAVOY / LIFE

OPERATION RESCUE

Overflying a part of Berlin still in ruins in 1948, a USAF C-54 arrived laden with cargo. In June, the USSR had cut all land and river links to the city, which lay 110 miles inside East Germany. To supply 2.5 million Berliners with life's necessities, America and Britain began an airlift that averaged 625 flights daily for 318 days.

CHARLES F. JACOBS / BLACK STAR

VOYAGE OF THE DAMNED

The postwar destination of many vessels packed with displaced Jews (like the ragtag *Szold*, right), was Palestine — Biblical Israel. All were turned away by the British, overseers of the territory since 1922. The cruel 1947 rejection of the ship *Exodus*, recounted in a book and a film, turned international public opinion against London. On May 14, 1948, the modern state of Israel was founded as a homeland for world Jewry.

DAVID DOUGLAS DUNCAN

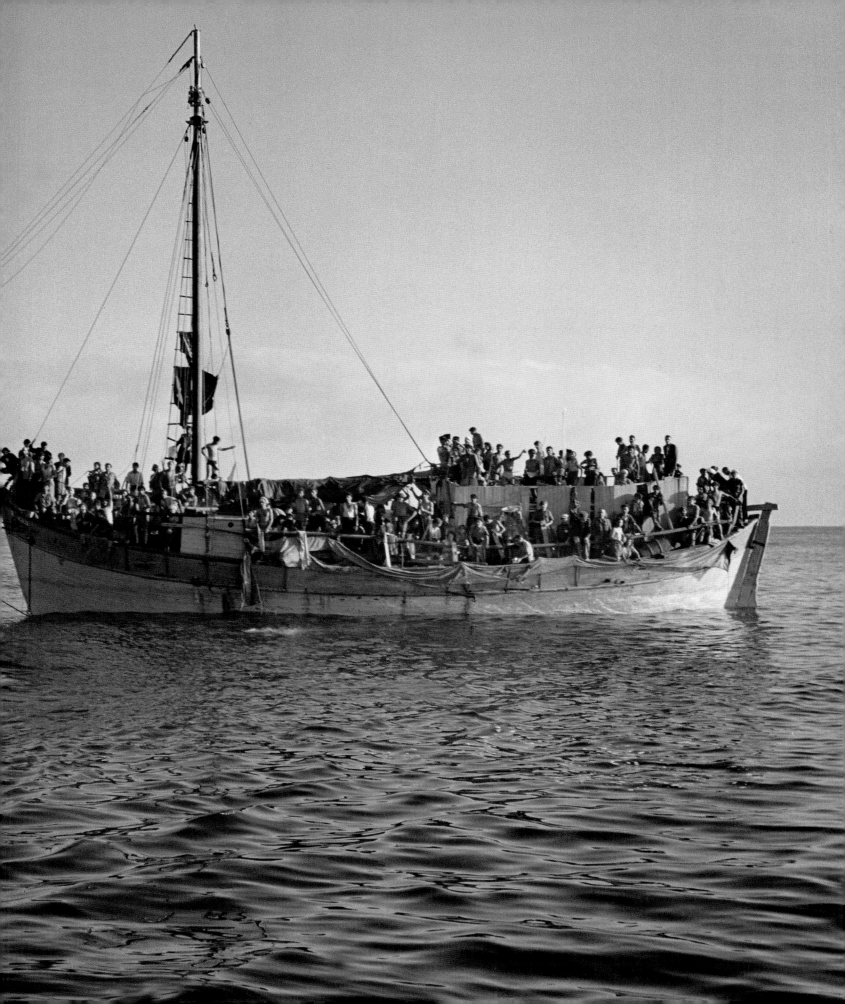

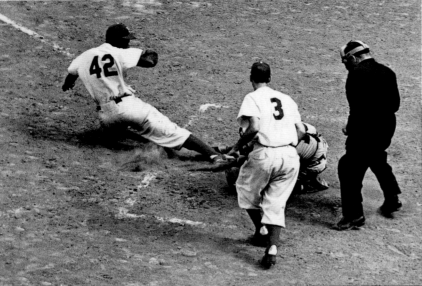

ONE IS A LONELY NUMBER

Jackie Robinson (above, stealing home in 1948) was the object of much attention — and vilification. The UCLA graduate had been chosen to break the national pastime's color barrier by Branch Rickey, 66, general manager of the Brooklyn Dodgers (right, with grandson). Pro football had already accepted black fullback Marion Motley of the Cleveland Browns, and the baseball sage knew that a number of Negro league players, among them, Robinson, could help his team. He was right. By 1953, six of the 16 big league teams were suiting up blacks. Last to integrate: the Boston Red Sox, who called up Pumpsie Green in 1959.

ABOVE: HY PESKIN / LIFE
RIGHT: GEORGE SILK / LIFE

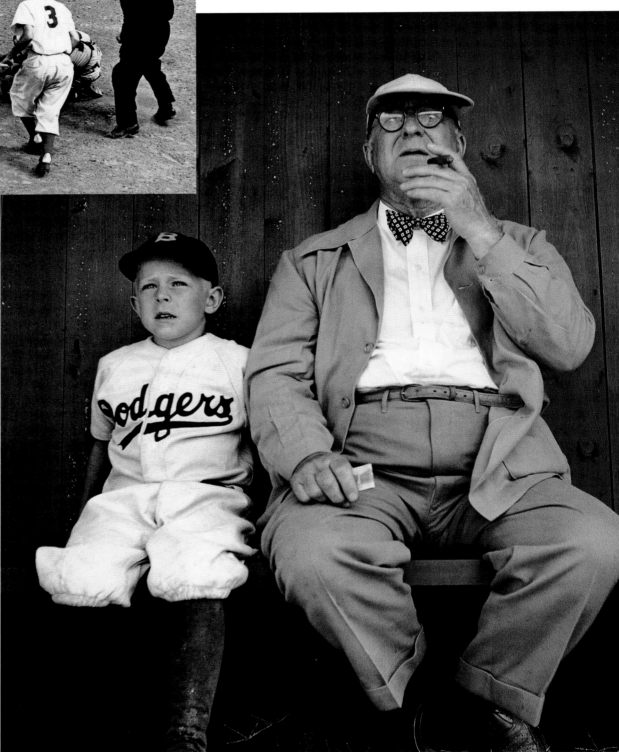

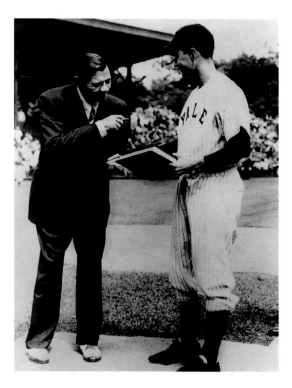

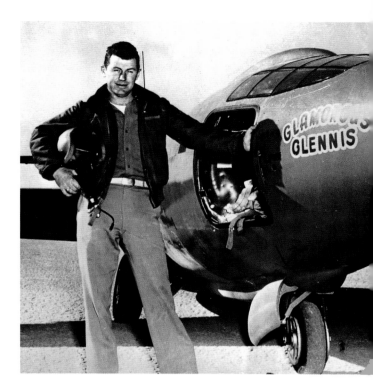

CALL HIM SKY KING

That sharp clap of a sonic boom over California on October 14, 1947, came from this jet piloted by this cockpit stud, Chuck Yeager, 24. The plane (named for his wife) was the first craft to fly faster than the speed of sound under its own power. Some had feared the X-1 might disintegrate. When it passed 700 mph and didn't, gone was the barrier to the jet age in military and commercial flight.

CORBIS / BETTMANN-UPI

THE BABE GOES IVY

Three months before his death from cancer, good-field, great-hit Yankee outfielder Babe Ruth, 53, donated his papers to Yale University. Accepting them in New Haven, Connecticut, on June 5, 1948, was the captain of the Eli team. Perhaps the first baseman, 23, knew his own scouting report (good field, no hit); George Bush chose a game other than baseball.

YALE UNIVERSITY

WELCOME TO THE BURBS

The new instant community outside Los Angeles at right was one of a rash put up by developers in the immediate postwar years. In Long Island's Levittown, two bedrooms and a slice of lawn could be had for $6,990. Growing up in such tract houses would not affect speech patterns until, like, wow, the 1980s?

LOOMIS DEAN / LIFE

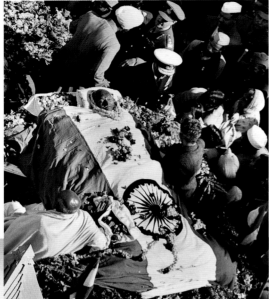

A PASSAGE FROM INDIA

By ending its 89-year colonial rule of India in 1947, Britain washed its hands of the violent, age-old rivalry between Hindus and Muslims. (Below, casualties in Calcutta were a grisly feast for vultures.) Partitioning off the new state of Pakistan for minority Muslims set off more violence. Most prominent of the million-plus victims: Mohandas Gandhi (inset), assassinated in 1948 by a fellow Hindu for his pacifist, nonpartisan views.

MARGARET BOURKE-WHITE / LIFE (2)

CRY THE BELOVED COUNTRY

Historically, South Africa's 11 million nonwhites shared few of the rights enjoyed by the nation's 2.5 million whites. In 1948, after parliament was won by ultrasegregationists, they had even fewer. The harsh new law of the land, called apartheid, regulated every facet of nonwhite life, from public facilities (like an oceanside bench in Durban, right) to marriage (not with a white).

N.R. FARBMAN / LIFE

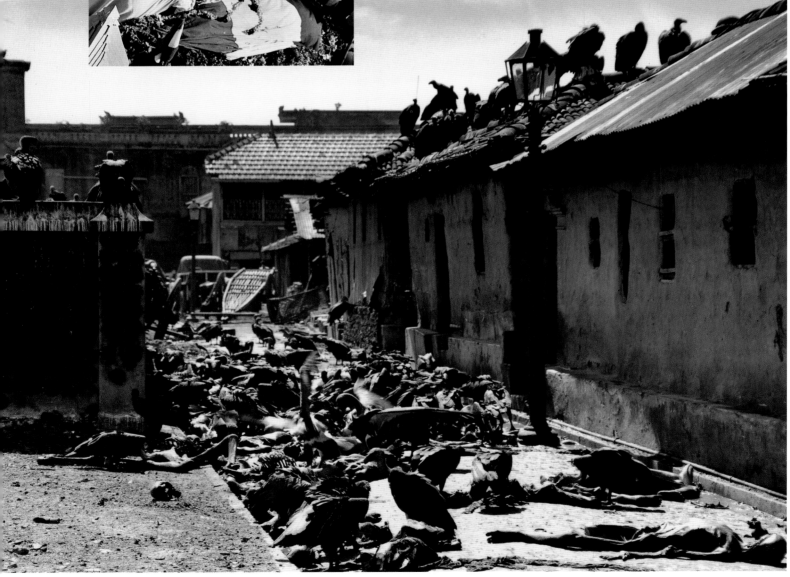

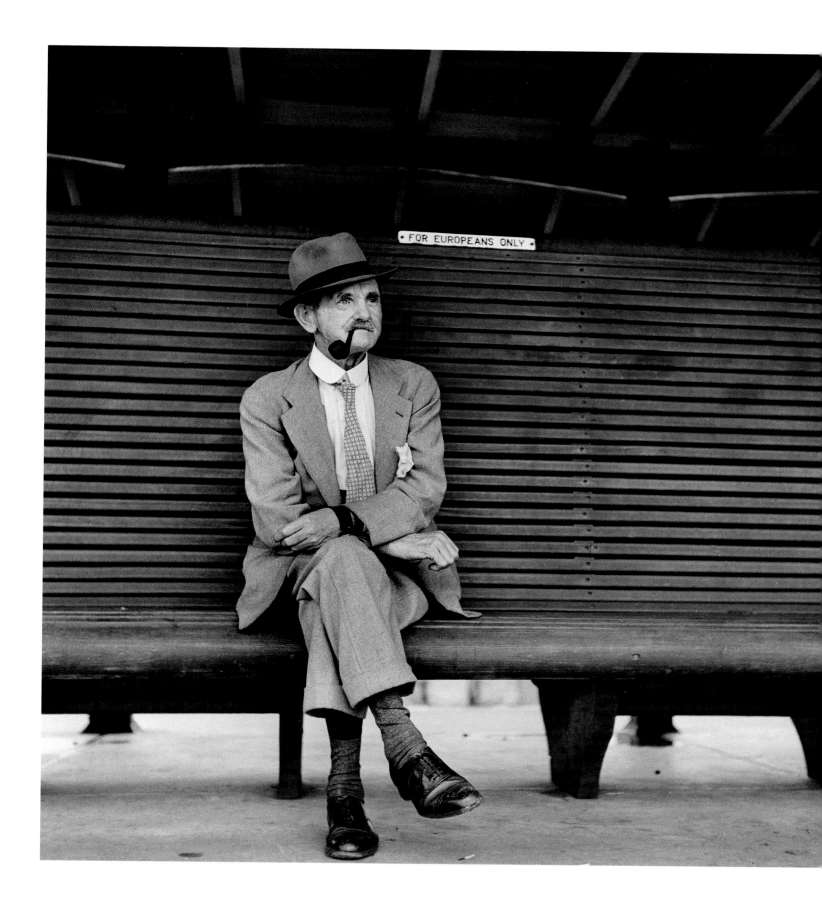

ACQUIRING A NEW HABIT

The 99.9 percent of Americans who owned no TVs in 1948 began changing their minds when two prime-time pioneers became must-watch phenomenons. Comic Milton Berle, 40 (far right, with Judy Canova), locked up Tuesday night so tightly that movie houses and bars suffered; NBC soon re-upped him for 30 years at $200,000 per. Sunday night belonged to a CBS variety hour hosted by gossip columnist Ed Sullivan, 45 (at mike, right). Among his opening night guests: Jerry Lewis, 22, with arms crossed; past him, Richard Rodgers and Oscar Hammerstein; and past the host's left shoulder, Dean Martin, 31. Budget for this "really big shew": $1,375.

RIGHT: CBS PHOTO ARCHIVE
FAR RIGHT: RALPH MORSE / LIFE

EVERY VOTE COUNTS

Election Day, 1948: Casting ballots in Independence, Missouri (pop. 30,000 plus), were, from left, Margaret Truman, 24; her mother, Bess, 63; and her father, Harry, 64. If Dad looked subdued, it was because all opinion polls projected a comfortable win for presidential challenger Thomas E. Dewey. Wrong.

AP

>
TWO-PIECE BOMBSHELL

Itsy-bitsy teeny-weeny, the Louis Reard creation wasn't. Still, a stunned Paris fashion press was quick to dub it "bikini," after the atoll in the Pacific where the U.S. tested nukes. Starchy French resorts insisted on one-piece suits. Along the Riviera, they complied by tanking the tops.

NINA LEEN / LIFE

>
WHO NEEDS A BRUSH?

A half century after being mocked as Jack the Dripper, Wyoming-born Jackson Pollock won U.S. Postal Service endorsement. The artist began to drizzle paint on canvas in the late 1940s; those early works helped launch the abstract expressionist school. (The Postal Service took artistic license in basing its stamp on a Martha Holmes photo; it painted out Pollock's ever-present cigarette.)

U.S. POSTAL SERVICE

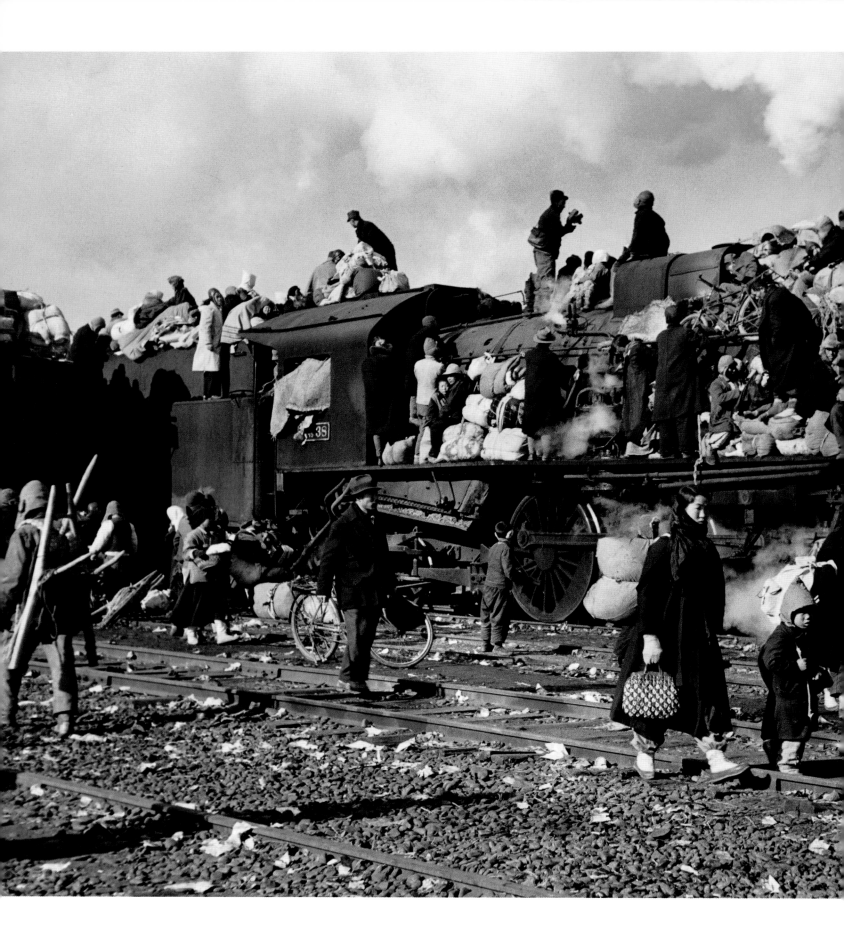

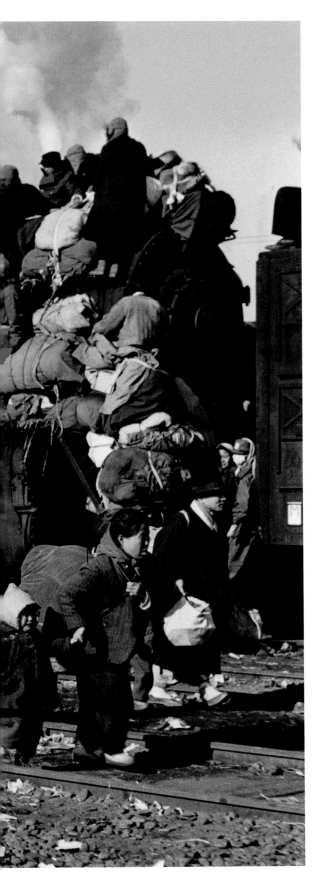

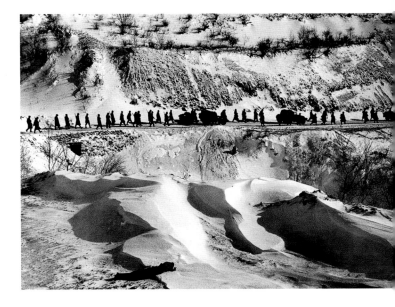

NEW LAND WAR IN ASIA

The refugees streaming into Yongdungpo, near Seoul (left), in 1951 bespoke the war racking their country. Korea had been freed from a long Japanese occupation in 1945 — only to be split at the 38th parallel in 1948. The North (capital: P'yŏng-yang) fell under Soviet rule, while the South (capital: Seoul) became a republic. On June 25, 1950, the North mounted a massive invasion. Two weeks later, the U.N.'s first multinational police force — at that time, 18,000 troops provided by the U.S. — began landing at Pusan. Douglas MacArthur, 70, was recalled to duty to head the force, which won back lost territory and drove into the North. But in November, Communist China entered the fray; soon, U.S. troops were retreating south down the mountainous peninsula (top right). Combat see-sawed into 1951 (middle right, GIs under fire near Anyang), with American air power (bottom right, a snow-covered carrier) partially checked by the new Soviet MiG-15 fighter jet. In April, when MacArthur vowed to cross the Yalu River to fight Chinese troops in China, Truman fired him. Truce talks, begun in late 1951, were finally concluded in mid-1953. But at century's end, there was still no peace.

CLOCKWISE FROM LEFT:
CARL MYDANS / LIFE;
DAVID DOUGLAS DUNCAN;
JOHN DOMINIS / LIFE (2)

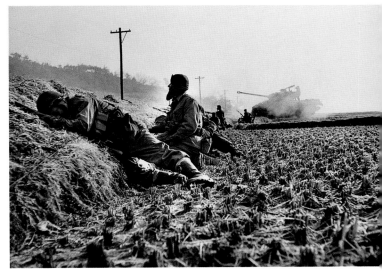

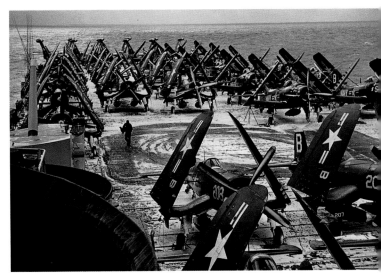

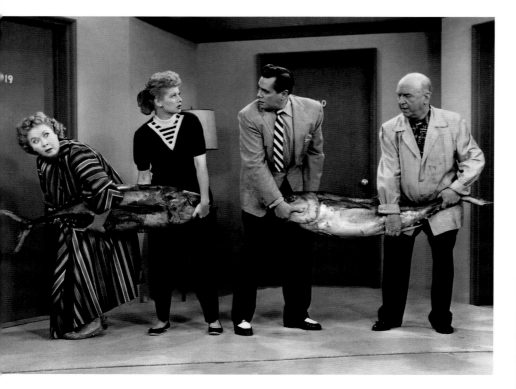

DID SOMEONE SAY SUSHI?

In 1951, to coax Lucille Ball to TV, CBS met two demands. Real-life hubby Desi Arnaz, Cuban accent and all, would be in the sitcom (with Vivian Vance, left, and William Frawley). And though most other network shows originated live from New York, with only a few saved on low-res kinescopes, Ball, 40, would stay in L.A. and do her shows on film. This meant *I Love Lucy*'s slapstick could be sharpened by editing — and its episodes could be rerun for all time.

CBS PHOTO ARCHIVE

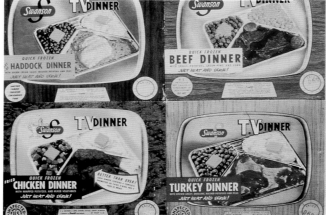

SEMI-FAST FOOD

When U.S. stores began to stock a new frozen-food product in 1954, television had penetrated into 26 million households, up from 172,000 in 1948. TV dinners took only 25 minutes to cook. Though they tasted like K rations, many a World War II and Korea vet scarfed them up without a beef.

COURTESY OF SWANSON DINNERS

MY BABY SHOT ME DOWN

This posse was enjoying (except maybe the cowtot at far right) a tie-in merchandising blitz that predated Davy Crockett and Star Wars. The guns, duds and other goodies were under license to early TV Western hero William Boyd (inset, with nag Topper). The actor had bought tube rights to 66 of his Hopalong Cassidy B-flicks, which played just fine on the small screen.

BERNARD HOFFMAN / LIFE
INSET: NBC

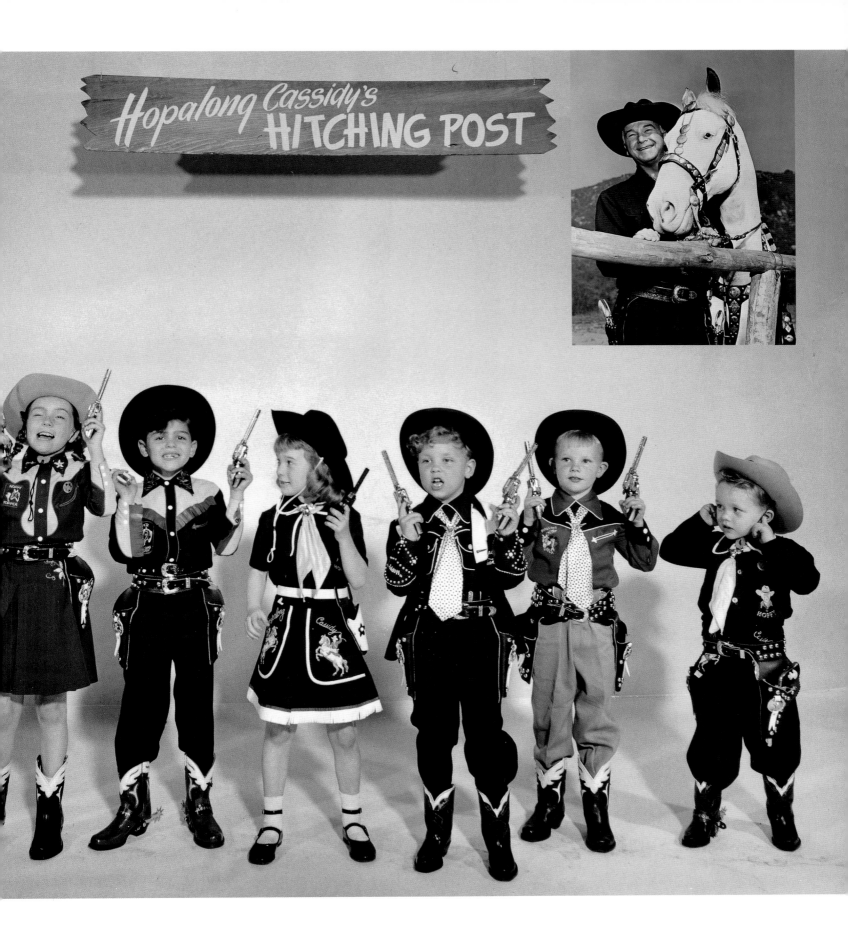

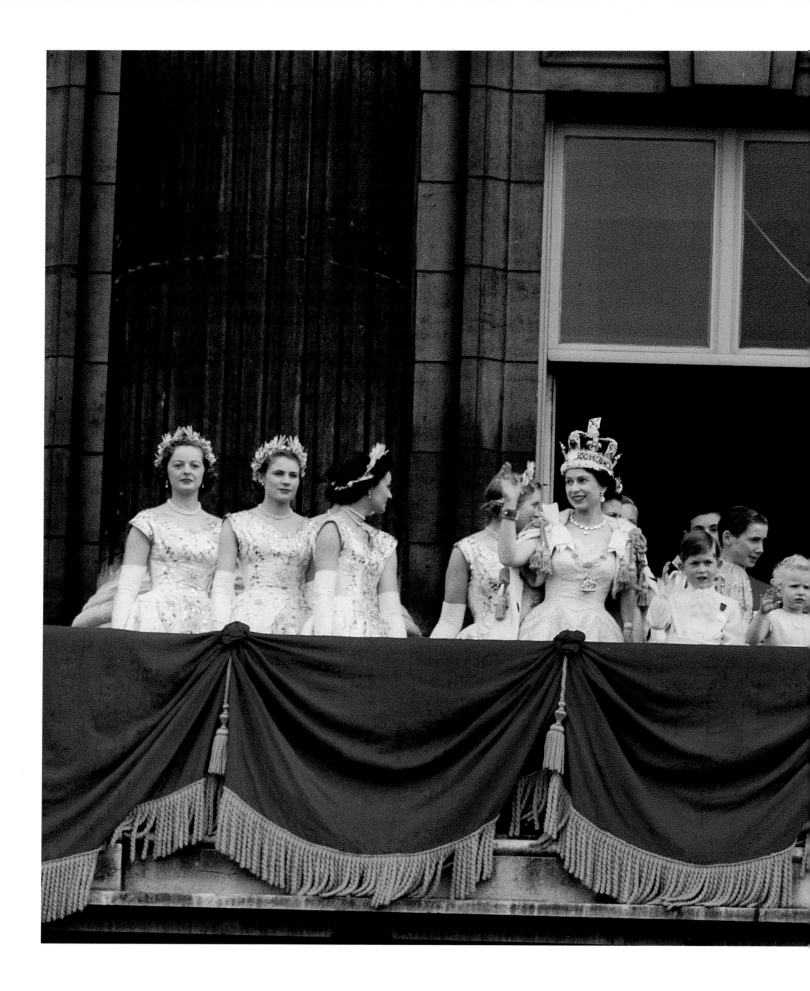

> **WE LIKED IKE**

Tanks rumbled past the White House in January 1952 to salute America's 34th president, Dwight D. Eisenhower, 62 (in front of near right pillar). The military hero had defeated Adlai Stevenson. Also on the reviewing stand: Harry Truman, seated behind Ike; Mamie Eisenhower; and Pat and Vice President Richard M. Nixon.

HANK WALKER / LIFE

< **LONG LIVES THE QUEEN**

Ten years old when Edward VII's abdication shifted the scepter to her father, she became, at 25, Queen of Great Britain and Northern Ireland. Elizabeth II's Coronation Day wave in 1953 was mirrored by her children, Charles, 4, and Anne, 2. (Andrew would be born in 1960, and Edward in 1964.) In 1996, her reign surpassed Elizabeth I's to become the fifth longest in British history.

FRANK SCHERSCHEL / LIFE

> **A BLOODY REGIME ENDS**

On Joseph Stalin's 29-year watch, purges and planned famines killed more Soviets than did World War II. So the tears were *krokodil* in March 1953 as Kremlin brass bore away the 73-year-old dictator's body. After five years of savage infighting among his successors, one leader emerged: earthy Ukrainian Nikita Khruschev, 64.

LIFE

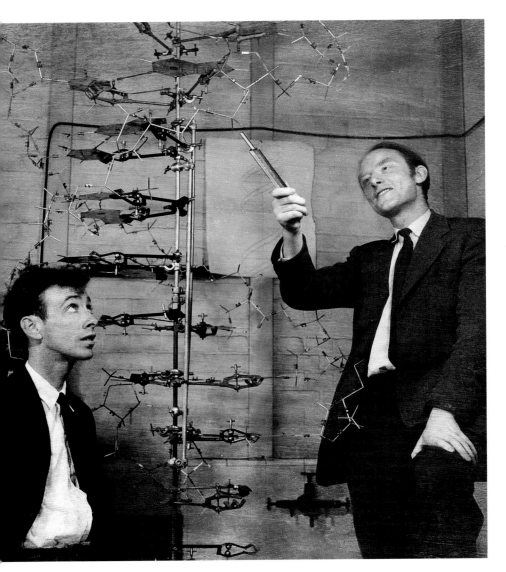

WELCOME HOME, SON

Stunned U.S. Army private John Ploch was one of 13,444 soldiers under U.N. command repatriated in 1953 from North Korean POW camps. Many told of having undergone psychological pressure so intense that it felt like torture — a practice soon dubbed "brainwashing." When an armistice was signed on that July 27, the three-year undeclared war had claimed an estimated four million lives, including those of 54,000 Americans. Yet the map of the Koreas was virtually unchanged.

MICHAEL ROUGIER / LIFE

IT'S IN OUR GENES

American biophysicist James Watson, 25 (above), still seemed perplexed at a May 1953 session to show what he and English colleague Francis Crick, 36, had built. It was a model of deoxyribonucleic acid, the molecule carrying the genetic code that enables cells to replicate. The structure of DNA, they had determined, was a double helix. Their find would ripple through worlds as diverse as medicine, agriculture and criminology.

BARRINGTON BROWN / PHOTO RESEARCHERS

TOP OF THE WORLD, MA!

The air was much thinner where they had recently been: atop Mount Everest's 29,028-foot summit. On May 29, 1953, Edmund Hillary, 33 (above left), of New Zealand and Tenzing Norgay, 39, a Sherpa of Nepalese descent, became the first to stand on the planet's highest point. They admired the Himalayan view for 20 minutes, then started back down.

JAMES BURKE / LIFE

SPY TRIAL OF THE CENTURY

In 1950, eight Americans were charged with passing Manhattan Project secrets to Moscow. Three pleaded guilty and joined in jail three who were convicted by juries. Remaining were New Yorkers Julius Rosenberg, near left, an electrical engineer, and his homemaker wife, Ethel. Both were avowed leftists. Though many at the time thought the government's case left room for reasonable doubt, they alone were condemned to die. The sentences led to a deluge of calls for clemency, but the Rosenbergs were executed on June 19, 1953; she was 37, he was 35.

AP

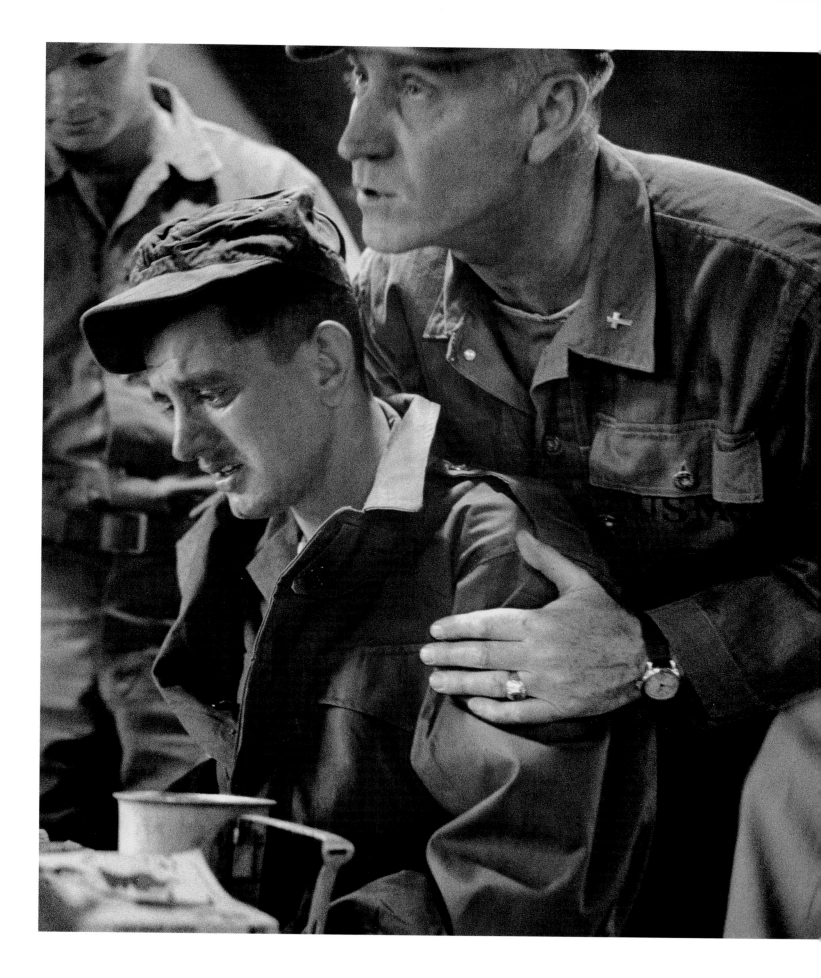

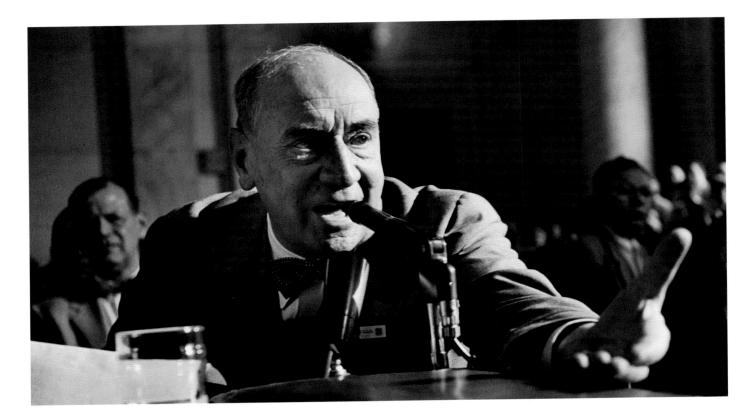

SHADES OF SALEM

Not since its colonial days had the U.S. been so riven by suspicion. The enemy: fellow travelers of a devil called communism. The anticapitalist world according to Marx had never played well in America; in the late Teens, the rise of Bolshevism set off a Red scare. Postwar, as an Iron Curtain sliced across Europe, the stakes seemed even higher. In 1947, the House redefined un-American behavior and found Hollywood full of it. Next, the one-two punch of the Rosenbergs and Korea. If Stalin could steal our A-secrets, and Beijing and P'yŏng-yang our young men's lives, what was left to safeguard but our hearts and minds?

UP CLOSE AND PERSONAL

"Have you no sense of decency, sir?" asked Joseph Welch (left) on June 9, 1954, in nationally aired Senate hearings on charges that the U.S. Army was riddled with Reds. In defense of the Army, the Boston lawyer, 64, aimed his anger at chief accuser Joseph McCarthy, 46 (right). The junior senator from Wisconsin was a household name for his Commie-bashing. In 1950, before a women's club in Wheeling, West Virginia, he had waved a list of 205 Reds in the State Department (but kept most of the names to himself). Even after McCarthy later hinted that Ike might be pink, no one curbed his demagoguery. That same moral tone deafness was his downfall. Invited in the spring of 1954 by Edward R. Murrow to rebut a *See It Now* chronicling of his misstatements, McCarthy called America's most respected journalist "the leader and cleverest of the jackal pack." He answered lawyer Welch with similar bluster. The public had enough. So did fellow senators, who condemned McCarthy that fall for unbecoming conduct. The very real threat of Communism did not end, but the fratricidal specter of McCarthyism had.

TOP LEFT AND RIGHT:
HANK WALKER / LIFE

They Had a Dream

The first ship bearing Africans to America most likely docked at Jamestown, Virginia, in 1619. From the start, slavery divided the country's whites, who eventually settled their differences with arms. The Civil War freed the nation's blacks. But left intact were the legacies of bondage, the cruelest of which was the perception that skin color mattered. Epic legislation, earned with tears, sweat and blood, has spelled out basic civil rights but not put an end to racism. Which is ironic. If the geneticists have it right, everyone living in the United States is an African-American, descended — like the rest of humanity — from the people who ranged the sub-Saharan tropics 400,000 years ago.

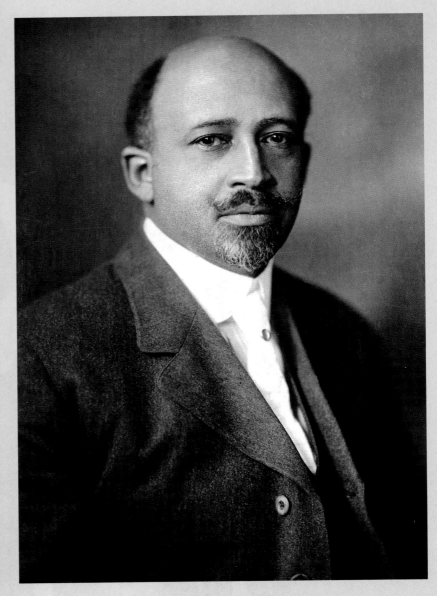

TURNING NEITHER CHEEK

W.E.B. Du Bois's 1903 book, *The Souls of Black Folk*, rejected the tolerance of racism favored by Booker T. Washington. In 1910, at 42, the sociologist (Harvard's first black Ph.D.) co-founded the NAACP. Du Bois grew impatient with the movement's slow progess and, late in life, renounced his U.S. citizenship. He died in Ghana one year before the Civil Rights Act of 1964.

CULVER PICTURES

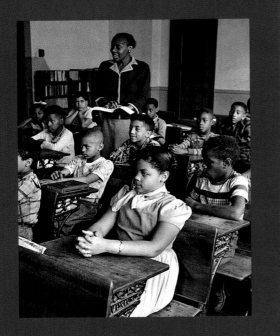

SUFFER THE CHILDREN

It was not the classroom her parents wanted for Linda Brown, 10 (wearing scarf). But a school 17 blocks nearer their Topeka, Kansas, home was whites only. The Browns sued the school board in 1952. On May 17, 1954, the nine white justices of the U.S. Supreme Court ruled that in "public education, the doctrine of separate but equal has no place." The decision would affect 11 million white and black students in 17 states.

CARL IWASAKI / LIFE

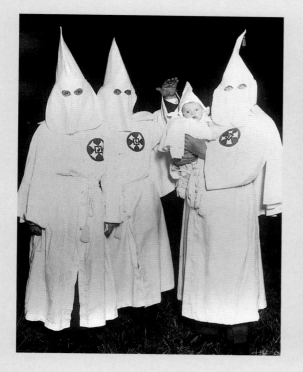

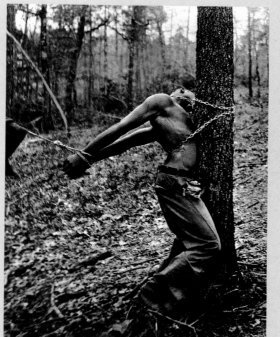

JIM CROW IN KHAKI

Finished with basic training at Fort Huachuca, Arizona, in August 1943, the all-black 93rd Infantry Division was set to go. By then, the all-black Tuskegee Airmen were already dogfighting with distinction in Europe. Still, though more than one million African-Americans served in World War II, most were relegated to labor battalions. And those who did see action fought in segregated units.

CHARLES STEINHEIMER / LIFE

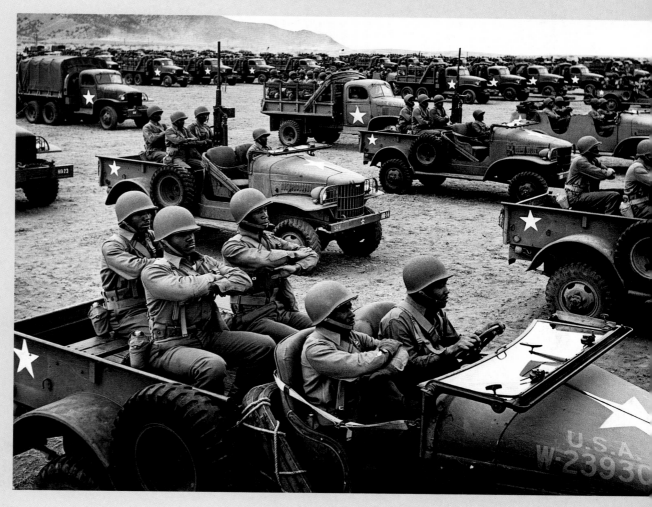

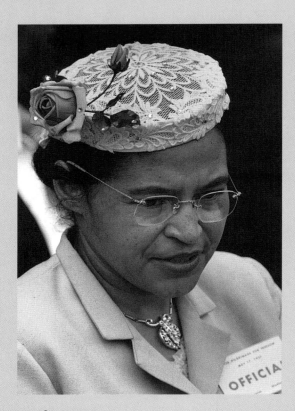

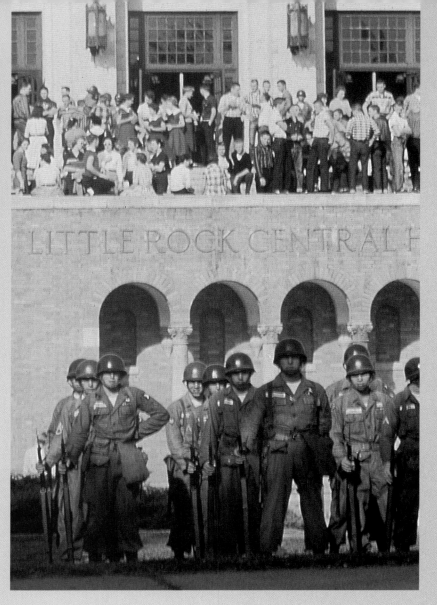

MOVE? NOT THIS TIME

She paid the bus fare, so despite local law (blacks to the back), seamstress Rosa Parks, then 42, decided not to give up her seat to a white man. When she was hauled into court four days later, on December 5, 1955, blacks in Montgomery, Alabama, stopped taking buses. The boycott, led by the Reverend Martin Luther King Jr., 26, ran for 381 days, until the Supreme Court struck down the ordinance.

PAUL SCHUTZER / LIFE

>

THE CROSSING GUARDS

Even the mayor didn't want this to happen: the 101st Airborne in front of Central High in September 1957, ready to take on not only white supremacists but also the Arkansas National Guard. Why? So nine black students could enroll. Governor Orval Faubus, 47, had resisted integration by calling out his Guard. Seeing schoolkids rebuffed at bayonet-point, Ike sent in paratroopers.

JOHN BRYSON

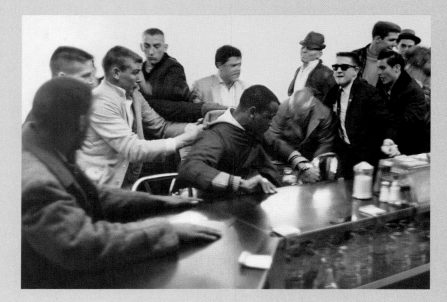

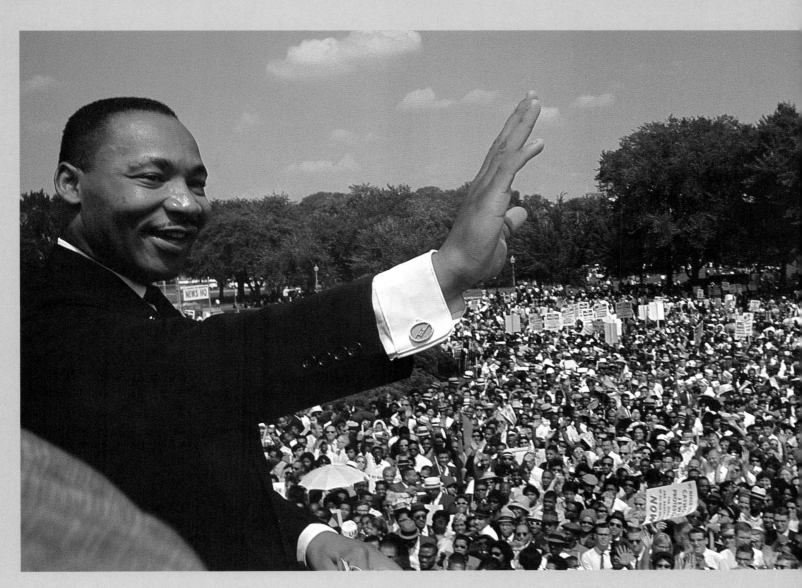

BEAUTIFUL DREAMER

On August 28, 1963, before some 250,000 fellow citizens thronging the Mall in Washington, D.C., and uncounted millions watching on live TV, Martin Luther King Jr., 34, related his vision for a more equitable America. King had flaws. (The FBI gathered personal dirt in an effort to shut him up.) But his strengths — passion, soaring language — pushed the civil rights movement over the top.

FRANCIS MILLER / LIFE

<

ETHICAL FOOD FIGHT

Unreconstructed Southerners (like these in March 1960 in Nashville) did not take kindly to the new civil rights strategy of passive resistance. Blacks would not leave whites-only lunch counters until served. Chains like Woolworth's (at whose Greensboro, North Carolina, store the first sit-in occurred) were too timid to do the right thing.

VIC COOLEY / NASHVILLE BANNER

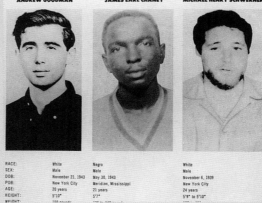

MISSING CALL FBI

THE FBI IS SEEKING INFORMATION CONCERNING THE DISAPPEARANCE AT PHILADELPHIA, MISSISSIPPI, OF THESE THREE INDIVIDUALS ON JUNE 21, 1964. EXTENSIVE INVESTIGATION IS BEING CONDUCTED TO LOCATE GOODMAN, CHANEY, AND SCHWERNER, WHO ARE DESCRIBED AS FOLLOWS:

	ANDREW GOODMAN	JAMES EARL CHANEY	MICHAEL HENRY SCHWERNER
RACE:	White	Negro	White
SEX:	Male	Male	Male
DOB:	November 23, 1943	May 30, 1943	November 6, 1939
POB:	New York City	Meridian, Mississippi	New York City
AGE:	20 years	21 years	24 years
HEIGHT:	5'10"	5'7"	5'9" to 5'10"
WEIGHT:			

MARTYRS TO THE CAUSE

The three, who were devoting the summer of 1964 to registering rural black Mississippians to vote, were last seen on a dirt road in Neshoba County. They had been stopped for speeding. Six weeks later, their tortured and bullet-riddled corpses were dug up near the town of Philadelphia. Seven locals were convicted, including the chief deputy sheriff of Neshoba County.

CORBIS / BETTMANN-UPI

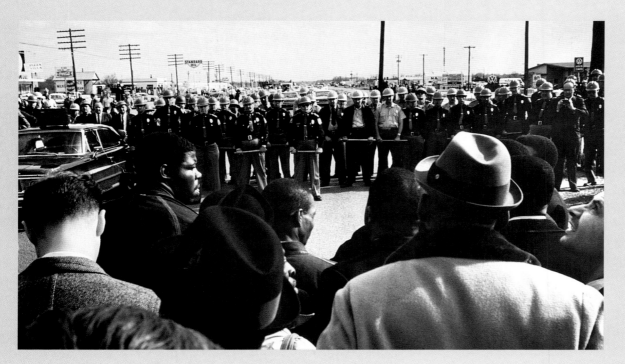

MARCH ON SELMA

Word obviously had not reached law enforcers in Selma, Alabama, that nine months earlier President Lyndon B. Johnson had signed the Civil Rights Act of 1964. The cops soon busted blacks trying to sign up to vote. Those arrests sparked several mass marches. (After one, the KKK shot dead civil rights worker Viola Liuzzo, 38.) That summer, Congress passed the Voting Rights Act of 1965.

FRANK DANDRIDGE / LIFE

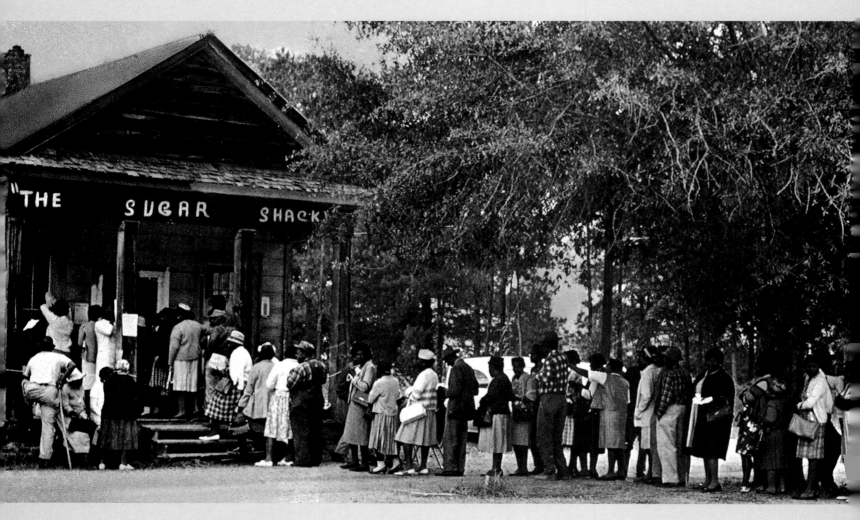

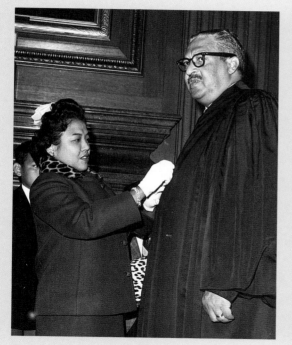

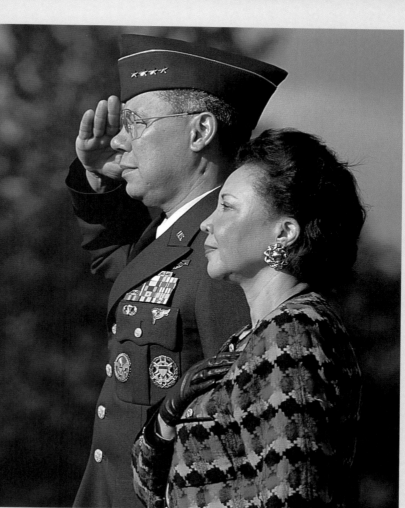

A U.S. BENCHMARK

On October 2, 1967, with a hand from wife Cecilia, Thurgood Marshall, 59, prepared to be sworn in as the Supreme Court's 96th — and first black — justice. His legal views were no mystery to LBJ, who named him, nor to the Senate, which confirmed him (by 69–11). Just 14 years earlier, Marshall had stood before the Court to argue the landmark *Brown* v. *Board of Ed.*

AP / WIDE WORLD

<

A SWEET VICTORY

Had this store in Peachtree, Alabama, ever drawn such a queue? But on May 3, 1966, they were there to vote, not to buy. Racial discrimination was now a federal crime, as were voter-competency tests and poll taxes. So for the first time, blacks of Wilcox County, who outnumbered whites by nearly three-to-one, had a say in how they were governed.

CORBIS / BETTMANN-UPI

ON THE ROAD AGAIN

He was easy to parody: the ear-catching speeches, briskly rhymed; the eye-catching photo ops, nicely timed. But the Reverend Jesse Jackson (above, 42, during his 1984 White House run) had an agenda beyond glory. His voter-turnout drives and can-didacies were a message to blacks that the ballot was theirs to use — or lose.

BRUCE TALAMON

TIME TO SMELL THE ROSES

Colin Powell, first black to head the Joint Chiefs, had overseen Desert Storm, so now, in 1993, with wife Alma, he gave the last salute of a 35-year career. The Army was still segre-gated as he grew up in New York during World War II. His time was Vietnam (10.5 percent of U.S. troops were black). Courted by the GOP to oppose Bill Clinton in 1996, he passed.

CYNTHIA JOHNSON / TIME

END OF A SCOURGE

In April 1955, Dr. Jonas Salk, 40, of Pittsburgh injected a schoolboy with his newly approved vaccine against the highly communicable disease polio. It was the culmination of eight years of research and field trials (first human guinea pig: himself). Salk's dead-virus vaccine, as well as Alfred Sabin's more effective live-virus version, approved in 1960, virtually eradicated the childhood scourge.

ALBERT FENN / LIFE

FAMILIAR YET SO NEW

The New York art world was in thrall to abstract expressionism when a Georgian hit town. In 1954, Jasper Johns, 24 (an admirer of Dadaist Marcel Duchamp), began to make deadpan paintings of common icons: the Stars and Stripes, targets, even numbers. A smash 1958 gallery show helped pave the road to Pop Art. In 1999, a Johns fetched $7.1 million at auction.

PETER STACKPOLE / LIFE

A RACE AGAINST TIME

Even Roger Bannister, a medical student as well as a premier British miler, wondered if the human body was built to run that distance in less than four minutes. But on May 6, 1954, the future neurologist, 25, became the first, breaking the tape in 3:59.4.

OXFORD DAILY MAIL

MADE FIRST IN JAPAN

In 1954's *The Seven Samurai* (co-starring Toshiro Mifune, right), feudal warriors save a rural village. The balletic battles staged by director Akira Kurosawa, 44, were soon copied. The plot, too (as *The Magnificent Seven*). A later Kurosawa picture became the spaghetti Western that made Clint Eastwood; yet another inspired George Lucas to create Princess Leia and droids R2D2 and C3PO.

©1954 TOHO CO. LTD.
ALL RIGHTS RESERVED.

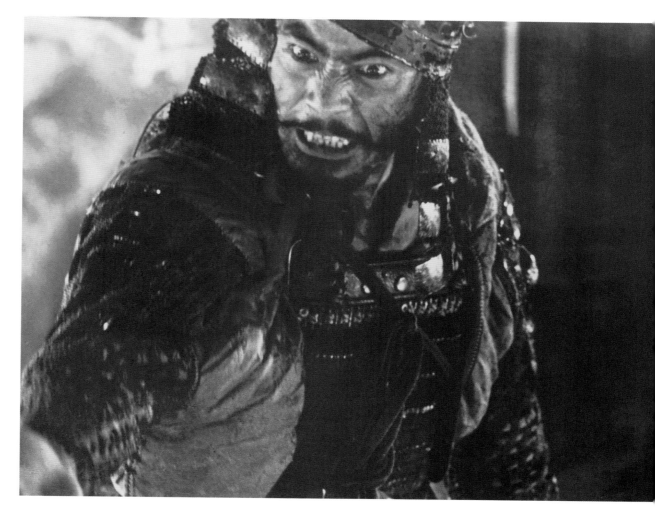

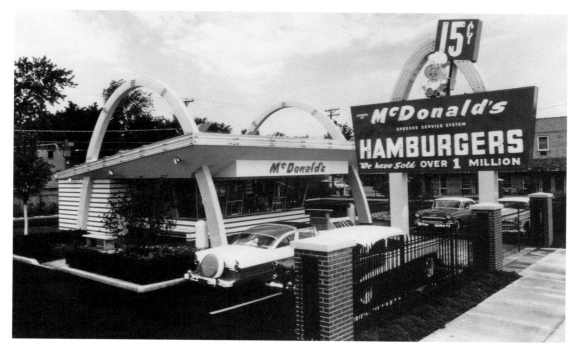

ARC DE GRAND MAC

Why were the owners of a single San Bernardino, California, drive-in (left) ordering so many milkshake makers from him? Ray Kroc, 52, flew out in 1954 to learn that the McDonald brothers — Richard, 45, and Maurice, 52 — were franchising their innovative fast-food techniques. An impressed Kroc bought in and later paid the burger kings $2.7 million for all rights.

CORBIS / BETTMANN

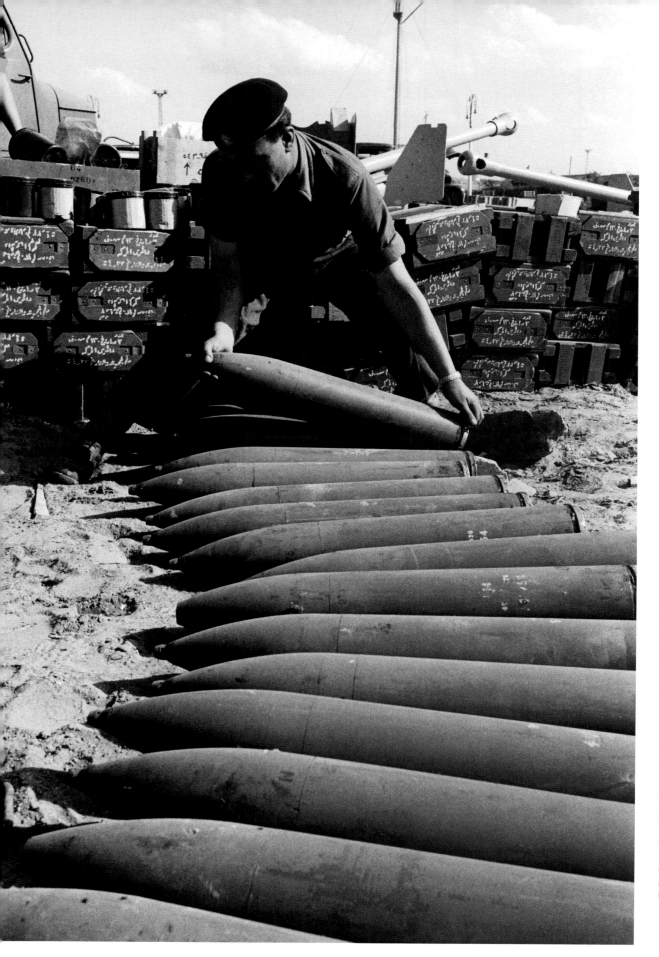

<

CRISIS AT SUEZ

In Port Said, on the 100-mile-long Suez Canal, a British soldier inspected a cache of captured Egyptian munitions. Three months earlier, Egypt's Gamal Abdel Nasser had seized the internationally run waterway. On October 29, 1956, Britain joined France and Israel in an attack to win it back. Their victory was short-lived. A month later, the U.S. and USSR, in a rare Cold War accord, backed sending in a U.N. police force to clear the canal zone of combatants.

CORBIS / BETTMANN / HULTON-DEUTSCH COLLECTION

>

CRISIS IN HUNGARY

The world's eyes were on Suez when, on November 4, 1956, Moscow rolled 2,500 tanks (above right) and 120,000 troops into Budapest. Hungarians, hoping to evict their Soviet overlords, had recently decapitated a statue of Stalin in their capital. Now they not only fought their invaders but also executed members of the hated secret police (right). The outgunned freedom fighters took a reported 10,000 casualties before giving in. The U.S., needing Soviet cooperation in the Middle East, did not intervene.

TOP RIGHT:
MICHAEL ROUGIER / LIFE
RIGHT: JOHN SADOVY / LIFE

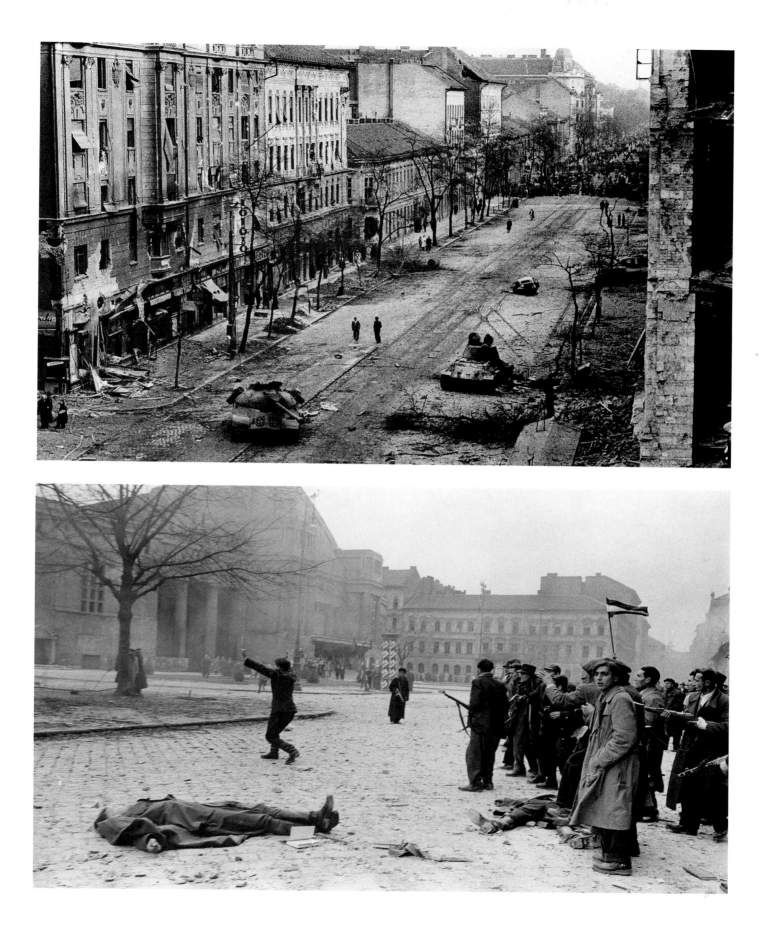

ROLL OVER, BEETHOVEN

The backbeat-driven sound sure riled the geezers, but there was more to it than that. Rock and roll had a musical inevitability. Back in 1947, Les Paul had taken a perfectly good guitar and stuck a cord in it. R&B had been Freed into white mainstream culture. But not until a movie director showcased a failed two-year-old single did rock reach critical mass. The movie: 1955's *Blackboard Jungle*, about juvenile delinquents. The song: "(We're Gonna) Rock Around the Clock" by Bill Haley and His Comets (above near left). The next year, Elvis Aron Presley, 21, of Tupelo, Mississippi, went gold with "Heartbreak Hotel" (left). The talented but haunted singer (older twin Jesse Garon was stillborn) redefined idolatry. In 1957, when Dick Clark, then 28, launched *American Bandstand* on national TV, not all chart toppers were rock (right). Soon they were. Clark continued on in an industry that — like Dorian Gray and some warhorse acts — would refuse to age.

TOP NEAR LEFT:
CORBIS / BETTMANN-UPI
LEFT: DON CRAVENS / LIFE
RIGHT: PAUL SCHUTZER / LIFE

UNCHAINED MELODIES

Alan Freed (here in 1959, at 33) is the man to laud — or damn — for midwifing the sound that swept the world. In 1951, while disc jockeying at a radio station in Cleveland, he began to spin 45s cut by rhythm-and-blues artists. His mostly white audience did not protest what was then called "race music." Freed gave it a more upbeat name, with help from the title of a 1947 R&B song by Wild Bill Moore ("We're Gonna Rock, We're Gonna Roll").

COSTA MANOS / MAGNUM

DIAL M FOR MARRIAGE

She went to the Riviera to film Hitchcock's *To Catch a Thief* — and caught a prince. In April 1956, Oscar winner Grace Kelly, 26, was wed to Rainier III, 32, ruler of Monaco, a 482-acre principality pirated from France by his Grimaldi forebears in 1297. She instantly brought class to a mecca for gamblers and tax cheats once described as "a sunny place for shady people."

THOMAS D. MCAVOY / LIFE

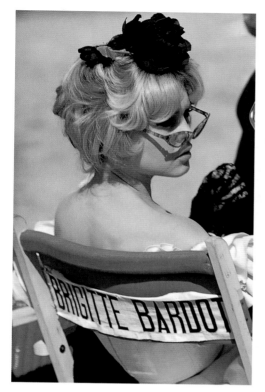

THE GAUL OF HER

Hollywood in the Fifties could be naughty *(Peyton Place)*, but nudity was a no-no. So imagine the long lines for *And God Created Woman*, a 1957 French import that spent zip on costuming starlet Brigitte Bardot, 23. The convent-schooled daughter of a Parisian industrialist hated her sexpot image — but remained true to form in some four dozen roles.

LOOMIS DEAN / LIFE

AN ANCHOR AWAY

On October 29, 1956, NBC gave John Cameron Swayze, its newsreader of seven years, a Timex and added a second chair. Soon, the grave Chet Huntley, 44 (above, left), in New York and the wry David Brinkley, 36, in Washington, D.C., were TV's top-rated newscasters. Their final sign-off ("Good night, Chet"; "Good night, David") came on July 31, 1970.

NBC

A HIT AND A MISS

Buoyed by demand for its two-seat Thunderbird (above left), unveiled in 1955, Ford went public. Gulp. In 1957, another rollout (left), developed at a cost of $250 million, caught no one's fancy. Only 110,000 Edsels had been sold when the company pulled the plug.

ABOVE LEFT:
AUTOMOBILE QUARTERLY
LEFT: CORBIS / BETTMANN-UPI

< COURTING GREATNESS

Surely, growing up in
Harlem, Althea Gibson
never expected to be feted
with a ticker tape parade
downtown. But in 1957, at
29, she had just become
the first black to win a
major singles tennis title,
the Wimbledon. (Nine
weeks later, Gibson added
the U.S. Nationals, now the
Open, crown.) By the time
the pro tour took root in the
late 1960s, alas, her game
was past its prime.

> BEFORE THE FALL

She went from nude calen-
dars to Hollywood B-icon:
the breathless, brainless
blonde whom gentlemen
preferred. Marilyn Monroe
sought more. In choicer
roles, as in 1959's *Some
Like It Hot*, she proved
herself one funny lady.
Personal happiness was
harder. After marriages to,
among others, Joe
DiMaggio and playwright
Arthur Miller (here, in
1956), she entered hapless
affairs with, among others,
JFK before OD'ing on drugs
in 1962, at age 36.

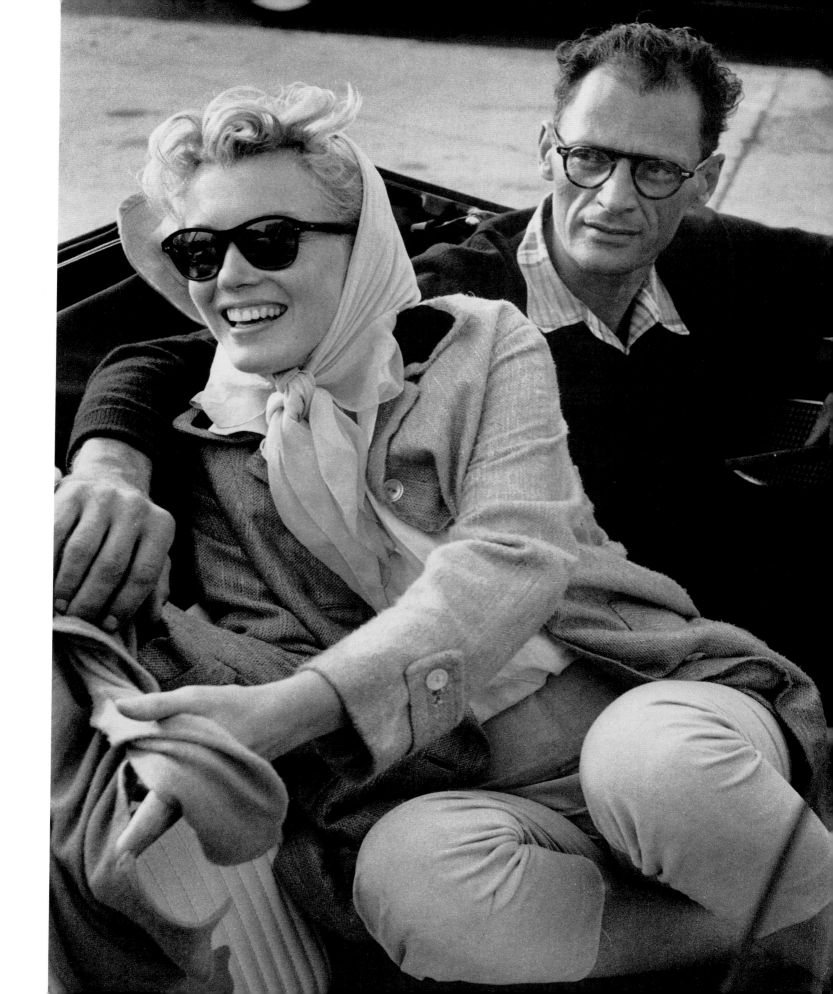

JUST ONE WORD: PLASTICS

The Hula-Hoop challenged were in the minority in 1958; 25 million sold, at $1.98 each, before the fad wound down. The previous year, the same company, Wham-O, had introduced another polystyrene novelty that would have more hang time: the Pluto Platter (soon renamed Frisbee).

ARTHUR SHAY / LIFE

MAY I BE YOUR FRIEND?

Like Venus, she arrived full blown (if anatomically incorrect). Like Gidget, she's got pals (Ken, Midge). Like Imelda, she's into shoes (one billion pairs and counting). Barbie Millicent Roberts made her debut in time for Christmas, 1959. Girlhood, as well as family budgets, has never been the same.

AP / WIDE WORLD

MIGHTY LIKE A ROSE

On October 4, 1957, the USSR launched into orbit *Sputnik I*, the first man-made satellite. The second, set for November 3, carried a passenger: a *laika* (not its name, but rather the Russian word for various husky breeds). The 13-pound dog survived its ascent into space aboard *Sputnik II*; the trip, alas, was one way.

SOVFOTO

SUDDEN DEATH, NEW LIFE

It may not have been the greatest pro football game ever, but Colts vs. Giants on December 28, 1958 (above), was the most important. The NFL championship riveted TV fans through four quarters — plus 8:15 of the first overtime in league history (final: Baltimore 23, New York 17). Madison Avenue decided the sport was hot; CBS locked in a long-term contract; and in 1960, ABC helped fund a rival league, the AFL.

HY PESKIN / SPORTS ILLUSTRATED

ENCORE, MON GENERAL?

A France roiled by chaos in 1958 reached back into history for help. Heeding the call: 6' 4" Charles de Gaulle. In World War II he led the Free French movement from exile. A string of weak governments since then had let slip France's colonial empire. (Vietnam bid adieu in 1954, North Africa was now in open revolt.) To restore calm, De Gaulle, 67, demanded extraordinary powers. He was granted them.

CORBIS / BETTMANN-UPI

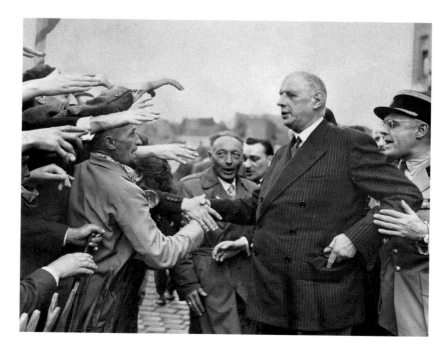

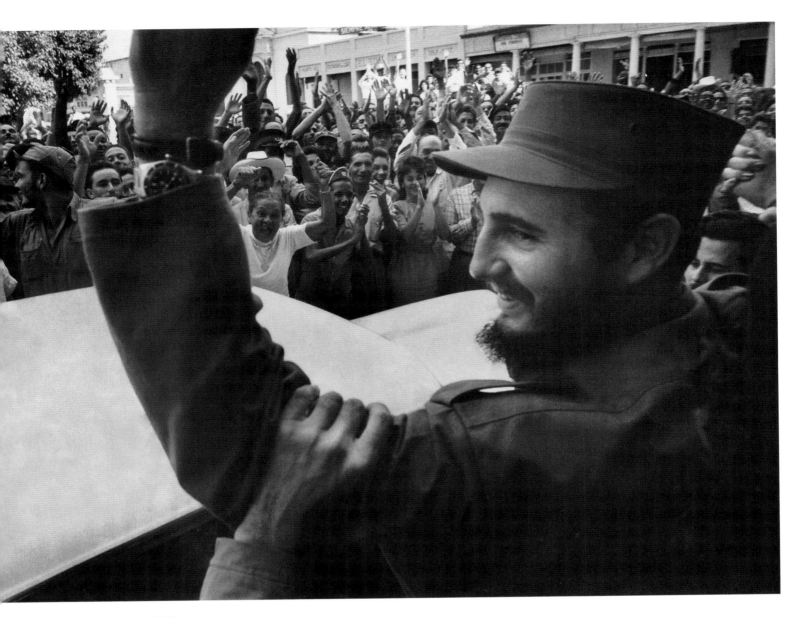

THE YANQUI CLIPPER

Only the important wear more than one watch. The man being cheered in Cienfuegos, Cuba, on January 8, 1958, was *muy importante*: At 31, lawyer turned rebel Fidel Castro had won control of his Caribbean nation after a three-year guerrilla war to oust Mafia-corrupted dictator Fulgencio Batista. Castro said he was an anti-imperialist, not a Communist. Who knew?

GREY VILLET / LIFE

NOT HIGH ENOUGH

America's new spy plane had extra-long 80-foot wings to let it photograph enemy sites from 13 miles up, in theory well above antiaircraft range. But the USSR celebrated May Day, 1960, by downing a U2 flying over Sverdlovsk. Its CIA pilot was supposed to chomp a poison pill. He didn't, so Francis Gary Powers fell to earth alive and gave the USSR a Cold War propaganda coup.

JOHN BRYSON

PARENTHOOD, PLANNED

Women of childbearing age queued at a public clinic in Charlotte, North Carolina, for the first birth-control pill to win Food and Drug Administration approval (in 1960). Enovid 10, a mix of the hormones progesterone and mestranol, was developed by endocrinologist Gregory Pincus and tested by gynecologist John Rock. Cost of a one-month supply: $11.

JIM MAHAN / LIFE

VENI, VIDI, VICI

Wasn't he the greatest? Out strolling the Via Veneto, U.S. Olympian Cassius Marcellus Clay Jr., 18, of Louisville, Kentucky, seemed as pleased as punch when Signorina Marisa Tropeana asked to admire the gold medal he'd just won at the 1960 Games in Rome. Next up for the light heavyweight: a professional boxing career.

AP

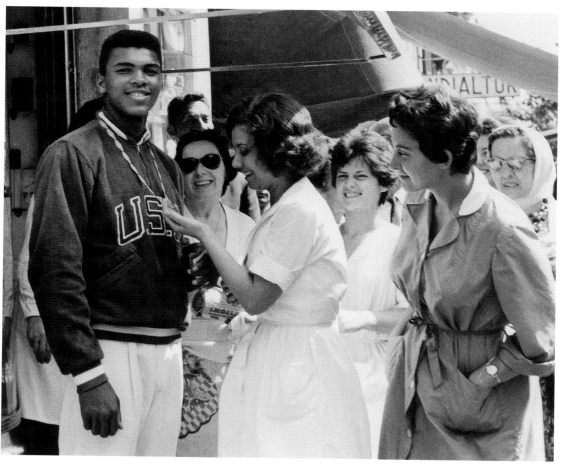

CHANGE OF RULE

A not unwelcome casualty of World War II was European colonialism. Powers great and small were too drained to keep aloft their imperial flags. (The British forfeited India, the Dutch gave up Indonesia.) But not until *uhuru* — freedom — swept across Africa did mapmakers panic. Between 1956 and 1963, 29 independent states came into being on the continent. Few were prepared for self-governance. In addition, many inherited borders drawn not by rivers and mountains but by colonial surveyors indifferent to age-old ethnic territoriality. Together, these factors proved the seeds of future grief.

BATTLING THE MAU MAU

From 1952 to 1956, paramilitants like these were the law in Kenya. The British colony in East Africa was fighting an insurrection led by native Kikuyu who called themselves Mau Mau. Though the revolt was quelled by colonial volunteers and foreign mercenaries, Britain in 1963 granted Kenya its freedom.

ALFRED EISENSTAEDT / LIFE

REVERSALS OF FORTUNE

On August 15, 1960, on the day French Congo became, simply, Congo, a native of Brazzaville donned traditional regalia to celebrate with a French *colon* (above). The neighboring Belgian Congo, to the south, had gained independence six weeks earlier. But by 1964, the former French colony was in the Communist camp and the former Belgian colony in the midst of a gruesome civil war.

TERRENCE SPENCER / LIFE

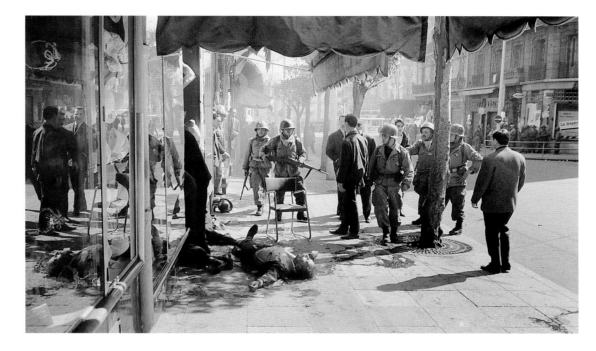

LA GUERRE EST FINIE

Almost four years after France called on Charles de Gaulle to solve its Algerian crisis, the North African colony was still a battle zone (right, a death in Algiers). Refusing to let go was a coalition of *pieds noirs*, or longtime colonizers, and right-wingers in France itself. De Gaulle finally set a pullback for mid-1962. Some 1.4 million Europeans fled Algeria while the Muslim majority (below) ratified the nation's independence.

RIGHT: PARIS MATCH
BELOW: DALMAS-SIPA PRESS

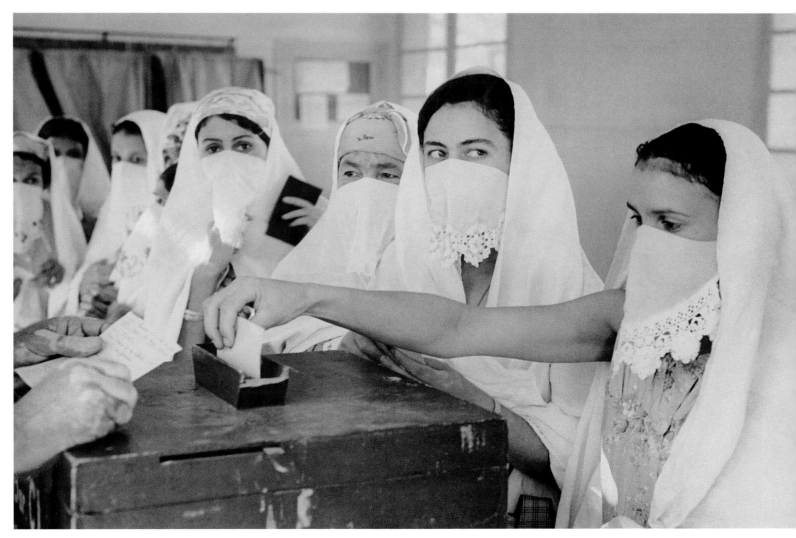

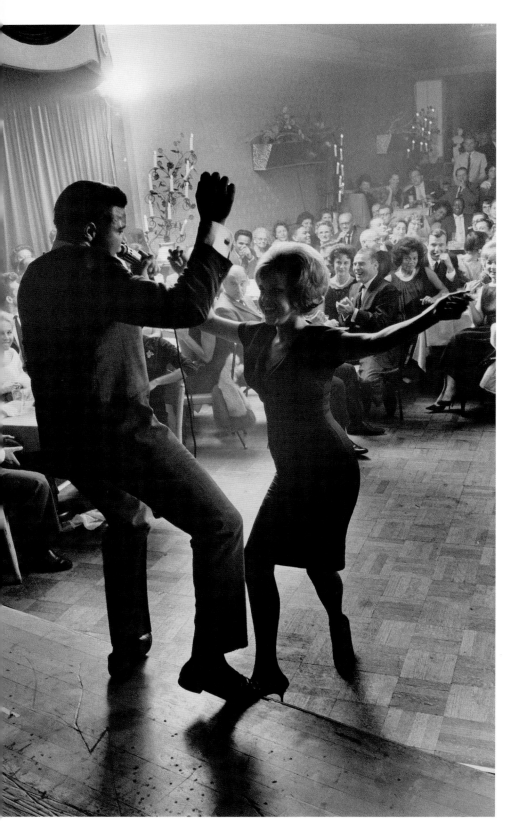

COME ON, LITTLE MISS . . .

That was no typical rock crowd packing a Hollywood boîte in 1961 but devotees of America's hottest singer, Ernest Evans, a.k.a. Chubby Checker, 20 (showing a patron how to do the new fad, the Twist). An easy step for the Hula-Hoop generation, it set off an intense, but brief, spate of weird dances. Remember the Bristol Stomp, the Loco-Motion, the Freddie?

RALPH CRANE / LIFE

AN ELECTION TO SWEAT

In 1960, thanks to the two-term Constitutional limit, a vacancy sign went up at 1600 Pennsylvania Avenue. The two major-party rivals agreed to a series of face-offs (above) meant to evoke the Lincoln-Douglas debates of 102 years earlier. These, though, were aired nationally. Radio audiences gave the edge to Vice President Richard M. Nixon, 47. TV audiences noted his five o'clock shadow, his perspiration, and favored the more stylish Senator John F. Kennedy, 43. Perhaps the medium was indeed becoming the message. JFK won 118,550 more votes (out of 68.8 million).

ABOVE: PAUL SCHUTZER / LIFE
RIGHT: ED CLARK / LIFE

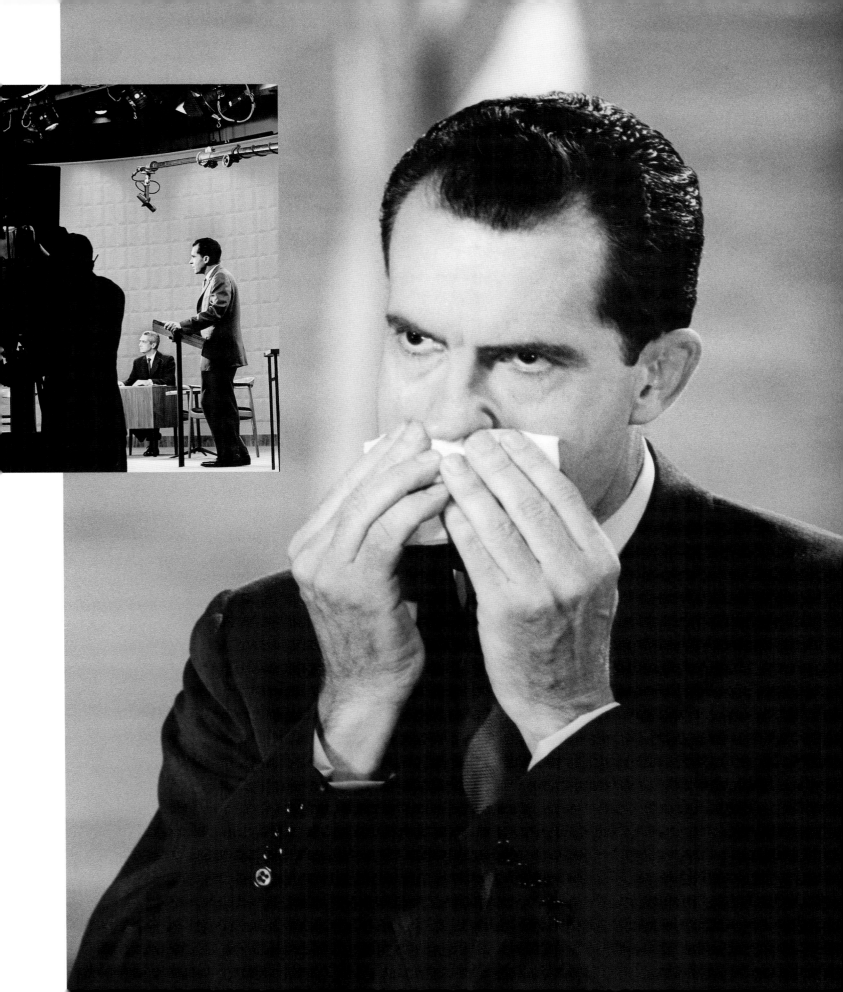

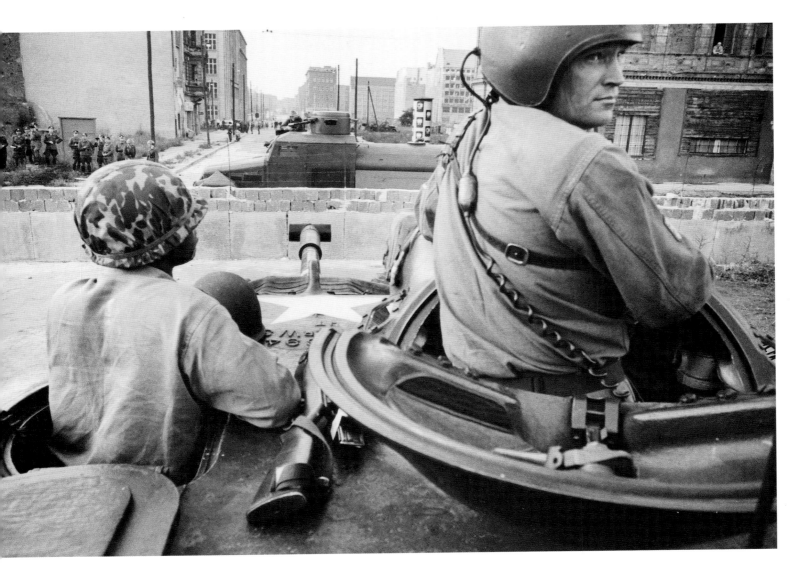

BRICK BY BRICK

In August 1961, GIs and East German troops confronted each other across the crude wall being built by the Communists to bisect Berlin. Reason: Too many East Germans were fleeing to the West via the Allied-run sector of this partitioned city. The Wall was an instant Iron Curtain icon; in 1963, it played a key role in John le Carré's breakthrough thriller, *The Spy Who Came In from the Cold*.

PAUL SCHUTZER / LIFE

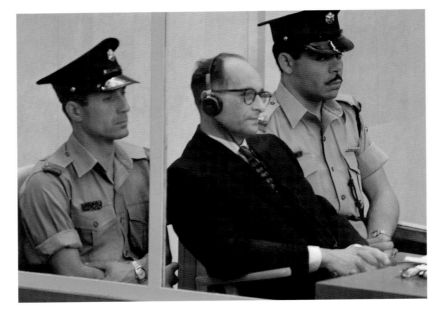

A COUNTRY'S REVENGE

A year earlier, the man in the glass booth had been at liberty in Argentina. Now, in 1961, Adolf Eichmann, 55 (with headset, left), sat in a Jerusalem court facing charges of genocide. His kidnapping had drawn global criticism, which Israel ignored. Eichmann, overseer of Hitler's extermination of Europe's Jews, was judged guilty and hanged the following May.

GJON MILI / LIFE

THE HIGH FRONTIER

The first human in space:
Soviet cosmonaut Yuri
Gagarin, 27 (left), two days
after his April 12, 1961,
mission. Welcoming him
in Moscow was Nikita
Khrushchev (as future
premier Leonid Brezhnev,
54, hovered in the back-
ground). Gagarin's craft,
Vostok I, hit 17,400 mph
on the 89-minute flight.
That May 5, astronaut Alan
Shepard Jr., 37 (inset),
became the first American
in space. He rode *Free-
dom 7* to an altitude of
115 miles but did not orbit
the planet, as had Gagarin.
Although the U.S. was
playing catch-up, JFK
boldly vowed to put an
American on the moon by
the end of the decade.

JAMES WHITMORE / LIFE
INSET: NASA

273

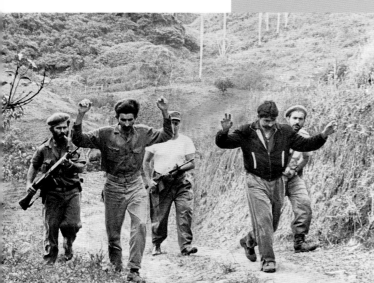

A RECIPE FOR SAUSAGE

During Ike's last, lame-duck months, his CIA set up covert camps (mostly in Florida, right) to train anti-Castro exiles yearning to reclaim Cuba. An invasion date was set. JFK had been in the Oval Office less than three months when he reluctantly green-lighted the strike (while vetoing U.S. air support). On April 17, 1961, 1,500 paramilitants waded ashore at the Bay of Pigs. Three days later, 400 were dead and the rest captured (above). Castro, until then a professed anti-imperialist, declared himself a Communist.

ABOVE:
DOCUMENTATION ROGER PIC
RIGHT: LYNN PELHAM / LIFE

DESTINATION: CUBA. COURSE: COLLISION

At their first summit, in 1961 in Vienna, Soviet premier Nikita Khrushchev judged John F. Kennedy to be weak. The next summer, he began arming new ally Fidel Castro with medium-range ballistic missiles. On October 14, a U.S. spy plane photographed launch sites under construction. On the 22nd, JFK ordered an air and sea quarantine of Cuba. It took six days of angry negotiations, by way of intermediaries, letters and telexes, before Khrushchev caved and agreed to take back the weapons. (A Soviet freighter carrying home missiles was escorted by a U.S. warship, below.) Shaken by their close brush with nuclear war, the superpowers, in 1963, installed a hot line between Moscow and Washington.

RIGHT: ARTHUR RICKERBY / LIFE; BELOW: CARL MYDANS / LIFE

INVISIBLE TERRORS

Biologist Rachel Carson could also write; witness *The Sea Around Us*, her 1951 best-seller. Ten years later, at 54 (above), she finished another book. It eloquently examined how pesticides like DDT, in use only since the 1940s, were contaminating the food chain. *Silent Spring* led to a U.S. ban on most uses of DDT in 1972, eight years after Carson's death. It also sparked a global rethinking of man's place in the ecological scheme.

ALFRED EISENSTAEDT / LIFE

BUT THE MODEL WAS CHEAP

Cezanne painted a wine bottle, and no one blinked. Yet people howled at the canvases of Andy Warhol (right, painted in 1963, when the Pittsburgh native was 35). That many of his works seemed straight out of a supermarket flyer was precisely the point; if nothing else, Pop Art was fueled by artistic irony.

THE ANDY WARHOL FOUNDATION / ART RESOURCE

A TRAGIC RUSH TO MARKET

The German girl at right was born armless because of a sedative, popular in Europe, taken by her pregnant mother. But thalidomide never made it to the U.S. The FDA, for want of key test data, kept rejecting the drug until its side effects were clear (from 1959 on, 3,000-plus babies with defects in Germany and Great Britain).

STAN WAYMAN / LIFE

>
TWO EMANCIPATORS

Enfranchisement was not the same as emancipation, argued 42-year-old writer turned housewife Betty Friedan in her 1963 best-seller, *The Feminine Mystique*. It joined 1949's *The Second Sex*, by French existentialist Simone de Beauvoir, in rejecting the notion that biology was destiny — and thus mothered America's Women's Lib movement.

STEVE SCHAPIRO / LIAISON

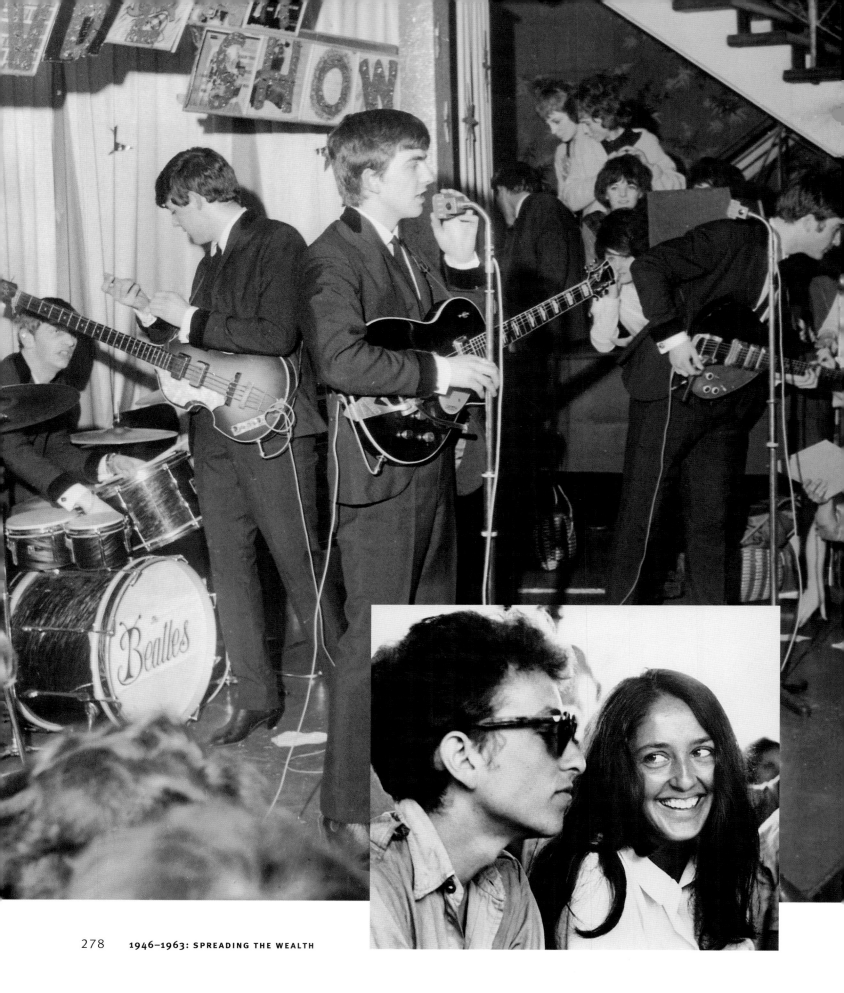

> **SOME FUNNY GIRL**

Barbra Streisand, 20, was just a kooky singer from Brooklyn when she guested on *The Tonight Show* in early 1963. But then, Johnny Carson, 38, had eased into the host's seat only four months earlier; most TV fans still knew him as the emcee of an afternoon quiz show, *Who Do You Trust?* Stardom was two years off for Babs. Retirement was 29 years off for Johnny.

BILL EPPRIDGE / LIFE

< **FOR OUR NEXT NUMBER . . .**

Band's name? Cute. New drummer? Seems to be working out. Haircuts and stage attire? Need work. Footwear? Puleeeze! The year was 1963, the venue Liverpool's Cavern Club. John, 22, George, 20, Paul, 21, and Ringo, 22, were doing fab in Europe. Most Americans, though, thought a Beatle was a German car — until January 1964, that is, when "I Want to Hold Your Hand" crossed the Pond.

KEYSTONE

< **THE LION WEEPS TONIGHT**

The old folkie's home beckoned hum-and-strum acts like the Kingston Trio after a 1963 hootenanny in Newport, Rhode Island, led by (inset) Joan Baez, 22, and Bob Dylan, 22. As if sensing which way the Sixties were blowin', the writer-singers revived the social consciousness of such fabled balladeers as Joe Hill, Woody Guthrie and the Weavers.

DAVID GAHR

A STILT SHALL LEAD THEM

Bevo Francis and Frank Selvy did it against hapless college foes. But no pro hit the century mark in one game until March 2, 1962, when 7' 1" Philadelphia Warrior Wilt Chamberlain, 26, eased in points 99 and 100 (left) against the New York Knicks in Hershey, Pennsylvania. Next best NBA single night's work: Wilt with 78 points.

AP / WIDE WORLD

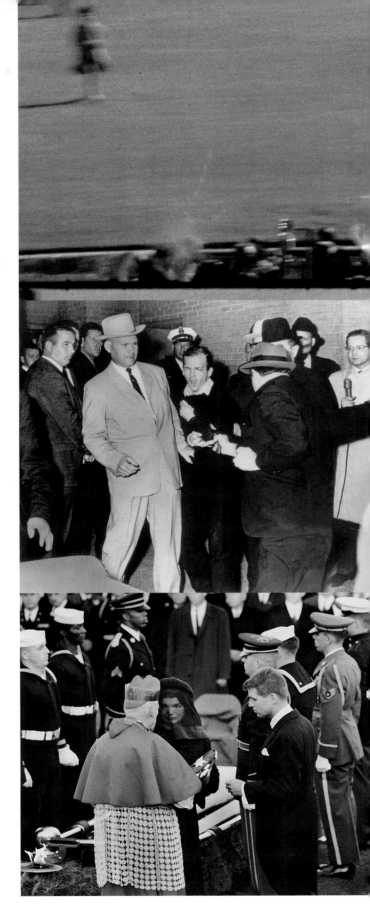

DEATH OF A PRESIDENT

The couple at ease shortly before their 1953 wedding (left) seemed even more chic a decade later as they arrived in Dallas (inset). JFK, 43, wanted to mend a few political fences before the 1964 election; Jacqueline Bouvier Kennedy, 34, had joined him despite her aversion to politics. They set off by car for a rally downtown. At high noon, the motorcade passed through Dealey Plaza. From the sixth floor of a warehouse on the square rang three shots. The last bullet shattered the president's head (top right); 30 minutes later, he was pronounced dead. Dallas police soon arrested a warehouse worker. Lee Harvey Oswald, 24, was a troubled ex-Marine marksman who on quitting the corps tried, in vain, to become a Soviet citizen. The day after Oswald's arraignment, he was slain — on live TV (middle right) — by Jack Ruby, a Dallas strip-joint owner with mob ties. Even as conspiracy theories emerged to explain this stunning series of improbable events, Mrs. Kennedy was back in Washington (bottom right, with Robert F. Kennedy, 38), burying her husband.

CLOCKWISE FROM LEFT: FRANK JURKOSKI / CORBIS / BETTMANN-INP; ART RICKERBY / LIFE; ABRAHAM ZAPRUDER; BOB JACKSON / DALLAS TIMES HERALD; HENRI DAUMAN

REQUIEM

<

LES FRERES LUMIERES
1862–1954, 1864–1948

Their surname, in French, means "light," which the brothers became the first to capture on a length of film — and then project back onto a screen as pictures that moved. Auguste, far left, and kid brother Louis exhibited the first movie (of their factory at quitting time) in 1895. It took 32 years to add *son* to *lumière*.

TIME INC.

>

JIM THORPE
1888–1953

A football All-America at Carlisle Indian Industrial School in Pennsylvania, he also won the pentathlon and decathlon at the 1912 Stockholm Games — only to forfeit the medals after it was learned he had played semipro baseball. Those golds were restored to Thorpe's family in 1983.

CULVER PICTURES

<

EUGENE O'NEILL
1888–1953

He fled his dysfunctional family by going to sea, but then tuberculosis landed him in a sanatorium. At 24, O'Neill began writing plays. Into such tragedies as *The Iceman Cometh* and *Long Day's Journey into Night*, he poured his personal anguish; they earned him a 1936 Nobel and revolutionized American drama.

HORACE BRISTOL /
CORBIS / BETTMANN

MARGARET MITCHELL
1900–1949

While recovering from an ankle injury in 1926, the ex-journalist started work on a Civil War novel. It would take more than twice as long to complete as the conflict itself. *Gone with the Wind* was an instant best-seller and won the author a Pulitzer, yet she never wrote another book. Mitchell died in her native Atlanta, run down by a drunken driver.

CORBIS / BETTMANN-ACME

SINCLAIR LEWIS
1885–1951

As a struggling writer, he peddled plots to Jack London. Then came 1920's *Main Street*, a caustic portrait of his hometown, Sauk Centre, Minnesota. In that and following novels, he skewered Yankee provincialism; Babbitt became synonymous with mindless conformity. Lewis declined a Pulitzer in 1926 but not a Nobel in 1930.

ALFRED EISENSTAEDT / LIFE

GARY COOPER
1901–1961

During a break from starring in Hollywood's 1932 adaptation of Ernest Hemingway's *A Farewell to Arms*, Cooper traded hunting tips with the author (far right). Of the actor's 90-plus movies, the most memorable — from *The Virginian* to *High Noon* — reflect his laconic youth on a ranch in Montana.

ERNEST HEMINGWAY
1899–1961

His weapon of choice was the pen, his R & R of choice women, hunting and fishing (not necessarily in that order). The fatalism he brought to tales of combat, bullfighting and the pursuit of big game, as well as his lean prose style, pointed American novelists in new directions. Too macho to abide his burly body's aging, Hemingway ended his own life with a shotgun.

ROBERT CAPA / MAGNUM

GEORGE BERNARD SHAW
1856–1950

Prescient in his political correctness, he believed in socialism, feminism and vegetarianism (and a 42-letter alphabet to simplify spelling). The Irish-born Protestant promoted most of his causes in pointed social comedies such as *Pygmalion*, the basis for *My Fair Lady*. Offered many honors in his lifetime, Shaw accepted only one (a 1925 Nobel, so he could give the cash to the Anglo-Swedish Literary Alliance).

RALPH MORSE / LIFE

RAYMOND CHANDLER
1888–1959

His day jobs were straight (accountant, oil company exec); his imagination was noir. He used his fictional alter ego, L.A. private eye Philip Marlowe, to dig beneath the city's sunny facade and stare unblinkingly at the rot. *The Big Sleep*, *The Long Goodbye* and other hard-boiled Chandlers led to many an imitation. Most came out just plain overcooked.

RALPH CRANE / LIFE

EVA PERON
1919–1952

Her acting won no praise, but it led the Buenos Aires native out of poverty and into the plum role of First Lady of Argentina. Evita's generous social programs endeared her to the masses and sealed support for dictator husband Juan. Her own loyalty was boundless. Left too weak from cancer to stand, she was once wired-and-plastered upright, then camouflaged the brace under her flowing mink coat.

MICHAEL ROUGIER / LIFE

ALBERT CAMUS
1913–1960

Even while editing an underground paper for the French resistance, the Algerian-born journalist found time to write *The Stranger*. The novel, whose fatally disaffected antihero personified existentialism, won worldwide acclaim. Subsequent works reflected the anxieties of postwar Europe so precisely that Camus was given a Nobel three years before his death in a car accident.

LOOMIS DEAN / LIFE

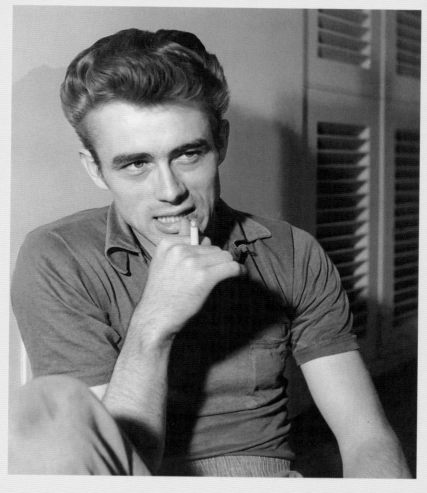

JAMES DEAN
1931–1955

In life a star, in death he inspired a cult to rival Valentino's. The Hoosier began acting in his teens. The brooding volatility he projected in live TV dramas and on Broadway led him west to make *East of Eden* and *Rebel Without a Cause*. Dean died in character: He totaled his Porsche before the release of his third and final movie, *Giant*.

LARRY FRIED / TIME INC.

ROBERT FROST
1874–1963

Rejected by U.S. publishers, the poet went to London where, with the help of Ezra Pound, his first book was released in 1913. By the time he came home, his verses on rural New England had won him fans on both sides of the ocean. Despite his celebration of the farming life, it really wasn't for him: Frost milked his cows at night so he could snooze in the morning.

HOWARD SOCHUREK / LIFE

ALBERT WOOLSON
1847–1956

He had banged that same drum far more quickly as a member of the First Minnesota Regiment, Heavy Artillery. At 106, he picked up the sticks (above) only to amuse little Frances Kobus, 3. Woolson died three years later, the last of the 3.1 million who had worn the Blue or the Gray in the American Civil War.

AP / WIDE WORLD

FRANK LLOYD WRIGHT
1867–1959

Forging a distinctly American style of architecture was the raison d'être of Wright, here at Taliesin West, his winter home and studio in Arizona. Though an early advocate of mass-produced construction materials, he had a gift for making buildings seem to emerge organically from their sites. His love of free-flowing interiors is evident in New York City's spiraling Guggenheim Museum.

ALLAN GRANT / LIFE

BILLIE HOLIDAY
1915–1959

The self-taught singer transcended a grim childhood in Baltimore to reign as the supreme jazz vocalist of her era. Lady Day toured with the bands of Count Basie and Artie Shaw and, with saxophonist Lester Young, cut a stack of LPs good until the end of time. Her own time came too early: She was a casualty of heroin.

GJON MILI / LIFE

HANK WILLIAMS
1923–1953

His songs about lyin', cheatin' and drinkin' won the failed rodeo rider a home at Nashville's Grand Ole Opry. Though the hillbilly Shakespeare read no music, his own ballads were soon covered by such mainstream artists as Jo Stafford and Tony Bennett. Williams's own vices undid him; drugs and alcohol are suspected of triggering a fatal heart attack.

AP / WIDE WORLD

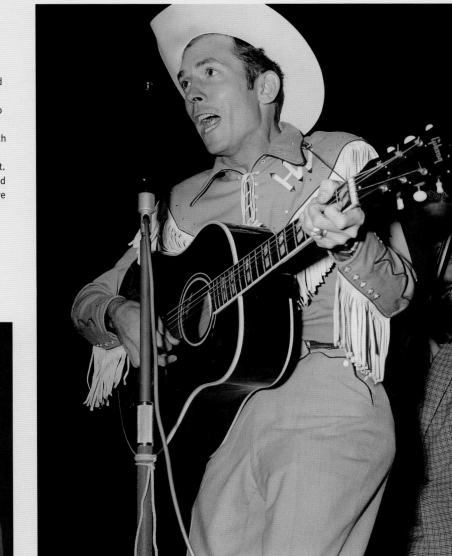

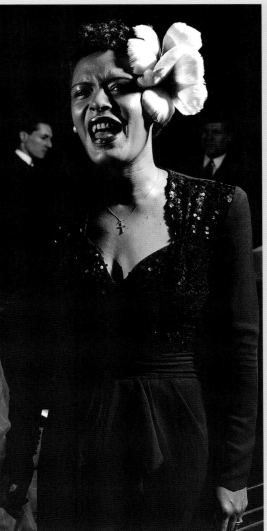

By April 29, 1975, the U.S. was evacuating its nationals (and a few foreign friendlies) one by one out of Vietnam. The next day, Saigon, scene of this airlift, fell to the Communists, who renamed it Ho Chi Minh City.

HUBERT VAN ES / CORBIS / BETTMANN-UPI

1964–1975

DISSENT AND DISOBEDIENCE

Choosing Sides in a Culture War

BY TODD GITLIN

THE ADAGE GOES, "If you say you remember the Sixties, you weren't there," meaning that if you really had been authentically "there," then drugs or rage or bitter disappointment or some other excess was bound to have shredded your memory. But the adage is wrong. For in a real sense, everyone old enough was "there," whether they knew it or not. Everyone old enough — every one-time dissenter, every onetime opponent of dissenters, every bystander, that is to say, everyone — is either gripped by some memory of the convulsions of the Sixties or is ducking them. All kinds of wild notions about those convulsions are the stuff of selective memory and sloganmongering partly because the convulsions ran so deep. This is why people still turn present-day political disputes into debates about the meaning of the Sixties and watch Sixties miniseries and dress up for Sixties parties and listen to Sixties music — or despise all of the above. When I was in college, in the early Sixties, I never heard anyone debating the Thirties or bemoaning the fact that they missed the Thirties or going to Thirties movies or dressing up for Thirties parties or listening self-consciously to Thirties music.

The Sixties are still in play, still vivid with controversy, still cherished and resented because so much dust got kicked up and no one was immune. The Sixties amounted to one collision after another, as if the culture were an enormous pile of fissionable material and each collision shook loose particles that collided with other particles until the entire society was undergoing a chain reaction.

When the young Mario Savio, leading thousands of Berkeley students into a sit-in on December 2, 1964, told them, "There is a time when the operation of the machine becomes so odious, makes you so sick at heart, that you can't take part, you can't even passively take part, and you've got to put your bodies upon the gears and upon the wheels, upon the levers, upon all the apparatus, and you've got to make it stop," he was speaking from the heart of the civil rights movement, which spoke of "putting your body on the line." He was also speaking from the civil disobedience tradition — as American as Henry David Thoreau — that runs like a red thread from Thoreau to Leo Tolstoy to Mohandas Gandhi to Martin Luther King Jr. and the Southern black students who started sitting in against racial subjugation. Most veterans of that era loathe the reckless violence and ideological caricatures that polluted it — the chants of "Off the Pig," the campus bombings, the ambushes by and of police and, not least, the assassinations. But even someone, like myself, who distinguishes between the constructive and destructive elements must wonder whether we can cherish the achievements — greater racial justice, greater freedom for women and gays, greater reluc-

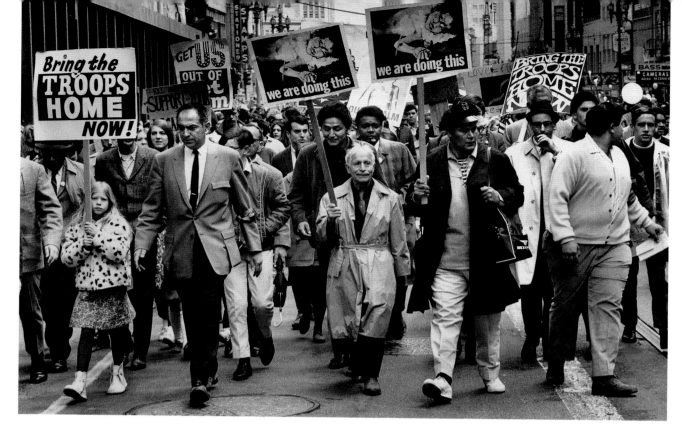

Not only the usual better-Red-than-dead coalitions opposed U.S. action in Vietnam; these San Franciscans stopped downtown traffic in April 1967. By then, 440,000 Americans were in Big Muddy.

RALPH CRANE / LIFE

tance to use national violence — without recognizing that the passions of change, once unleashed, do not easily know where to stop.

Today it is commonly said that the Sixties were a time when individualism ran amok, when the sense of larger loyalties melted down and reckless narcissists clamored Me, me. Tom Wolfe, with his gift for caricature, spoke of the "Me Decade." To Newt Gingrich, the Sixties represented a watershed in American history, for between 1607 and 1965, he said just after ascending to the Speakership of the House in 1995, "there is a core pattern to American history. Here's how we did it until the Great Society messed everything up: Don't work, don't eat; your salvation is spiritual; the government by definition can't save you. . . . From 1965 to 1994, we did strange and weird things as a country. Now we're done with that, and we have to recover. The counterculture is a momen-

tary aberration in American history that will be looked back upon as a quaint period of Bohemianism brought to the national elite." But anything that can be said simply about that decade is false. Conservative caricatures are no fuller than any others, and these miss the truth that the individualist streak co-existed uneasily with a streak of solidarity, so we might just as well speak of the We Decade.

There were many We's. The We in "We shall overcome," the strongest anthem of the civil rights movement, meant We who believe in racial equality, and later, We Negroes, and later still, We blacks, and eventually, We African-Americans. Soon came the We of the student movement, the We of the movement against the Vietnam War, the We of the hippies or freaks — the Age of Aquarius or the counterculture, as outsiders called them, fused into the semblance of tribes, devoted to drugs and sexual experiments and non-Western religious auras, laden with more or less vague hopes of transcending mundane modern existence. With the revelation of how fragile was the consensus cementing conventional

America, there came We Chicanos, We Native Americans, We Asian-Americans. Then came, as women moving into colleges and workplaces ran up against male insults and restrictions, what the English theorist Juliet Mitchell called "the longest revolution" — the We of the women's movement, the sisterhood that affirmed, through many variations, that women were, in an important sense, as Simone de Beauvoir had put it, "made, not born"; that freedom for women was a touchstone of human equality. Then the We of homosexuals, gays and lesbians, perhaps most threatening of all to bedrock assumptions about human identity. Then the environmental movement, kicked off on Earth Day, April 22, 1970, an offshoot of student protests (suspected by radicals, at that, of draining energy from the antiwar cause).

Each of these movements started small, with little groups of militants. Most of the origins took place far from the glare of the media. In the case of women, solidarity was kindled in small face-to-face sessions that the women's movement called "consciousness-raising groups," by which it meant getting together to understand personal experiences of denigration and abuse as forms of systematic oppression. That technique flourished in many circles, including therapies and religions. Over time, each We tended to harden, to accentuate the differences between one camp and the other. Radicals despised liberals, whom they blamed for the Vietnam War, for insufficient commit-

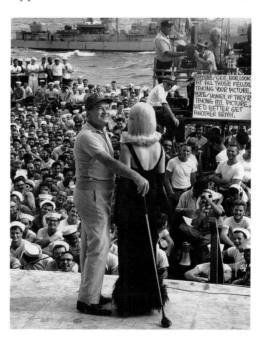

At 62, Bob Hope was still on the road to the next yuk. The gobs aboard USS *Fort Ticonderoga* in January 1966 enjoyed an act the comic (who enlisted in the USO in 1941) had bravely performed in various theaters of World War II and Korea.

CORBIS / BETTMANN-UPI

ment to equality and for affluence-soaked complacency overall. Each We tended over time to repel, or neglect, all those who stood outside its circle. In August 1968, at the end of the Democratic National Convention in Chicago, demonstrators felt exhilarated for having survived the police mayhem, indifferent (or contemptuous) of the majority who, watching the mayhem on TV, sided with the police, prefiguring the Republican victory of Richard M. Nixon, with his appeal to law and order — an appeal that ended ignominiously with a flurry of illegal actions, known generically as Watergate but mainly designed to suppress the movements Nixon feared and despised.

The war in Vietnam became America's longest during Nixon's first five years in office as he, still bombing, was phasing out American fighters. Eventually, more than 58,000 U.S. troops were dead and more than three million Vietnamese in armies, hamlets and cities, in a war that extended back to the Eisenhower Administration and that nearly everyone felt, in the end, had snapped something in American life, the only question being just what.

In Vietnam, the Cold War glowed napalm-hot, and throughout this period the East-West confrontation remained a nuclear danger, though by the end arms control agreements had also become routine. Amid such a drastic atmosphere, strange it is to imagine a time when love could be thought of as a social principle, pleasure a public act. "Make love, not war" was perhaps the definitive slogan. The sense of utopian possibility coexisted with the apocalyptic sense that we were all, in the words of P.F. Sloan's

1965 rock hit, "on the eve of destruction." Self-indulgence flourished, as did the sense that a new world was, or had better be, at hand. Psychedelic drugs, sexual liberties (for men, and eventually for women, thanks in no small part to the Pill and the overturning of anticontraception and antiabortion laws), musical extravagance — any initiative might do. Individual choice was enshrined, and who knew what might start the world all over again? In the slogan of the women's movement, the personal was felt to be political.

The Sixties were far, far more than their dissenters and disobeyers. Alongside the New Left, a sort of helix winding around it, the conservative movement grew. The Goldwater campaign of 1964 was defeated in the short run but sprang loose the two-term California governorship of Ronald Reagan — a campaign waged, in significant part, against student militants and countercultural upheaval — followed, years later, after left-of-center reformers failed, by Reagan's ascendancy to the presidency at the helm of a coalition of business conservatives and moralists running against the Sixties. The Sixties were also the era of religious revival among Protestant evangelicals, African-Americans and many others. The search for one or another orthodoxy, one or another revitalized principle of authority, gained momentum against the instability, doubt and flux that had become normal. Newt Gingrich's own excess was a product of the decade he professionally deplores. So was his enthusiasm for technical solutions to social problems, from the moon landing to the personal computer.

Authority and the revolt against authority, rebellion and counterrebellion, sexual liberty and its threat to the order of things, assertions of rights by members of despised groups, followed by counters from everyone else — these are old themes in American life. America, a child among nations, proved a young rebel again, and a rebel with lessons to teach,

Only 26 percent of America backed his Vietnam policy. Still, the March 31, 1968, address to the nation by President Lyndon B. Johnson, 59, was a stunner. He ended it by saying he would not seek another term.
ALFRED EISENSTAEDT / LIFE

as moral upheavals during this decade found fervent reverberations around the globe, thanks in part to the glare of the media spotlight.

There have been few periods in history when so many assumptions have been shaken so fast in so many parts of the world. When convulsions this many and fierce set in — as with the Protestant Reformation, the French Revolution and World War I — it takes decades to sort out the consequences. After revolution comes reaction. After reformation comes counterreformation. After the Sixties came backlash, reform and anxiety. This is why, a full generation after the fact, the very name of that decade spurs fervent disputes — echoes of the original collisions.

Todd Gitlin is a professor in the departments of culture, communication, journalism and sociology at New York University. He is the author of eight books, including The Sixties: Years of Hope, Days of Rage *(1987) and a recently published novel,* Sacrifice.

HE WILL BURY WHO?

A mote got into Nikita Khrushchev's eye in October 1964. Days later, it was a stick; the Kremlin ousted its premier after six years both turbulent (the Cuban missile crisis) and buffoonish (at a U.N. meeting, he banged on the desk with one of his shoes). Yet Khrushchev, 70, was the first Soviet leader to leave office alive. He and wife Nina finished their days at a dacha near Moscow.

HENRI DAUMAN

ACHTUNG! WAR IS FUNNY!

Peter Sellers's Dr. Strange-love, title character of the 1964 Stanley Kubrick Cold War satire, is a German now advising the Pentagon ("He's *our* Nazi"). This lampoon of the nuclear arms race is not subtle; other characters are named Merkin Muffley (also played by Sellers), Buck Turgidson, Bat Guano. But it did uncork a considerable supply of precious bodily fluids — tears of laughter.

ARCHIVE PHOTOS

THE MOUTH THAT ROARED

By KO'ing Sonny Liston in March 1964 (below), Cassius Clay became, at 22, world heavyweight champ. Soon he embraced the Black Muslim faith and adopted the name Muhammad Ali. But in 1967, upon refusing to be drafted, Ali was stripped of the title. He had to sit out three years. Not until 1974 did he reclaim the crown, by rope-a-doping George Foreman in the "Rumble in the Jungle" in Zaire.

HERB SCHARFMAN / LIFE

THE DAY BINGO DIED

On September 12, 1964, beverage distributor Paul Cardone (and wife Martha) of Gloversville, New York, hit a $100,000 jackpot in a neighboring state. Cost of ticket: three bucks. New Hampshire cleared $5.7 million from America's first legal lottery. By 1999, 37 states were conducting such drawings.

STEVE SCHAPIRO / LIFE

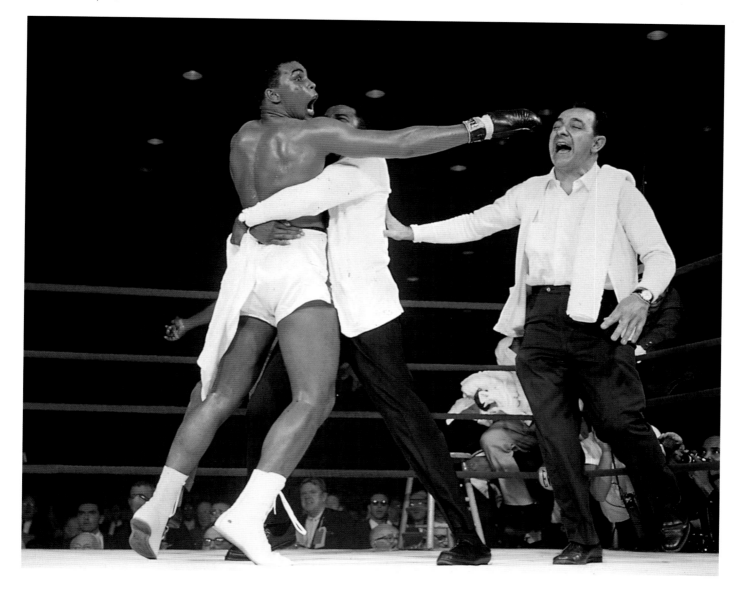

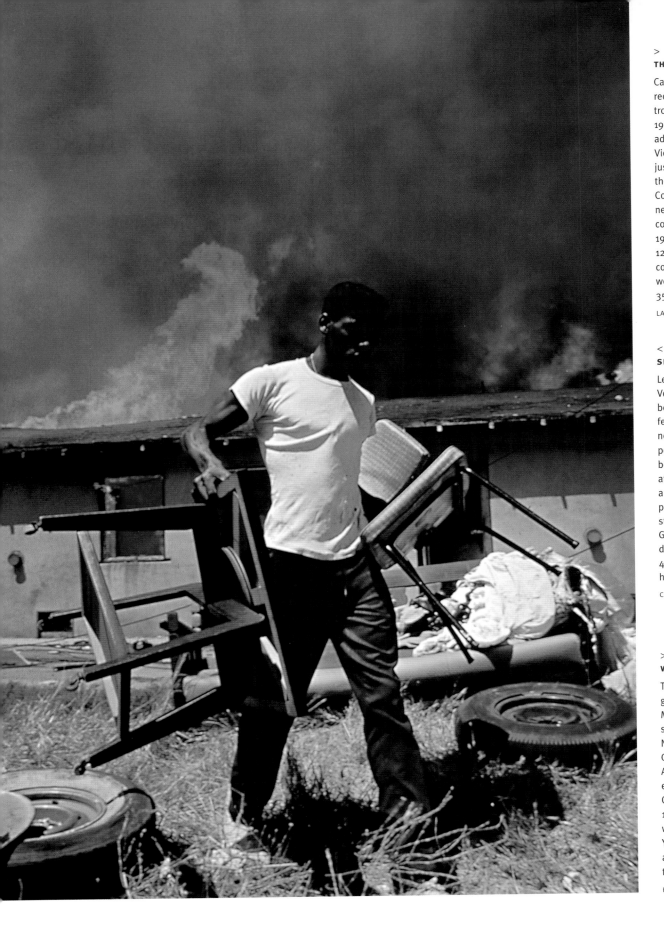

> **THE STREAM WOULD WIDEN**

Captain Vernon Gillespie, on recon with Montagnard troops, was, in November 1964, one of 23,000 U.S. advisers training South Vietnam's army. But LBJ had just won four more years in the White House. He had Congress's O.K. to use "all necessary measures" to contain the North. By August 1965, there would be 125,000 American troops "in country" — and draft boards would soon be inducting 35,000 men a month.

LARRY BURROWS / LIFE

< **SHAPE OF THINGS TO COME**

Less than a week after the Voting Rights Act of 1965 became law, a Los Angeleno fell victim to the lawlessness ravaging Watts. The poor South-Central neighborhood became a war zone after the August 11 arrest of a black motorist. L.A. riot police couldn't reclaim the streets; 12,500 National Guardsmen needed five days. The toll: 34 dead, 4,000 arrested, damages as high as $200 million.

CO RENTMEESTER / LIFE

> **WAKE ME WHEN IT'S OVER**

These commuters couldn't get home. Less fortunate Manhattanites were riding subways or elevators on November 9, 1965, as the Great Blackout hit New York. All told, 30 million people in eight states, Ontario and Quebec lost power for some 12 hours. The utilities said it was a freak surge. Yet in New York, the lights went out again on July 13, 1977, this time for more than a day.

HENRI DAUMAN

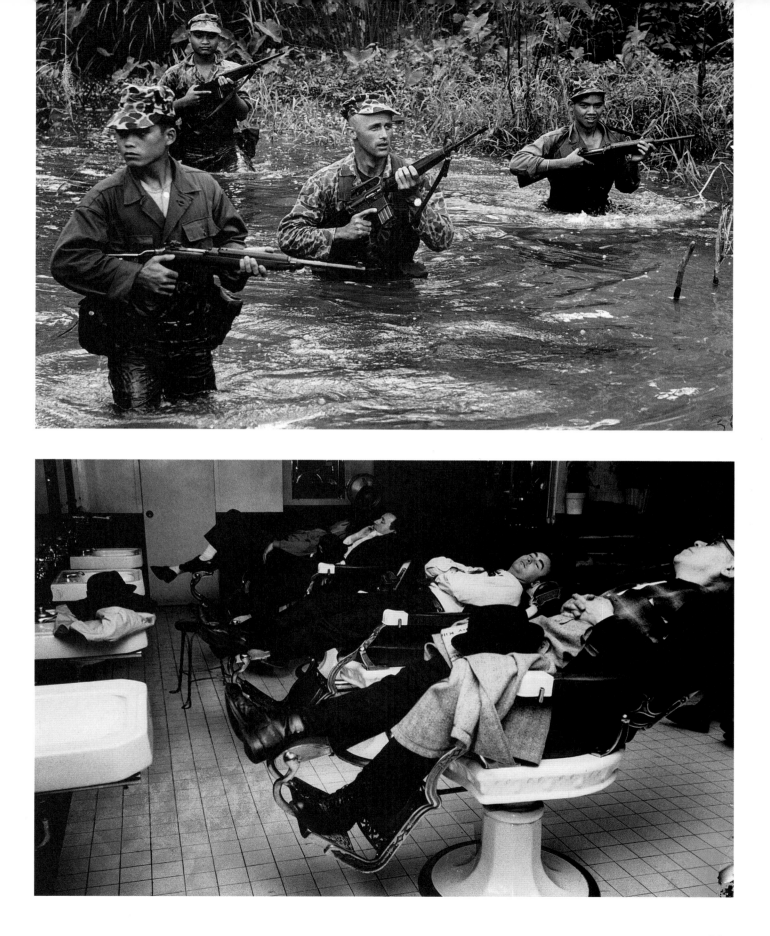

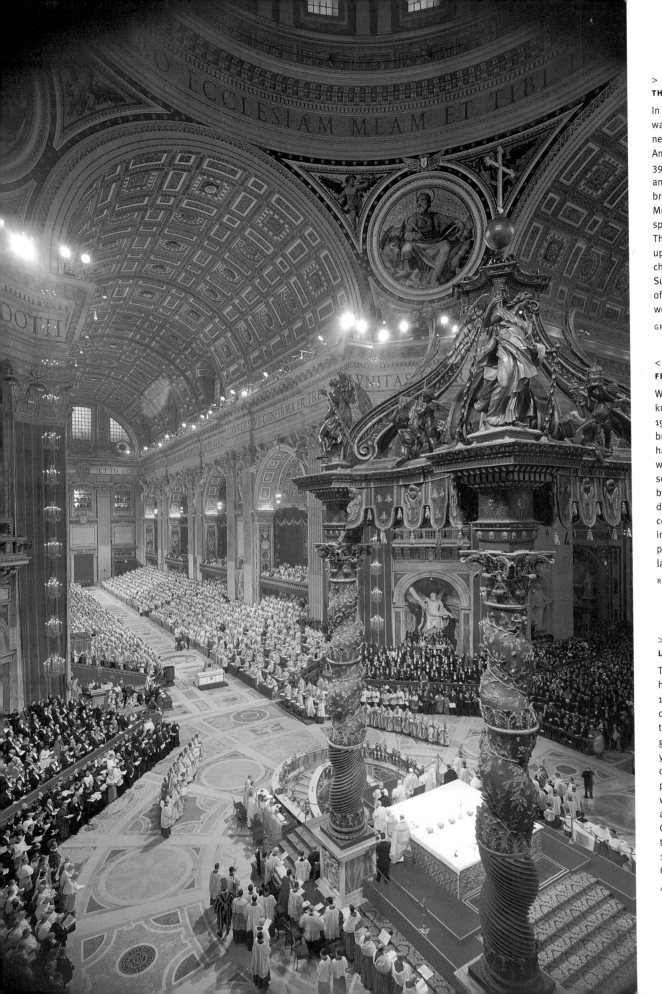

THE WRITING ON THE WALL

In mid-February 1965, he was trying to jump-start his new Organization of Afro-American Unity. Malcolm X, 39 (with wife Betty Shabazz and their daughters), had broken with the Black Muslims over tactics to speed black empowerment. The split proved fatal. At the upcoming rally miswritten in chalk at near top right (that Sunday was actually the 21st of February), three men would shoot him dead.

GREG HARRIS / LIFE

<

FRESH WIND IN ROME

When the Catholic conclave known as Vatican II ended in 1965 (left), the Church had brought itself into greater harmony with a changing world. The extraordinary session was opened in 1962 by Pope John XXIII, 80. He did not live to see such council decisions as reaching out to non-Catholics and permitting services in languages other than Latin.

RALPH CRANE / LIFE

LITTLE (BLOOD-)RED BOOK

To rekindle the spirit that had swept him to power, in 1966 Mao Tse-tung, 72, called for a Cultural Revolution. What he wanted and got was class warfare. His youthful Red Guards zealously targeted academics, professionals — and anyone who questioned the absolute wisdom of the Great Helmsman. Tens of thousands died in the 10-year spasm that cost China its near future.

AP

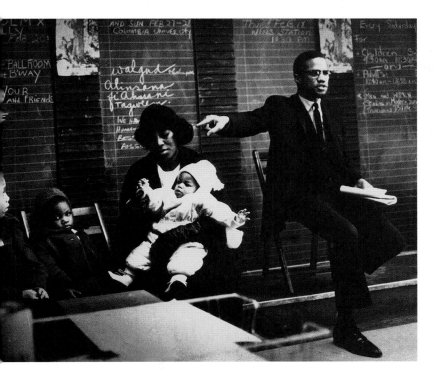

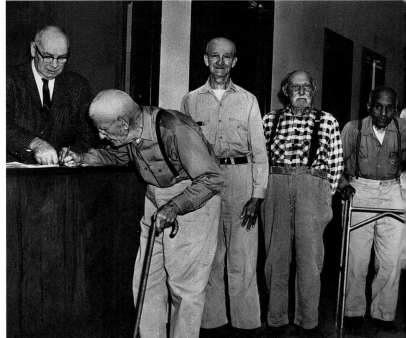

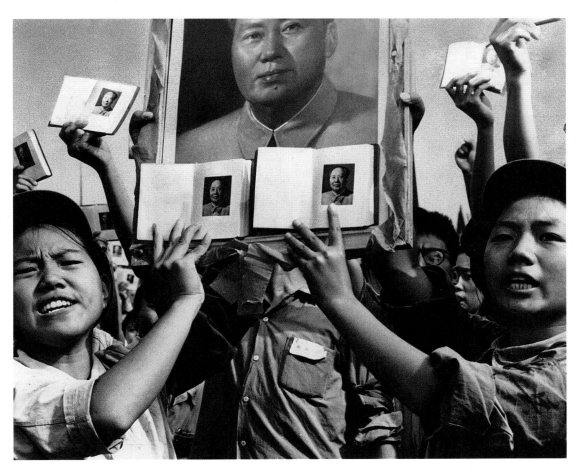

UNCLE SAM WANTS YOU!

The cutoff date was nearing, so a Social Security official went to the Smith-Esteb Memorial Home in Wayne County, Indiana, on January 11, 1966. These residents were thus able to enroll in a federal health-insurance program for seniors signed into law by LBJ in mid-1964. Medicare was launched with 19 million subscribers (who paid $3 per month); by 1999, it covered almost 39 million (paying $45.50 per month).

AP

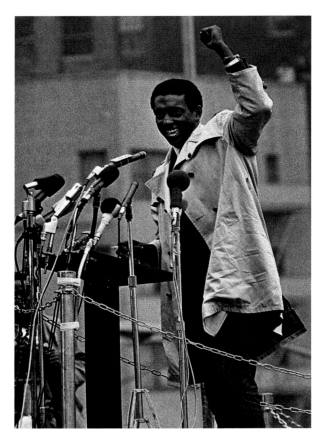

<

POWER TO THE BROTHERS!

In 1967, Stokely Carmichael, 25, exhorted an antiwar rally in front of the U.N. The Trinidadian native was an early-1960s Freedom Rider and later head of the Student Nonviolent Coordinating Committee. He broke from the pacifist civil rights mainstream but then soured on radical extremism after a short stint with the Black Panthers.

PETER GOULD / TIME INC.

>

FAST WAR, SLOW PEACE

Israel heard the rattle of sabers from a coalition of Arab states, so on June 5, 1967, it launched preemptive strikes on Egypt and Syria. Jordan counterattacked. By Day 3, Israel was winning on all fronts (right, Egyptian POWs in the Sinai). On Day 6, the war was over. Top spoil: the Old City of Jerusalem, site of Judaism's sacred Wailing Wall (inset), won from Jordan. Gravest unintended consequence: From the shattered Arab lands would emerge the militant Palestine Liberation Organization, or PLO.

DENIS CAMERON
INSET: DAVID RUBINGER / TIME

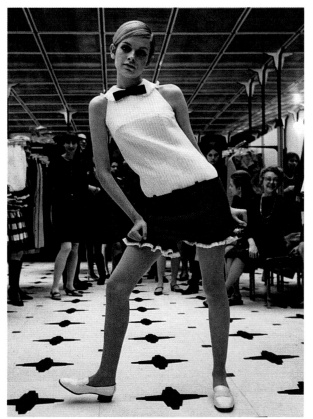

<

. . . AS A STICK OF MACARONI

She arrived in America at 17 with Carnaby Street glam. And a who-cares attitude. And a nom de catwalk that said it all: Twiggy. Leslie Hornby's 5' 6", 91-pound frame was a perfect hanger for the skimpy costumes being stitched in Swinging London. And in 1967, no tabloid reporter would stoop to find out what she didn't eat for dinner.

HOWELL CONANT / LIFE

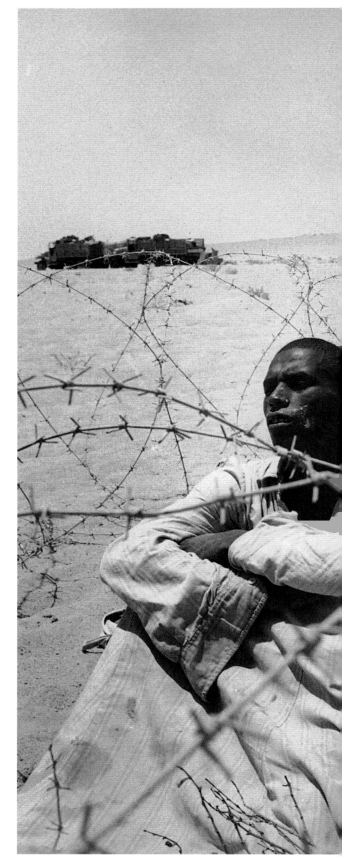

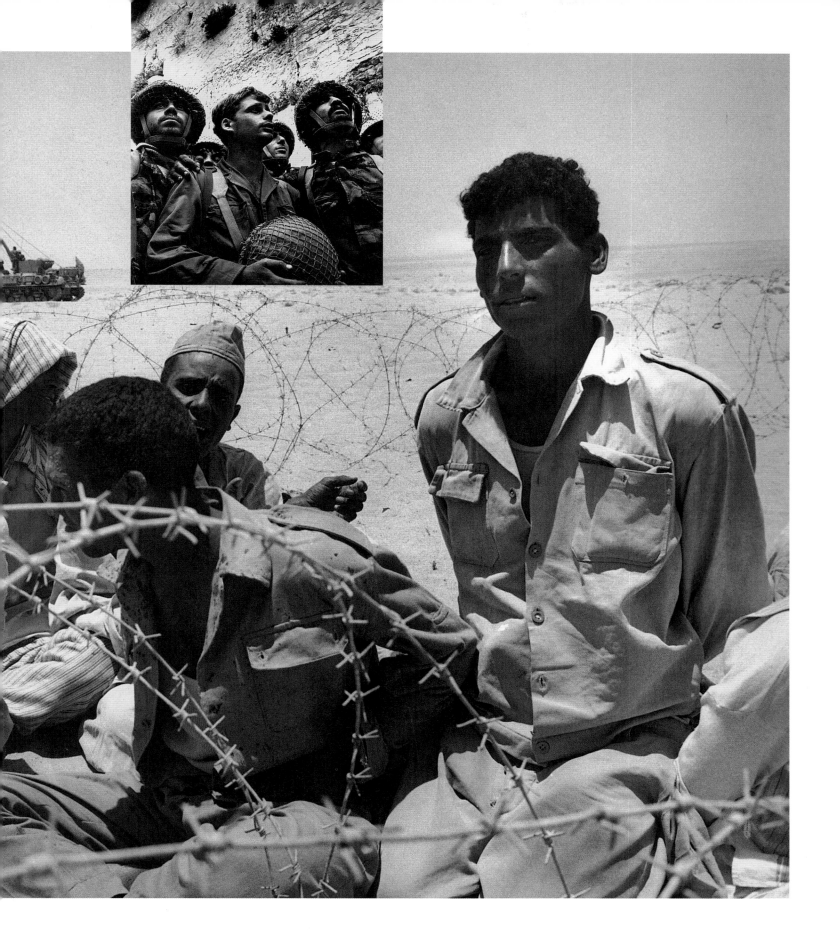

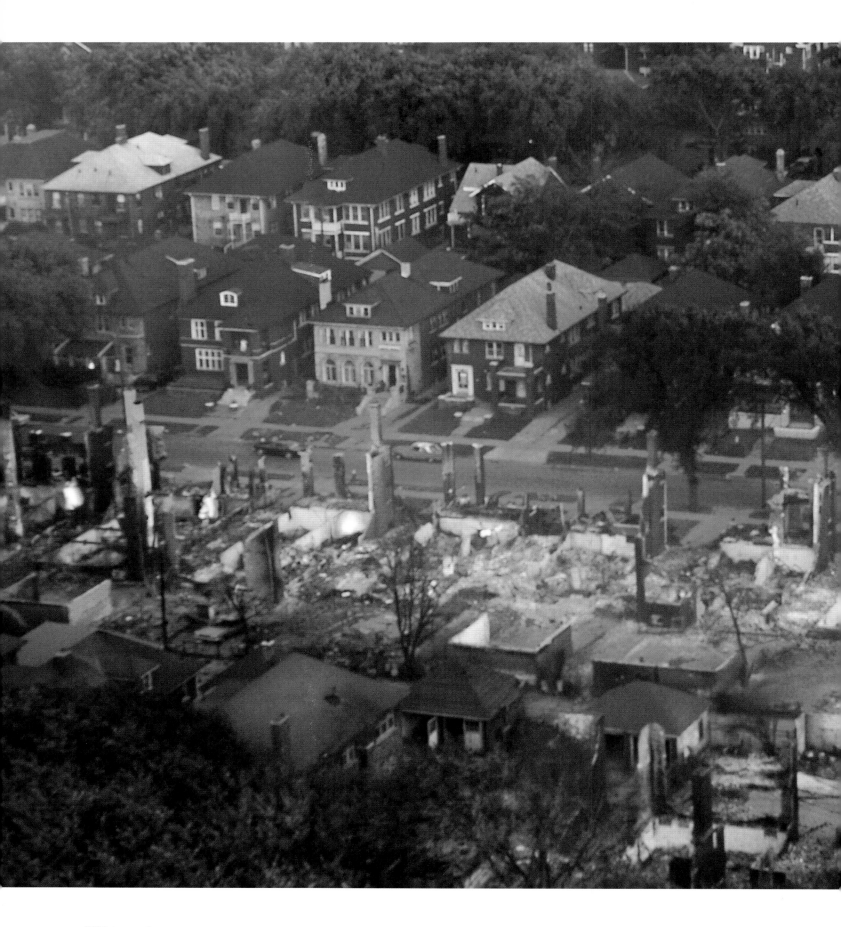

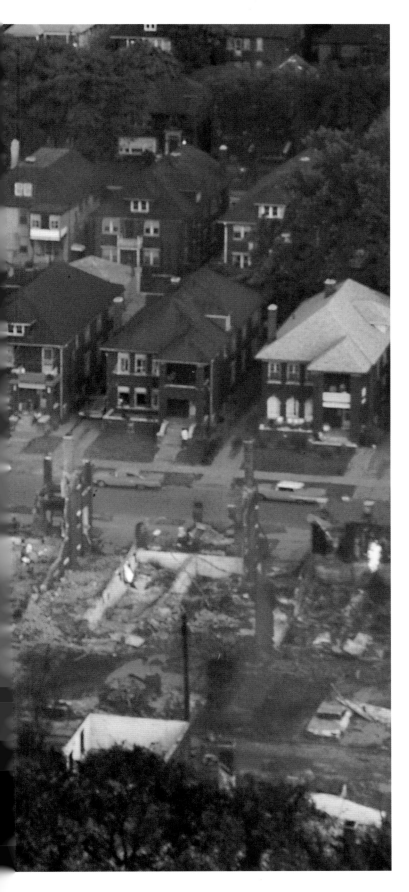

The Fires This Time

Watts was no aberration. Two years later, in 1967, inner cities combusted across America. The worst rioting again sprang from friction between blacks and cops. Detroit police busted an after-hours club; the ensuing week of arson and looting (left, a middle-class black neighborhood) was biracial, but 36 of the 43 dead were black. Newark's police beat a black motorist; the ensuing four days of strife left 26 dead, 24 of them black (while wounding bystanders like young Joe Bass Jr., below). In November, the Census Bureau reported that compared with whites, nonwhites were twice as likely to be unemployed and thrice as likely to live in substandard housing.

LEFT: DECLAUN HAUN / LIFE
BELOW: BUD LEE / LIFE

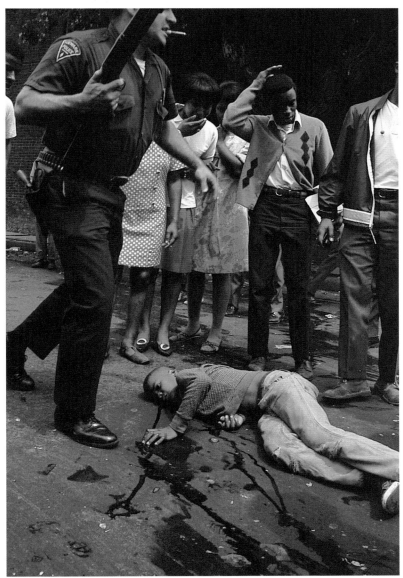

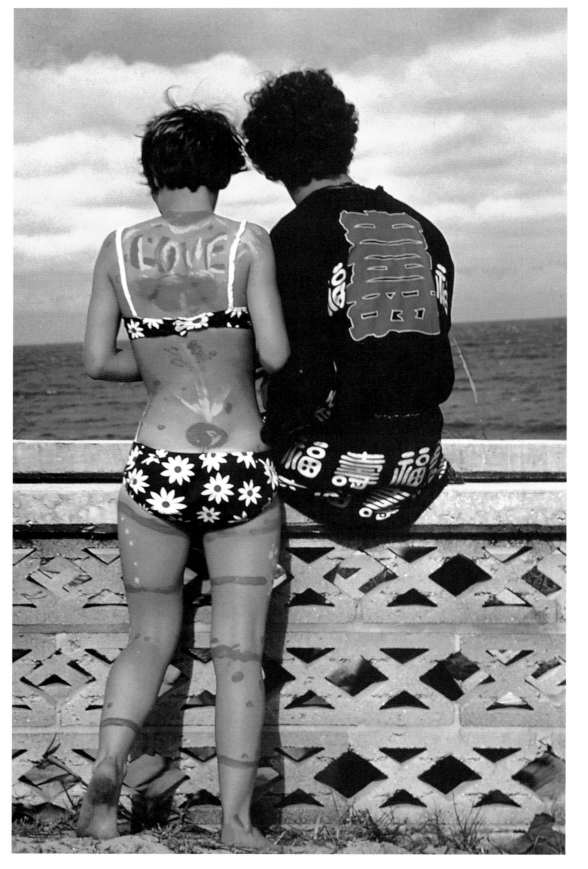

<

GOOD VIBRATIONS

The AM lyrics in 1967 echoed the tribal desires of young America. Groovin' on a Sunday afternoon. There's a new generation with a new explanation. Come on, baby, light my fire. All you need is love. But the issues of the day would not quit: 128 cities hit by racial rioting, 125,000 antiwar marchers in New York City. This Summer of Love was far from endless.

LYNN PELHAM / LIFE

>

TAKE 2 TABS, TUNE OUT

An Army brat and psychologist, by 1967 Timothy Leary, 47, was America's new Alexis de Tokeville. Testing the therapeutic uses of hallucinogens at Harvard had cost him his job, so Leary went freelance and became an early proselytizer of dope, including LSD. Before his death in 1996, he'd begun dabbling in, natch, virtual reality.

BEN MARTIN / TIME

>

HITTING THE GEE SPOT

Everything we always wanted to know about sex (but were afraid to ask) could be found in *Human Sexual Response* by William Masters, 51 (far right), and Virginia Johnson, 41. Kinsey had studied amatory preferences; the two St. Louis clinicians documented the body's reaction to this stimulus or that. Their 1966 book was sexually revolutionary.

LEONARD MCCOMBE / LIFE

EASTERN MENDICATION

It was a time for gurus, ashrams and sitars (heard on the Beatles' epic 1967 LP, *Sgt. Pepper's Lonely Hearts Club Band*). But those saffron-robed street beggars? Strictly from New York City's East Village, where, at 70, A.C. Bhaktivedanta of Calcutta had begun to *hare hare, hare rama*, and so forth. The chant and simple communal Hare Krishna lifestyle were a good trip for many.

VERNON MERRITT / LIFE

APOCALYPSE 1968

The year began with a reassuring sense of order as Vince Lombardi barked the Green Bay Packers to a second Super Bowl title. Nice things did happen (California's Redwood National Park was born). And joyous things (Marvin Gaye's "I Heard It Through the Grapevine"). And cutting-edge things (the first ATM, in Philadelphia). But mostly, it was bad news on the doorstep. From the growing generation gap there developed a crack that cleaved along cultural fault lines. The year quickly clenched itself into a fist that never did relax. And the anger still haunts.

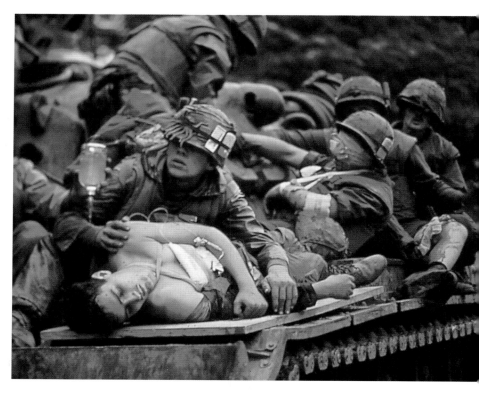

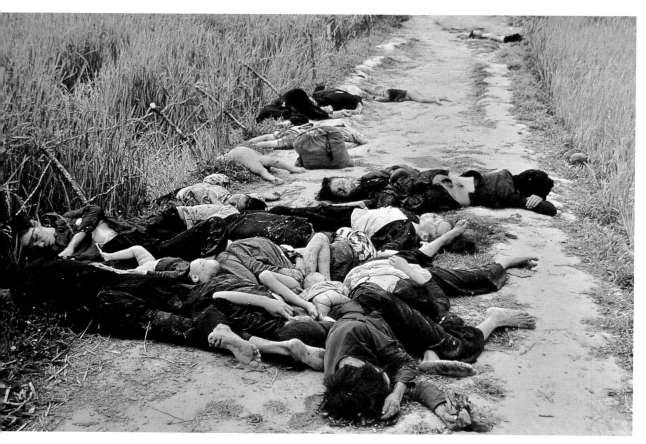

KNEE DEEP IN BIG MUDDY

At year's start, there were 500,000 U.S. combatants in country. Few expected a 41-city assault by North Vietnamese regulars and Vietcong guerrillas on the lunar new year, called Tet, which occurred on January 30. American casualties ran high at bastions like Hue (above). The Tet Offensive achieved little militarily but much politically: It galvanized enough antiwar opposition to undermine the Johnson presidency. Ordered to step up the pacification campaign, GIs commanded by Lieutenant William Calley snapped on March 16 at a hamlet called My Lai (left). Not until 20 months later was the slaughter of 347 villagers exposed. At Calley's trial, some Americans thought him a hero.

ABOVE: JOHN OLSON / LIFE
LEFT: RONALD HAEBERLE / LIFE

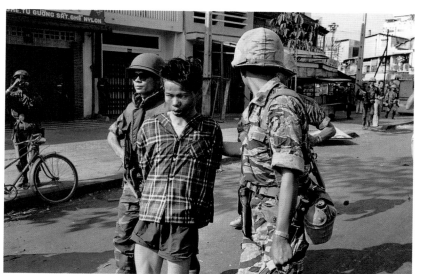

Street Justice in Saigon

Day 2 of the Tet Offensive. Suspected Vietcong Bay Lop (left) had already undergone interrogation by South Vietnamese national policemen. One (middle left) decided to show off the prisoner to the unit's top kick. He was Brigadier General Nguyen Ngoc Loan, 37, whose summary judgment of guilt (bottom left) was captured in a still photograph that revulsed the world. Heedless, Loan talked briefly with a television cameraman before striding away (below). Before his death in 1998, Loan operated a pizza parlor in Dale City, Virginia.

EDDIE ADAMS / AP (4)

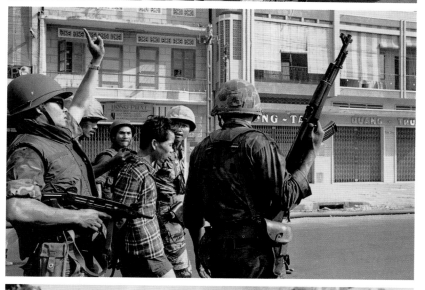

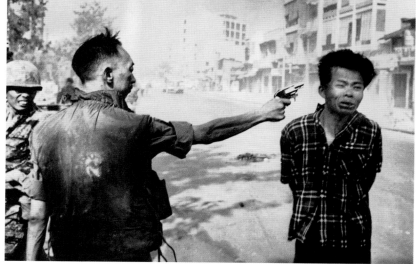

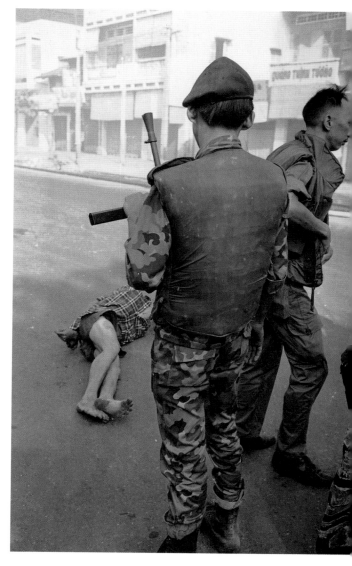

APOCALYPSE 1968

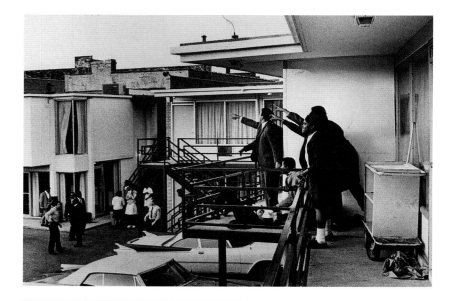

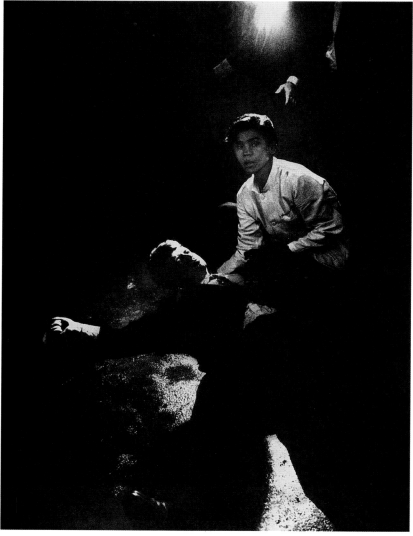

MLK (1929–1968)

Martin Luther King Jr. had gone to Tennessee in support of striking sanitation workers in Memphis. On April 4, stepping from his room at the Lorraine Motel, the civil rights leader was felled by a 30.06 round fired from a nearby boardinghouse. In 1969, escaped con and white supremacist James Earl Ray, 41, was found guilty; he died in jail in 1998.

JOSEPH LOUW / LIFE

RFK (1925–1968)

Robert Francis Kennedy had gone to California to run in the Democratic presidential primary. On June 6, stepping from a victory party in Los Angeles's Ambassador Hotel, the New York senator was felled by three .22 rounds fired point-blank. In 1969, disgruntled Palestinian Sirhan Bishara Sirhan, 25, was convicted of the crime. California abolished the death penalty in 1972; Sirhan's sentence became life imprisonment.

BILL EPPRIDGE / LIFE

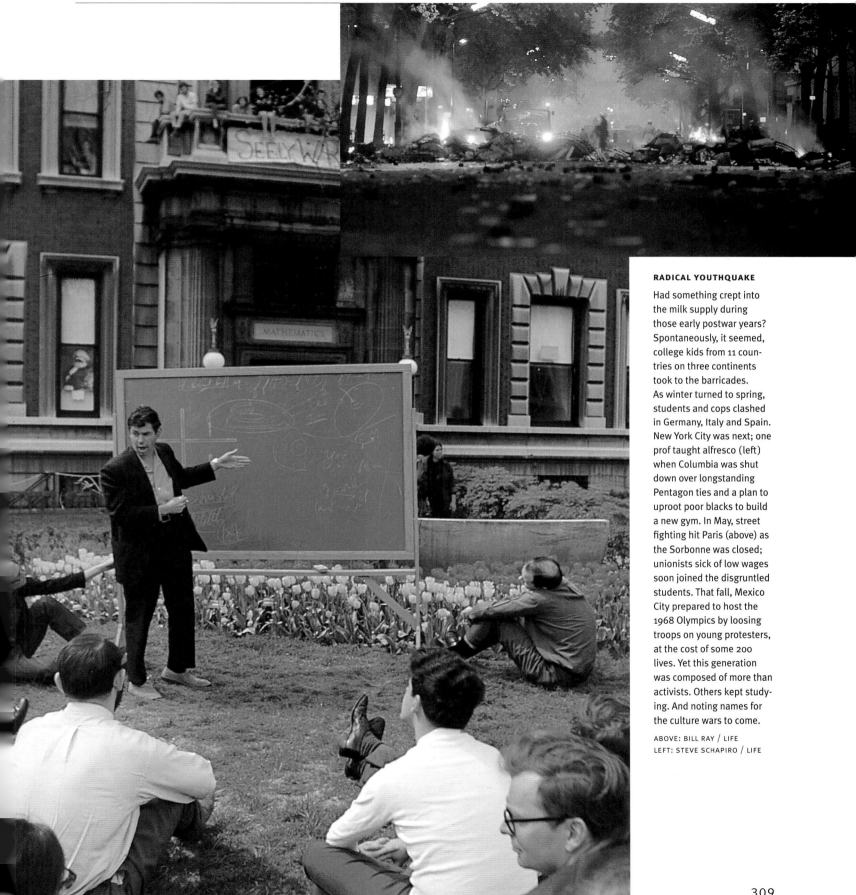

RADICAL YOUTHQUAKE

Had something crept into the milk supply during those early postwar years? Spontaneously, it seemed, college kids from 11 countries on three continents took to the barricades. As winter turned to spring, students and cops clashed in Germany, Italy and Spain. New York City was next; one prof taught alfresco (left) when Columbia was shut down over longstanding Pentagon ties and a plan to uproot poor blacks to build a new gym. In May, street fighting hit Paris (above) as the Sorbonne was closed; unionists sick of low wages soon joined the disgruntled students. That fall, Mexico City prepared to host the 1968 Olympics by loosing troops on young protesters, at the cost of some 200 lives. Yet this generation was composed of more than activists. Others kept studying. And noting names for the culture wars to come.

ABOVE: BILL RAY / LIFE
LEFT: STEVE SCHAPIRO / LIFE

APOCALYPSE 1968

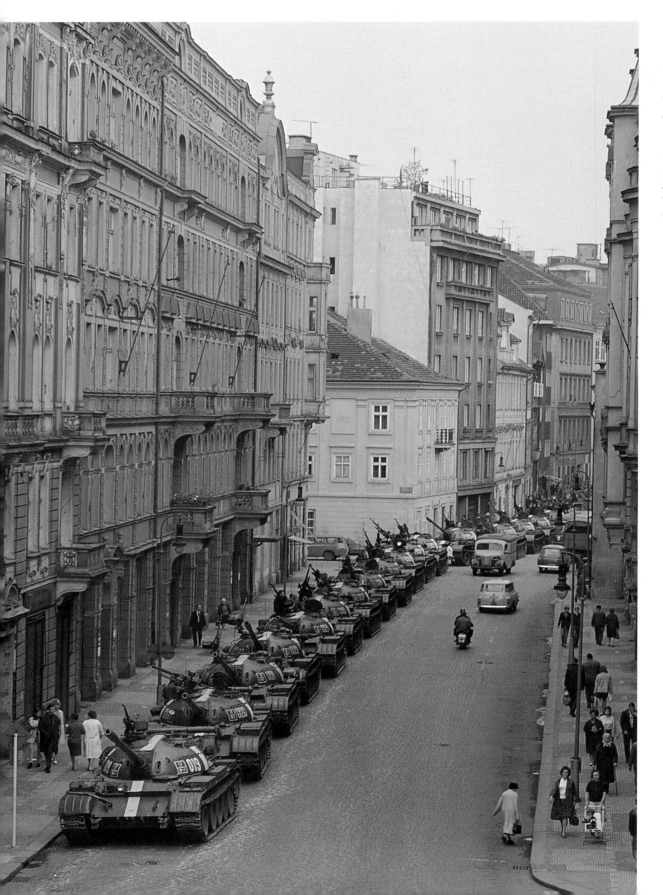

HEADBANGERS BALL

John Evans of NBC News ignored his injuries to take notes; the August Democratic National Convention did not lack for stories. Delegates still reeling from LBJ's decision to quit arrived in a Chicago girded for war. Mayor Richard Daley, fearing Yippies would spike city reservoirs with LSD, had his cops in full riot mode. So for five days, they beat up not only young longhairs but also journalists, even ones on the convention floor.

CHICAGO SUN TIMES

TWO V'S FOR VICTORY

His body language was typically ungainly, but at an October GOP rally in Ohio, that trademark salute of Richard Nixon's seemed justified. He was pledging "peace with honor" in Vietnam and law and order at home. Further, his opponent, Vice President Hubert Humphrey, was tarred by the Democratic debacle in Chicago. Nixon sensed the prize was his. He was right.

WALTER BENNETT / TIME

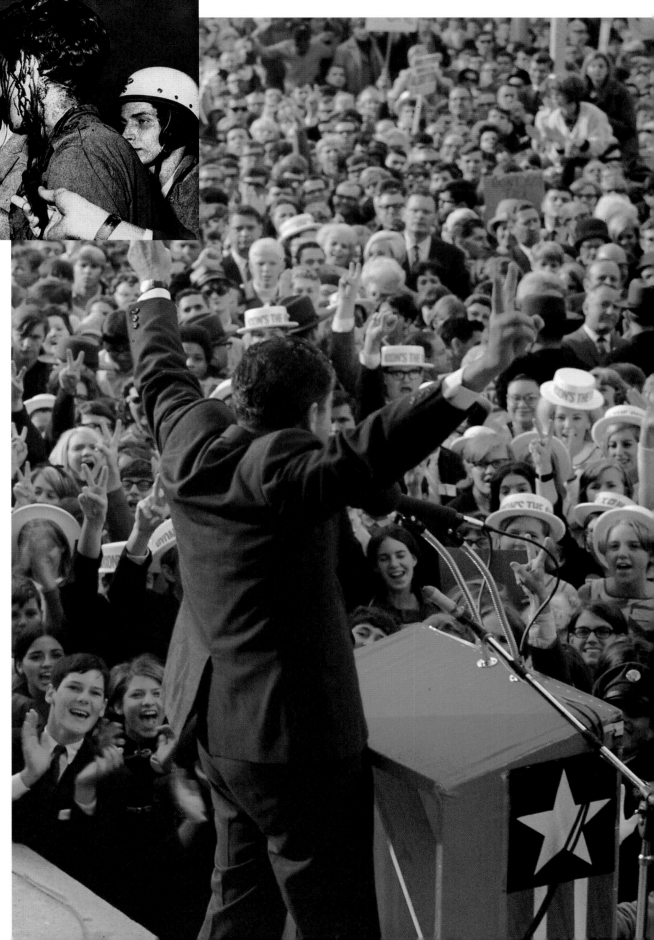

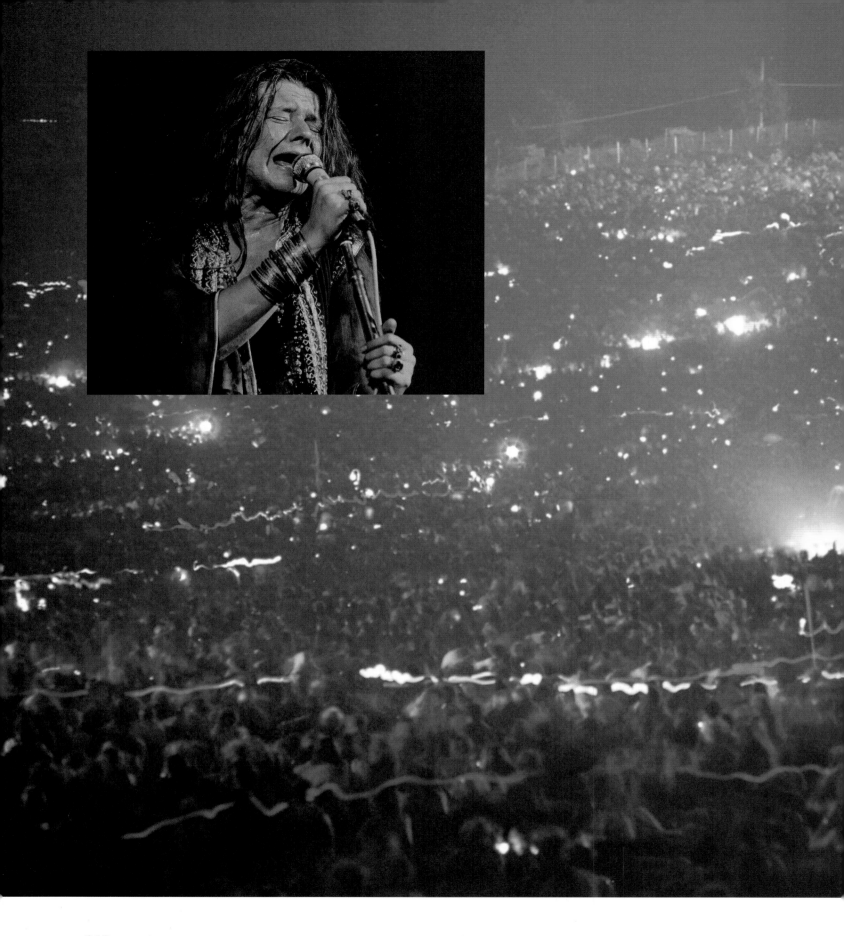

THE NEW MUCKRAKERS

The young lawyers on the House steps in 1969 were members of a firm recently founded by Ralph Nader, 35 (foreground). Its mission: ferret out suspect corporate practices like failing to correct the bad auto design exposed in Nader's 1965 *Unsafe at Any Speed*. An angered GM tried to smear the author; caught, it paid up. Nader used the $284,000 to help fund his Raiders.

JOHN ZIMMERMAN / LIFE

< WELL, FLICK MY BIC

Jimi showed. So did Baez. And Santana. And Grace and the Airplane. And Janis, 26 (inset), with *Bobby McGee*. They came in August 1969 to Max Yasgur's farm in Bethel, New York, 60 miles from Woodstock. In renting out his spread, Yasgur, 49, expected "three days of peace and music" — not a circus of the naked and the dead-to-the-world (from drugs). Some 300,000 attended. Many more now say they did.

JOHN DOMINIS / LIFE
INSET: HENRY DILTZ /
CORBIS / BETTMANN

> SEND IN THE CLOWNS

Betting their bippies that vaudeville was not dead, Judy Carne, 29 (near right), Goldie Hawn, 22, and Chelsea Brown, 21, became resident ding-a-lings on 1968's NBC show *Laugh-In*. The show recycled shtick without shame (here come de judge; sock it to me; knock-knock, who's there?). Yes, five of six gags were groaners. But in prime time, a laff a minute ain't bad.

TRANSWORLD FEATURE SYNDICATE

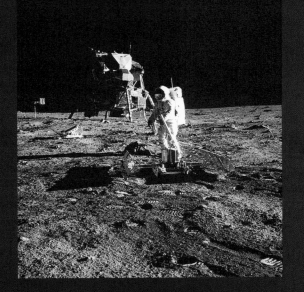

<

MISSION: POSSIBLE

On July 20, 1969, just five months short of the target date set eight years earlier by JFK, Neil Armstrong, 38 (left), of Wapakoneta, Ohio, stepped from the *Apollo 11* lander onto the surface of the moon, followed by Buzz Aldrin, 39, of Montclair, New Jersey. Said Armstrong, "That's one small step for man, one giant leap for mankind." Indeed.

NASA

TURNING POINT:
EXPLORING THE HEAVENS

Upward Mobility

Sputnik I broke free of earth before two-thirds of all Americans now alive were born. Perhaps that is why the twinkles in the night sky awe us less than they did our forebears. Manned missions go unnoted unless their peril is brought tragically home. Unmanned missions? Snore. Yet it is the high-tech drones that have stretched the bandwidth of astronomical data. For example, we now know the universe has expanded since the Big Bang 13 billion years ago, has no boundary and may, or may not, contract. (Probably not.) But all we have learned in a historical eye blink still leaves unanswered the most vexing question: Within the vast firmament beginning where our atmosphere ends, do any other beings dwell? At cosmology's door rightly meet science and religion.

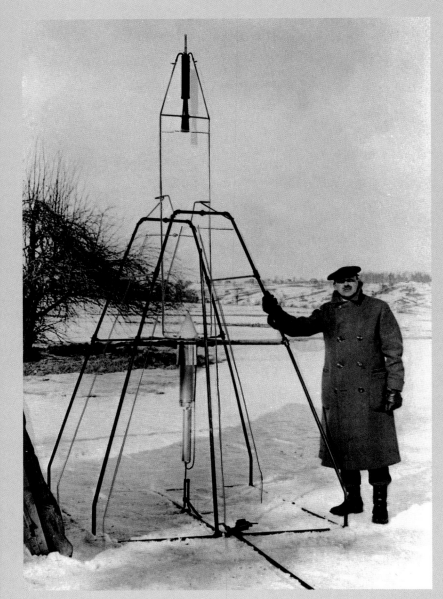

... LIKE A BIG PIZZA PIE

Tout Paris roared in 1902 at the finale (left) of the first sci-fi flick. In 1895, Georges Méliès, 34, had caught the first film by *les frères* Lumière (see page 282). A magician by trade, he drew on his craft to invent cinematic narrative. The 14-minute, 30-scene *A Trip to the Moon*, loosely drawn from an 1865 Jules Verne novel, was one of his 400-plus short works.

CULVER PICTURES

> ### HAIL, NOT HEIL!

More than his arm was in a sling when Wernher Von Braun, 33 (right), gave up to GIs in 1945. The Nazi rocket scientist had upgraded the Vergeltungswaffen-1 (Revenge Missile-1) into the more lethal, 13-ton V-2 (inset) that creamed Britain late in World War II. Braun cut a deal with the U.S., though (as did other Germans with the USSR), and ended up a NASA bigwig. A biography titled *Reaching for the Stars* was fast subtitled, by skeptics, *(And Hitting London)*.

U.S. ARMY (2)

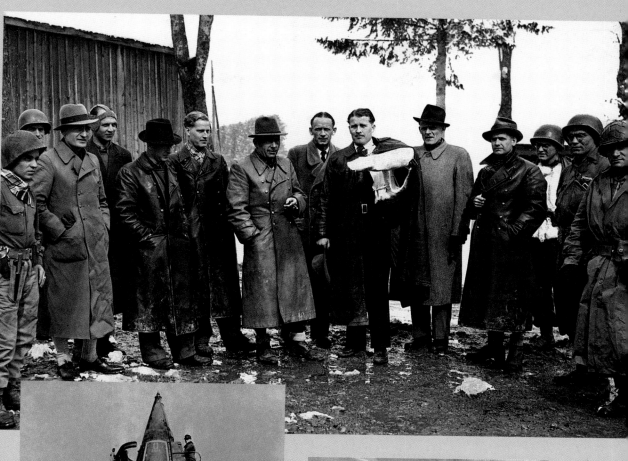

A BABY STEP INTO SPACE

He was so sure about his notions for a propulsion system to come that in 1914, at 32, Robert Goddard filed two patents. A prototype liquid-fueled rocket (left) was eventually built. On March 16, 1926, in Auburn, Massachusetts, Goddard ignited it. The device rose 41 feet into the air. Space was suddenly much closer.

SMITHSONIAN INSTITUTION

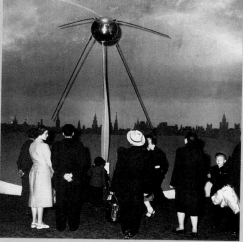

WE'RE NO. 1!

Muscovites in late 1957 were agog at a replica of *Sputnik I*, but think how miserable America's military and scientific elite felt. The 184-pound Soviet satellite was shot into orbit that October 4. It fell back into earth's atmosphere on January 4, 1958, and burned to a crisp.

ARCHIVE PHOTOS

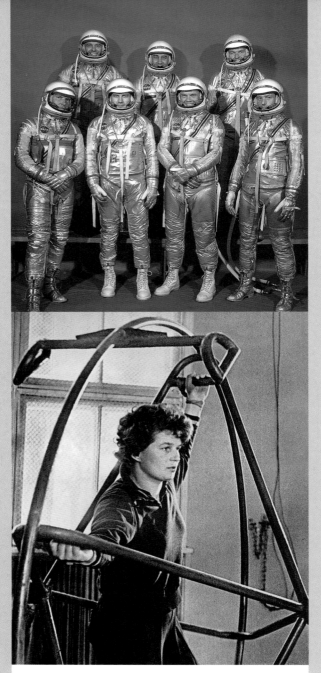

THE ORIGINAL RIGHT STUFF

After sifting through 508 applicants for Project Mercury (its expedited program to send a man into space), the six-month-old National Aeronautics and Space Administration in 1959 announced the chosen seven, whom it dubbed "astronauts." They were, clockwise from top left, Alan Shepard, Gus Grissom, Gordon Cooper, Scott Carpenter, John Glenn, Deke Slayton and Wally Schirra. All would make it off planet.

RALPH MORSE / TIME

FIRST TICKET TO RIDE

Crack Soviet parachutist Valentina Tereshkova, 26, went in the opposite direction on June 16, 1963, aboard *Vostok 6* and was thus the first woman and 10th human to orbit earth (48 times over three days). She later married a fellow cosmonaut, Andriyan Nikolayev. The couple had one daughter.

SOVFOTO / TASS

NASA RECYCLES

The launch of *Columbia* on April 12, 1981 — and its pilot-controlled landing back at Cape Canaveral 54 hours later — was to have opened a new era of space exploration. With a shuttle fleet that would grow to four, NASA hoped to run a mission a month. But the vehicles needed longer than planned in turnaround; it took 57 months to send up the first two dozen. On flight 10, astronauts Bruce McCandless (inset) and Robert Stewart, using newly developed jet backpacks, became the first to take an untethered spacewalk.

CHARLES TRAINOR / MIAMI NEWS
INSET: NASA

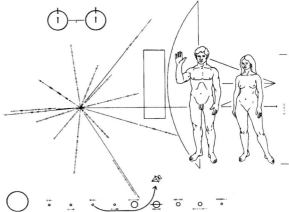

IF U CN RD THS MSG

Affixed to the skin of the space probe *Pioneer 10* is the gold-oxidized aluminum plate pictured at left. Its sign language reveals where, when and by whom the craft was launched. On June 13, 1983, 11 years and three months after leaving earth, *Pioneer 10* passed Pluto's orbit. So far the first man-made object to leave the solar system has not been returned to sender.

NASA

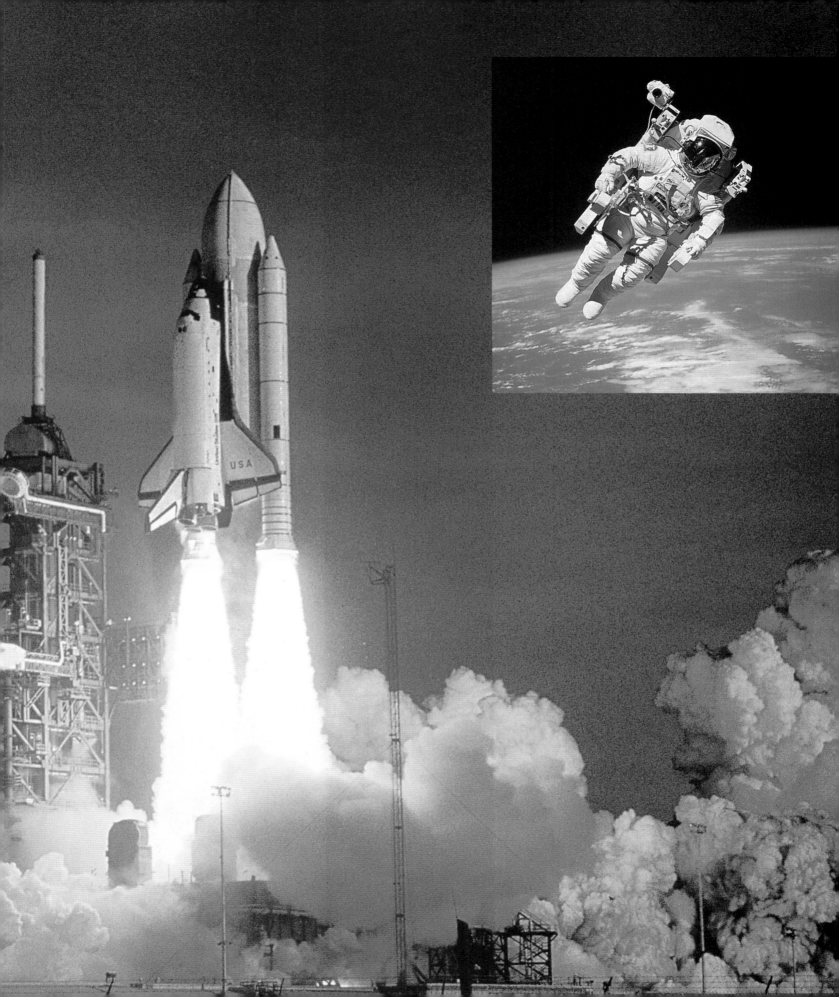

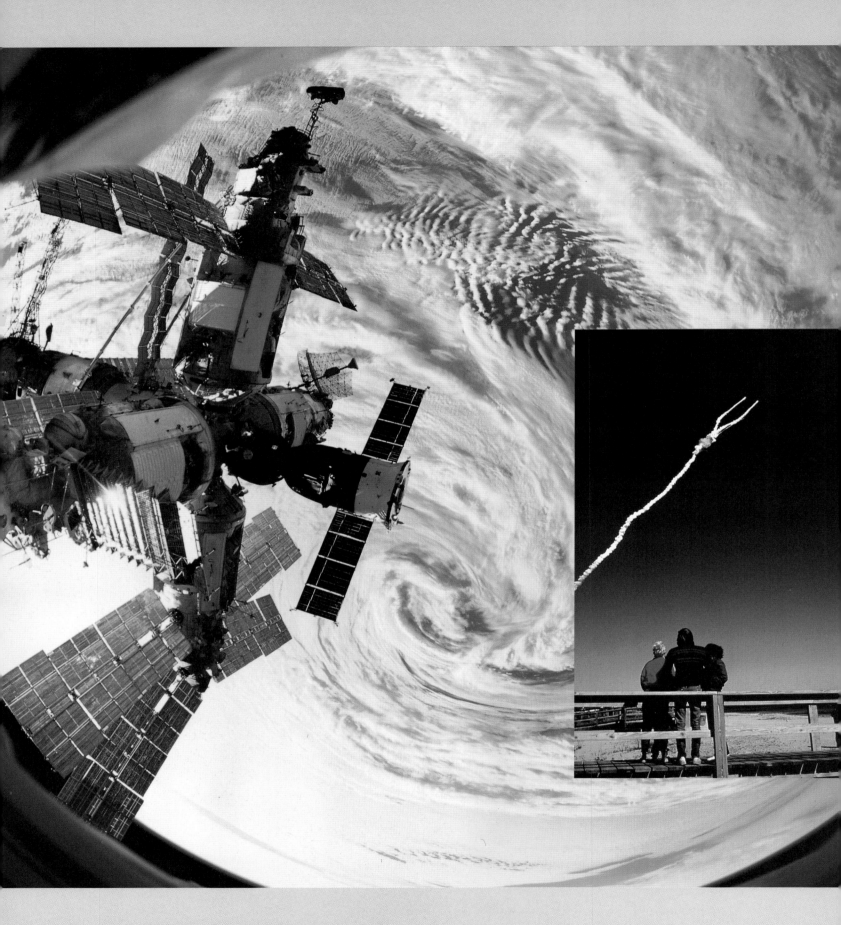

HIGH HANDSHAKE

The space station *Mir* orbited a peaceful 240 miles above a September 1996 storm lashing the Indian Ocean. This photo was taken from NASA's *Atlantis*, which was rendezvousing with the Russian craft to exchange a crew member. It was the fourth binational space hookup since 1975's historic Apollo-Soyuz docking.

NASA

SEEING RED

On July 4, 1997, earthlings finally got a ground-level view of the fourth rock from the sun (left). Earlier landings on Mars, starting with the USSR's *Mars 3* in 1971, were by craft that, unlike NASA's *Sojourner*, carried no cameras. The 24½-pound, six-wheeled microrover (top speed: 39 yards per hour) beamed back vistas of Ares Vallis, an ancient flood plain, and tested Martian soil, for four months.

NASA

"WE HAVE AN ANOMALY"

January 28, 1986. It was the 25th shuttle mission, and *Challenger*'s 10th flight. Among the crew: Christa McAuliffe, 37, a New Hampshire teacher. Seventy-three seconds after liftoff (inset), a $900 gasket blew. The results were catastrophic. At least four of seven astronauts survived the blast but died when the craft hit the Atlantic Ocean.

MALCOLM DENEMARK / FLORIDA TODAY / LIAISON

BACK TO THE FUTURE

No, John Glenn hadn't found a device to help him tune out sonorous Senate speeches; it's a NASA rig to monitor a sleeping wearer's body functions. Though a four-term senator, the first American to achieve orbit longed for a second ride beyond the wild blue. He got it on October 29, 1998; at 77, Glenn became the oldest person in space.

SHELLY KATZ / LIAISON

MADAM PRIME MINISTER

In 1969, Israel's Knesset selected as the nation's fourth prime minister 70-year-old Golda Meir, at right with General Haim Bar-Lev. Born in Kiev and raised in Milwaukee (where she was known as Goldie Mabovitch to her public school pupils), Meir had emigrated to Palestine in 1921. Her signature is on Israel's 1948 Proclamation of Independence.

DAVID RUBINGER / TIME

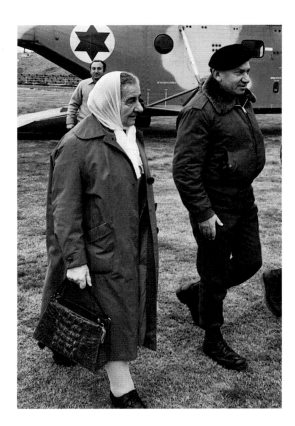

HELTER SKELTER

The murders in Beverly Hills were beyond savage; the man ordering them, ex-con and failed songwriter Charles Manson, 35 (above), beyond understanding. In August 1969, a "family" of dropouts devoted to him slashed and shot to death five people (including eight-months-pregnant actress Sharon Tate, 26). Why? Manson was angry at a record company exec who often hung out at Tate's estate.

VERNON MERRITT / LIFE

SCOFFING THE PIGS

Protesters really hammered it up (left) as the Chicago Eight went on trial in 1969 for disrupting the previous year's Democratic National Convention. (The number fell to Seven when Bobby Seale was jailed for contempt.) The trial took five months. The verdicts were mixed, but after appeals, none did any time.

AP

THE KILLING FIELD (OHIO)

After President Nixon ordered GIs into neutral Cambodia, even normally tranquil campuses like Kent State (above) reacted. On May 4, 1970, Ohio National Guardsmen fired tear gas at protesting students, then bullets. The fusillade wounded 11 and killed four (including Jeffrey Miller, right; the kneeling woman was later identified as Mary Ann Vecchio, 14, a runaway).

ABOVE: KENT STATE UNIVERSITY ARCHIVES; RIGHT: JOHN FILO

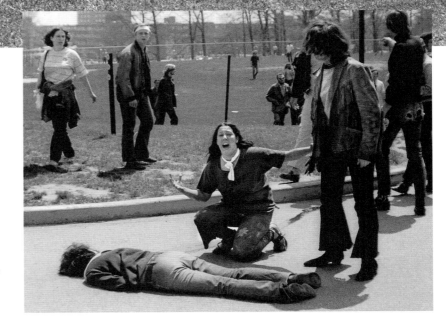

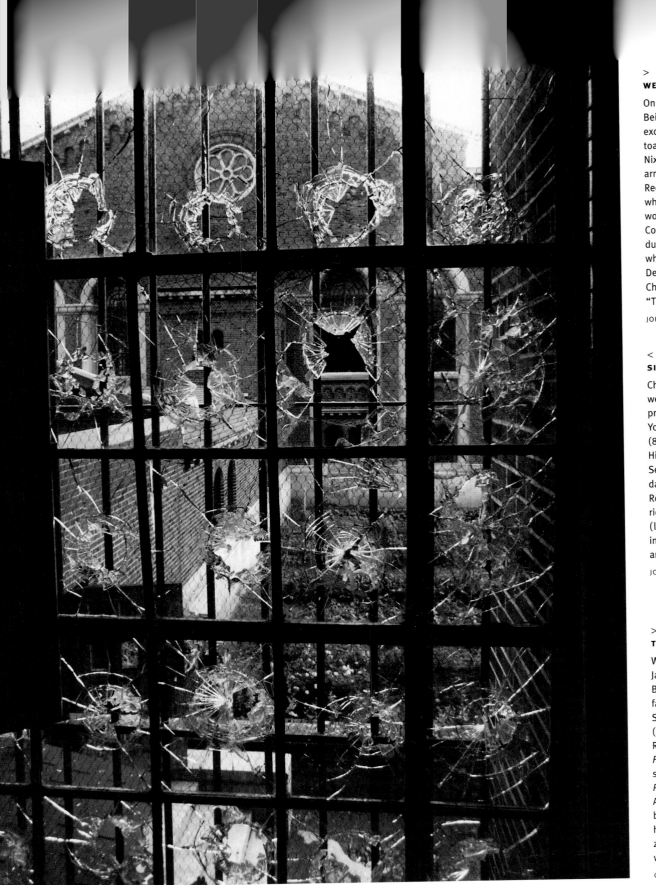

> **WEST, MEET EAST**

On February 22, 1972, in Beijing, Deng Yingchao exchanged *kampeis*, or toasts, with guest Richard Nixon. The President, armed with sterling anti-Red credentials, dared do what four predecessors would not: recognize Communist China. Later during his one-week visit, while sightseeing with Deng's husband (Premier Chou En-lai), he remarked, "This is a great wall!"

JOHN DOMINIS / LIFE

< **SITTING DUCKS**

Charging that conditions were inhumane at Attica prison, near Buffalo, New York, hard-core felons (85 percent black or Hispanic) seized it on September 9, 1971. Four days later, Governor Nelson Rockefeller sent in all-white riot cops. Their volleys (left) killed not only 29 inmates but also 10 guards and civilian workers.

JOHN SHEARER / LIFE

> **THOSE WERE THE DAYS**

Was America ready, on January 12, 1971, for the Bunkers (Carroll O'Connor, far right, and Jean Stapleton) and the Stivics (Sallie Struthers and Rob Reiner)? Yup. *All in the Family*, based on the British sitcom *Till Death Do Us Part*, made O'Connor's Archie a mouthpiece for bigotry and Reiner's Meathead a liberal jerk. And the zingers from both sides were pretty choice.

CBS PHOTO ARCHIVES

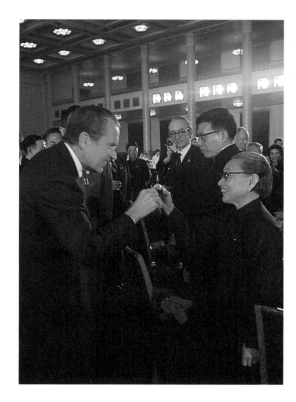

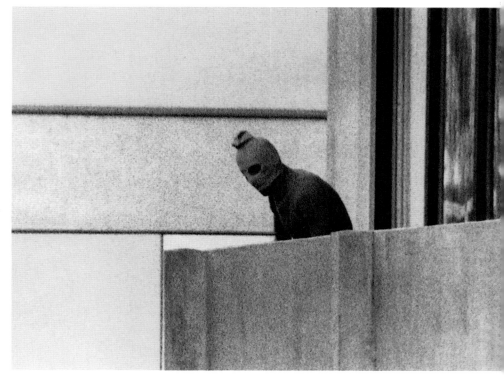

BLACK SEPTEMBER

Before dawn on Day 11 of the 1972 Munich Games, a hit team of masked Palestinians attacked the Israeli dorm in Olympic Village. They killed two and took hostage seven. Talks proved futile; Israel refused to free 200 Palestinian prisoners. That night the terrorists were promised a flight to Cairo. In a shootout at the airport, all the Israelis and five Palestinians died. The IOC ordered flags to be lowered but the Games to go on. They did.

AP

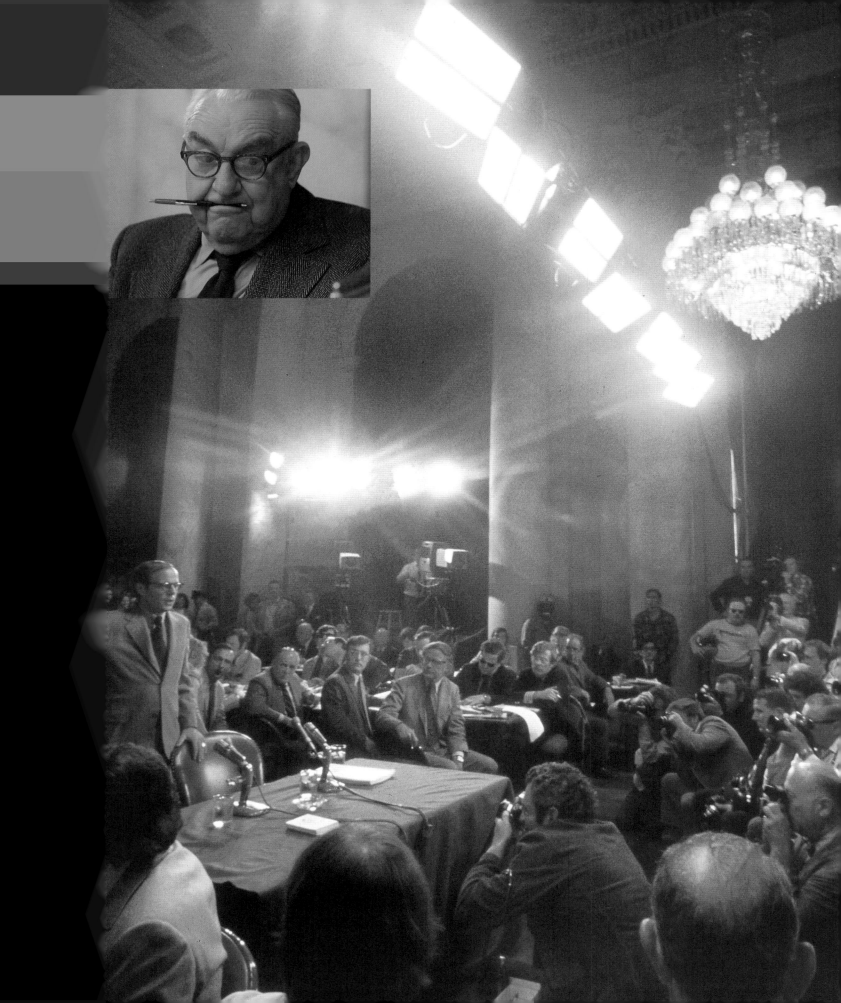

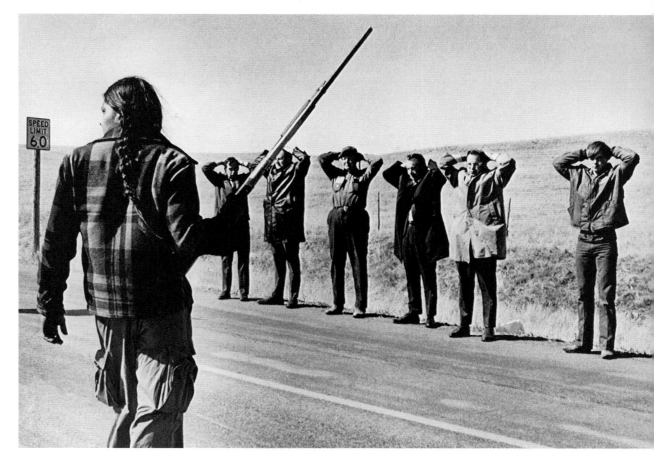

>
HIGHWAY SURRENDER

Four jacket-and-tie Feds and two locals stood under guard in 1973 at Wounded Knee, South Dakota, the site 82 years earlier of a U.S. Cavalry slaughter of 300 Oglala Sioux. Retaking the hamlet: American Indian Movement activists wanting more self-governance; they held on for 70 days.

CORBIS / BETTMANN-UPI

<
NEARER THE SMOKING GUN

As onetime White House lawyer John Dean (left) faced a Senate panel chaired by Sam Ervin (inset) in 1973, a minor 1972 burglary had already become a Washington controversy. The Watergate felons sat in prison. Top Nixon aides had quit. Now Dean, 34, said the President himself was part of the stonewall. Then senators learned that Oval Office talks were recorded. Nixon's fight to keep the tapes set off a graver crisis — a constitutional battle that would cost him his office.

GJON MILI / LIFE (2)

>
THE RIGHT TO NOT BEAR

The ink was barely dry on *Roe* v. *Wade* when societal fissures developed; these New Yorkers marched on St. Patrick's Cathedral to protest the Catholic Church's denunciation of the decision. In January 1973, the Supreme Court had held that women may legally obtain an abortion during the first trimester of pregnancy. The battle lines have not changed.

BETTYE LANE

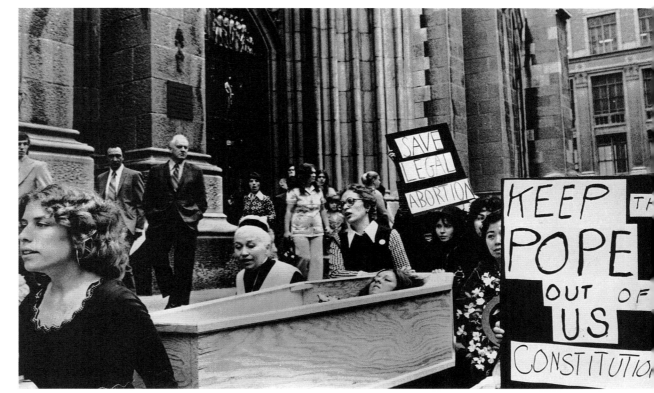

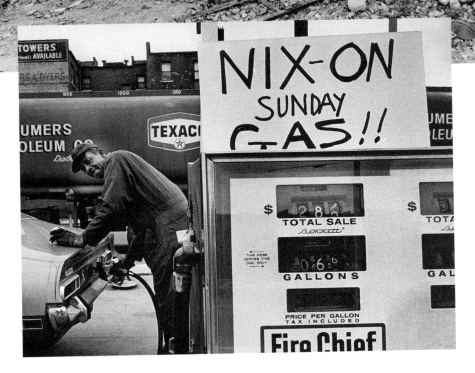

THE PAYBACK WAS CRUDE

Dazed Israeli troops at the Syrian border (above) took a break from defending against a surprise 1973 invasion co-mounted with Egypt on Yom Kippur, the highest Jewish holy day. The fourth Mideast war in 25 years lasted 17 days before Israel prevailed. OPEC, a hitherto weak cartel of oil-producing nations, quickly cut shipments to Israel's allies. By Thanksgiving, America felt the pinch (left, a station in Detroit). Gas was in short supply and had already risen in price by 20 percent, to 42 cents a gallon. More hikes were ahead.

ABOVE: HENRI BUREAU / SYGMA
LEFT: IRA ROSENBERG /
DETROIT FREE PRESS

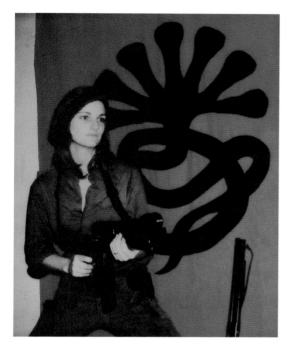

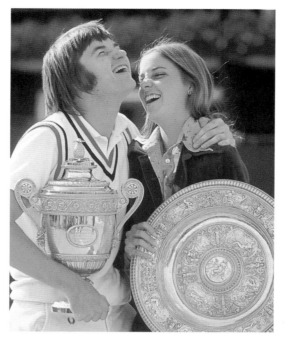

A PAIR OF ACES

They were already engaged when Wimbledon 1974 rolled around, so what better new-home furnishings than the singles trophies captured by Jimmy Connors, 22, and Chrissie Evert, 19? But their off-court doubles team fell apart later that year short of the altar. They did reunite in 1993 (to do a TV commercial for a drugstore painkiller).

TONY TRIOLO /
SPORTS ILLUSTRATED

CITIZEN TANIA

In April 1974, two months after newspaper heiress Patty Hearst, 19, was kidnapped in Berkeley, California, her parents got a snapshot (above); she had joined her captors, the Symbionese Liberation Army. The SLA robbed banks. Hearst was nabbed 18 months later. A jury rejected her brainwashing defense; she did 22 months before being freed by presidential commutation.

IN THE ON-DECK CIRCLE

Her 1974 practice swings were for show. Two years earlier, Maria Pepe had pitched three Little League games in Hoboken, New Jersey, before being lifted because she wasn't a boy. The state's civil rights office filed a case. The League lost and had to allow girls everywhere to suit up — but by then Maria was 14 and too old to play.

CORBIS / BETTMANN-UPI

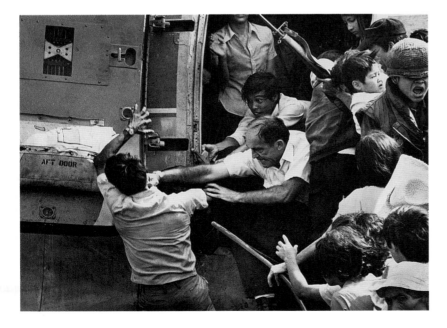

ERRORS WERE MADE

Spring 1975. The situation in Vietnam was worsening. This evac flight out of provincial capital Nha Trang was overloaded. The pilot had to slug a latecomer who would not take no for an answer. The undeclared war killed some three million Vietnamese and, officially, 58,000 American service personnel. The psychic damages are still being measured.

THAI KNAO CHUON / CORBIS / BETTMANN-UPI

A PEACEFUL TRANSITION

On August 9, 1974, Richard Nixon, 61, shrugged his last presidential salute (inset). Veep Gerald Ford, 61, and his wife, Betty, 56, went back to the White House to wait. Some 90 minutes later, by way of a presigned letter, Nixon became the only U.S. chief executive to resign (to avoid impeachment for his role in the Watergate coverup). At 12:03 p.m., Ford was sworn in as the 38th president. He soon pardoned Nixon; it would cost him his job in 1976.

DENNIS BRACK / BLACK STAR
INSET: BILL PIERCE / TIME

COMEDY ISN'T PRETTY

ABC had just launched a prime-time hour called *Saturday Night Live with Howard Cosell*, so in October 1975, a rival network called its 90-minute after-hours satirical revue *NBC's Saturday Night* — airing "Live! From New York. . . ." The gags were sometimes lame but not the charter troupe: counterclockwise from near right, Chevy Chase, 32; John Belushi, 26; Garrett Morris, 38; Laraine Newman, 23; Jane Curtin, 28; Dan Aykroyd, 23; and Gilda Radner, 29. They all live yet in reruns. Enjoy.

FOTO FANTASIES

REQUIEM

> **ROBERTO CLEMENTE**
1934–1972

He turned Pittsburgh's hapless Pirates into contenders and, twice, world champs. Three months after collecting his 3,000th (and last) hit, he flew on a mercy mission to earthquake-torn Nicaragua. The plane crashed. Baseball waived its five-year-wait rule to make Clemente the first Hall of Famer from Puerto Rico.

AL SATTERWHITE

< **MARGARET BOURKE-WHITE, 1904–1971**

The charter *Life* staffer took risks to cover combat; her transport to North Africa in 1942 was torpedoed and sunk. She also trained her eye on Southern poverty, the liberation of Nazi death camps and Gandhi's campaign to free India. Bourke-White's images helped define the new art of photojournalism.

MARGARET BOURKE-WHITE / LIFE

> **COLE PORTER**
1891–1964

Driven by lyrics both erudite and witty ("You're an O'Neill drama; you're Whistler's mama"), his tunes hooked both the café set and Middle America. A 1937 riding fall crippled Porter but not his career; he worked from bed, even staging musical tryouts (right). The last of his 20 Broadway shows was 1955's *Silk Stockings*.

GEORGE KARGER / LIFE

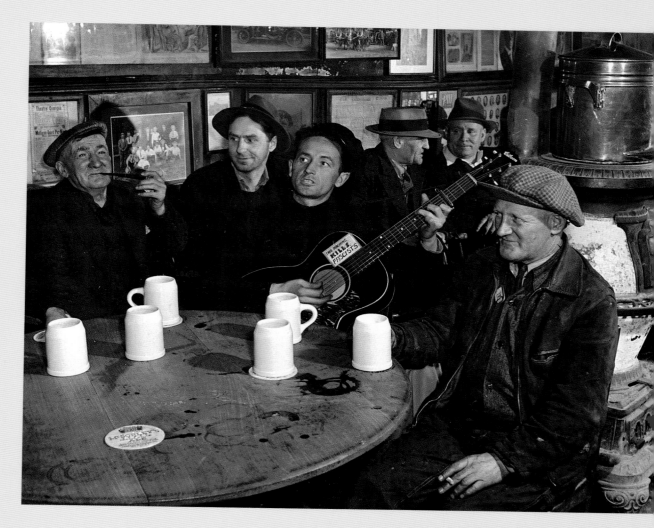

WOODY GUTHRIE
1912–1967

Saloons and hobo camps were favorite haunts of the one-man protest band (and paradigm for Sixties folksingers like son Arlo and Bob Dylan). Of his 1,000-plus songs, the best known is "This Land Is Your Land." It was later used in upbeat advertising campaigns. Funny; Woody wrote it to condemn the ownership of private property.

ERIC SCHAAL / LIFE

ERNESTO (CHE) GUEVARA
1928–1967

He was the original rebel without a pause. An Argentine of Spanish and Irish descent (one grandmother was a U.S. citizen), he forsook a medical career to foment revolution in five countries. In 1956, Guevara hooked up with Fidel Castro; Cuba was to be his only winner. His last guerrilla campaign was in Bolivia. The CIA found him, the Bolivians shot him.

LEE LOCKWOOD / TIME INC.

J.R.R. TOLKIEN
1892–1973

Inspired by the medieval lit he taught, the Oxford don began writing tales of a gnarly realm called Middle Earth that was populated by hobbits, dwarves and elves. Tolkien finished his epic *Lord of the Rings* in 1955. Thus, the 1,191-page trilogy was available in paperback by the time counterculture-era tune-outs were ready to tune in.

SNOWDON / TRANSWORLD
CAMERA PRESS

RUBE GOLDBERG
1883–1970

Four years of engineering classes, followed by six months at the San Francisco sewer department designing pipes, turned him to cartooning. Goldberg's forte was mocking man's urge to complicate. (At left, his alter ego, Lucifer Gorgonzola Butts, invents a remote-control shutter release.) He also did more serious work: A panel about nuclear war earned him a 1948 Pulitzer.

RALPH MORSE / LIFE

EARL WARREN
1891–1974

As California's attorney general in 1942, Warren urged that the state's Japanese-Americans be sent to camps. But as Supreme Court Chief Justice, he usually championed the rights of minorities. The Warren Court outlawed segregation in public schools in 1954 and in 1966 ruled that suspects must be read their constitutional rights before police questioning.

PAUL S. CONKLIN / TIME INC.

WALTER WINCHELL
1897–1972

Inside info, served up in punchy slang, marked his three-decade reign as the nation's top gossip. Winchell used his newspaper columns and radio broadcasts as a bully pulpit to crusade for those who returned his calls, be it FDR or Senator Joseph McCarthy. He also installed a tall fence and a loud alarm at his house to safeguard his own dirt.

CORBIS / BETTMANN-ACME

OSKAR SCHINDLER
1908–1974

Nominally a Nazi industrialist, he deliberately ran factories at a loss in occupied Poland and Czechoslovakia in order to save Jews (some 1,300 in all) from Hitler's death camps. His efforts led to not only repeated arrests by the Gestapo but also a brief postwar detention by the Allies. Schindler rests in Israel, where he is revered as a Righteous Gentile.

PHOTOGRAPHER UNKNOWN

NAT KING COLE
1919–1965

To accommodate a patron, the jazz pianist crooned "Sweet Lorraine." Six years later, Cole began committing his throaty voice and relaxed phrasing to vinyl. But while turning out evergreens like "The Christmas Song," "Mona Lisa" and "Unforgettable," he found signs like "Nigger Heaven" on the lawn of his home in a ritzy white part of L.A.

MURRAY GARRETT /
ARCHIVE PHOTOS

PABLO PICASSO
1881–1973

Not even a master can be perfect every time; in 1949, trying to draw one of his signature bulls for a time-lapse photo, Picasso ended up light-penning a mess. Not so the other works by the Spanish-born artist who, from his studio in the south of France, helped push modern art to Cubism and then beyond.

GJON MILI / LIFE

T.S. ELIOT
1888–1965

His densely allusive verse, which took its sounds and rhythms from contemporary speech, upended English literature. Eliot's fierce intellect illuminated such works as "The Waste Land" and his 1935 play, *Murder in the Cathedral*. But the Nobel Laureate also had a puckish side: *Old Possum's Book of Practical Cats* became the inspiration for the hit Broadway musical *Cats*.

E.O. HOPPE / TIME INC.

JACK BENNY
1894–1974

A fiddle was one comic prop (on radio and TV, the catgut yowled as if still in the cat), his supposed cheapness a second. To these he added a sense of timing as precise as an atomic clock, only calibrated much slower. Robber: "Your money or your life." Benny folds his arms and taps a foot. Robber: "Well?" Benny, annoyed: "I'm thinking about it!"

HERBERT GEHR / LIFE

REINHOLD NIEBUHR
1892–1971

The theologian's journey from Missouri-born Protestant to foreign-policy conceptualist began in the 1910s, while ministering to nonunionized autoworkers in Detroit. Hitler's rise led Niebuhr to drop his pacifism: He judged it moral for the U.S. to fight World War II and, later, Soviet expansion. But Washington ignored his advice to stay out of Vietnam.

ALFRED EISENSTAEDT / LIFE

ARTHUR MARX
1893–1964

Both hands were occupied, so he couldn't honk the bulb of his trademark horn. The middle of Minnie's five boys was the most talkative — offstage. The story is, Harpo was struck mute by stage fright as a child, won guffaws anyway and so romped through 12 Marx Brothers movies in pantomime.

BEN ROSS

On turning 200, these United States of
America numbered 50 (from 13), and its
218 million citizens (from 2.5 million) spoke
350-plus tongues (from a handful).

1976–1992

A GLOBAL BURST OF FREEDOM

A Historical Work in Progress

BY GARRY WILLS

THE SIGNAL EVENT of the 12-year span from 1976 to 1992 was the razing of the Berlin Wall, a symbol of the Soviet Union's collapse. This ending of the Cold War was so pivotal that British historian Eric Hobsbawn called 1989 the end of the 20th Century, and American omnimath Francis Fukuyama called it the end of history.

The Soviet Union's unraveling came as something of a surprise to those who should have anticipated it (notably the CIA), but like many great changes it begins to look inevitable in retrospect. As early as the 1970s, Richard Barnett called the Soviet Union the only country in the world that was ringed with hostile Communist regimes (China, Yugoslavia, Bulgaria). The failure of the world revolution was evident from the moment President Nixon brought China into alignment with the American camp (in 1972) — leaving the Soviets with the task of maintaining an armed border along four thousand miles of territory contiguous with China.

Internal dissent in the USSR, based on economic hardship, had long been brewing. The nine-year war with Afghanistan undermined Soviet morale far more disrup-

tively than Vietnam had damaged America. Russian leaders were trying to alleviate these festering internal wounds by easing off from their global commitments. Ronald Reagan, with his confrontational rhetoric about the Evil Empire, made it clear that they would have to pay a high price for any broadening of the Nixon-Kissinger détente. This concatenation of historical forces stretching back over time is simplified by the celebrants of President Reagan, who think that he, single-handedly, "ended the Cold War" by a massive arms buildup, forcing the Russians to say uncle before they spent themselves to death in an effort to keep up. Actually, Reagan's flexibility in negotiation once he reached the stage of dealing with Russian leaders (an activity he avoided in his first term) had as much to do with Russia's immediate hope of surcease as did the prospect of the antimissile defense known as "star wars" being used decades in the future. Reagan's four surprisingly chummy meetings with Premier Mikhail Gorbachev alarmed hard-liners, prompting columnist George Will to

Signing off in March 1981 as CBS News anchor: Walter Cronkite, 64. In 18 years of duty (reporting on Dallas, the U.S. space program, Vietnam), he had won the accolade Most Trusted American. His seat went to Dan Rather, 49.

BILL PIERCE / TIME

say that Reagan "had given away the farm." (It was hard for Reagan to treat people he actually met as the embodiment of evil.)

Two people who did not attribute the Cold War's end to Reagan alone believed it was the joint product of Reagan and Pope John Paul II — who, according to Carl Bernstein and Marco Politi, were the dei ex machina bringing this drama to a happy conclusion. History is rarely that simple, or one-sided. Such approaches give too little credit to the internal dissidents who put pressure on their leaders, men like Anatoly Marchenko, whose protests forced Gorbachev to free, and to deal with, Andrei Sakharov. They give too little credit, as well, to the nationalist leaders within the Soviet Union's orbit, typified by Lech Walesa in Poland or Vaclev Havel in Czechoslovakia. For that matter they give too little credit to Gorbachev, who saw the need for bending and who carefully maneuvered others along the difficult road toward recognition of the inevitable.

Yet this more nuanced view of what happened does not in any way remove the fact that Reagan played a key role. His presidency was the dominant political reality of this period in American history — his eight central years flanked by four years, on either side, of weak presidents: Carter in 1977–81 and Bush in 1989–93. Carter had promised to restore trust and virtue to the White House after the disillusionments of Vietnam and Watergate. His bold initiatives — for the Panama Canal treaties or the Camp David accords — were undermined by vacillations and loss of nerve. He was one of those who did see that the Soviet Union's power was overrated. But he backed off from that view when the Soviets invaded Afghanistan, and he made a feckless gesture of resistance by canceling American participation in the Moscow Olympics of 1980. He was bored with economics and did nothing about rampant inflation. In his so-called "malaise" speech, he blamed his own confusion on American diffidence. His greatest mis-

In a business suit, Ronald Reagan (here in 1984, at 73) looked even tougher to Moscow. The most popular president since FDR made some gaffes; his Cold War–ending Soviet policy was not one of them.
MICHAEL EVANS / THE WHITE HOUSE

take was yielding to pressure from Republicans like Henry Kissinger and David Rockefeller, who urged him to accommodate the ailing Shah of Iran, our former puppet in a CIA coup, when he sought admission to America for medical aid (as if none were available elsewhere). The predictable anger of the Iranian ayatollah Ruhollah Khomeini was expressed in the taking of American hostages. For a brief period Carter benefited from American anger at Khomeini. But the longer the captivity was extended, and the less Carter could do about it, the more his popularity sank, reaching record lows before the election that dislodged him.

Reagan was the perfect antidote for malaise. He radiated a mysterious confidence. At a time when political scientists were saying that strong presidents were a thing of the past, he proved them wrong. The nation found his certitudes bracing, even his ill-grounded ones. There was more youth in this septuagenarian politician than in all his soberer critics put together. He made of the 1984 Olympics in Los Angeles the perfect and antipodal response to Carter's non-Olympic year. Even when his foreign policy decisions were disastrous, as when 241 poorly guarded American Marines died in a Lebanon outpost, the victims of a truck bomb, he recovered with an instant and theatrical invasion of Grenada in which more medals were awarded than there were American combatants.

George Bush could not successfully follow such an act. Not quite trusted by his own party's right wing, he had to profess a loyalty to the Reagan legacy, only to find that there can be no such thing as Reaganism without Reagan. What was bequeathed by his predecessor was a mammoth national debt, the greatest in history (nearly three trillion dollars), run up by Reagan's huge tax cuts (30 percent over nearly three years), and heavy defense spending. The burden of this economic dislocation was falling on the poor — the bottom 10 percent of the population lost 10 percent of its income under Reagan, while the undertaxed top 10 percent had an increase in wealth of 24.4 percent. The top one percent gained an incredible 74.2 percent in wealth during Reagan's eight years. Despite this increasing inequity, Bush was lured into Reaganite rhetoric to win the election ("Read my lips — no new taxes"). When he tried to back off from that pledge, he did not have Reagan's gift for disguising realities, and the right wing savaged him for deserting the hero's legacy.

In foreign affairs, Bush worked for an orderly conduct of the Soviet Union's dismantling, but aside from that happy aspect of Reagan's presidency, he

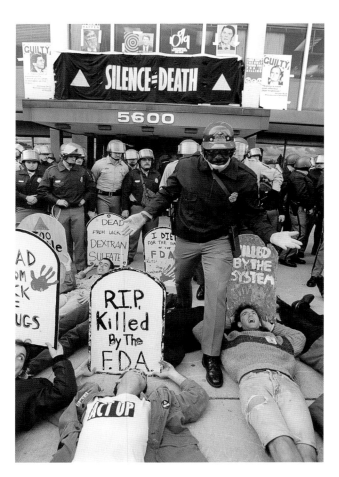

One cop took no chances with the group blocking FDA headquarters in Rockville, Maryland, in 1988. ACT UP was protesting the lack of medication for AIDS, which had already infected 1.4 million Americans.

J. SCOTT APPLEWHITE / AP

was encumbered by the aftereffects of Reagan's foolish anticommunism in Central America (the arming of Nicaraguan contras with money from the exchange of hostages with Ayatollah Khomeini, an affair in which Bush was complicitous despite denials). Bush's own limited war against Saddam Hussein lifted him vertiginously in the polls but gave him as brief a honeymoon as Carter had experienced in the early days of anger at Khomeini.

Though Reagan exuded an air of control during his tenure, this was essentially an illusion. His call for a return to the simpler values of the past veiled but did not alter a rate of cultural change that, along with technological and scientific advances, marks the last decades of this century. The religious right,

By 1980, preacher Jerry Falwell, 47, had branched from spiritual (his teleministry) into secular (his newly formed Moral Majority). Other Christian conservatives would soon coalesce into a pivotal voting bloc.

WILLIAM E. SAVRO / THE NEW YORK TIMES

which had stirred under Carter, became an electoral force with Reagan, who benefited from its development. But this was a response to changes the right could not reverse. Abortion continued to be legal, and prayer in schools illegal. Feminism was hardly checked by a president who appointed the first woman to the Supreme Court. Censorship lost many battles besides the high-profile Supreme Court ruling for Larry Flynt in 1988. Flynt had long been a target of Charles Keating, the antipornography crusader who later became a Reagan ally.

In all these moral skirmishes, America represented just one theater in a worldwide war of fundamentalism with modernity — a war marked by religious terrorism, jihad or holy crusade, and fatwa, placed most famously on the head of novelist Salman Rushdie. Muslim, Jewish, Catholic and Orthodox extremists bombed and shot the representatives of modern power in the Middle East, Ireland and the Balkans. This was a deadly but doomed effort. The writhings of orthodoxy, like the thrashings of a tree tortured by a storm, bore witness to the power at work on it, not to the order it hoped to impose. Computers were refashioning the secular world in ways that blind faith — whether in Reagan's benign lenity or the terrorists' despairing vigor — could not reverse.

Garry Wills is an adjunct professor of history at Northwestern University. He is the author of more than 20 books, including Nixon Agonistes *(1970),* Reagan's America *(1987) and* Lincoln at Gettysburg *(1992). Among his awards is the Pulitzer Prize for Literature.*

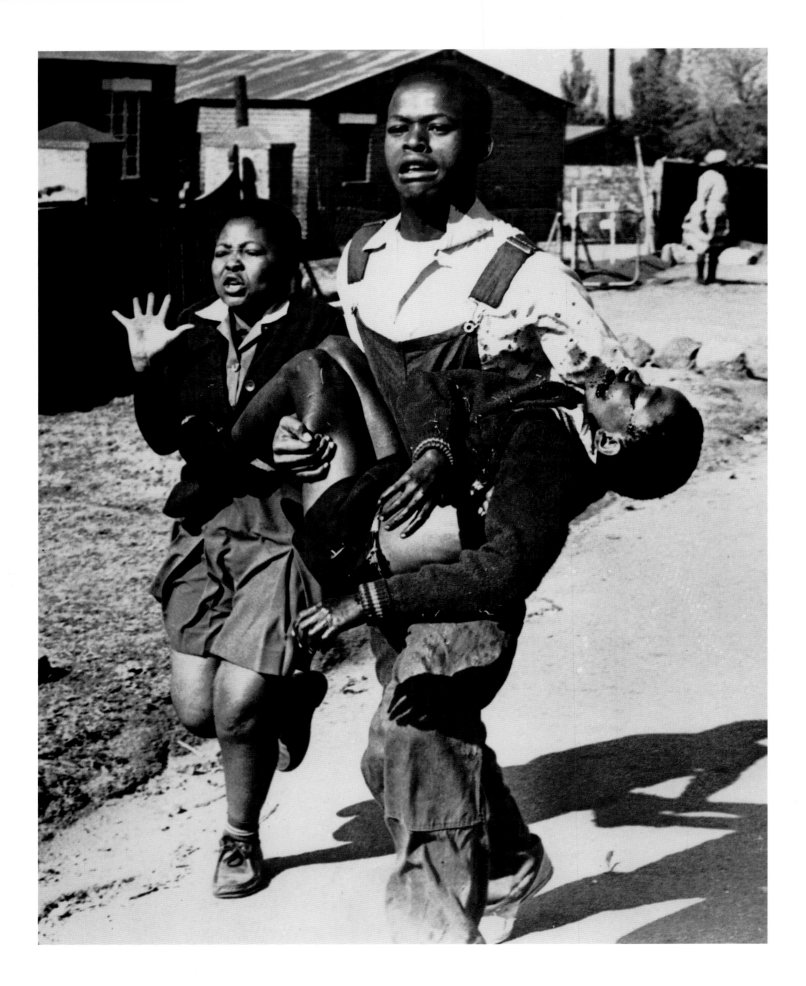

>

BRAVE NEW WORLD

So what if Susan Donner, 18, hadn't quite gotten the hang of curling her cap bill. In 1976, the Coast Guard Academy swab and 420 other women entered four U.S. service schools that had been, in their collective 431-year history, male only. (The others: Army, Navy, Air Force; the Merchant Marine Academy had broken rank in 1974.)

EVELYN FLORET

<

BURDEN OF GRIEF

Young Hector Petersen was peacefully protesting the bad schools in South Africa's black township of Soweto when he was shot dead (with three others) by riot police. The June 1976 incident sparked an uprising that claimed some 1,000 more lives in the next 18 months. One who died, though not in Soweto but under detention: 30-year-old activist Steven Biko.

AP

>

WE GIVE IT A 10

She would land perfectly on the balance beam at the 1976 Olympics. The 14-year-old, 86-pound gymnast Nadia Comaneci won this and two other golds at Montreal (notching the first seven perfect scores in Games history). But her brutal training in Communist Romania had taken a toll; the next year, she attempted suicide. Comaneci defected to America in 1989.

CO RENTMEESTER

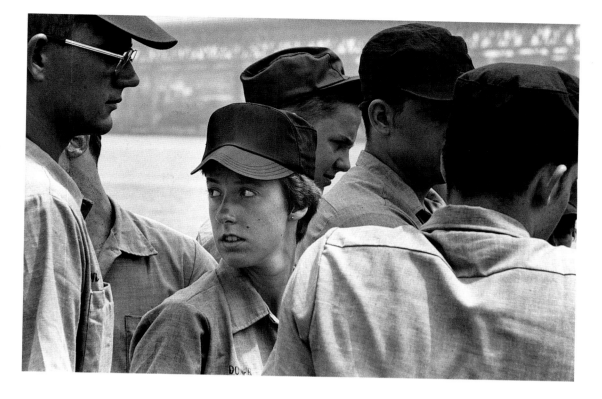

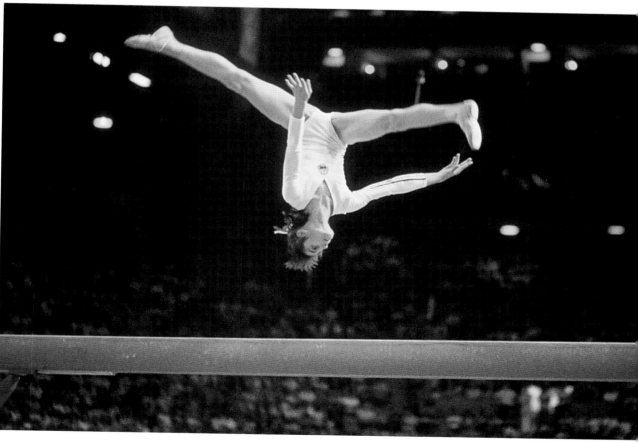

DISTURBING THE FIELD

O.K., so the desert was in Tunisia, not on the planet Tatooine in a galaxy far, far away. And those droids were actually British actors Anthony Daniels, 30 (left), and Kenny Baker, 41. Still, we suspended disbelief over 1977's *Star Wars*, filmed by director George Lucas, 33, for $7.8 million. The fifth (of nine) episodes of the saga that changed not only Hollywood but also pop culture is due in theaters May 19, 2002.

LUCASFILMS

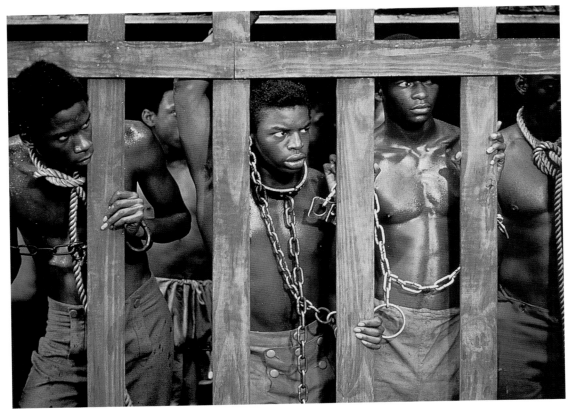

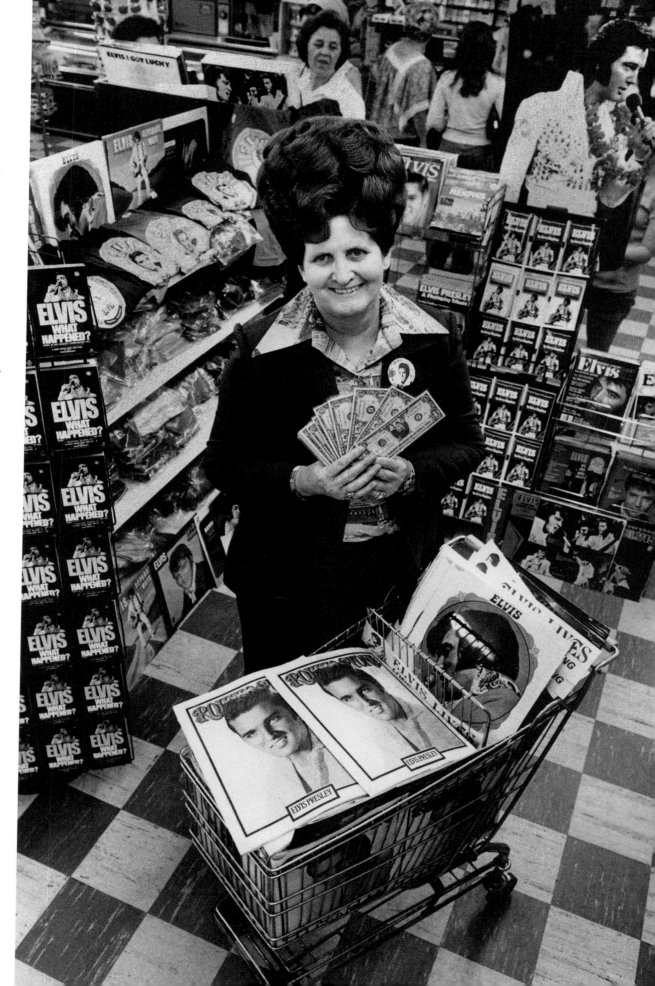

<

SOLE OF A NEW MACHINE

Jim Fixx took up jogging to slim down — and dropped 60 pounds. By 1978, the magazine editor, 46, had regained the weight in his wallet: *The Complete Book of Running*, about his new passion, was on its way to selling one million copies in the U.S. alone. Road rage was immediate. That year, 9,875 started the New York Marathon. The first race, in 1970, had drawn 126 entrants.

KEN REGAN / CAMERA 5

>

NO CRYING IN THE CHAPEL

Elvis died on August 16, 1977, at 42, in his home in Memphis. June Rhodes, a clerk at a store across the street from Graceland, quickly began pitching the ton of memorabilia the King had left behind. (Not to mention those impersonators who hog karaoke night, perform weddings and skydive en masse.) Pick of the lot: the 88 Presley albums that remain in print.

MICHAEL D. MAPLE / CONTACT

<

ONE MAN'S FAMILY

The crucial first hours of the miniseries had to be carried by an unknown: Levar Burton, 19 (left, center), playing an 18th Century African enslaved to America. Having spent $6 million to adapt Alex Haley's best-selling *Roots*, ABC turned Chicken George and aired it over eight straight nights of a nonsweeps month. Mistake. More than half of America caught part of the epic, and the finale drew 80 million.

WARNER BROTHERS

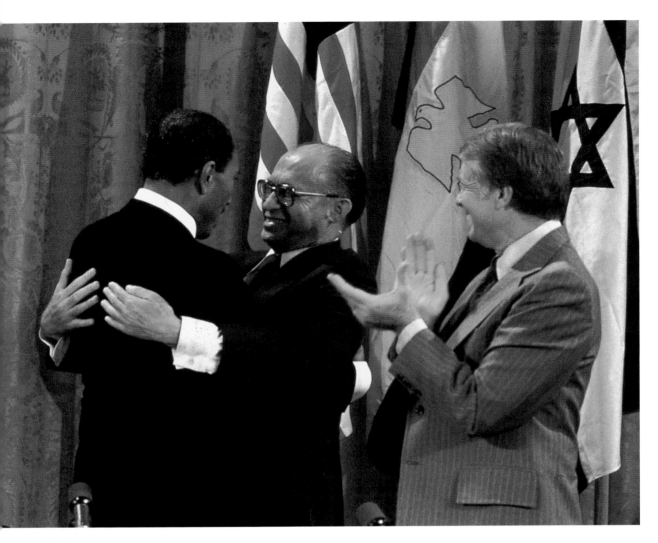

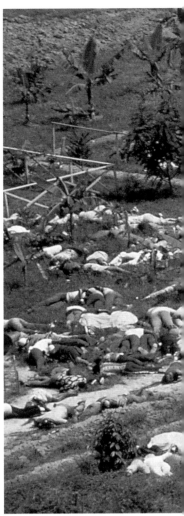

A HISTORIC HUG

Five years earlier, there was only enmity between Egyptian president Anwar Sadat, 59 (left), and Israeli prime minister Menachim Begin, 65; now, in September 1978, they were in open embrace. The Yom Kippur war had cost both nations dearly. So after 12 grueling days of talks at Camp David refereed by President Jimmy Carter, 54, Sadat and Begin unveiled the first Israeli-Arab peace accord ever.

DAVID HUME KENNERLY

A CANARY CALLED CHRYSLER

Like any unemployed 54-year-old, Lee Iacocca was pleased to find work. In July 1978, the auto exec had been fired by Ford in part because only Fords had a future there. Now, 15 weeks later, he was saying yes to Chrysler. Wasn't that company almost bankrupt? No problem.

CHUCK TURNER

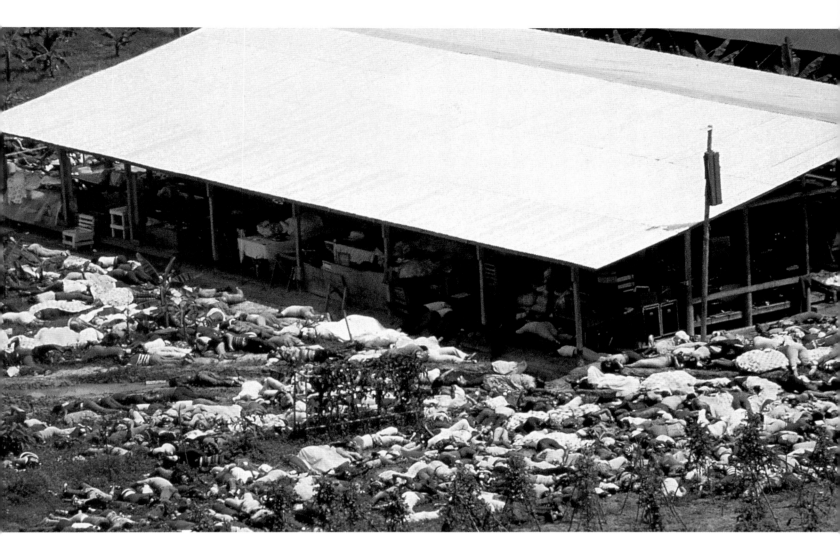

LAMBS TO SLAUGHTER

A year after following Jim Jones to equatorial Guyana, members of his People's Temple were fatally betrayed by the cultist. Jones, 47, who had fled the Bay Area because his tactics were being probed, panicked on November 18, 1978, when congressional investigators arrived. He had some of them shot. Then he told his flock to drink poisoned Fla-Vor-Aid. After some 900 had, he put a gun to his own head.

DAVID HUME KENNERLY

FACE OF THE FUTURE

Fifteen-month-old Louise Brown of England was a September 1979 guest on Phil Donahue's talk show. Her claim to fame? She was the first child born of an egg fertilized outside her mother (who could not conceive but did carry the in vitro, or test-tube, baby to term). Louise didn't need biochemist Pierre Soupart to attest to her obvious good health.

CORBIS / BETTMANN-UPI

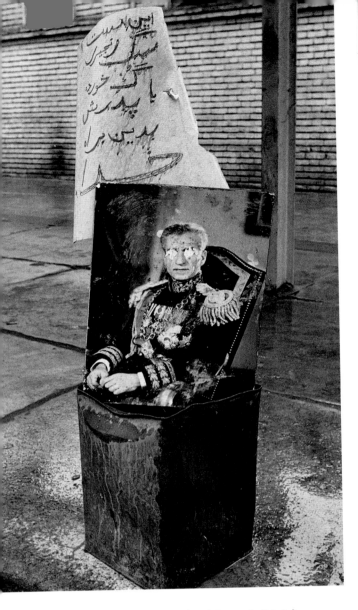

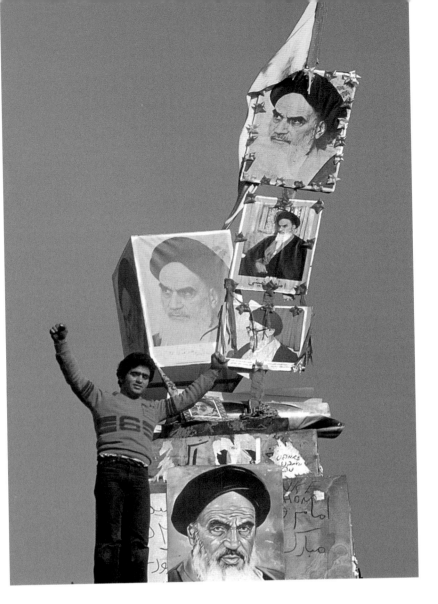

Trashing a Leader (and Some Infidels)

No one was more stunned in January 1979 than the Shah of Iran. After 37 years, the westernized Reza Pahlavi, 59, was told rather pointedly (above) by conservative Muslims to quit the Peacock Throne. Two weeks later, adoring Shiites (above right) welcomed their Ayatollah Ruhollah Khomeini, 79, back from a 15-year exile. In October, Jimmy Carter allowed the Shah to enter the U.S. for treatment of his terminal cancer. Khomeini got even by allowing young fundamentalist radicals to seize the American embassy and 52 hostages (right). The 444-day siege cost Carter reelection in 1980.

CLOCKWISE FROM ABOVE: AP; KAVEH GOLESTAN;
ALAIN MINAM / LIAISON

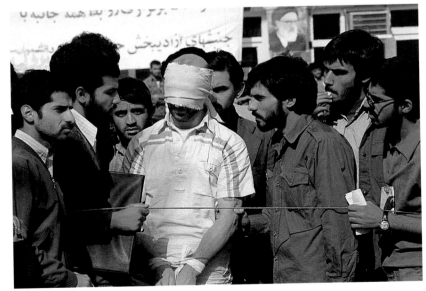

ACTIONS AND REACTIONS

These Afghan guerrillas didn't care that the Soviet paratroopers landing in Kabul in late 1979 had been invited by a puppet government. The mujahedin wanted them (and the 100,000 Soviet soldiers who followed) out. So did the Muslim states staking the rebels to arms and cash. So did the CIA, which even flew in a blind firebrand cleric from Egypt to advise the mujahedin. After the humbled Soviets withdrew in 1989, Sheikh Omar Abdul Rahman was allowed covert entry to the U.S. He would soon say his thanks at the World Trade Center.

STEVE McCURRY / MAGNUM

<
REWIRING HISTORY

One paradox of Communism had always troubled Polish shipyard electrician Lech Walesa: In urging workers of the world to unite, it also banned them from uniting in unions. In 1979, at 36, he founded, at his workplace in Gdansk (left), Solidarity. Walesa placed himself in personal jeopardy, but both he and the movement survived to send shock waves through the entire Soviet empire.

AP / WIDE WORLD

>
THEY GOT GAME

Larry Bird, 22, had shown that white men need not jump in leading Indiana State (11,474 students) to the 1979 NCAA finals. Waiting were Earvin (Magic) Johnson, 19, and overdog Michigan State (44,756 students). David didn't beat Goliath. But the All-Americas ignited March Madness by putting on a show they then took to the NBA.

JAMES DRAKE / SPORTS ILLUSTRATED

<
AN OOLONG, I BELIEVE?

Campaigning American pols taste whatever the locals offer. In 1979 British by-elections, Margaret Thatcher tasted tea. And passed the test. Returned to Parliament at 54, she was named her nation's first woman prime minister. It was a position that the iron-willed Thatcher (one nickname: Attila the Hen) would hold for 11 years, a 20th Century record.

BEN MARTIN / TIME

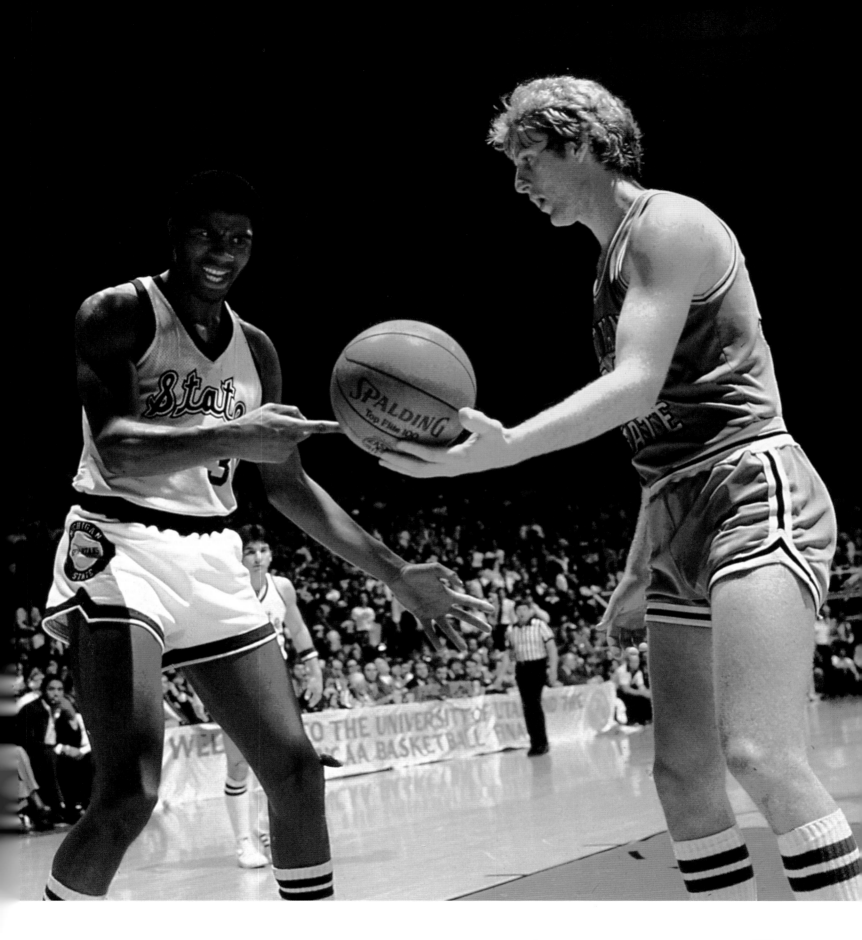

See It Now

In 490 B.C., it is told, one Pheidip-pides ran 25-plus miles to tell fellow Athenians of their victory at Mara-thon. Information traveled no faster than the swiftest messenger. George III didn't hear of some colonies de-claring independence until mid-August 1776. In 1861, news was relayed between Missouri and Cali-fornia in 10 days by teams of riders — but the Pony Express was put down after 18 months by the first trans-continental telegraph. Radio cut everyone in on the electronic action, and today, the latest from anywhere is but a mouse-click away. Data 24-7 have a downside. If we let our reflexes respond, we forfeit the time to verify, to reflect, to frame options. The upside is knowledge, which em-powers. Why else do dictators try to limit such messengers as satellite TV?

< LIVE FROM ATLANTA

At 6 p.m. Eastern time on June 1, 1980, any of Amer-ica's 15.2 million cable-TV subscribers surfing their channels might have seen Atlanta-based entrepreneur Ted Turner, then 41, person-ally inaugurate his Cable News Network. A loser, said skeptics; there wasn't enough news to fill out a 24-hour schedule.

DAVID BURNETT / CONTACT

> EXTRA! EXTRA!

Telegraphers quickly sped news of the British victory in May 1902 across the 6,000 miles separating South Africa and England, but then it was up to newsboys to spread the word around London. One British scribe who made a name for himself covering the Boer War: Winston Churchill.

TIME INC.

> GOING TO THE SAD SOURCE

Bad news traveled fast in 1912. But details were hard to come by, New Yorkers learned; the latest list of *Titanic* survivors was avail-able first at the White Star offices (right). The disaster received the era's equivalent of saturation coverage: *The New York Times* ran it Page One for 14 straight days.

TIME INC.

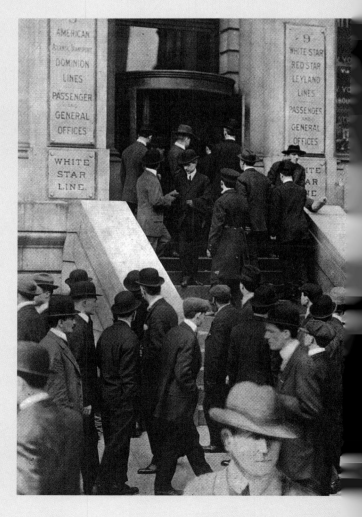

THE FIRST WEBMASTER

By 1926, David Sarnoff, 35, had parlayed his fame for being the first on land to hear *Titanic*'s distress calls (see page 28) into a post at RCA, which made radios. To perk up sales, he began joining individual stations into a network that would carry common programming. That November 15, the National Broadcasting Company opened for business with 25 affiliates.

CORBIS / BETTMANN

WNZI IN BERLIN

At the 1936 Olympics, a German crew field-tested an early TV camera. Six years earlier, pioneers in the U.S. had demonstrated the new medium in the studio and, on August 20, successfully beamed a signal from midtown Manhattan as far as 98 Riverside Drive (three miles). But television's introduction would be delayed by World War II.

HEINRICH HOFFMAN / LIFE

MY FELLOW AMERICANS

FDR was the first president to harness modern mass communications when, from the White House on March 12, 1933, he addressed the nation live on radio. Roosevelt conducted 29 more "fireside chats" (including this one in 1941 in front of Latin American diplomats) during the remainder of his years in office.

THOMAS D. MCAVOY / LIFE

THE PRESTIDIGITATOR

More animated than any daytime soap in March 1951 were the hands of Frank Costello, 60. He was testifying before a televised Senate hearing into syndicated crime on condition that his face be kept off camera. Asked if he knew of any mob called the Mafia, the man who was don of New York replied with a quick thumbs-down.

ALFRED EISENSTAEDT / LIFE

A TRAGEDY SHARED

On November 25, 1963, more than 100 million grieving Americans watched from home as the caisson bearing the casket of John Fitzgerald Kennedy rolled down Pennyslvania Avenue in Washington, D.C. Also shown live were the service for the president at St. Matthew's Cathedral and his burial at Arlington National Cemetery.

FRED WARD / BLACK STAR

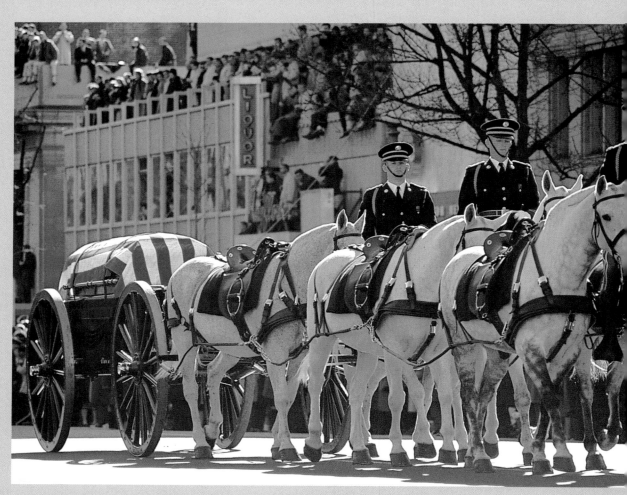

< ECHO TO EARTH: I COPY

It was just a 100-foot-diameter balloon wrapped in aluminum foil, but when NASA placed *Echo I* into low-earth orbit on August 12, 1960, another pathway to global telecommunications had opened. Radio signals could be bounced off the satellite's metallic skin. *Telstar*, launched in 1962, permitted the relay of television signals.

NASA

> MORE THAN MET THE EYE

A Buddhist monk immolated himself on a busy Saigon street in June 1963 to protest alleged South Vietnamese persecution of his co-religionists; all told, 22 men and women died in such dreadful fashion over a five-year period. In the U.S., where the shocking images made newscasts and front pages, the suicides were often misinterpreted as a sign of Buddhist resistance to the Vietnam War.

AP

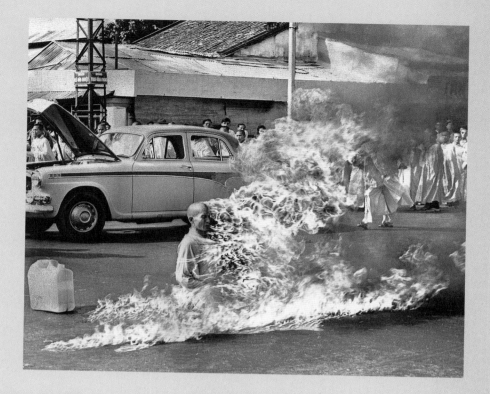

A HOLY MUST-SEE

It was 4:56 a.m. on July 21, 1969, in Castel Gandalfo, Italy, but Pope Paul VI, 71, was glued to the tube — as was the rest of the world. Astronaut Neil Armstrong was stepping from the lunar lander *Eagle* onto the moon. His Holiness was a space fan; in a blessing a week earlier, he had predicted, "Science fiction becomes reality. . . ."

CORBIS / BETTMANN-UPI

HERE COMES THE BRIDE

In 1969, some 200 million people worldwide tuned in for the investiture, at Caernarvon, of the Prince of Wales. On July 29, 1981, the audience swelled to 750 million for the marriage (right), at Westminster Abbey in London, of Prince Charles, 32, to Lady Diana Frances Spencer, 20.

DAVID BURNETT / CONTACT

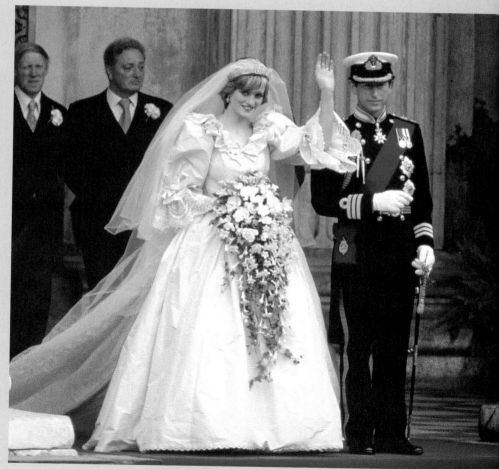

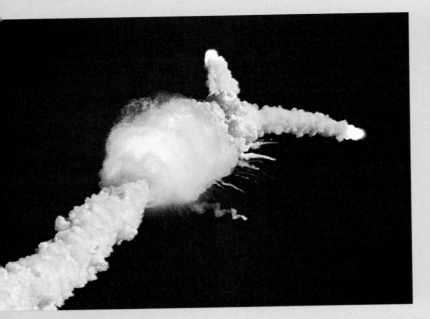

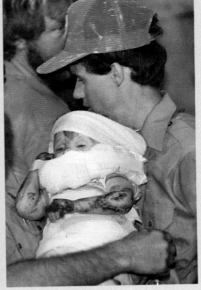

< LITTLE GIRL DOWN BELOW

The broadcast networks cut from their prime-time shows on October 16, 1987, to show the rescue of 18-month-old Jessica McClure; almost 59 hours earlier, she had fallen into an uncapped well in the yard of her aunt's unlicensed day-care center in Midland, Texas. Savior Robert O'Donnell (left) was not prepared for unsought fame. Tele-movie producers promised much but delivered nada; in 1994, he took his own life.

ERIC GAY / AP

A FIRE IN THE SKY

Unlike the early days of NASA, when network anchors went in person to the Cape to cover space shots, only CNN livecast the launch of January 28, 1986. By early afternoon, though, videotape of *Challenger*'s disastrous ascent was rerunning on all channels.

AP

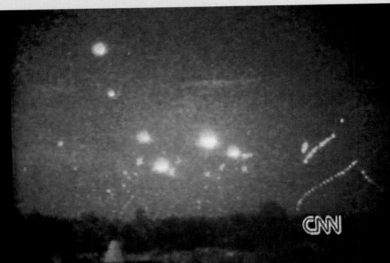

< WATCHING A WAR BEGIN

The images Americans saw on the night of January 16, 1991, seemed like an early low-resolution video-arcade game: rising sheets of anti-aircraft fire, sudden flares of detonating bombs. It was not *Missile Command* but rather the first Allied air raids on Baghdad. Operation Desert Storm had started on live TV.

CNN

> SLO-MO ON THE FREEWAY

The Juice was loose! Just after 6:30 p.m., Pacific time, on June 17, 1994, ex-football star O.J. Simpson, 46, a fugitive charged with two counts of homicide, was spotted on I-405 in a pal's Bronco. Minutes later, L.A. news choppers joined the police pursuit. Their live pictures preempted network programming in the East until the suspect gave up.

JOSEPH VILLARIN / AP

> WHEN THE WORLD WEPT

Princess Diana's death in August 1997, at 36, in a Paris traffic accident, focused the world on London, where floral tributes inundated Kensington Palace (right) and her funeral cortege passed an estimated two million. By then, the entire planet was within line of sight of at least one communications satellite; anyone with a television could join in the mourning, real time.

PETER TURNLEY /
CORBIS / BETTMANN

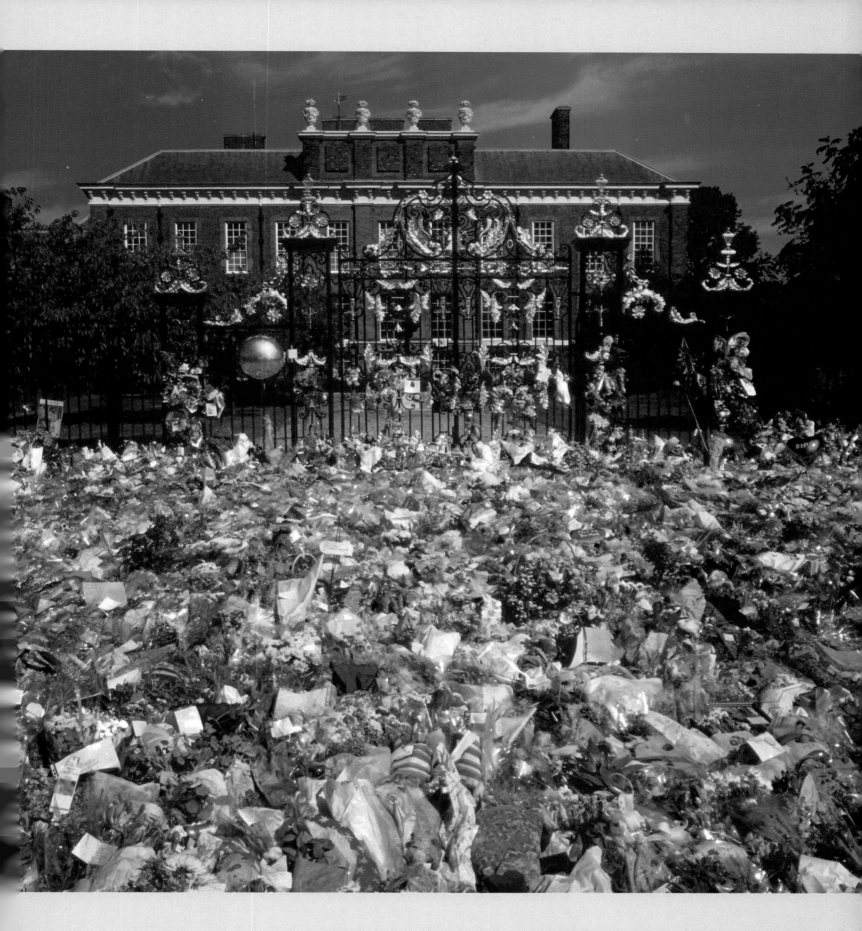

<
JOHN LENNON (1940–1980)

The newly cut "(Just like) Starting Over" would be his 85th chart hit, including those with the Beatles. The psychic wounds from the Fab Four's breakup were healing. His ex-mates were doing well. There was even public banter about a reunion concert. But on December 8, a songwriter manqué turned stalker shot Lennon dead.

>
TARGET: THE PRESIDENT

By waving to the crowd as he departed from a luncheon at a D.C. hotel on March 30, 1981, Ronald Reagan, 70, left himself open to a .22 bullet. The aspiring assassin, hoping to catch the eye of an actress he was obsessed with, also wounded three others, most critically press secretary Jim Brady, 40. Reagan's recovery began in the OR: Eyeing the docs, he quipped, "Please tell me you're Republicans."

>
ANWAR SADAT (1918–1981)

Few Arab leaders had been as bellicose toward Israel — nor as committed to lessening Mideast hatred. The Egyptian president's peace efforts (see page 346) led to a shared Nobel (with Menachim Begin). As well as to his death: Sadat was attending a military parade in Cairo on October 6 when Muslim fanatics stormed the reviewing stand.

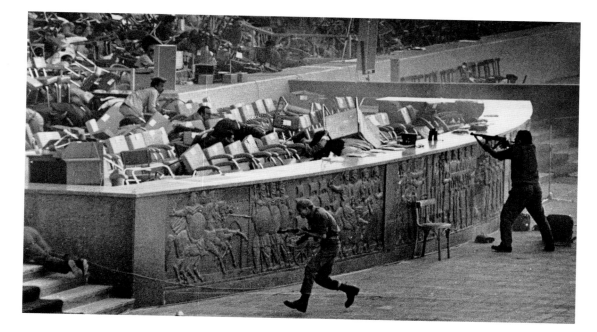

TARGET: THE POPE

In greeting the 10,000 at his weekly audience in St. Peter's Square on May 13, 1981, Pope John Paul II, 60, left himself open to two 9 mm bullets to the abdomen. The would-be assassin was an escaped Turkish con who said his motives were not religious. He claimed to be a hired gun for Bulgarians fronting for Moscow, which feared the Polish-born pontiff would lend moral aid to Lech Walesa's Solidarity.

FOTAM

C:> REVENGE OF THE NERDS

Computer tyros Paul G. Allen, 27 (left, in July 1981), and William H. Gates III, 25, had heard that IBM, about to market its first PC, needed some nuts-and-bolts system code. The Seattle pals pooled $50,000 to buy an existing piece of software that they tweaked and retitled MicroSoft Disk Operating System (MS-DOS). Big Blue gave the kids a break and licensed it.

SEATTLE POST-INTELLIGENCER

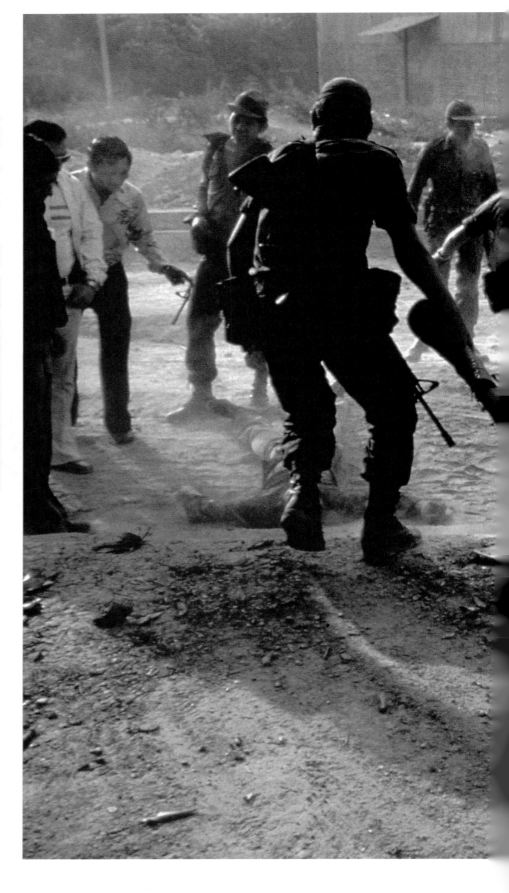

WHAT RIGHT TO VOTE?

By 1982, El Salvadorans had understandably come to fear Election Day violence. (Here, troops in suburban San Salvador clean the streets of dead leftists.) The Central American nation of 4.6 million was for 12 years a free-fire zone in which Cuban-backed guerrillas and U.S.-backed death squads clashed; a truce was reached in 1992.

DON McCULLIN

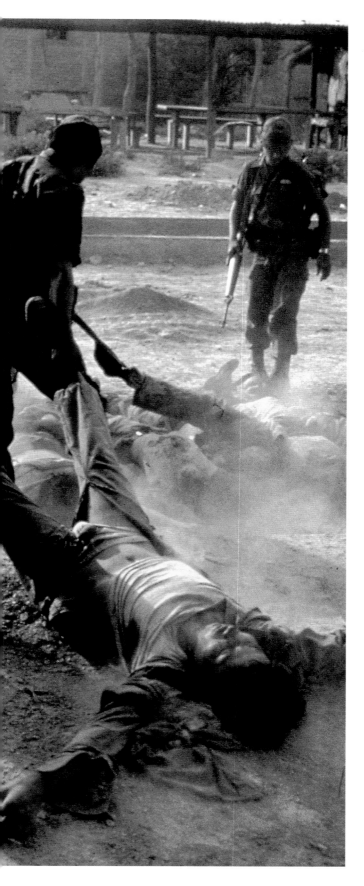

AN END TO HIS TROUBLES

The bearers at the Belfast, Northern Ireland, cemetery were masked against unsmiling British eyes. In the casket rested IRA comrade — and new member of his nation's parliament — Bobby Sands, 27. Jailed on an arms charge, he fasted to death in 1981 to protest prison conditions. Nine others from the outlawed Irish Republican Army followed, an act that won sympathy from many (but not from Prime Minister Thatcher).

JAKE SUTTON / LIAISON

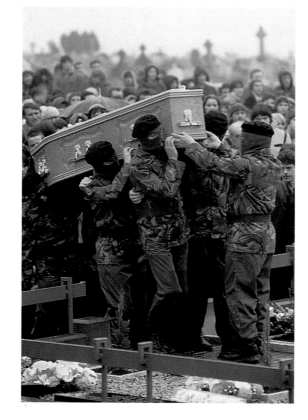

I'M NOT LIKE OTHER GUYS

Thriller was rock's Main Event in 1983: the LP by Michael Jackson, 25, is No. 1 all-time (25 million and counting) and the video (right) legitimized the new cable service MTV. Sadly, the onetime Jackson Five cutie wasn't the Mike to be like. From moonwalker extraordinaire, he morphed into a morbid collector (bidding on Elephant Man's bones) and then a cosmetic-surgery-ravaged hermit.

VESTRON VIDEO

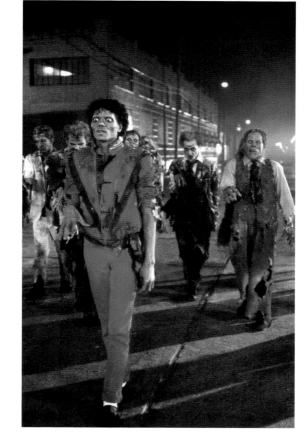

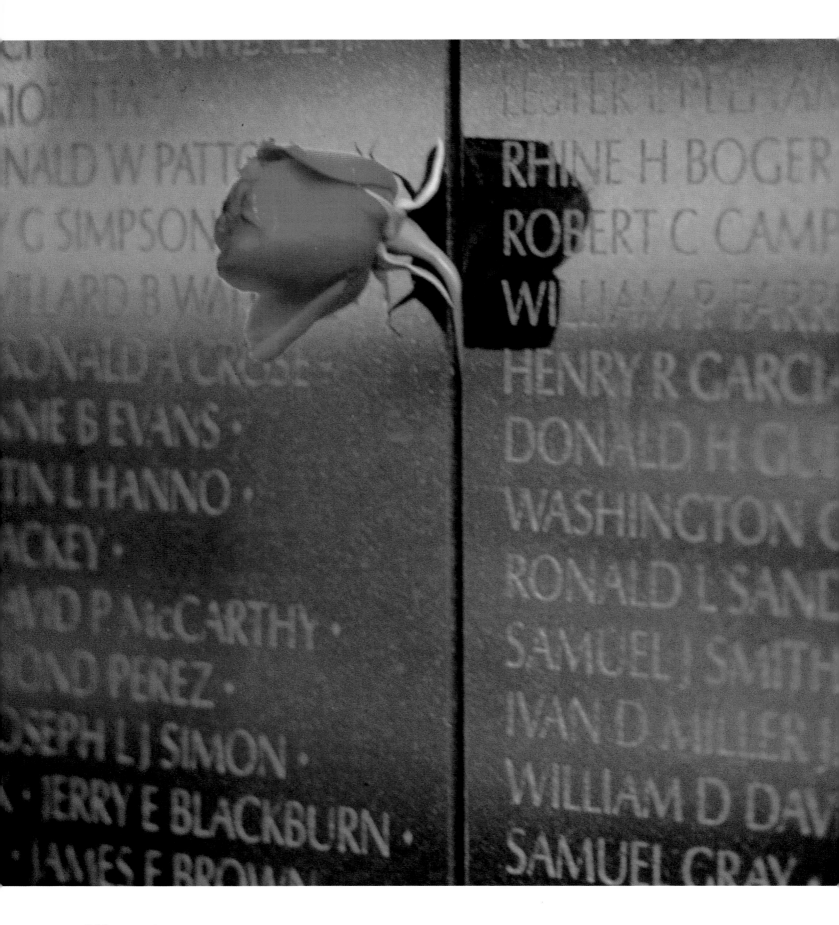

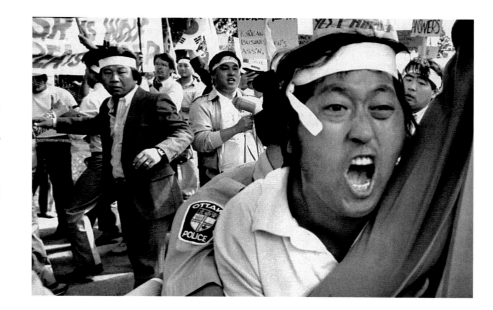

> **TRAGEDY OF ERRORS**

In Ottawa, South Koreans stormed the Soviet Embassy after the shoot-down, in 1983, of a Korean Air Lines 747 with 269 aboard. Questions remain. Why did the flight stray in and out of USSR airspace for nearly two hours? How could a Soviet fighter pilot mistake a jumbo jet for a warplane? And why did Allied intelligence, which monitored KAL 007, not warn its captain?

ANDY CLARK /
CP PICTURE ARCHIVE

> **E.T., PHONE BANKER**

The little critter (with on-planet pal Henry Thomas, 10, right) required more high-tech wizardry from director Steven Spielberg than did Bruce, his Great White. But then 1982's *E.T. The Extra-Terrestrial* had more box-office teeth ($400 million versus *Jaws*'s $260 million) and so much charm that it drew a PG despite the rank put-down, "penis breath."

UNIVERSAL STUDIOS

< **A WALL OF TEARS**

In November 1982, more than seven years after the end of the longest U.S. war, the Vietnam Veterans Memorial was dedicated on the capital's Mall. On the twin walls of polished black marble, designed by Maya Lin, then 21, were first incised 57,939 names, in order of death. That number has grown. There are still some 2,000 MIAs; room has been left for them.

ROBERT C. BURKE / LIAISON

< **THEY BROKE THE MOLD**

The year the Cabbage Patch Kids sprouted, 1983, they retailed for $17.99 — if you could find one. The gimmicks, besides their downright homeliness: Each guaranteed-unique doll came with "adoption papers" and often had an odd name (Ferieca Netty, Olive Jody) said to be taken from a 1938 state of Georgia birth registry.

RAEANNE RUBENSTEIN

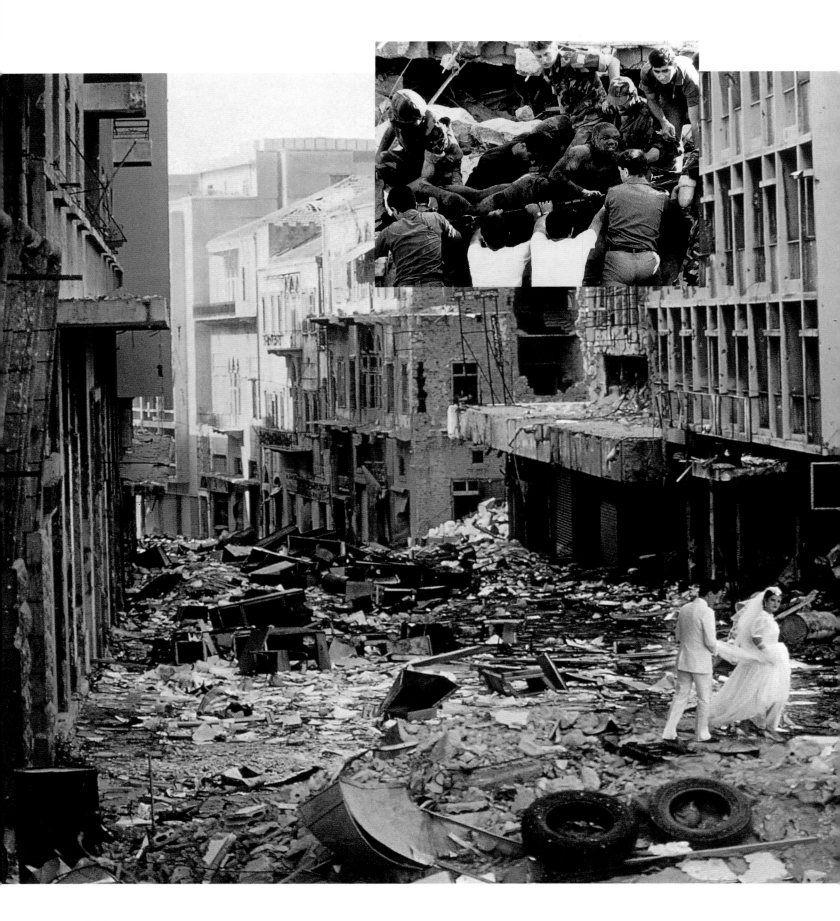

> **BUMP AND RUN**

A tangle late in the 3,000 meters (between America's falling Mary Decker, 26, and barefoot Zola Budd, 18, running for Britain) was a rare glitch at the 1984 Los Angeles Olympics. They were the first Games to turn a nice profit. And with the USSR saying *nyet* — tit-for-tatting America's boycott of 1980's Moscow Games — Team USA won a national-best 174 medals.

DAVID BURNETT / CONTACT

< **LOVE AMONG THE RUINS**

The bridal couple threading through the Beirut rubble symbolized the Lebanese city once a gem of the Mediterranean; they were crossing the Green Line that split his Muslim sector from an altar in her Christian sector. In 1982 Ronald Reagan sent U.S. Marines to the city to keep the peace. On October 23, 1983, their barracks was truck-bombed (inset), with a death toll of 241.

JAY ULLAL / BLACK STAR
INSET: BILL FOLEY / AP

> **HEAR ME ROAR**

In July 1984, Martina Navratilova, 27, scorched Wimbledon (right) as she had the French Open and would the U.S. Open. The Czech-born naturalized American was on the run of a lifetime: In one stretch of 20 Grand Slam events, she won 12. Wielding a serve-and-volley game rare for women's tennis, she retired in 1994 with 167 titles, most by any player. Any.

LEO MASON / SIPA

PAGING DR. HUXTABLE

The first black to co-star in a prime-time drama (1965's *I Spy*) struck out on his next three series. In 1984, Bill Cosby, 47 (here with Keshia Knight Pulliam, 5), tried a new sitcom on NBC. *The Cosby Show* would finish in the top five each of its first seven seasons (including at No. 1 from 1985 to 1988) and thus command record rerun fees (half a billion dollars for 125 episodes).

NBC

LISTEN UP, HOMEY

The sample-scratching, insult-woofing music that started in America's inner cities stayed there until 1984, when the LP *Run-D.M.C.* went gold. The artists, from near right: Jason Mizell, 19; Joseph (Run) Simmons, 19; and Darryl (D.M.C.) McDaniels, 20. The group got a bigger boost when their "Rock Box" became MTV's first rap video.

KEN REGAN / CAMERA 5

YAKKETY-YAK

Oprah Winfrey's boots were made for talkin'. At 31, the onetime TV newsreader was hosting an a.m. show in Chicago (left); in 1986, she went national. Oprah's emotive, confessional style (childhood abuse, avoirdupois) fast made her the queen of syndication. On buying rights to her show in 1988, Winfrey also became TV's most powerful, not to mention richest, woman.

KEVIN HORAN

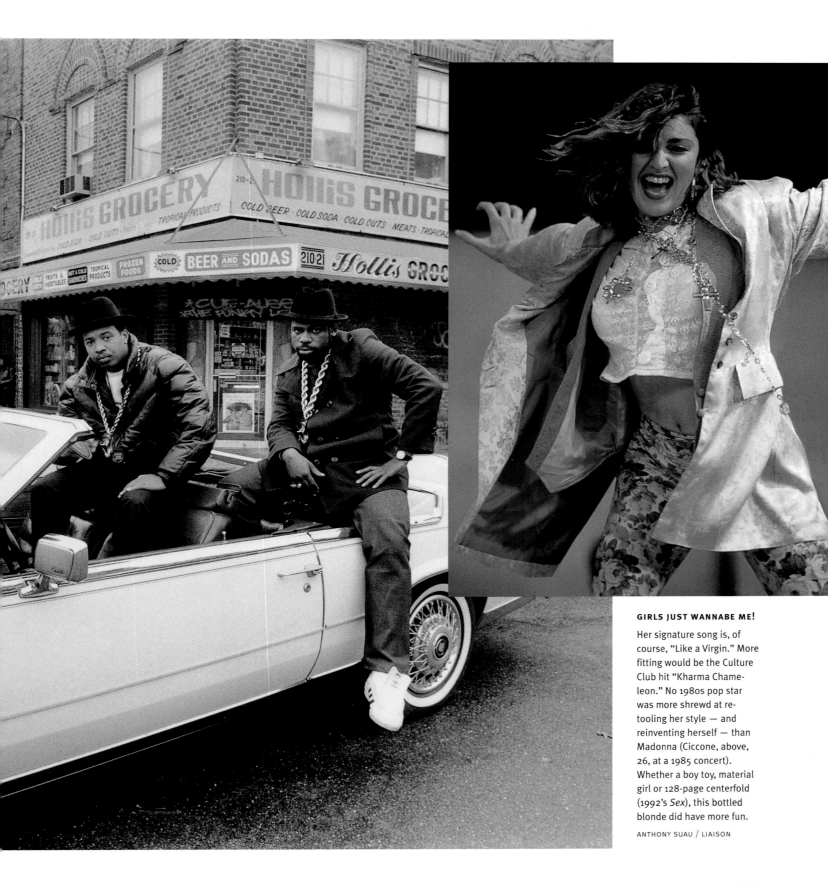

GIRLS JUST WANNABE ME!

Her signature song is, of course, "Like a Virgin." More fitting would be the Culture Club hit "Kharma Chameleon." No 1980s pop star was more shrewd at re-tooling her style — and reinventing herself — than Madonna (Ciccone, above, 26, at a 1985 concert). Whether a boy toy, material girl or 128-page centerfold (1992's *Sex*), this bottled blonde did have more fun.

ANTHONY SUAU / LIAISON

A RELUCTANT POSTER BOY

The 1985 announcement by actor Rock Hudson, 59, that he had AIDS led to greater public understanding and sympathy — and to safer sex and closer screening of blood supplies. The not-so-new epidemic (the first suspected case dates to 1959) peaked in the U.S. in 1993. But globally, the as-yet-incurable disease remains on the rise.

ALAIN VAN DE WALLE / LIAISON

EVEN HOPE DISAPPEARED

Starvation had taken her parents, so an Ethiopian girl awaited death at a make-shift orphanage (below). The 1984 famine, in the midst of a civil war, was not East Africa's first or last. It may have been the most tragic. Desperate images like this led to all-star rockathons and epic airlifts of food. Few relief supplies reached the victims; they were blocked by rival warlords.

DAVID BURNETT / CONTACT

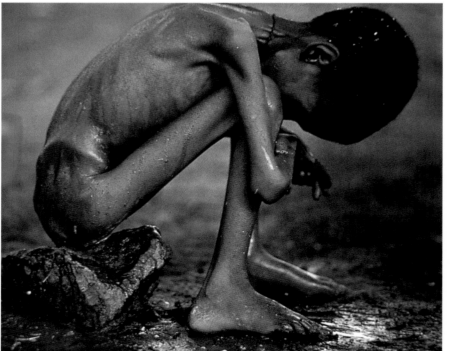

CUTTING TO THE CHASE

A disaster like *Challenger* (inset, the crew's NASA portrait) begs for answers; thus, 13 eminences were tapped to sit on 1986's blue-ribbon Rogers Commission, including Nobel physicist Richard Feynman, 67 (left). Witnesses agreed a booster-rocket gasket had failed, but not why. Suspecting that the abnormally cold temperature on launch day was a factor, Feynman ran a simple test on live TV. He dunked a strip of the rubbery gasket in a pitcher of ice water for one minute, then bent the now-stiffened O-ring material. It snapped.

DIANA WALKER / TIME
INSET: NASA

TAKE IT OUT OF PETTY CASH

When Michael Milken talked, Wall Street listened; at 40, he was the king of junk bonds. Entrepreneurs used the high-risk, high-yield paper to fund start-ups (like MCI). Real-life Gordon Gekkos used them to fund hostile takeovers (RJR Nabisco). In 1990, Milken admitted he played favorites. He had to do hard time and pay a $600 million fine. Still, that was merely $50 million more than his salary and bonus for 1987.

STEVE SMITH

THIS LADY WAS PUMPED

The official tally at home was 1,060 pairs — and who knew how many more Imelda Marcos, 57, carried aboard her 1986 flight into Hawaiian exile with husband Ferdinand, 68. The Filipino dictator's 20-year reign was long backed by the U.S. despite his record of stolen elections, human rights violations and personal greed. Now, however, his Pacific island nation was no longer needed as a pit stop en route to Vietnam.

ROBIN MOYER / TIME

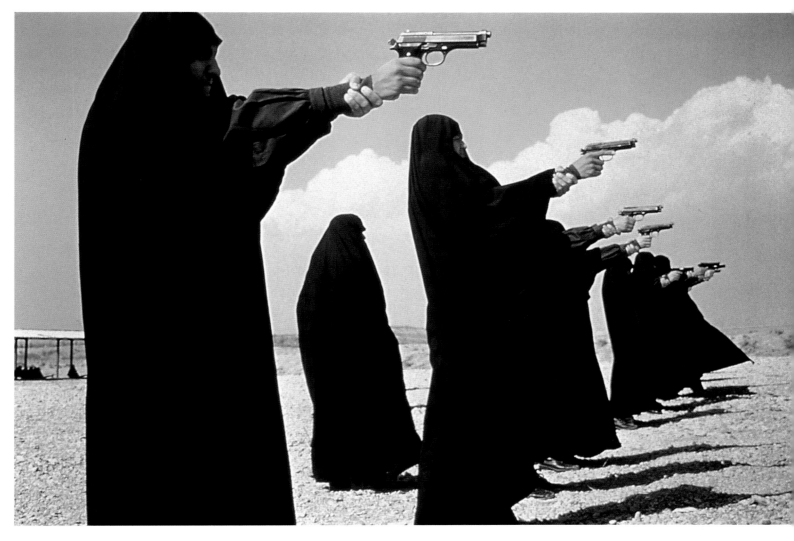

VEILED THREATS

As a border war between Iran and Iraq dragged into its sixth year, Iranian women joined home-guard units (though they had to take target practice in chadors). The conflict over oil fields and a strategic waterway was settled in 1988. Iraq lost some 120,000 men. But for distracting Ayatollah Khomeini while killing 300,000 Iranians, Saddam Hussein earned the thanks of Washington.

JEAN GAUMY / MAGNUM

A HOLE IN THE SKY

The pink area in this computer-tinted satellite photo was not pretty to atmospheric researchers: It confirmed that the ozone layer over Antarctica was thinning. Not until 1958 did scientists study the layer (five to 25 miles up) that absorbs harmful ultraviolet rays. It thickened until 1970, then began to thin, increasing the risk of skin cancer. Whether the thinning is permanent or a cyclical phenomenon (like El Niño) remains unclear.

NASA

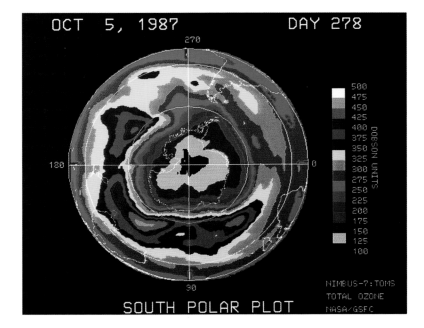

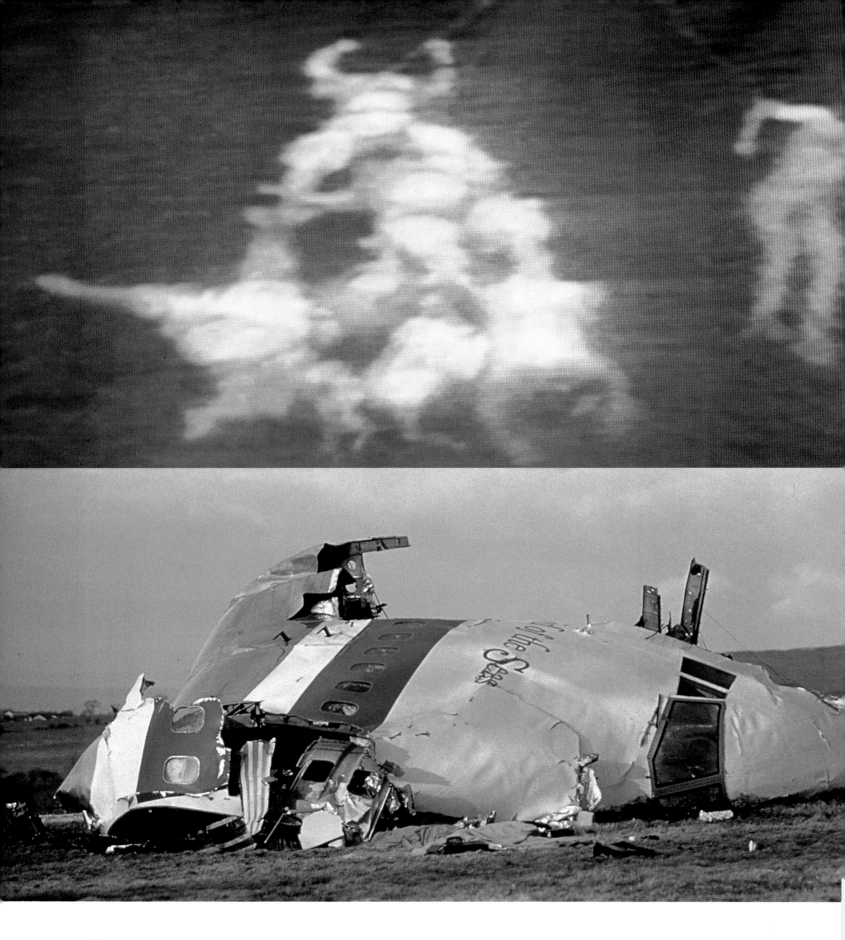

50 NEW WAR ZONES

In the decade and a half since *Roe* v. *Wade*, the debate on abortion had only intensified. Emerging pro-life groups such as Operation Rescue began picketing abortion clinics. Then in 1989, the Supreme Court gave states the right to enact abortion laws (subject to judicial review); soon, state capitals began to feel the heat.

DIANA WALKER / TIME

<

DEADLY QUID PRO QUO

The corpses at top left had been passengers on an Iran Air flight downed in July 1988 by missiles fired in error from USS *Vincennes*, on patrol in the Persian Gulf; 290 died. In December, 259 died on a Pan Am flight downed by a hidden bomb; the falling debris killed 11 villagers in Lockerbie, Scotland (below left). Claiming credit: several radical Islamic groups.

TOP LEFT: SIPA
BOTTOM LEFT:
STUART FRANKLIN / MAGNUM

COGITO ERGO SUM

Lou Gehrig's disease took English physicist Stephen Hawking's body. Yet he kept positing theories that led to an academic chair once held by Isaac Newton and, at 46 (right), published the 1988 best-seller *A Brief History of Time*. In 1999, Hawking agreed to be ribbed on *The Simpsons* — and even did his own (computer-generated) voice-over.

TERRY SMITH

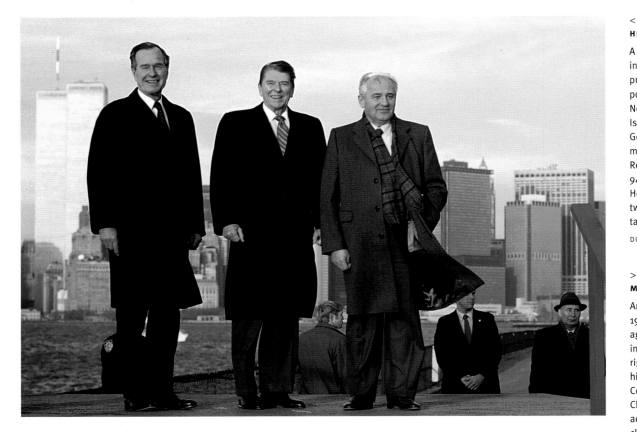

HELLO, GOODBYE

A new world order was nigh in December 1988 as three presidents of two superpowers met in one place. To New York City's Governors Island went Mikhail Gorbachev, 57, in his 45th month as Kremlin head; Ronald Reagan, 77, in his 94th month in the White House; and George Bush, two months away from taking office.

DIRCK HALSTEAD / TIME

>
MAN OF STEELY NERVES

An indelible image from 1989: one lone Chinese against a column of T-59s in central Beijing (inset, right). More astonishing: his chat with the tank crew. Cordiality soon vanished. China's rulers wanted 100-acre Tiananmen Square cleared of a pro-democracy sit-in that began in mid-April. On June 4, the army went in. No body count has ever been released.

STUART FRANKLIN / MAGNUM (2)

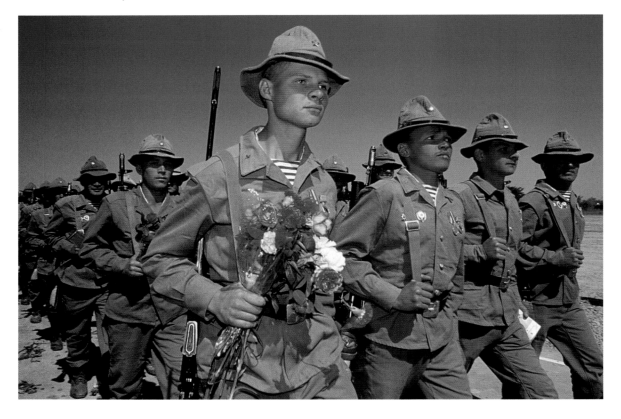

<
IVAN WENT HOME

In May 1988, these troops were part of the first Soviet units to march out of Afghanistan. Moscow's death toll from nine years of warfare: 15,000. The Red Army's inability to crush the mujahedin damaged military morale, a fact noted in the West (and in Eastern Europe). Afghanistan would later erupt in a civil war won in 1996 by the ultra-fundamentalist Taliban.

ANDY HERNANDEZ / LIAISON

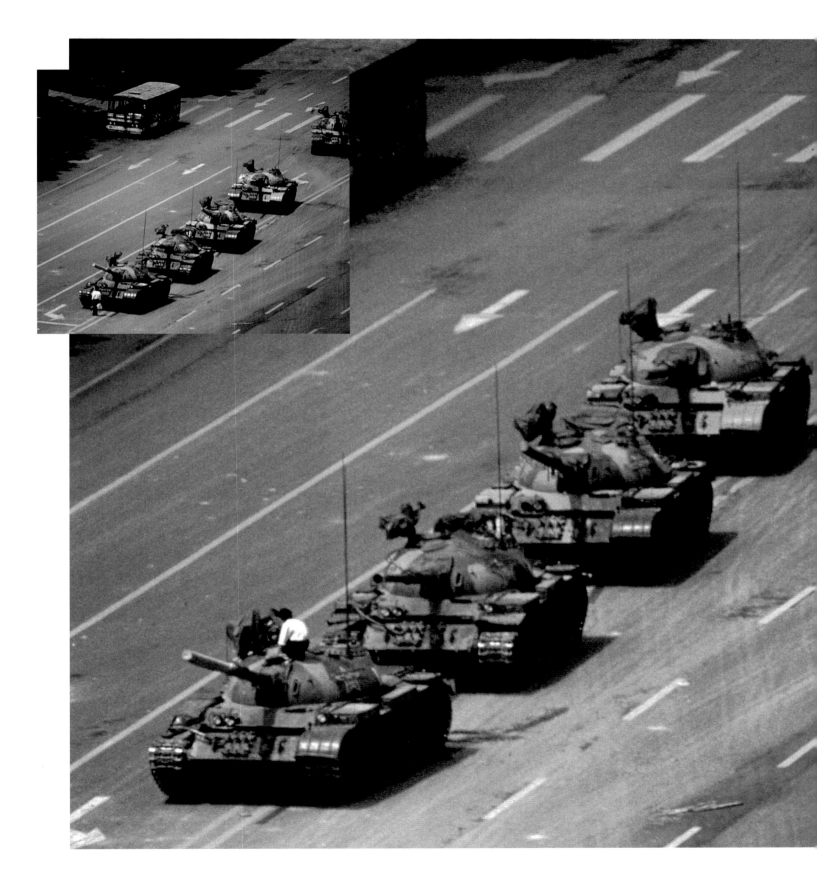

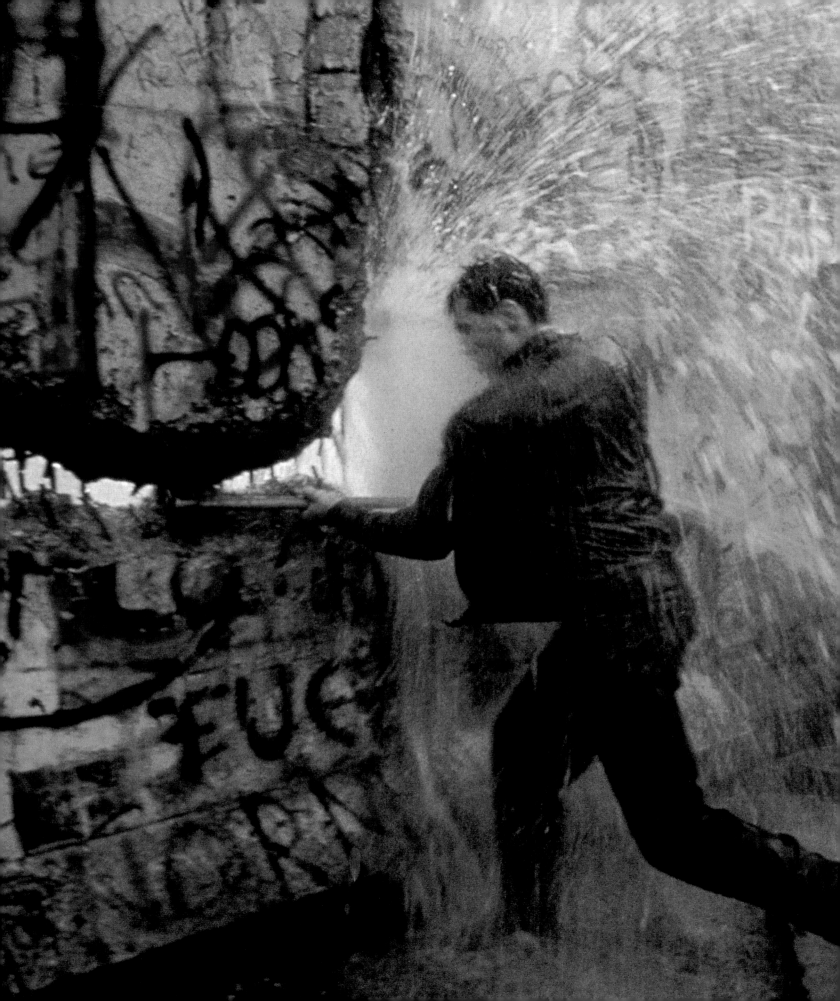

DEATH BE NOT PROUD

Jack Kevorkian's IV drip was first tested in June 1990 by an Alzheimer's victim. It worked: The potassium chloride killed her. The assisted suicide renewed a euthanasia debate already complicated by medical technology: When is it O.K. to unplug? In 1999, after Kevorkian, by then 70, had assisted in 130-plus deaths, a jury finally convicted him of second-degree murder.

AP

BAD NEWS, GOOD NEWS

Nature designed an otter's fur to repel seawater, but this one was in Prince William Sound, Alaska, in 1989, after the tanker *Exxon Valdez* ran aground and leaked some 11 million gallons of oil. Wildlife beyond count died, some colonies forever. Yet predictions of long-term disaster overlooked the fact that the Sound had recouped from another major ecodisaster, the earthquake of 1964.

TONY DAWSON

<

SCRAP-IRON CURTAIN

East Berlin guards would normally have used rifles, not water jets, on the West German savaging the Wall. But it was November 1989, and 160 million people in five nations had said to their Soviet overlords, Enough. First to bolt, in August, was Poland, followed by Hungary, East Germany, Bulgaria, Czechoslovakia and Romania. Moscow, drained by Afghanistan, did not intervene.

TONY SUAU / LIAISON

<

WHOM DO YOU BELIEVE?

Law professor Anita Hill, 35, testified reluctantly at the 1991 Senate hearings on Supreme Court nominee Clarence Thomas, 43. He was George Bush's pick to replace a fellow black, the retiring Thurgood Marshall. Hill gave accounts of lurid sexual harassment by former boss Thomas. She was vilified, he was confirmed (by 52–48, the tightest vote of the century).

SCOTT ANDERSEN / AP

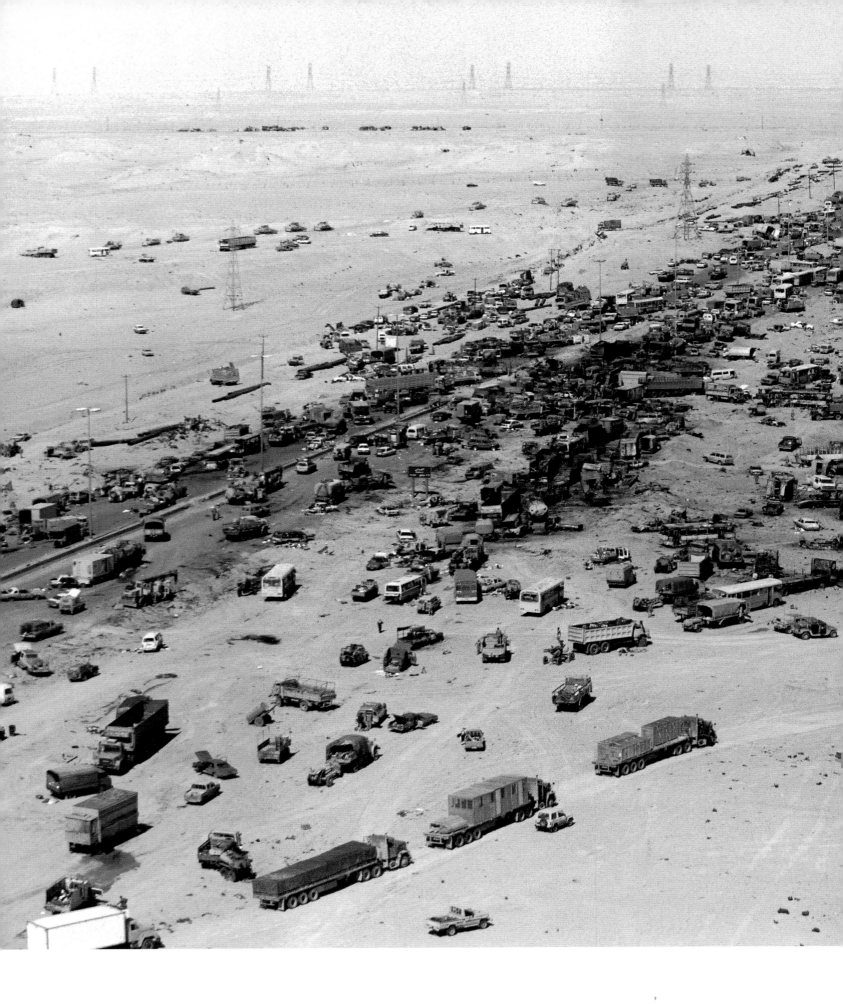

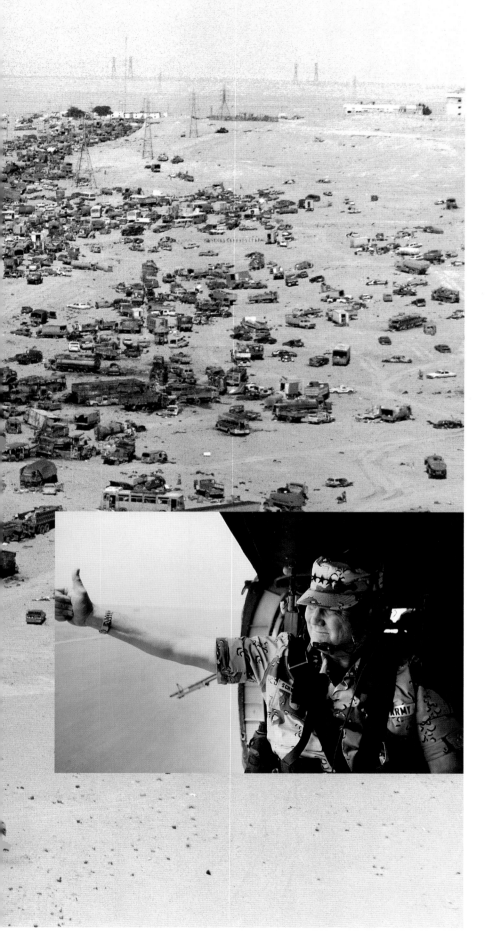

A Lopsided Duel in the Desert

The fastest route home was also the deadliest (left) for Iraqis whose occupation of Kuwait abruptly ended in late February 1991. Saddam Hussein, their self-venerating president (above), had made the mother of all miscalculations. His country and its tiny neighbor (pop: 1.9 million, only half native Kuwaitis) had long argued over a shared oil field. Already praised by the U.S. for his war with Iran, Hussein in mid-1990 got official word that Washington didn't care about Persian Gulf border disputes. He promptly seized Kuwait. Whereupon 28 nations (nine of them Arab states) formed a 690,000-strong force led by U.S. general Norman Schwarzkopf, 56 (inset). Operation Desert Storm opened with fierce air and missile attacks on Iraq. On February 23, the ground campaign began. It took 100 hours to clear Kuwait of Iraqis. But the drive stopped short of Baghdad, leaving Hussein, 53, still in dictatorial power.

LEFT: DENNIS BRACK / BLACK STAR
ABOVE: ALEXIS DUCIOS / LIAISON
INSET: HARRY BENSON

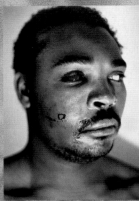

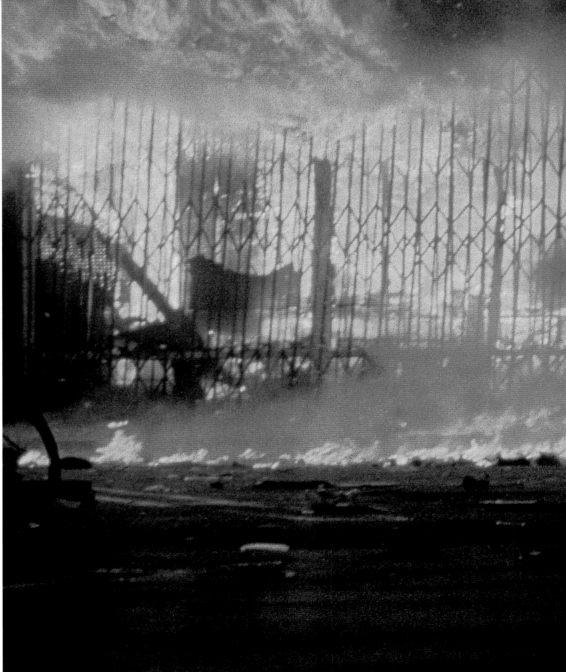

AM 12:53:30

DOUBLE JEOPARDY

It was a case of same song, different verse in Los Angeles in 1991. Early on March 3, cops were right to bust the driver who had led them on a high-speed chase — but not with their nightsticks, boots and stun guns. An onlooker taped the attack and gave his sickening footage (above) to a local TV station. In days, the brutalized victim, Rodney King, a 25-year-old laborer (inset), became the symbol of the LAPD's callous treatment of minorities. Four white officers were put on trial. Their acquittal a year later, by an all-white suburban jury, inflamed the city's heavily black South-Central district (right). The riot ran for two days. Its toll: 50-plus dead, 2,000-plus injured, 12,000 arrested, $1 billion in damages and a racial polarization that would soon become evident in the murder trial of O.J. Simpson.

SCOTT WEERSING / LIAISON
ABOVE: GEORGE HOLIDAY / KTLA-TV

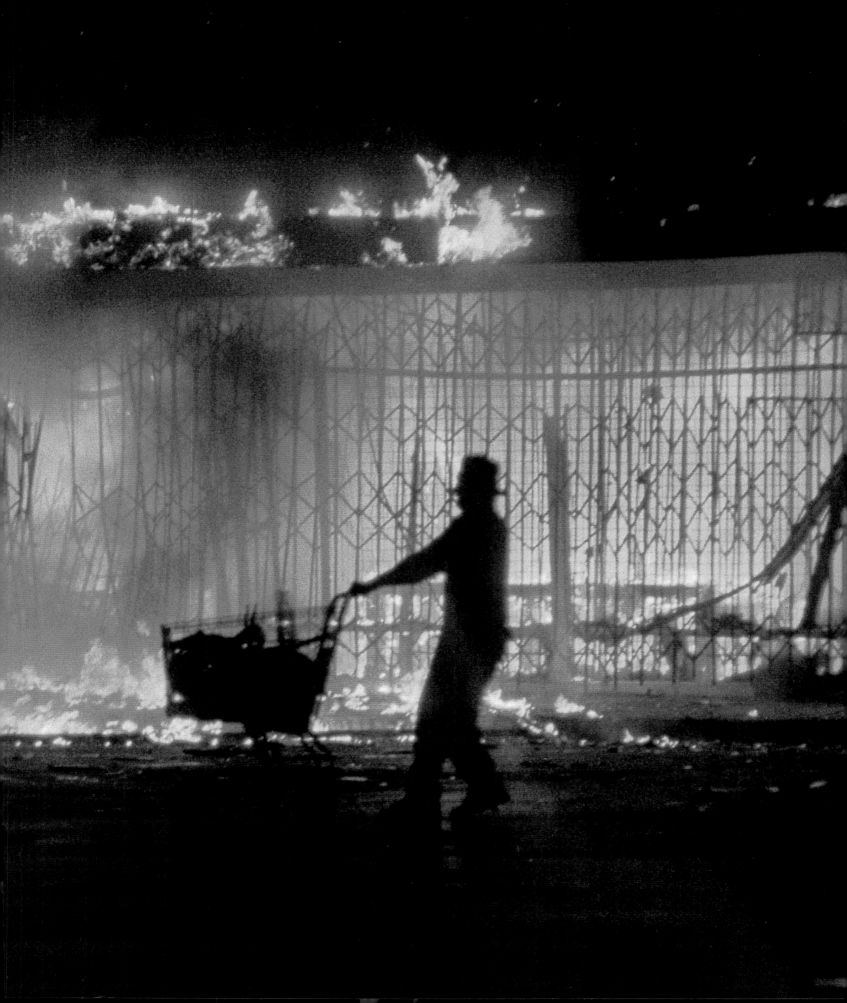

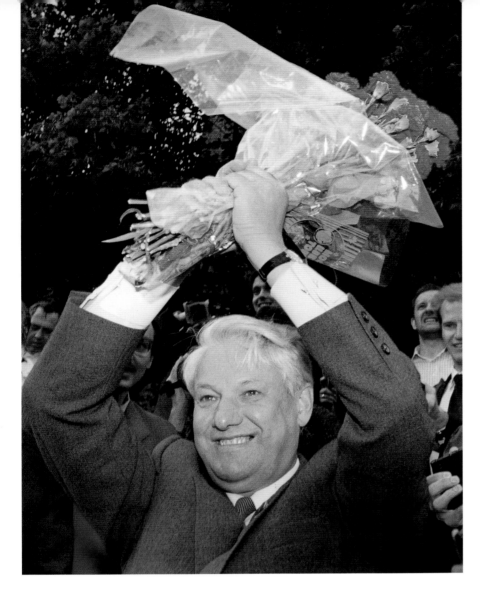

THE BEAR TAMER

On May 29, 1990, Boris Yeltsin, 59, became president of Russia — and thus No. 2 man to Gorbachev in a USSR on life-support. Its Eastern European empire was gone, and member republics were seceding. In August 1991, Kremlin die-hards tried a coup. Yeltsin heroically intervened; then, after parliament shuttered the Communist Party, he got Gorbachev to dissolve the Soviet Union itself.

AP

OUT OF THE OZARKS

The Bush Administration was still basking in Desert Storm's patriotic glow when from the mosh pit of 1992 Democratic long-shots and no-names rose Bill Clinton. Hadn't the Arkansas governor, 45, already fessed up in prime time to a less than perfect marriage? And didn't his staff fear another bimbo eruption? The White House surely anticipated Dukakis II.

CYNTHIA JOHNSON / TIME

A FUNNY THING . . .

. . . happened on the way to Election Day, 1992: Ross Perot, 62 (and, as ever, on *Larry King Live!*). The Texas data-processing mogul, mad at George Bush over Vietnam MIAs, check-booked himself into the race and fragged the president. The U.S. economy soured. The Rodney King case verdicts rocked Los Angeles. More of Perot's 19.7 million votes came from disaffected Republicans than from Democrats.

SHELLY KATZ / LIAISON

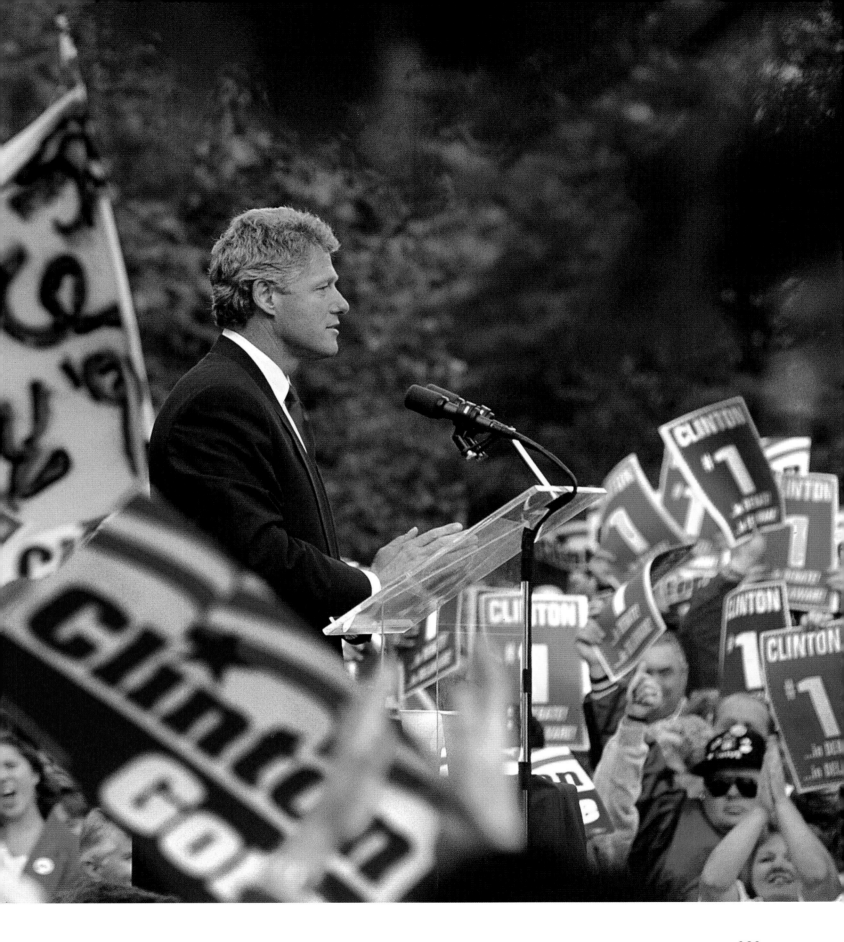

> GEORGIA O'KEEFFE
1887–1986

Her earliest works were abstracts, but by the time other American painters embraced the school, she had moved on to her signature series of oversized flowers. O'Keeffe resettled in New Mexico in the 1940s. There, her startlingly sensual vision turned austere and haunting: The late canvases are often of desert-scoured skulls.

DAVID GAHR

< VLADIMIR NABOKOV
1899–1977

A Russian aristocrat uprooted by revolution, he lived mostly in boardinghouses and fraying hotels. Nabokov wrote 10 novels in his native tongue before switching to English. The success of 1958's *Lolita*, a riotous tale of ruinous obsession, meant more leisure to pursue his own passion: butterflies.

CARL MYDANS / LIFE

> DOCTOR SEUSS
1904–1991

Theodor Geisel won honors for writing ads and World War II documentaries. Then he won fame and fortune for writing (and illustrating) 47 books for children of all ages. The blue-green abelard at right was one of his whimsical chimeras; another was a cat in a hat.

JOHN BRYSON

BOB MARLEY
1945–1981

When "I Shot the Sheriff" was covered by a Brit (Eric Clapton), the curious sought out the artist whose song it was. By then, of course, Marley was already a legend in his native Jamaica. His Rastafarian dreadlocks and enjoyment of ganja played as well off-island as his reggae. A political activist to boot, he survived a 1976 assault but not cancer.

RICHARD CREAMER / RETNA, LTD.

BING CROSBY
1903–1977

He cloaked his personal demons behind an insouciant stage manner and a croon that mellowed America. Crosby took his act from nightclubs to radio to movies (most famously, seven *Road* flicks with Bob Hope) to TV. One of the few to be a headliner in five decades, his voice will always make Christmas cheery and bright.

JOHNNY FLOREA / LIFE

GRETA GARBO
1905–1990

No, she never portrayed Catherine the Great (but did play Anna Karenina). It was news when Garbo talked (1930's *Anna Christie*). And laughed (1939's *Ninotchka*). And fled (1941, after 25 Hollywood roles). The enigmatic Swede spent the rest of her years roaming Manhattan's Upper East Side in disguises that fooled no one.

MGM

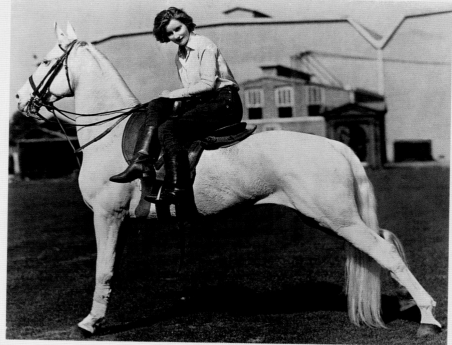

MARIA CALLAS
1923–1977

Her high-octane portrayals of tragic heroines revived neglected repertory at opera houses around the world. But the U.S.-born diva's penchant for off-stage melodrama (sudden cancellations, a public dumping by Aristotle Onassis for the widowed Jackie Kennedy) undid her career. Only a fatal heart attack kept Callas from writing her tell-all memoirs.

ELIOT ELISOFON / LIFE

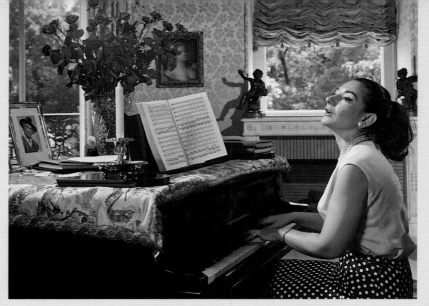

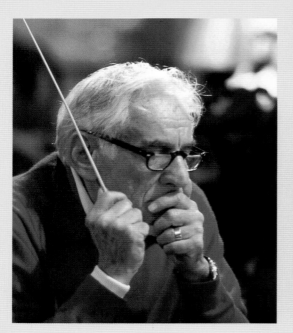

LEONARD BERNSTEIN
1918–1990

In 1943, he was called in to lead the New York Philharmonic without rehearsal. His brilliant debut propelled the American conductor onto podiums here — as well as in Europe, reversing decades of tradition. Long-haired but not stuffy, Bernstein hosted TV specials to attract kids to classical music and also composed for the masses (including *West Side Story*).

HENRY GROSSMAN

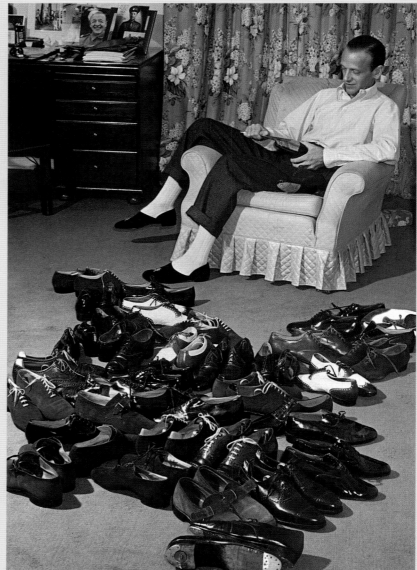

FRED ASTAIRE
1899–1987

Despite enough custom size-eight-and-a-halfs to choke a clotheshorse, those tootsies got hot. Their owner danced through 33 Hollywood musicals, notably 10 opposite Ginger Rogers. If genius is 90 percent perspiration, Astaire never let us see the sweat as he revolutionized the art of hoofing and redefined our image of gentlemanly sophistication.

BOB LANDRY / LIFE

TENNESSEE WILLIAMS
1911–1983

He loaded his dramas with faded belles, cripples and brutes from the Deep South, but their tortured search for happiness and forgiveness is universal. In just 11 years, Williams (born in Mississippi) wrote *The Glass Menagerie*, *A Streetcar Named Desire* and *Cat on a Hot Tin Roof*. Booze and drugs were his downfall; he choked to death on a medicine-bottle cap.

W. EUGENE SMITH / LIFE

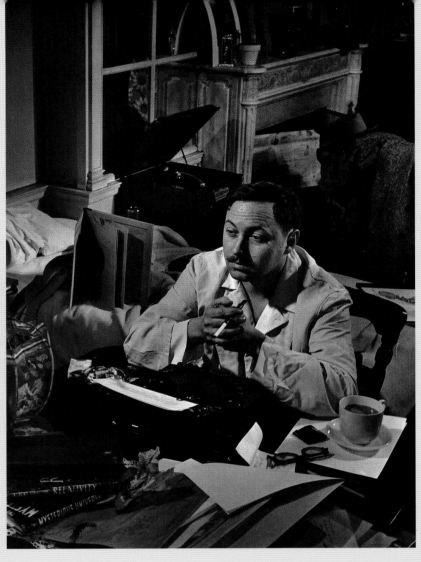

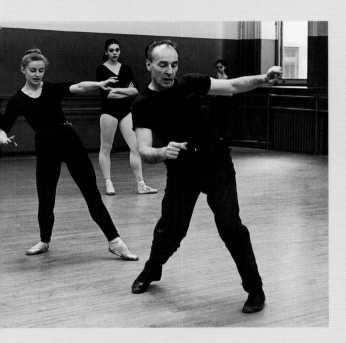

GEORGE BALANCHINE
1904–1983

One of the last dancers schooled under the czars — and, in 1924, one of the first to defect from the USSR — he originally worked in Paris with Diaghelev. Balanchine came to the U.S. in 1934. At the New York City Ballet, the imperious Mr. B choreographed a repertoire of plotless pieces that jetéd classical ballet forward into the 20th Century.

MARTHA SWOPE / TIME INC.

MARGARET MEAD
1901–1978

Never one to succumb to mynah distractions, Mead began her anthropological career at age eight by studying her sisters' speech. In the mid-1920s, she lived with natives on Samoa and New Guinea; they inspired her revolutionary thesis that sex roles are determined by culture. Mead's lack of supporting data invited criticism, but not her zest for fieldwork.

CORBIS / BETTMANN

ALFRED HITCHCOCK
1899–1980

He framed his thrillers as races against the clock (or a ravening flock). He dragged out suspense like a gleeful psycho. He gave his heroes flaws not unlike his own, which owed to a vertiginously repressed youth. He treated actors like cattle, yet prodded, from some, career performances. But it was his trademark cameos that made each of his 53 movies a Hitchcock.

LISA LARSEN / LIFE

CHARLIE CHAPLIN
1889–1977

Surrealistic slapstick made the London-born comedian Hollywood's first global superstar; in the era of silents, who didn't understand the Little Tramp? Chaplin had no such luck in talkies. His growing left-wing sympathies (and continuing taste for teenage girls) led the U.S. to deny him reentry in 1952. The privilege was restored in 1973 so he could accept an honorary Oscar.

W. EUGENE SMITH / LIFE

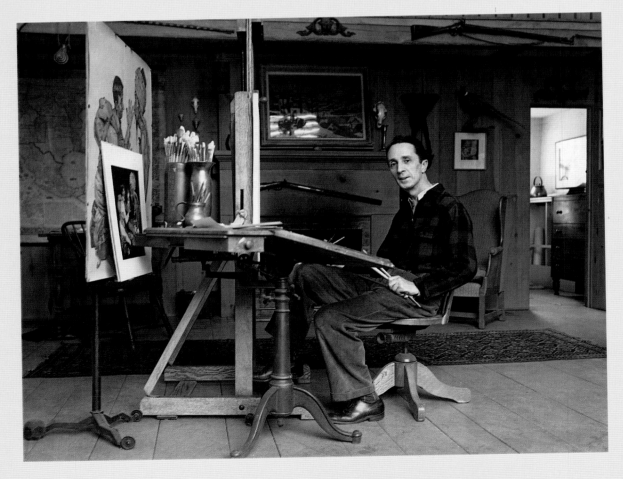

NORMAN ROCKWELL
1894–1978

Painting from life was de rigueur for the artist: The faces of neighbors routinely graced his signature *Saturday Evening Post* covers. Not all Rockwell's works were as saccharine as those Americana set pieces. In his last 14 years, he applied his precise brush to social issues like segregation's tragic costs.

AP

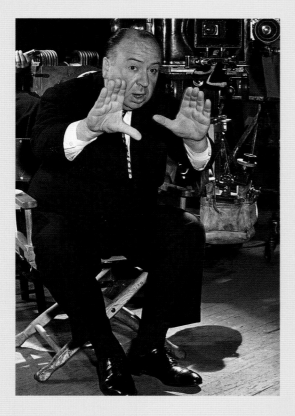

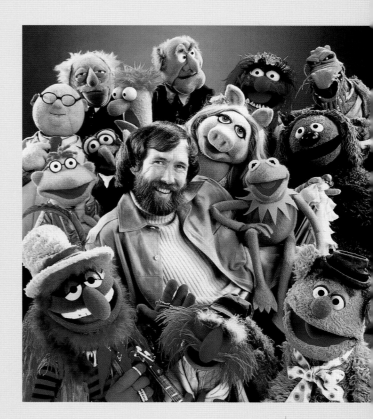

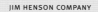

> ### JIM HENSON
> ### 1936–1990

Big Bird, Cookie and the grouchy Oscar belonged to *Sesame Street*, the PBS show that the innovative puppetmeister helped make must-watch kidvid. But the Muppets belonged to Henson, who Miss Piggy-backed them into a showbiz empire. Until his death (from a rare but treatable strep), he always found time to give voice to his alter ego, the gentle, wry Kermit T. Frog.

JIM HENSON COMPANY

JOHN WAYNE
1907–1979

It's a pity Gary Cooper beat him to the punch line: "If you want to call me that, smile." Wayne brooked no insubordination in his 250-plus movies (playing cowboys, soldiers, cops and even a Mongol, but never the villain). In 1955, he spurned a new CBS Western called *Gunsmoke*. Musta hadda hunch the tube was too danged small for him.

PHIL STERN / CPI

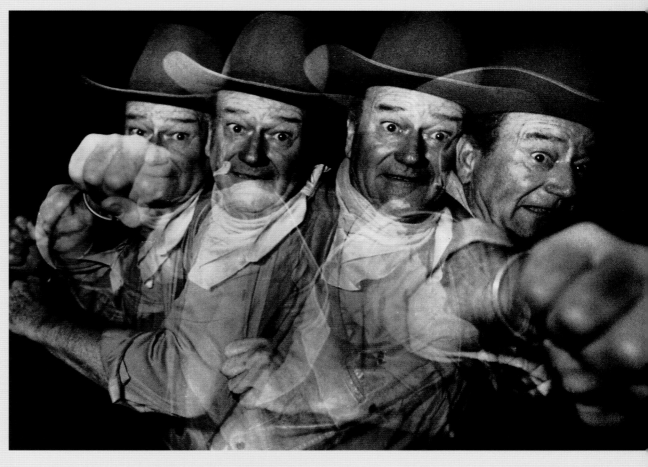

1993–1999

There was no silencing this lamb's creation in July 1996. Dolly, here on her first birthday, was from neither the union of ram and ewe nor a test tube; she was cloned by Scottish geneticist Ian Wilmut from a single cell of her mother.

MURDO MACLEOD / SIPA

And Now the News: Man Bytes Dogma

BY PAUL SAFFO

WELCOME TO THE decade of the dot, that tiny bit of Internet grammar whose ubiquity in E-mail addresses and Web URLs so neatly captures the giddying impact of technology on our lives at century's end.

Seven years ago, the Internet was little more than a cyberspace wilderness traversed by nerds and early adopters, while the Web was an obscure tool unknown to all but a handful of researchers. Today, the Internet is a more potent medium than television, and the Web is driving the Dow into the stratosphere as it reinvents one new industry after another.

If the dot is the Nineties' symbol, then the S-curve is its trajectory. This is the curve of Moore's law, which dictates that the number of circuits packed onto computer chips doubles every 18 months with the result that the power of the chips doubles at the same rate and their cost drops by half. It is why a Furby has several times the processing power carried on board the Apollo command module, and the latest generation of video-game players out-performs the best graphics supercomputers of a decade ago.

The S-curve is everywhere we look in this decade. It is the curve of traffic on the Internet, of transactions on the World Wide Web, of cellular phone sales and, at moments, of unread E-mail lurking in our in boxes. It is the curve of new scientific discoveries and also is the curve of our collective surprise and uncertainty as we struggle to understand the revolutions swirling around us. Thus, the ubiquitous dot is not merely a mark in cyberspace but also the anchor in the exclamation points and question marks punctuating our astonishment at all that is afoot.

Technology empowers. It floods our lives with options and overwhelms us with choice, and it places us squarely in the middle of the revolutions it generates. But with choice comes the burden of choosing wisely. Computers and E-mail can free us from the tyranny of rush hour or lure us into working 24 hours a

In this tiny Montana shack were built mail bombs — 16 in 17 years — that killed three, maimed 23. The Unabomber gave his technophobic rationale in a 1995 screed. His kid brother recognized the author's style. In 1998, Ted Kaczynski, 55, drew life times four.

RICHARD BARNES

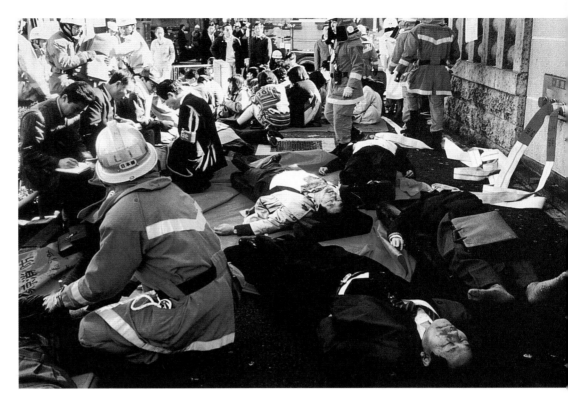

day. Satellites and video can remind us that the world is indeed a global village or simply display a missile's eye view of warfare in real time. New wonder drugs can lower infant mortality or simply allow us to grow more hair, improve sexual performance and have litters of designer children.

Technology also changes our view of reality even when it does not touch us directly. This decade has seen one astonishing technology-enabled discovery after another. The Hubble telescope has reached deep into look-back time and reminded us that even "empty" corners of the sky are teeming with galaxies. Robots drift through the oceans, revealing unimagined geographies and discovering exotic life-forms that would have taxed the imagination of a science fiction writer a decade earlier. The universe keeps getting bigger, but so does our world, as we discover that this planet we live on is vastly more subtle and complex than we ever imagined.

"I'm all for progress; it's change I object to." That sentiment, expressed by Mark Twain a century ago, is echoed in our ambivalence toward technology and the life-changing choices it forces upon us. We complain about E-mail and phone calls, but we still rush out to buy the latest, smallest cell phone so that we are never out of touch. The *Titanic* disaster fascinates us as a tale of techno-hubris even as we are transfixed by the submarine robots that brought images of the wreck into our living rooms. And *Star Wars* still works its magic as a morality tale about the battle between technologies that amplify the human spirit (Luke Skywalker) and technologies that extinguish it (Darth Vader).

Without a doubt, we have become steadily more dependent upon ever more complex and obscure technologies. In general, the less visible a computer is, the more important a role it plays in one's life. Smash my laptop, and I'll pull out a pen and paper and keep working. Crash the computer switch in the local phone exchange, and I am isolated. But mess with the computer running the power grid, and I'm thrown back to an age of candles and oil lamps with rotting food in the refrigerator.

The past two decades have been punctuated by reminders of the complexities — and cost — of our myriad technological choices. Techno-disasters from Chernobyl to Bhopal, from TWA Flight 800 to mad-cow disease, splash across the news. Technology undoubtedly is an amplifier, not just of our hopes, but also of our carelessness, our ignorance

and studied inadvertence. While we fret over distant risks, greater dangers lurk closer to home, from daily rush-hour auto fatalities to cancers triggered by waste products from the technologies we surround ourselves with. As Socrates observed, "Nothing vast enters life without a hidden curse."

While the majority of us fret, an addled few have been tempted to extremes trying to overcome their dependence on what they perceive to be distant and impersonal technologies. Neo-Luddite Theodore Kaczynski sought to make his antitechnology statement with lovingly crafted bombs that were themselves skillful examples of earlier technological art. Others are even more aggressive in their embrace of the technology they seek to repudiate: the Aum Shinrikyo cult built secret labs to produce the sarin they released in a Tokyo subway attack and even visited Africa in a quest for the Ebola virus.

Aum illustrates a special terror created by technology — the increasing chaos-making power it confers on ever-smaller groups and, ultimately, upon individuals. It took a bureaucracy of more than a hundred thousand people to build the first atom bomb; now a crude weapon is not beyond the reach of a few determined terrorists. Or as Aum's botched attack pointed up, why bother with nukes at all when one can confect enough ricin in a kitchen to kill half of San Francisco? What took Timothy McVeigh a vanload of fertilizer to accomplish might one day be pulled off by a crazed innovator with a briefcase full of bugs.

The Y2K bug has become the poster child for our growing technological ambivalence. Alarmists fear that it will crash our computers and paralyze society like some scene from *The Day the Earth Stood Still*. This is unlikely in the extreme, and Y2K may prove to be the biggest nonevent of the century, but no one can say for sure. If something so obviously avoidable as the Y2K flaw was built into our computers, what subtler and more serious defects lurk in the techno-logical systems we trust ever more of our lives to?

Our unease about technology can itself amplify minor problems into major tragedies. A careless software error by an amateur astronomer led in the fall of 1996 to the myth that a "Saturn-like" alien spacecraft was shadowing comet Hale-Bopp. Broadcast over talk-show radio and the Internet, the myth was seized upon by the Heaven's Gate cultists, who were then moved to mass suicide. It is told that they purchased a large amateur telescope in order to view the incoming spacecraft — and promptly returned it as defective when, upon observing the comet, they failed to spy the nonexistent craft. Y2K is this season's cometary apparition: Some fundamentalist preachers have seized upon Y2K as one more proof of a coming Armageddon. Just as Heaven's Gate was moved to suicide by an irresponsible myth, will others see religious portent in otherwise minor computer glitches and welcome the new century with acts of eschatological terrorism?

Meanwhile, the S-curve is serving up a new helping of life-changing technological wonders. Digital technology is front and center in this decade of the dot, but larger shifts are already afoot. The sweep of the century reveals an interesting pattern — about every 30 years, a new technology takes the lead in shaping our lives. Chemistry dominated the first third of the century, giving us everything from aspirin to plastic but also making the First World War the chemist's war of poison gas and novel explosives. Physics defined the second third of the century, taking us down into the structure of the atom and outward to the edges of the universe but also leaving us the dark gift of nuclear weapons used to end World War II. And today's digital marvels are but the capstone on three decades in which information technology has been at center stage.

But revolutions beget revolutions, and even though information technology still holds more than its share of surprises, we are entering the new cen-

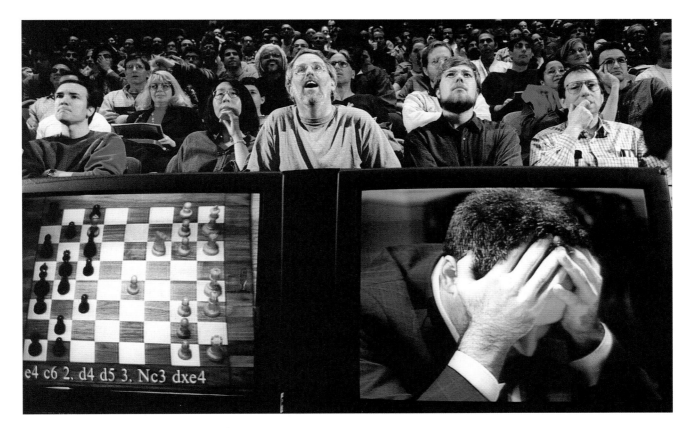

Rather than his next move against IBM's Deep Blue, Gary Kasparov should have been thinking about another computer, *2001*'s HAL. The world chess champ, 34, didn't and so, in 1997, lost a six-game match. Pssst: Next time, Gary, use your opposable thumb and go for its RAM.
AFP

tury on the cusp of a vaster revolution shaped by biology. The stumbling first steps of a newborn cloned Dolly are portent to this gathering change. Look for the first human genome to be decoded soon after century's end, with reverberating consequences stacked up like hurricanes across the first half of the next century. It will be a brave new world of potent biopharmaceuticals and gene therapy, a world in which cancer and heart disease are conquered much as polio and smallpox were in this century. It will also be a world of artificial organisms, of regenerative medicine and possibly of rejuvenation. A handful of genetic visionaries think that the next generation born on this planet may live a thousand years — provided it can afford the bill.

The Nineties and its S-curve of technological wonders have delivered us to a frontier of vast and terrible freedoms. Our technologies are not all-powerful, but they are all-changing, for first we invent our technologies, and then we turn around and use our technologies to reinvent ourselves. We are gazing to the edge of the universe and probing to the heart of matter. We are building the first halting artificial companions, and we are tinkering with the very stuff of what makes us human. Our inventiveness brought us here. Now let us hope that we will also discover the wisdom to lead us through the wilderness of choices that await us in the century ahead.

Paul Saffo is director of the Institute for the Future in Palo Alto, California, which provides forecasting services to major corporations and government agencies. He holds degrees from Harvard, Cambridge and Stanford and is the author of two books and many articles.

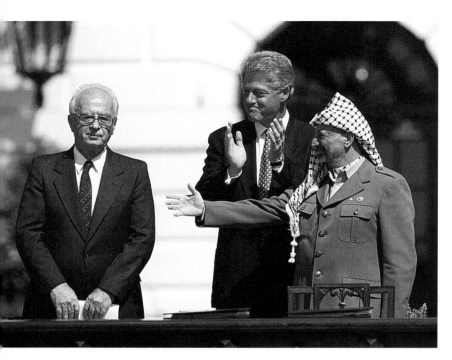

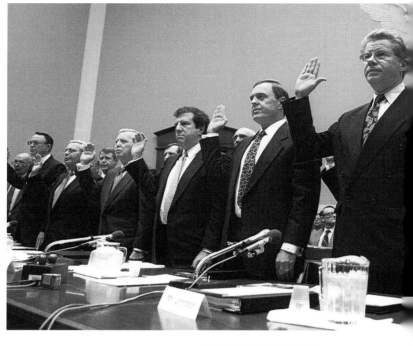

DANGEROUS PEACE

Israeli prime minister Yitzhak Rabin, 71, did not hide his feelings at a 1993 photo op with Bill Clinton and PLO leader Yasir Arafat, 64. But he then shook hands on an accord to give Palestinians more autonomy. The next year, he signed a peace pact with Jordan. Sixteen months later, in Tel Aviv, Rabin was shot dead by a right-wing Israeli.

CYNTHIA JOHNSON / TIME

TALL TARGETS

Had the terrorist parked his rental truck closer to a girder in the garage below Manhattan's World Trade Center in February 1993, the blast would have killed far more than six and injured far more than 1,000. The hit was directed by Omar Abdul Rahman, 54, ex-adviser to Afghanistan's mujahedin (see page 349). The blind cleric hoped to topple one 110-story tower into its twin.

MARK CARDWELL / REUTERS / ARCHIVE PHOTOS

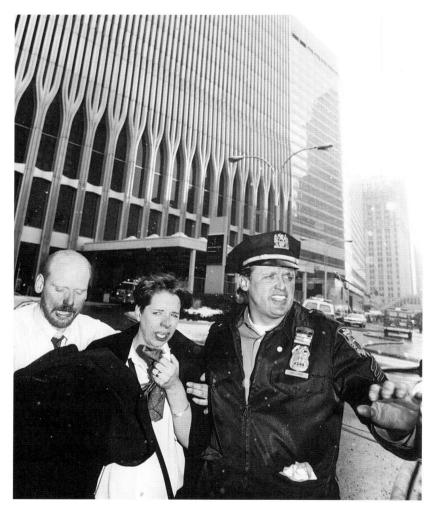

WHERE THERE'S SMOKE

In April 1994, eight corporate chiefs swore to Congress they were not merchants of menace. Though their mainstay product had been declared hazardous to humans by the U.S. Surgeon General 30 years earlier, the cigarette moguls insisted they had no personal knowledge of risks. Yet in 1997, their industry headed off a legion of lawsuits by coughing up $368.5 billion.

JOHN DURICKA / AP

>
BETRAYED BY BLOODLINES

Some 1.5 million fled the African nation of Rwanda in spring 1994 — this family to next-door Tanzania — when five centuries of tribal animosity between Hutus and Tutsis flared into another civil war. An estimated 500,000 were less fortunate: They died so brutally that in 1998, a U.N. tribunal found the nation's then prime minister guilty of genocide.

JOE ALEXANDER / AFP

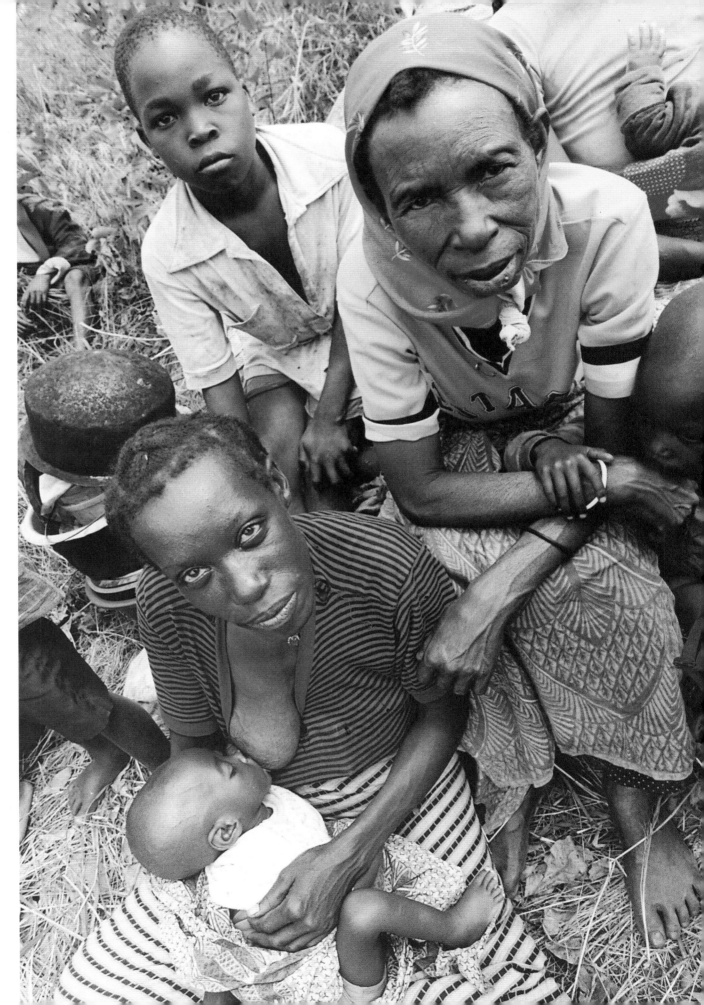

SIC TRANSIT GLORIA

Newt Gingrich's prize for steering the GOP to congressional majorities in 1994: the House Speaker-ship (and a *Time* Man of the Year cover the next year, here being photographed by Gregory Heisler). The ex-history teacher, 52, had correctly read the backlash against big-government Clinton proposals like health-care reform. In 1998, Gingrich was sure Monicagate made the lame-duck president a sitting duck as well. America disagreed. When the Republicans' edge was trimmed, the Speaker quit.

P.F. BENTLEY / TIME

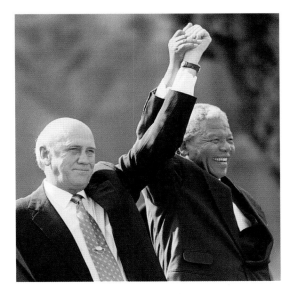

PEACE IN THEIR TIME

Apartheid ended not with a bang but with this salute. In May 1994, Nelson Mandela, 75, was sworn in as South Africa's president and his predecessor, F.W. de Klerk, 58, as a deputy president. Four years earlier, De Klerk had freed Mandela after 27 years as a political prisoner. Their subsequent dialogue on black-white power sharing won them a joint Nobel — and their beloved country a multiracial future.

JUDA NGWENYA / REUTERS / ARCHIVE PHOTOS

IF THE GLOVE DOESN'T FIT

On June 13, 1994, 12 hours after a double homicide in Brentwood, California, one victim's ex was held for questioning. The televised trial of former grid star O.J. Simpson, 47, the next year became a three-ring judicial circus in which lawyers, witnesses, even the judge did pratfalls. The evidence trickling out over 36 weeks convinced jurors that yes, they must acquit.

JOHN BARR / LIAISON

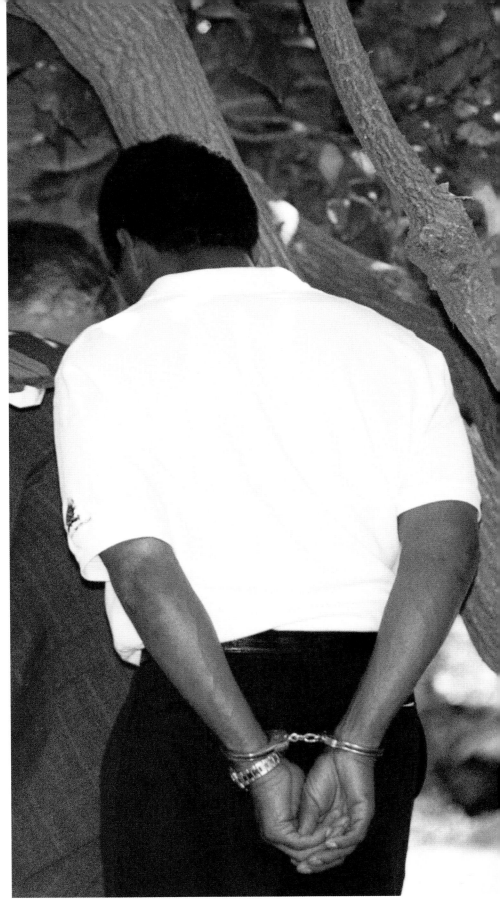

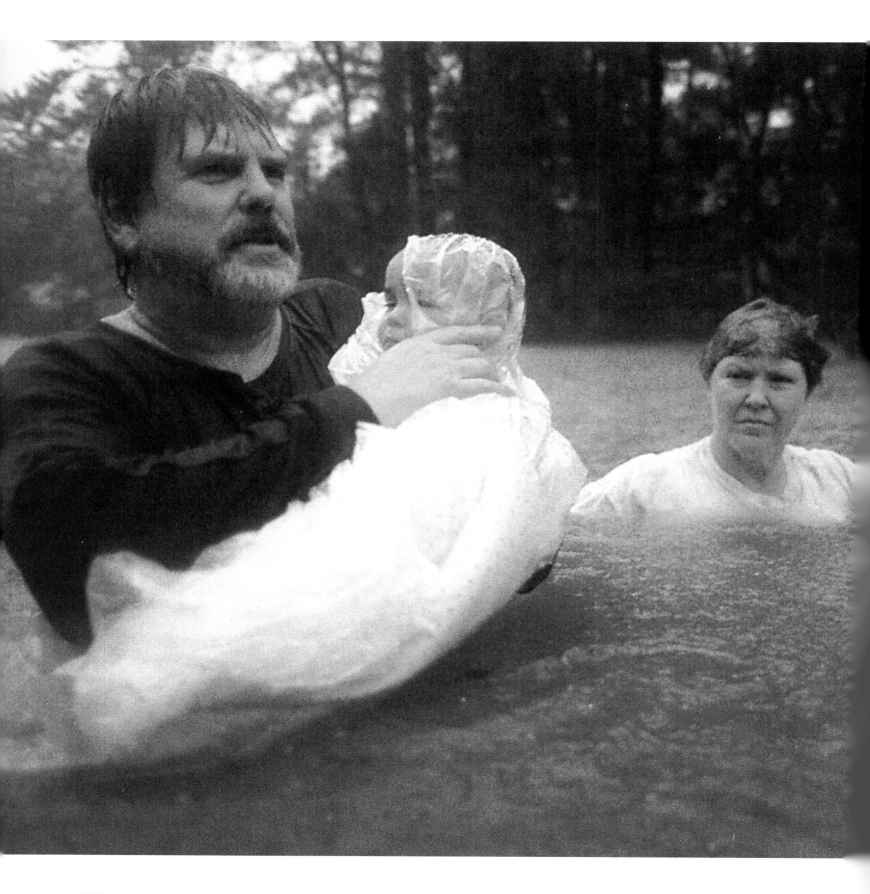

CLOUDS OF DOOM

Tannie Shannon, cradling granddaughter Andrea, and wife Frances, leading the family pet, sought high ground after the floodgates to Texas's Lake Conroe had to be opened in October 1994 after three days of torrential rain. By then, the Lower 48 was heeding the Weather Channel. In 1989, Hurricane Hugo blitzed the Carolinas. Hurricane Andrew, which sliced across South Florida and Louisiana in 1992, was worse. And in 1993, the Mississippi River, swollen by 100 days of rain, flooded parts of nine states and left 70,000 homeless.

DAVID LEESON /
DALLAS MORNING NEWS

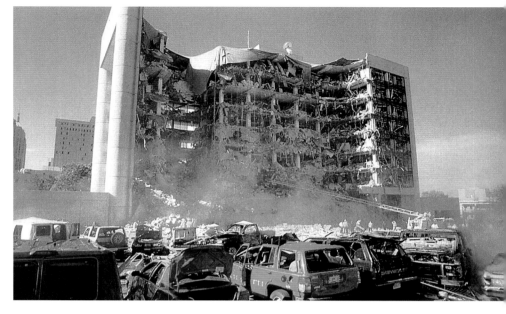

THE ENEMY WAS US

A federal office building in Oklahoma City was felled on April 19, 1995 (above), by a truck bomb that killed 168 — among them, 19 tots in a child-care center — and injured 850. Home-brewing the explosive from feed-store chemicals and highly combustible racing fuel: homegrown terrorist Timothy McVeigh, 28 (right, with his lawyer during a 1996 pretrial interview). The Desert Storm veteran believed in the far-right radicalism of a crazy quilt of militiamen, survivalists and others. Oklahoma City was his answer to Waco, Texas, where, beset by federal agents, 75 members of survivalist David Koresh's cult had died on April 19, 1993. For his crime, McVeigh received the death penalty.

ABOVE: JIM ARGO / DAILY
OKLAHOMAN / SABA
RIGHT: ROBBIE McCLARAN

Our Family Tree

The past roars with things to tell us. We have begun to hear, thanks to 20th Century know-how. These days, a chip of bone, a fretted flint, a petrified seed can be scanned like bar codes for date of origin. So we are able to push back ever further in our century-long search for the missing link, that mutational species of primates evolving into Homo sapiens. We've also refound some long-lost kin. Guess what? Even the earliest bonded. And cocooned. And lit fires. And buried their dead. And made war — and art (below). Which is to say, they stopped dragging their knuckles much earlier than we so smugly thought. How's this for a notion: We'd be hardly more awkward around a native of way-back-when than we are visiting a country where the natives speak a different tongue.

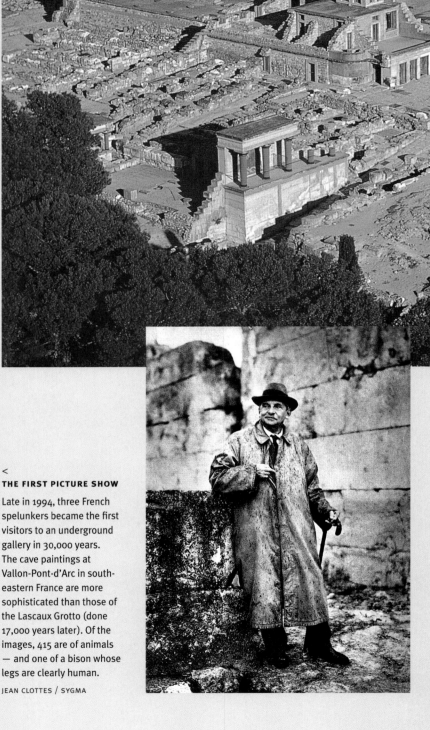

< **THE FIRST PICTURE SHOW**

Late in 1994, three French spelunkers became the first visitors to an underground gallery in 30,000 years. The cave paintings at Vallon-Pont-d'Arc in southeastern France are more sophisticated than those of the Lascaux Grotto (done 17,000 years later). Of the images, 415 are of animals — and one of a bison whose legs are clearly human.

JEAN CLOTTES / SYGMA

A MONKEY'S AUNT

Fossil fragments found on Piltdown Common, Sussex, rocked the world when, in 1912, the reconstructed skull at right was pronounced that of "the missing link"! Who had lived in England! Alas, tests in the 1950s showed the cranium to be a woman's and the jawbone an orangutan's. Piltdown Man was a hoax. Whodunit? One suspect: mysterian Arthur Conan Doyle (see page 157).

ARCHIVE PHOTOS

REAL-LIFE FLINTSTONE

From 1927 on, paleontologists began to find, in caves near Peking, a trove of skeletal remains more than 400,000 years old. They also unearthed tools and singed animal bones. Strikingly identical to modern humans from neck down, Peking Man had not much of a forehead. (Its brain averaged four-fifths the size of ours.) The original specimens vanished during the 1941 Japanese invasion of China; more have since been discovered.

AMERICAN MUSEUM OF
NATURAL HISTORY

IN THE YEAR 2525 (B.C.)

The six-acre palace complex at Knossos on Crete (above) was the lifework of British archaeologist Arthur Evans (inset). Drawn to the island partly by the Greek myth of the Minotaur, a half-bull, half-man monster, in 1900 he began to dig up a lost culture of maritime traders. The Minoans also worshiped bulls; and one of their written languages was a forerunner of Greek.

ABOVE: GORDON GAHAN /
NGS IMAGE COLLECTION
LEFT: TIME INC.

A CITY IN THE CLOUDS

Yale historian Hiram Bingham (an Indiana Jones prototype) was searching the Peruvian highlands for a legendary lost Inca city in 1911 when he came upon Machu Picchu (above). It was a key ceremonial center for the advanced civilization that ruled much of the Andes for 200-plus years before its 16th Century conquest, in just 40 years, by Spain.

TIME INC.

DINNER AT EIGHT

Beginning with his dig at the Iraqi site of Ur in 1922, Leonard Woolley (above right) reversed the cruel loot-and-run philosophy of fieldwork. The British archaeologist documented each find, no matter how small. Among his prizes from Ur: the above inlaid panel showing a royal banquet circa 2500 B.C., when the pre-Babylonian kingdom of Sumer ruled ancient Mesopotamia.

ABOVE:
FRANK SCHERSCHEL / LIFE
ABOVE RIGHT:
CORBIS / BETTMANN-UPI

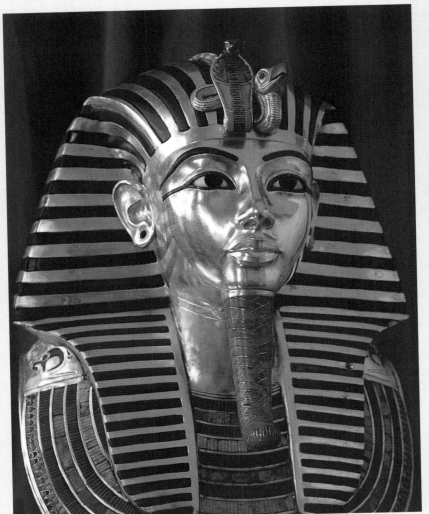

BEST FACE FORWARD

Thirty-three centuries after his reign in Egypt ended, Tutankhamen's burial place was unsealed (see page 93). In 1976, the Boy King's gilded sarcophagus mask was the gaudiest of 55 relics sent on a six-city U.S. tour. Museums were SRO with crowds gawking at the gold sculptures, alabaster vases and jewelry. And to think — Tut was a lesser pharaoh.

WALTER SANDERS / LIFE

CURIOUS GEORGE NO. 1

The year Lindy soloed the
Pond, another aviator
noticed animals like a 100-
yard-long monkey (right)
etched into a high desert in
southern Peru, as well as
far larger geometric shapes.
There are some 800 miles
of Nazca Lines, drawn prob-
ably about the time of
Christ by persons unknown.
How had earthbound artists
gained the perspective to
plan some 300 meticulous
geoglyphs? They didn't,
said Erich von Daniken in
his 1969 best-seller, *Chariot
of the Gods?*; it was done
by visiting aliens. Mix in a
little Roswell fever and
presto: *The X-Files*.

WILLIAM ALBERT ALLARD /
NGS IMAGE COLLECTION

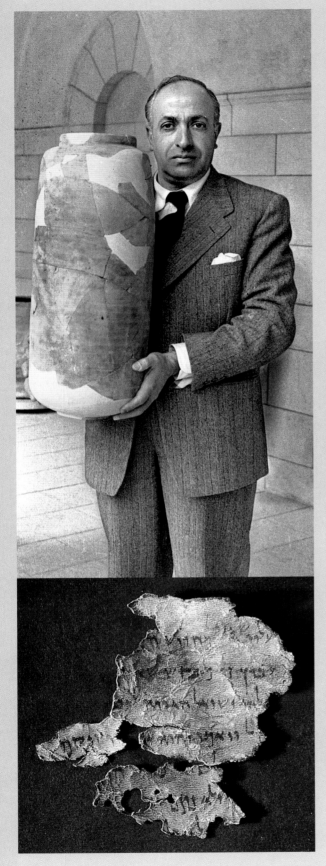

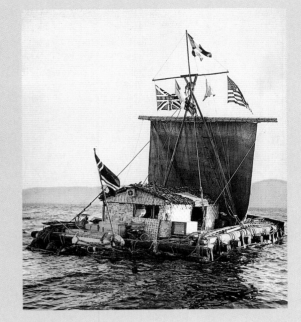

PRESENT AT THE CREATION

Two millennia ago, near Khirbat Qumran by the Dead Sea, a clay urn (left, after restoration) containing some leather scrolls was placed in a cave. It was found in 1947 by young Bedouins. Though the leather had split (below left), the Hebraic script was legible. The scrolls (plus others found nearby) were worth unfragmenting: The texts give a firsthand look, from the epicenter, of the emergence of Christianity from its Judaic roots.

LEFT: CORBIS / BETTMANN- UPI
BELOW LEFT:
LARRY BURROWS / LIFE

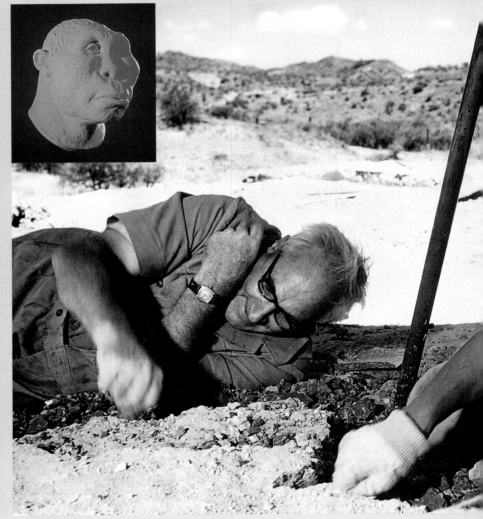

A SPLASHY VOYAGE

Norwegian ethnologist Thor Heyerdahl, 32, made news in 1947 when he and a five-man crew sailed a balsa-log raft, *Kon-Tiki*, from Peru to a Polynesian isle in 101 days. Why? To show that perhaps it had been South Americans, not Asians, who first peopled the mid-Pacific archipelagos. As science, it was dubious; as a recruiting poster for anthropology, it was brilliant.

CORBIS / BETTMANN-INP

ETERNAL COMPANIONS

In 1974 farmers digging for water near Xi'an in northwest China struck historical gold: an imperial tomb filled with 6,000 bronze horses (right) and life-size terra cotta warriors (each with a unique face), and more. Shih Huang-ti rated the send-off; he had ordered work begun on a Wall that would eventually stretch 1,500 miles across China.

EASTFOTO / XINHUA NEWS AGENCY

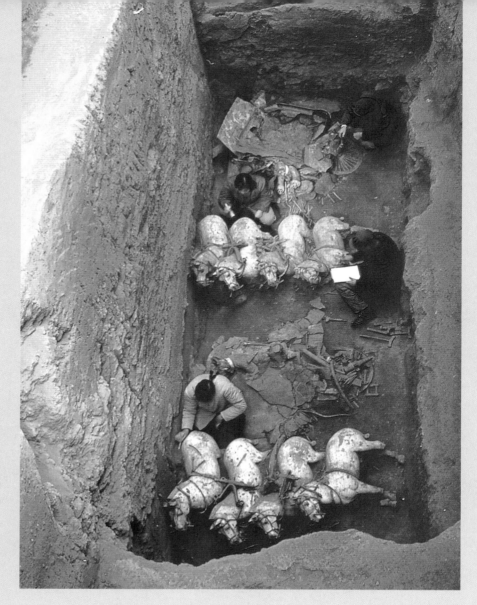

SURROGATE PARENTS

The hands-and-knees patience of British fossil hunters Louis and Mary Leakey yielded, in 1959, skull chips that forced a quantum revision of evolutionary theory. The fragments were of a tool-using hominid (recreation, inset) who lived 1.75 million years ago in Tanzania's Olduvai Gorge; later finds pushed our earliest two-legged ancestors back to 4.4 million B.C.

ROBERT SISSON, ROBERT OAKES (INSET) / NGS IMAGE COLLECTION

FROZEN IN TIME

One day 5,300 years ago a man of about 30, at right, was crossing the Tyrolean Alps when overtaken by a blizzard. His icy tomb did not thaw until 1991. So well preserved was he that we know his eye color (blue) and basic diet (milled grains). We also learned that in the Stone Age, some guys cut their hair short and sported tattoos.

GERHARD HINTERLEITNER / LIAISON

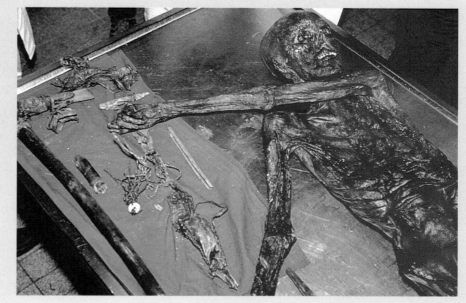

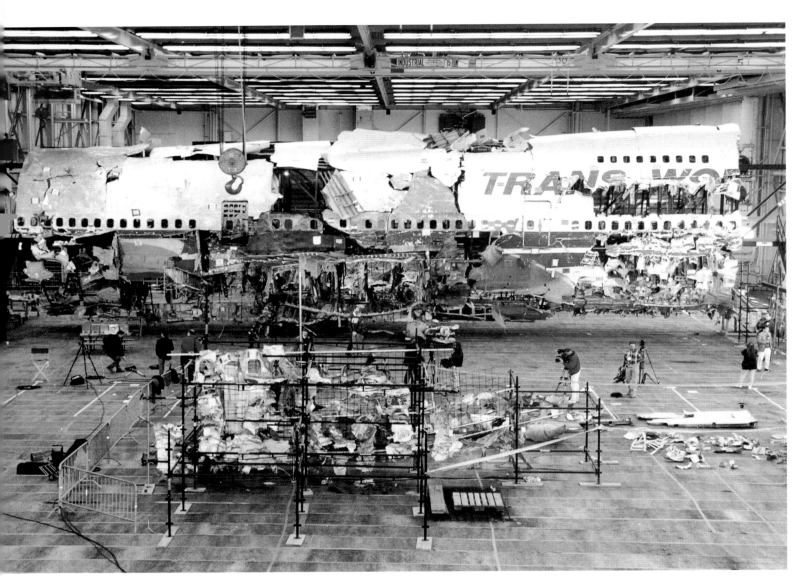

THE TELLTALE JIGSAW

Only by meticulously reconstructing debris from a fallen 747 were federal investigators able to analyze a disaster that spooked America. In July 1996, with terrorists threatening to disrupt the Atlanta Olympics, TWA Flight 800 had just left New York for Paris when it blew up in midair. By December 1997, the chief suspect was a subtle design flaw.

JEFF CHRISTENSEN / REUTERS / ARCHIVE PHOTOS

AN EARLY ENCOUNTER

On the White House rope line in summer 1995 was West Wing intern Monica Lewinsky, 22. What transpired between her and Bill Clinton is graphically documented in independent counsel Kenneth Starr's 1998 report, whose juicy parts made it sell like hotcakes. In 1999, after the President survived impeachment, a quicky bio of Monica hit bookstores. It sold like lukewarmcakes.

SYGMA

STAND AND DELIVER

If those from Venus could have a new artifice (the Wonderbra), so could those from Mars (Viagra, to ensure that old soldiers don't fade away). This was one blue bomber even antidruggies like Bob Dole could endorse. By 1999, seven states had said that any medical insurer covering a cure for male erectile dysfunction must also reimburse the costs of female contraception.

ED GABLE / TIME

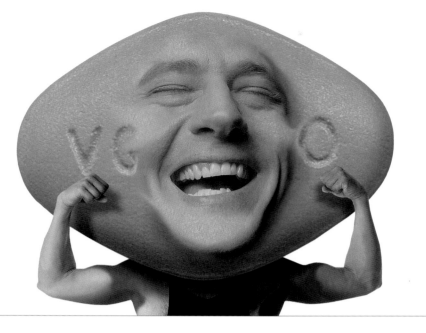

BURNING BRIGHT

On April 13, 1997, Tiger Woods, 21 (below, accepting his Masters jacket from outgoing champ Nick Faldo), became the first African-Asian-American to take one of golf's major titles. The Augusta course where he won was, until 1975, closed to people of color unless they were caddies. On tour, Woods would still occasionally hear racist barbs not aimed at the Thai portion of his heritage.

JOHN BIEVER / SPORTS ILLUSTRATED

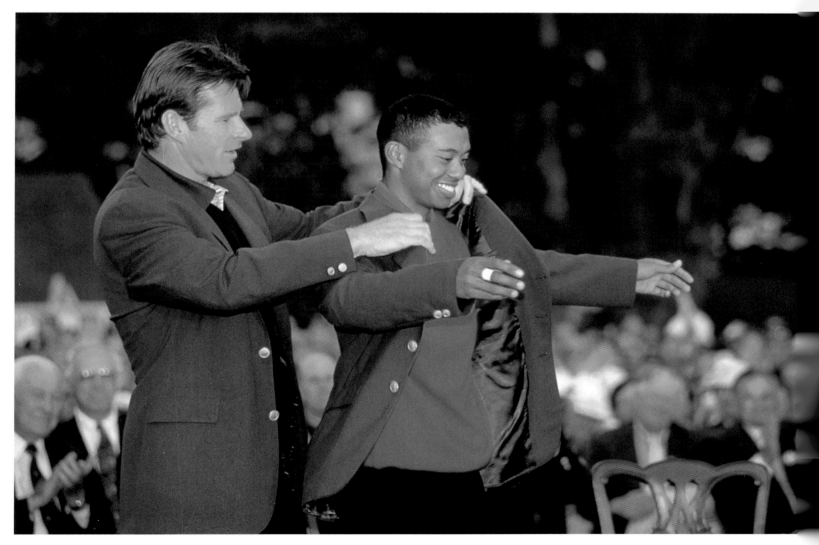

> LET'S GO TO THE VIDEOTAPE

Michael Jordan, unlike Alexander the Great, retired when he had no worlds left to conquer. Six titles in 13 years — including a second threepeat in June 1998 — and 29,277 points. So in early 1999 (with wife Juanita's O.K., as long as no more baseball), he rejected $21.2 million and went about his businesses. If Michael, 35, looked choked up, consider the NBA: It had no Air apparent.

JOHN BIEVER /
SPORTS ILLUSTRATED

< THE STARR CHAMBER

The president is a perjurer, and that's illegal, Kenneth Starr, 52, warned a House panel in November 1998. Starr had been appointed, under a Watergate-era act, to hunt for executive misconduct; his probe into a land scam resulted, four years later, in charges of sex and lies on videotape. The House impeached. The Senate acquitted. Starr was the last of two dozen independent counsels; Congress let the act lapse in 1999.

DAVID BURNETT / CONTACT

> A NEW CHASE BEGINS

Thirty-seven seasons after their dad hit a benchmark 61 home runs, Kevin Maris, 38 (near right), and brother Roger Jr., 39, greeted Mark McGwire, who had just nailed number 62. It was a year for going yard. Chicago Cub Sammy Sosa finished 1998 with 66, but McGwire, 34, outbashed him by four.

JOHN BIEVER /
SPORTS ILLUSTRATED

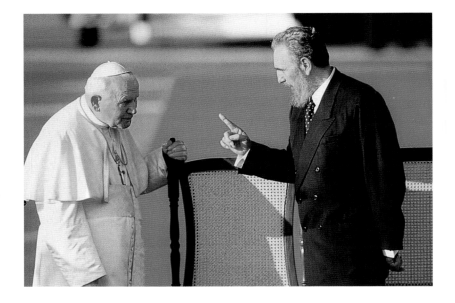

CUBA LIBRE? NOT TODAY

Fidel Castro, 71, had soft-
ened his antireligion policies
six years earlier, but he
was in no mood for the
sermon delivered by John
Paul II, 77, on a papal visit to
Cuba in January 1998. The
pontiff criticized his host's
poor human rights record.
However, he also criticized
the U.S. economic sanc-
tions against Cuba, levied
in 1962, "because they hurt
the most needy."

ANTONIO RIBEIRO / LIAISON

HOMOPHOBIA ON THE RANGE

Lured from a straight bar in
Laramie, Wyoming, a gay
college student was roped to
this fence in October 1998
after being beaten, burned
and robbed. Matthew
Shepard, 21, was barely
alive when found after 18
hours. His death five days
later was cheered on a
Web site run by a Kansas
minister: godhatesfags.com.

STEVE LISS / TIME

UNCONTROLLED GUNS

On a hilltop in Littleton,
Colorado, stood crosses for
the 15 victims of an April
1999 high school massacre.
Included were two for the
young shooters (one at far
right), who also wounded
23 (among them, Patrick
Ireland, inset). The pro-gun
NRA lamented this, as well as
seven earlier student ram-
pages that killed 17, but then
opened its convention in
nearby Denver anyway.

KEVIN MOLONEY / LIAISON
INSET: CNN

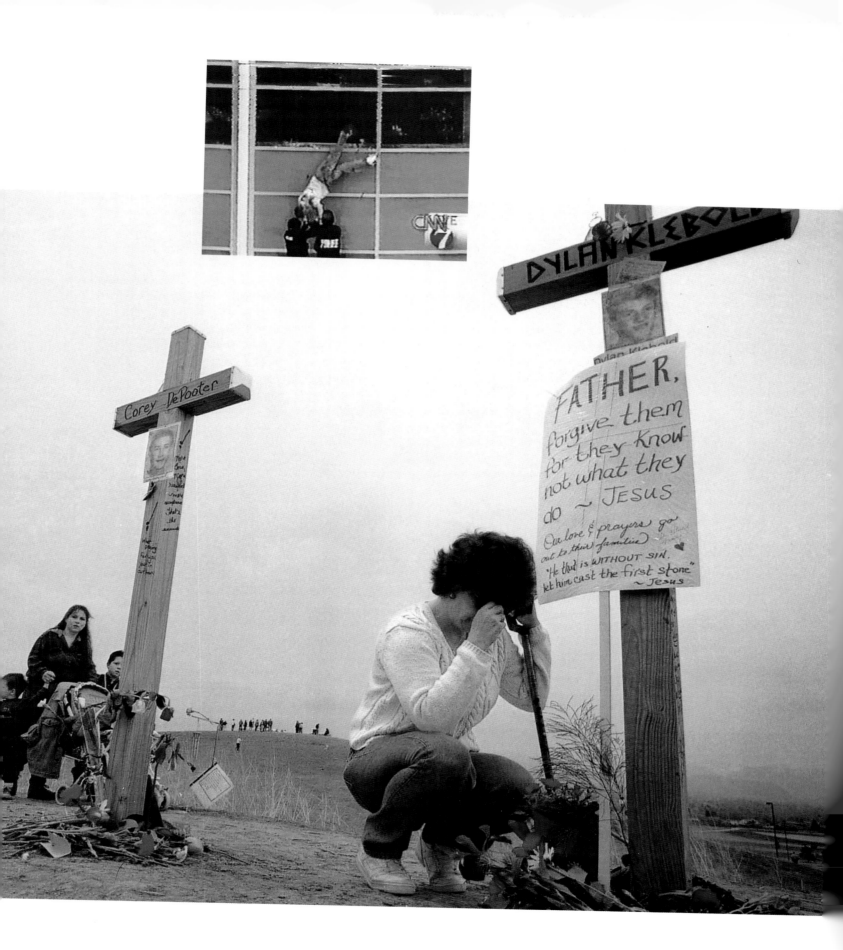

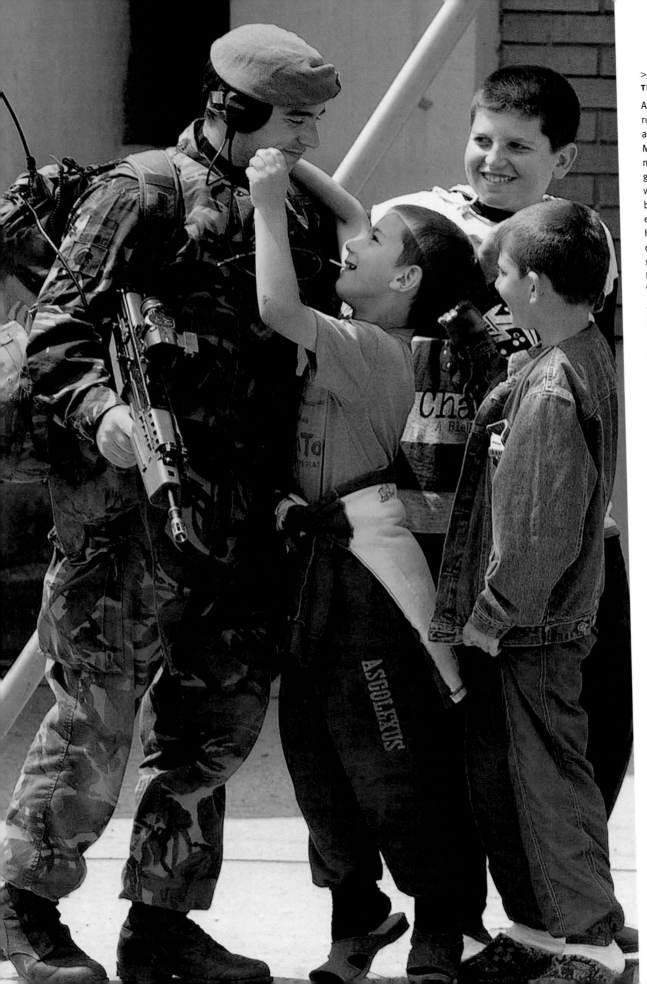

THE WHITE PEARL

As Pelé, Brazil's Black Pearl, ruled men's soccer a third of a century ago, so America's Mia Hamm, 27, has dominated the rising women's game. The Air Force brat was also the most visible beneficiary of Title IX, a law enacted three months after her birth that required colleges to fund women's sports. Hamm led Team USA to the 1999 Women's World Cup finals. They won.

CHUCK SOLOMON / SPORTS ILLUSTRATED

<

NO PLACE LIKE HOME

Welcoming a U.N. peace-keeper to Kosovo province in Yugoslavia in June 1999 was no stretch for these kids; restoring their lives would be. They and fellow ethnic Albanians had been targeted for "cleansing" by Belgrade. It was the latest sad chapter of a seven-year, religion-fueled civil war ruining the nation that had hosted 1984's sparkling Winter Games at Sarajevo.

YANNIS BEHRAKIS / REUTERS / ARCHIVE PHOTOS

WHAT'S THE NEXT MOVE?

By June 1999, Hillary Rodham Clinton, 51, and her husband, Bill, 52, had lived in public housing for 16 straight years. (Daughter Chelsea grew up without a place to call home.) Now their latest lease was nearing its end. Buy or rent? Because even if certain events were to keep them inside the Beltway, members of the Senate are not entitled to free digs.

STEPHEN JAFFE / CORBIS / BETTMANN-AFP

A GRRRL NAMED SUE

Air Jordan was grounded so the Second City turned its lonely eyes to another bigfoot (right, as modeled by paleontologists). Some 67 million years ago, the 40-foot-long, five-ton Sue — after Susan Hendrickson, who discovered the amazing fossil in 1990; its gender is unknown — ruled what is now South Dakota. Its 300-plus bones having been reattached, the T-rex is now ready to rule Chicago's Field Museum.

IRA BLOCK /
NGS IMAGE COLLECTION

REQUIEM

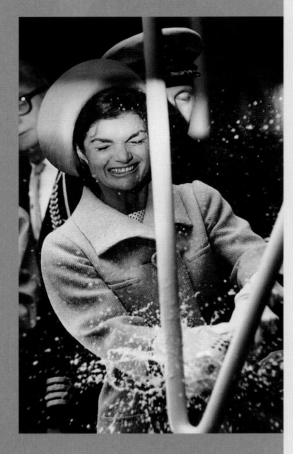

JACQUELINE KENNEDY ONASSIS, 1929–1994

The woman even world leaders called Jackie (to her discomfort) never shed a public tear despite reversals to make Sophocles weep. Two high-profile yet vacant marriages were by her design; one stillborn child, a second who lived but 40 hours and presidential widowhood were not. She was a working girl early and late in life. Her professional legacy does not draw our eye. Her personal grace surely does.

BILL EPPRIDGE / LIFE

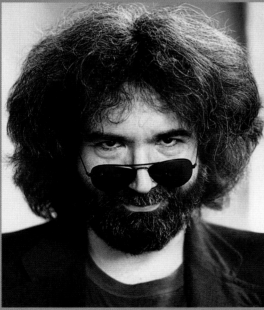

JERRY GARCIA 1942–1995

In Jerry's 30 years fronting the band, the Grateful Dead lived on tour, giving free-form concerts — powered by his extended guitar jams — that left fans glassy-eyed. Even those who were clean. Cherry Garcia was a witty name for an ice cream flavor, though he probably preferred Heavenly Hash. Garcia never did kick his drug habit; he was in rehab when the heart attack hit.

HENRY GROSSMAN

AUDREY HEPBURN 1929–1993

Her elfin charm, Euro-tinged English and swan's neck were captivating in movies from *Roman Holiday* to *My Fair Lady* to *Breakfast at Tiffany's*. When her career waned, Hepburn (who once subsisted on ground-up tulip bulbs in Nazi-ruled Holland) took on the role of UNICEF ambassador. While visiting famine victims in Somalia, she began to feel weak. It was cancer.

BOB WILLOUGHBY

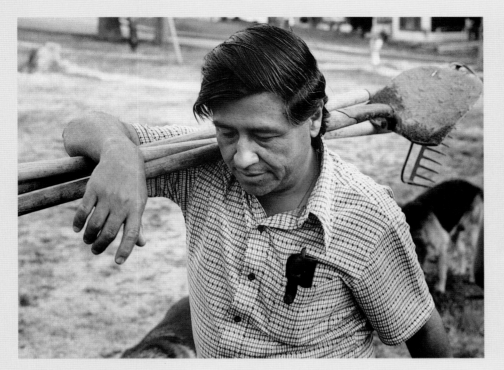

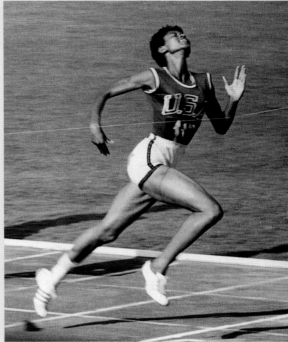

CESAR CHAVEZ
1927–1993

He taught Anglo-Americans the word *huelga*, or strike. Born in Yuma, Arizona, to migrant workers, he himself was a stoop laborer except for a Navy stint during World War II. In 1965, Chavez began a strike against California grape growers that was won in 1970. He soon organized other agribiz workers and, in 1977, even took on the Teamsters — and beat them.

BILL EPPRIDGE / LIFE

WILMA RUDOLPH
1940–1994

First she outran polio. Then she outran an impoverished childhood in rural Tennessee. In 1960, at the Rome Olympics, she outran the competition in the 100- and 200-meters, as well as in the sprint relay, to become the first American woman to win three golds at one Games. After hanging up her spikes, Rudolph worked in inner cities, showing kids the fastest way out.

MARK KAUFFMAN / LIFE

GEORGE BURNS
1896–1996

During his first career, which arced from vaudeville to radio to early TV, he was straight man for wife and comedy partner Gracie Allen (left). After her 1958 retirement, Burns claimed the punch lines — and delivered them winningly in movies (*The Sunshine Boys*, *Oh God*) and late-night talk shows until it was time to say, Good night, George. Good night, George.

ARCHIVE PHOTOS

JOHN F. KENNEDY JR.
1960–1999

Born two months before his family moved into the White House, the child spent his third birthday helping bury a dad hardly known. Kennedy did not enter politics despite his bloodlines and a surfeit of personal glamour, preferring to co-found a public affairs magazine. En route to a cousin's wedding the plane he was piloting crashed; on board were wife Carolyn, 33 (right), and sister-in-law Lauren Bessette.

DENIS REGGIE

ARTHUR ASHE
1943–1993

In 1968, he became the last amateur and first black to win the U.S. Open men's singles. When heart disease cut short his tennis career, Ashe took up an activism fostered by having to learn the game on segregated courts in Richmond, Virginia. To civil rights he would add championing other victims of AIDS, which he had contracted through a tainted transfusion.

JOHN ZIMMERMAN / LIFE

ALFRED EISENSTAEDT
1898–1995

On Martha's Vineyard in 1954 Eisie gazed into the other side of the lens. A German Jew, he arrived in the U.S. in time to become a charter *Life* photojournalist. His signature image was the Smooch (see page 214), but he also covered war, Americana, Hollywood and world leaders. The title of a 1966 anthology summed him up best: *Witness to Our Time*.

ALFRED EISENSTAEDT / LIFE

BENJAMIN SPOCK
1903–1998

The Common Sense Book of Baby and Child Care came out in
1946 — just in time for parents busy launching the Baby
Boom. Thus was the consulting pediatrician to a generation
blamed when some feed-on-demanders grew into hippies (or
worse). Dr. Spock decided a second opinion was needed, so
he shut his practice and joined the anti-Vietnam movement.

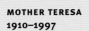
BOB GOMEL / LIFE

MOTHER TERESA
1910–1997

Along with a healer's hand, she had a fund-raiser's gift for
publicizing her empire of charity (right, with Princess Diana in
1997). At 18, Agnes Gonxha Bojaxhiu was sent by a Catholic
order to India. Twenty years later, she and her nuns began to
tend the leprous, the maimed, the dying. By the time Mother
Teresa won a 1979 Nobel, she oversaw 250 centers worldwide.

DIANA, PRINCESS OF WALES
1961–1997

At age 19, she accepted the proposal of a prince of the realm.
What followed was as if from a rock classic: *Every move you
make / Every vow you break / Every smile you fake / Every
claim you stake.* . . . Yes, we were watching her, always. And
we saw an adult life that began as a sanitized fairy tale con-
clude with a death macabre enough for the Brothers Grimm.

MIKE SEGAR / REUTERS / ARCHIVE PHOTOS

INDEX
TO PICTURES

Extended Picture Credits

While every effort has been made to give appropriate credit for photographs and illustrations reproduced in this book, the publishers will be pleased to rectify any omissions or inaccuracies in the next printing.

Page ii: NASA

Page 8, bottom: AMNH negative #336289, photocopy – P. Goldberg, courtesy Department of Library Services, American Museum of Natural History.

Page 16: Steinbrugge Collection, Earthquake Engineering Research Center, University of California, Berkeley.

Page 17, top: Picasso, Pablo; "Les Demoiselles d'Avignon." Paris (June–July 1907). Oil on canvas, 8′ by 7′8″ (243.9 by 233.7 cm). The Museum of Modern Art, New York. Acquired through the Lillie P. Bliss Bequest. Photograph, 1999, The Museum of Modern Art, New York.

Page 19: Millstein Division of U.S. History, Local History & Genealogy, The New York Public Library, Astor, Lenox and Tilden Foundations.

Page 20: Millstein Division of U.S. History, Local History & Genealogy, The New York Public Library, Astor, Lenox and Tilden Foundations.

Page 21, top: Brown Brothers.

Page 25, top: Millstein Division of U.S. History, Local History & Genealogy, The New York Public Library, Astor, Lenox and Tilden Foundations.

Page 29, top right: Courtesy of Colorado Historical Society, negative #F4715.

Page 37, top: Canadian National / Illinois Central.

Page 52, top right and bottom left: Harry Ransom Humanities Research Center, The University of Texas at Austin.

Page 55, top right: Halsman Estate.

Page 77, top right: S0117495, 40-12-05/10, color transparency. Bazille, Frédéric (1841–1870). Pierre Auguste Renoir, painter. Oil on canvas, 1867. 62 x 51 cm. Musée d'Orsay, Paris, France.

Page 81: Romana Javitz Collection, Miriam and Ira D. Wallach Division of Arts, Prints and Photographs, The New York Public Library, Astor, Lenox and Tilden Foundations.

Page 93, bottom: Photography by Egyptian Expedition, the Metropolitan Museum of Art.

Page 134: Vandamm Studio, The New York Public Library for the Performing Arts, The Billy Rose Theatre Collection.

Page 136, top: Dever / Black Star.

Page 146, bottom left: AMNH negative #325024, courtesy Department of Library Services, American Museum of Natural History.

Page 154, top left: Dever / Black Star.

Page 157, right: Liaison Agency.

Page 159, right: Reprinted with permission of Joanna T. Steichen.

Page 187: Mondrian, Piet; "Broadway Boogie Woogie" (1942–43). Oil on Canvas, 50 x 50″ (127 x 127 cm). The Museum of Modern Art, New York. Given anonymously. Photograph © 1999 the Museum of Modern Art, New York.

Page 217, bottom: S0075506, 40-12-11/66, color transparency. Munch, Edvard (1863–1944). "Self-Portrait, the Night," 1923. Munch Museum, Oslo, Norway.

Page 219, top left: Photograph, DN-003882, Emma Goldman, Chicago (Ill.), 1906; Photographer – Chicago Daily News Collection.

Page 230: Harry Ransom Humanities Research Center, Photography Collection, The University of Texas at Austin.

Page 239, top right: Harry Ransom Humanities Research Center, Photography Collection, The University of Texas at Austin.

Page 276, top right: S0114138, OC54.002, color transparency. Warhol, Andy (1928–1987). "Campbell's Soup Can, 19¢," 1962. Synthetic polymer paint and silkscreen ink and graphite on canvas; 72 by 54 inches.

Page 403, bottom: AMNH negative #315447, courtesy Department of Library Services, American Museum of Natural History.

Page 424: Material created with support to AURA/ST ScI from NASA-26555 is reproduced here with permission. Courtesy of Jeff Hester and Paul Scowen (Arizona State University) and NASA.

LIFE: Our Century in Pictures

Editor: Richard B. Stolley
Deputy Editor and Writer:
Tony Chiu
Designer: Susan Marsh
Picture Editor: Debra Cohen
Researcher: Carol Weil
Copy Editor: Richard McAdams
Associate Writer: Leslie Jay

Special thanks to Sheilah Scully, Ellen Graham, Gretchen Wessels (photo researchers), Kelli Green, Daniel Chui (scanners), Pamela Wilson, Annette Rusin, Brenda Cherry (researchers), Jill Jaroff (copy editor), Delia Chui (indexer), Sally Proudfit, Bob Jackson, Helene Veret, and Jennifer McAlwee.

Produced in cooperation with Time Inc. Editorial Services
Director: Sheldon Czapnik
Research Center: Lany McDonald
Picture Collection:
Beth Iskander, Kathi Doak
Photo Lab: Tom Hubbard
Time-Life Syndication:
Maryann Kornely

Life Magazine
Managing Editor: Isolde Motley
Publisher: Donald B. Fries

Published by Time Warner Trade Publishing
Chairman, Time Warner Trade Publishing: Laurence J. Kirshbaum
Publisher, Bulfinch Press:
Carol Judy Leslie
Senior Editor, Bulfinch Press:
Terry Reece Hackford
Production Manager,
Bulfinch Press: Sandra Klimt

FIRST EDITION
SIXTH PRINTING, 2000
ISBN 0-8212-2633-9
Library of Congress Catalog Card Number: 99-64899
PRINTED IN THE
UNITED STATES OF AMERICA

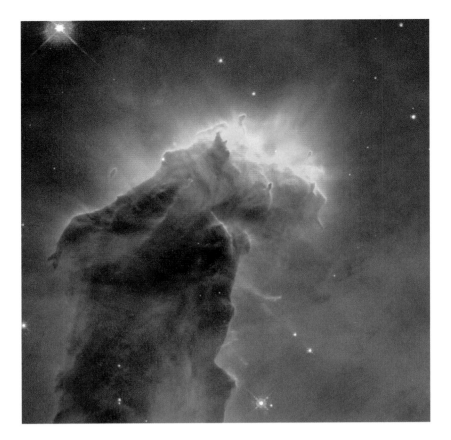

Seven thousand years ago, this is how one sector of the Milky Way looked.
Thanks to certain advances on earth in the last 100 years, we are able to capture light that
originated in deep space, and the deep past, and to interpret the snapshot (taken by the Hubble
telescope, orbiting above atmospheric distortion since 1990). Shown is a pillar of matter
in the Eagle Nebula. Within this celestial womb, stars are being born.

HESTER AND SCOWAN / NASA

LIFE: OUR CENTURY IN PICTURES

———————

DESIGNED BY SUSAN MARSH

PICTURES EDITED BY DEBRA COHEN

———————

COMPOSED IN META AND ITC BODONI BY RICHARD MCADAMS AND SUSAN MARSH

SEPARATIONS BY PROFESSIONAL GRAPHICS INC., ROCKFORD, ILLINOIS

PRINTED AND BOUND BY R.R. DONNELLEY & SONS COMPANY, WILLARD, OHIO,

AND QUEBECOR PRINTING, KINGSPORT, TENNESSEE